AHMANSON · MURPHY
FINE ARTS IMPRINT

THE AHMANSON FOUNDATION
has endowed this imprint
to honor the memory of
FRANKLIN D. MURPHY
who for half a century
served arts and letters,
beauty and learning, in
equal measure by shaping
with a brilliant devotion
those institutions upon
which they rely.

THE PUBLISHER GRATEFULLY ACKNOWLEDGES THE FOLLOWING
INDIVIDUALS FOR THEIR GENEROUS SUPPORT OF THIS BOOK.

BENEFACTORS

ANONYMOUS

JANET M. & WILLIAM F. CRONK

JUDY & BILL TIMKEN

SUPPORTERS

ANONYMOUS

JANE & JACK BOGART

MR. & MRS. RICHARD C. OTTER

THE PUBLISHER ALSO GRATEFULLY ACKNOWLEDGES THE GENEROUS
CONTRIBUTION TO THIS BOOK PROVIDED BY THE ART ENDOWMENT FUND
OF THE UNIVERSITY OF CALIFORNIA PRESS FOUNDATION, WHICH IS
SUPPORTED BY A MAJOR GIFT FROM THE AHMANSON FOUNDATION.

YOSEMITE

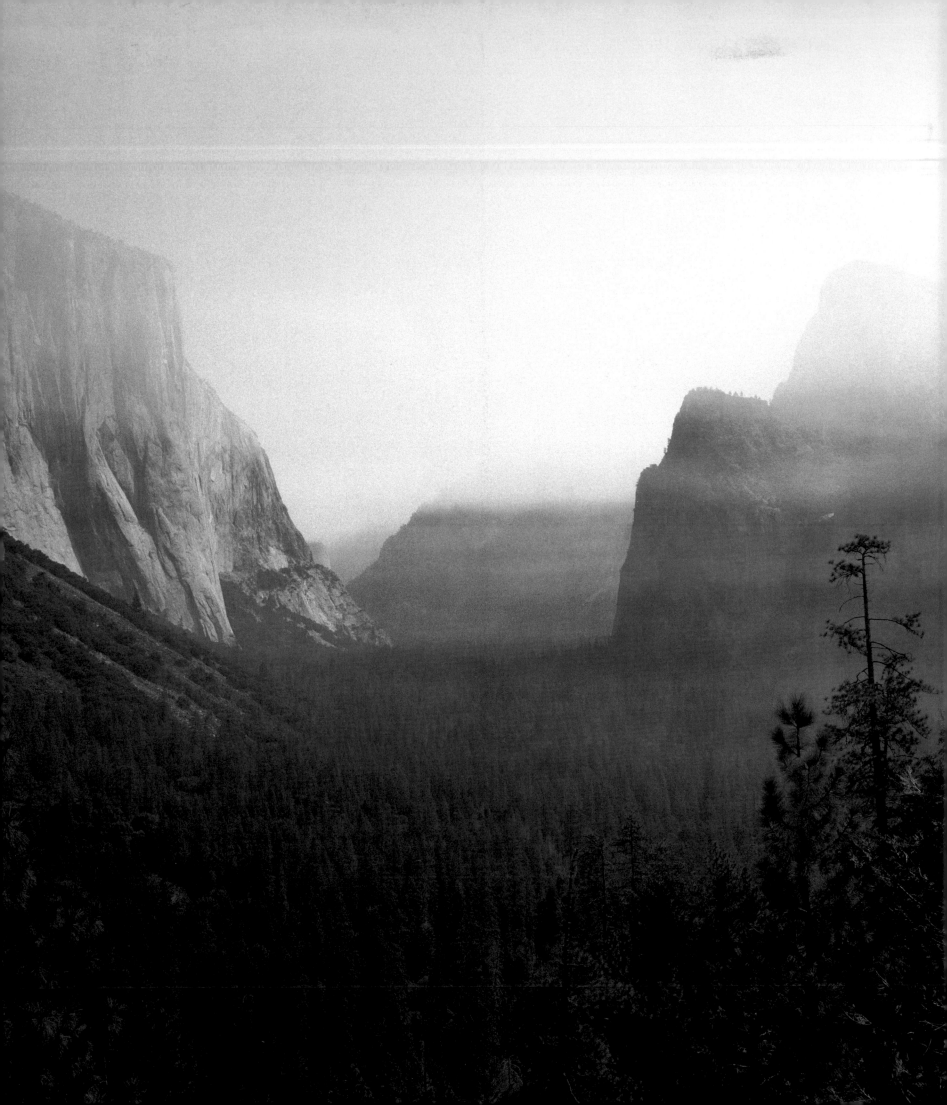

ART OF AN AMERICAN ICON

YOSEMITE

EDITED BY AMY SCOTT

AUTRY NATIONAL CENTER LOS ANGELES

IN ASSOCIATION WITH

UNIVERSITY OF CALIFORNIA PRESS BERKELEY LOS ANGELES LONDON

CONTENTS

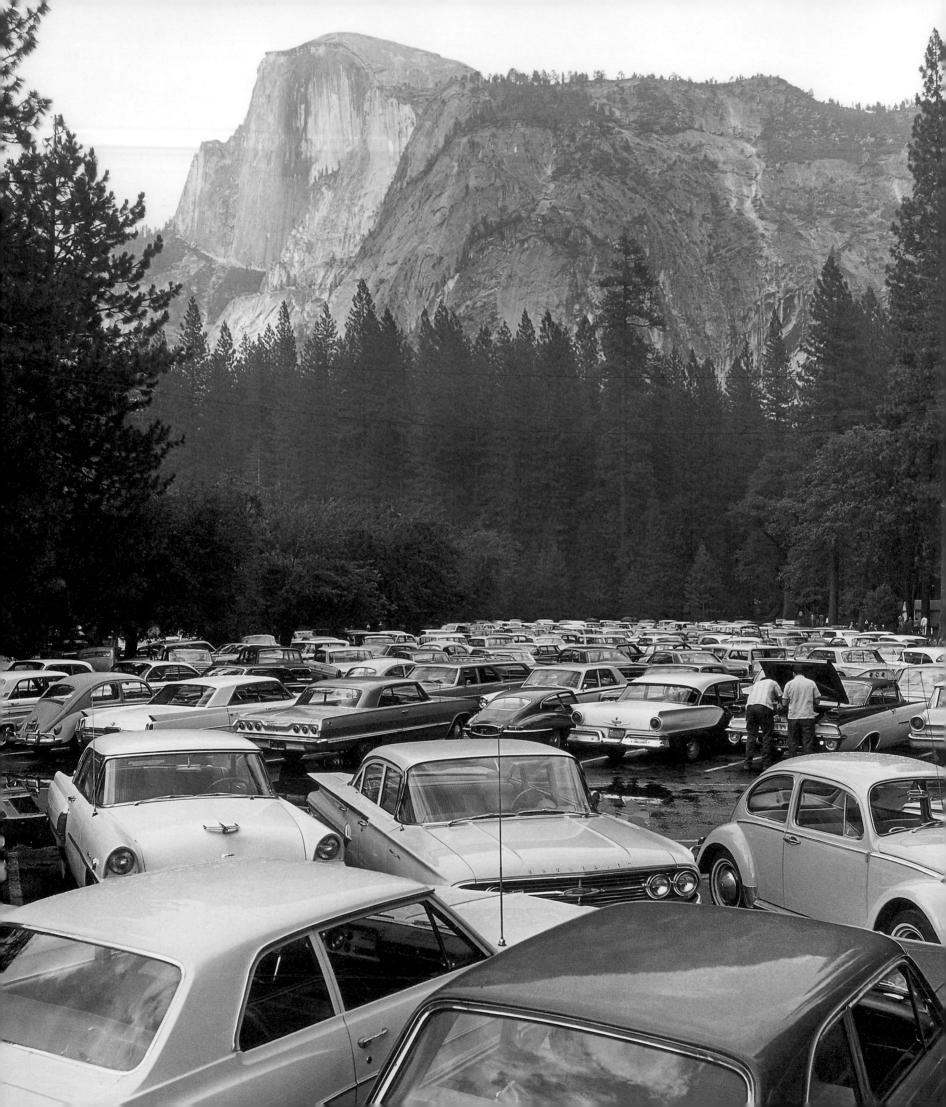

YOSEMITE CALLS

EACH YEAR, MORE THAN THREE MILLION PEOPLE enter Yosemite National Park, the majority on Highway 41. As they wind down the forested, two-lane road, visitors glimpse massive walls of granite emerging slowly from behind the trees, until they round a corner and suddenly find themselves in front of the three-thousand-foot face of El Capitan. Confronted with nature on such an imposing scale, many pull over on the shoulders provided for the occasion. Windows roll down and hatchbacks pop open; cameras are fished from bags and glove compartments. Fingers point as tripods are set up; shots are framed and shutters click.

In Yosemite, visitors encounter nature but see a work of art.[1] Yosemite has long been a place defined by its image, and whether we are aware of it or not, our visceral experience is conditioned by the perceptual framework we bring to the park. Long before our first visit, most of us have an idea of what Yosemite looks like and what it is about. This knowledge helps us frame our encounter with El Capitan, Yosemite Falls, Half Dome, and Yosemite in its entirety, and to understand our experience in visual terms. If the landscape seems marred by crowds or smog, it may be because the presence of such urban blights runs contrary to what decades of artistic production have led us to believe Yosemite should be. If we see the park in more modern terms, as a geological wonder and delicate ecosystem struggling to coexist with the demands of ever-increasing visitation, it is because we recognize how Yosemite's culturally constructed appeal

RONDAL PARTRIDGE
Pave It and Paint It Green (detail; see p. 131)
© 2003 Rondal Partridge

1

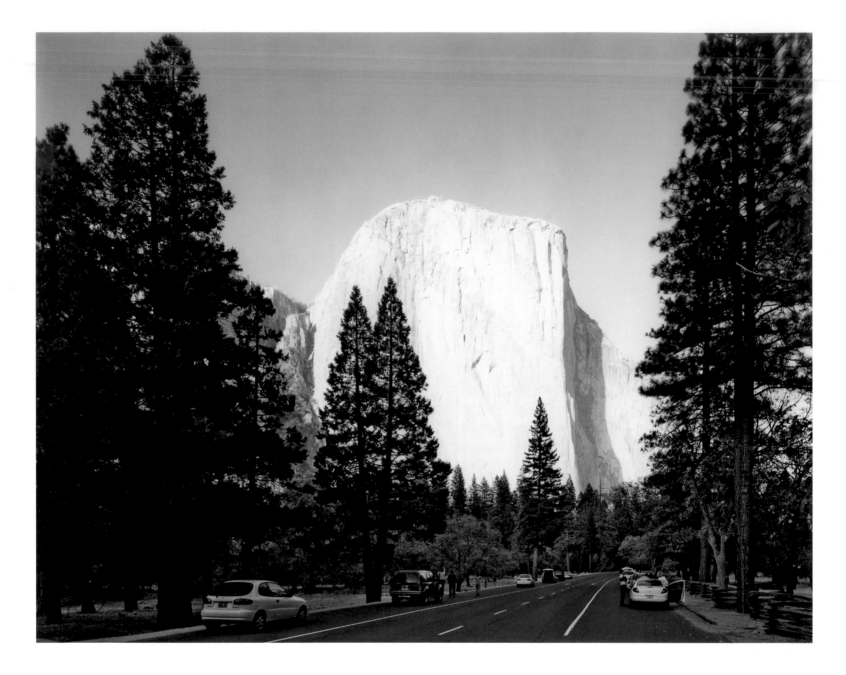

THOMAS STRUTH
El Capitan, 1999, C-print
Collection of Diane L. Butler.
Courtesy Marian Goodman Gallery, New York.
© Thomas Struth

has also become its undoing. If we choose to leave the valley altogether and camp somewhere in the backcountry, it is in the hope of finding an experience closer to the one that earlier artists envisioned. Or, if we file into one of the bustling valley gift shops in search of an Ansel Adams postcard along with thousands of others on a hot summer day, it is because we want a piece of the image that lured us to Yosemite in the first place, regardless of whether our own experience measures up.

Seeing Yosemite in artistic terms is a long-standing American practice, one that began

when an artist, Thomas Ayres, first entered the valley in 1855. By the 1860s, John Muir was engaged in his lifelong advocacy of the Sierran landscape. Using metaphors of divine artistry, he described how Yosemite had been "sculpted" from receding glaciers that had widened and deepened the valley over 250,000 years. Where ice once had been, Muir saw a "strikingly perfect" grand design, filled with architectural nuance in the form of natural domes, towers, fountains, and amphitheaters, all embellished by gardens and groves.[2] Muir, who was acquainted with many of Yosemite's more prom-

inent artists of the era, was both a visionary and a Victorian, and his way of seeing Yosemite would inform popular ideas about the role of wilderness in American society for decades to come.

An inherent premise of this book is the notion that art has played a major role in turning Yosemite into a defining icon of American nature, as well as in obscuring that for which it is celebrated. Artists were Yosemite's earliest and most effective proselytizers, and along with their paintings and photographs of its scenery, they sold promises of a spiritually and culturally important experience within America's ambitious program of bicoastal expansion. From Yosemite's geological phenomena and within an intellectual climate of scenic preservation, artists created an ultimate Western destination, one that fully merited the rugged journey to the valley floor in the days prior to its access by rail and auto. Displayed to the world in the 1860s, in New York, London, and Paris, their paintings and photographs framed Yosemite's geology in grand, picturesque terms, proclaiming the valley's spectacular scenery as the epitome of the sublime. It mattered that they saw it this way, and not as the first Euro-Americans had seen the Grand Canyon—as inhospitable and forbidding[5]—or as its Native inhabitants saw the valley—as a seasonal home, food source, and sometimes dangerous place inhabited by malicious spirits. Rather, artists elevated Yosemite in pictorial and conceptual terms above other Western places. Their work helped ensure that it emerged in the public view not as a natural barrier or as someone else's home, but as a cultural asset rich in metaphors that supported the national agenda of expansion.

As they popularized Yosemite as a symbol and a destination, early artists also positioned the valley's Native inhabitants as exotic decorations, establishing a dynamic between visitors and Native people that would exist for decades to come. This happened despite the largely unrecognized fact that the picturesque, highly photogenic landscape so admired by artists owed much to the Miwok. For perhaps thousands of years, Miwok had managed the vegetation in the valley; through regular burning, pruning, and careful hunting and harvesting, they prevented the encroachment of trees into meadows, kept the forests open and free of underbrush, and maintained the health and diversity of the valley's ecosystems.[4] Yet in the Yosemite envisioned by painters and photographers, the region's Native population is cast aside, relegated most often to the corners of pictures as decorations in an otherwise "untouched" wilderness; in this Yosemite, Indians inhabit the valley without affecting it, and they exist primarily for the viewing pleasure of whites.

These artists' work helped the U.S. Congress visualize a version of nature worthy of federal protection and enticed untold numbers of future visitors to the region. By the time Yosemite was established as a national park in 1890, therefore, it was one of the most recognizable landscapes in the country. Large, panoramic oils by Albert Bierstadt could be found on the walls of newly built mansions from California to Connecticut; chromolithograph versions of these were tastefully framed in Victorian parlors everywhere. Mammoth-plate photographs by Carleton E. Watkins and Eadweard J. Muybridge graced public galleries and private libraries; albumen prints by George Fiske, Julius T. Boysen, and others filled the scrapbooks of adventuresome leisure seekers.

Just as artists made Yosemite a cultural symbol and tourist destination, its exceptional geological features have had an effect on art production. By the nature of its physicality, size, and symbolic potential, as well as the demand for images and artworks that convey all this, Yosemite has represented a challenge for many artists, and they have responded with creative and technical innovations that have pushed the broader histories of landscape painting, photography, and basketry in new and significant directions. Carleton E. Watkins made photographic history when he designed a mammoth-size camera around a glass-plate negative large enough to photograph the valley's monuments and the big trees of the Mariposa Grove. Albert Bierstadt redefined both the physical scale and the market economics of American landscape painting with the monumental *Domes of the*

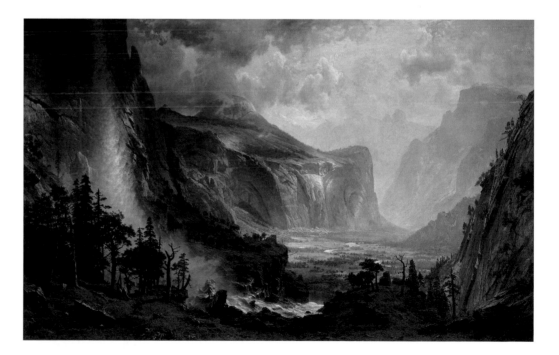

ALBERT BIERSTADT
The Domes of the Yosemite, 1867, oil on canvas
Collection of St. Johnsbury Athenaeum, St. Johnsbury, Vermont

Yosemite (1867), which sold for what was at the time a remarkably hefty price. In the twentieth century, Native weaver Lucy Telles's four-foot-wide, prize-winning creation for the 1939 Golden Gate International Exposition established new physical, technical, and aesthetic standards for basket weaving that rivaled in ambition and artistry the grand landscapes of Bierstadt. In the 1920s, as Telles was gaining increasing recognition as an artist, a young

Ansel Adams was embarking on a career that would soon establish the camera as the definitive creative tool of Yosemite imagery and considerably broaden the popular appeal of landscape photography. The Yosemite experience has been a memorable one for many of the artists who have visited the park, regardless of how long they stayed or what they saw while they were there. The modernist painter William Zorach described his time in the

CARLETON E. WATKINS
The First View of the Yosemite Valley, ca. 1866,
mammoth-plate albumen print
Courtesy California State Library, Sacramento

valley as "ecstasy," and Georgia O'Keeffe recalled that her first visit there—in 1938, with Adams—was "among the best things I have ever done."[5]

Commodification often undermines that which it celebrates, however, and Yosemite is no exception. In 2004, the park drew almost 3.3 million people, most of whom spent much or all of their time in the valley, in search of an experience in nature transcending the ordinary. Yosemite, like all national parks, has its share of commercially developed spaces and boundaries; these are especially dense in the valley, where they create many degrees of separation from the natural world. This built environment has affected artists in multifaceted ways. For many, the ever-increasing presence of hotels, parking lots, and trash cans runs contrary to Yosemite's essence—and yet tourists, along with concessionaires and boosters, have also provided important patronage, an irony inherent in some of the more famous images of the park, including those by Ayres, Bierstadt, and Adams, to name but a few. Adams's best-known work, beginning with his breakthrough *Monolith: The Face of Half Dome* (1927, p. 124), celebrates the park as an inspiring example of nature at its most grand, but he also took on numerous commercial commissions, such as *Half Dome from the Glacier Point Hotel* (1929, p. 125), in which the same rock is now framed by two tourists dressed in their cowboy best. While Adams's tourists have clearly embraced the adventurous spirit of the place, evidenced by their rugged boots and chaps, their involvement in the scenery is literally marginal.

A thorough art history of Yosemite is important for the same reasons that Adams was capable of immortalizing the very side of the park that the rest of his work sought to eschew. Despite being one of the most visited national parks in the country, Yosemite is a place where, on a summer day at the peak of the tourist season, one can walk thirty minutes from the packed visitor center and be more or less alone, trudging up toward Upper Yosemite Falls. As the cars and people on the valley floor grow smaller, the more the scenery resembles Adams's *Monolith,* or even Bierstadt's *Domes of the Yosemite,* and the closer one feels to

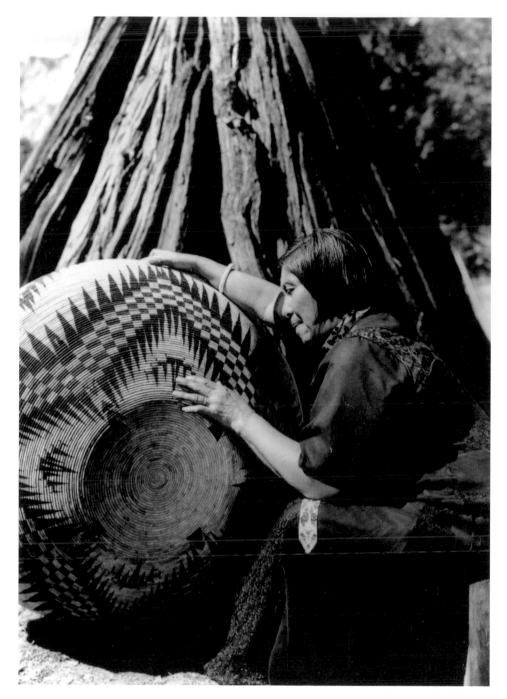

Lucy Telles and her big basket, ca. 1933
The Yosemite Museum, Yosemite National Park

approaching what the park is really about— or at least what Adams wanted us to think it is about. In Yosemite, the process of negotiating the tension between wilderness and nature on the one hand and development and commercialism on the other is both highly visible and ongoing. Even before the establishment of Yosemite as a national park, art played a central role in this process, and it continues to do so.

The art history of Yosemite thus provides an intriguing window into the dynamics of a relationship that has become one of the key themes of modern history. By exploring and updating the visual history of Yosemite, this publication reveals the concrete details of a process that can help us better understand the role of wilderness in an urban society.

———

The chapters that follow expand on the extant bodies of literature on American, California, Sierra Nevada, and Yosemite art history. Each is focused on a specific medium and era, offering a succinct history of a distinct genre and its key figures. Together, the chapters provide a comprehensive perspective on the evolution of Yosemite art and the changing ideas regarding nature, visitation, and park development it represents, and they encourage readers to think critically about the role art has played in shaping and defining popular conceptions of Yosemite as both a pristine wilderness and a sought-after tourist destination.

William Deverell's context-setting essay begins with the moment John Muir and Ralph Waldo Emerson come together in Yosemite in 1871 and goes on to describe the park as a meeting place where creative sparks fly. Emphasizing the continuity from Emerson to Muir to Adams, Deverell presents the joint vision of the latter two as an exemplification of Yosemite's status

as a cultural beacon. Kate Nearpass Ogden takes Bierstadt's work as a starting point to focus on the depiction and reception of Yosemite as the epitome of the sublime. Drawing on a vast body of literature devoted to Bierstadt and his genre, Ogden casts Bierstadt as the catalyst for the dominant practice of framing Yosemite as the grand standard of wilderness, while also examining the religious connotations of his work, its market economics, and its implications for Yosemite's developing tourist industry. Gary Kurutz's chapter on pioneer landscape photography shows the field being pushed in new directions as early photographers developed innovative tools to capture Yosemite's scenery.

Brian Bibby's chapter on Native art in the Yosemite region serves as a bridge between the nineteenth and twentieth centuries. Focusing primarily on baskets, first as functional objects and then as innovative artworks transformed by the demands of a growing market, Bibby positions Miwok and Mono Lake Paiute basketry as a substantive genre and an integral part of Yosemite's aesthetic history. Native Americans have long played a significant role in the visual experience of Yosemite, both as artists and as subjects of art. By weaving their presence into the story of Yosemite's art, this publication presents a more thorough and thoughtful history.

With the onset of the twentieth century, Bierstadt's romantic torch passed to Adams. Jennifer Watts considers Adams in this light, revealing his images of Yosemite to be the vehicle for the persistence of the sublime in American photography. Twentieth-century paintings of Yosemite are the topic of the book's final chapter. This is perhaps the least-traveled road in the existing literature, for Yosemite has long been considered the exclusive realm of the romantic artist. Yet twentieth-century painters, from Maurice Braun and Maynard Dixon to Georgia O'Keeffe and Wayne Thiebaud, continued to encourage experimentation in representations of the park, proving that Yosemite's artistic sheen remains bright.

Thanks to artists, Yosemite is—and long has been—a widely shared experience. Like much of the West, Yosemite remains an imagined place; art has shaped the way that we think about it, see it, use it, and protect it. Yosemite's monuments, its many visitors, and the infrastructure that enables and supports their presence are all part of a scene constructed over time. As both part of and witness to the modern experience, the ever-increasing crowds now also help ensure the ongoing cultural relevance of Yosemite as an important American landscape. Because visitation will undoubtedly keep rising, the work of artists in helping us see Yosemite as its earliest advocates intended—as a work of art—will also continue.

NOTES

1. Rebecca Solnit, *Savage Dreams: A Journey into the Land-
 scape Wars of the American West* (1994; Berkeley:
 University of California Press, 1999), 256. Solnit's
 statement on Euro-Americans' perceptions of Yosem-
 ite as art is in reference to Lafayette Bunnell, who
 wrote a fanciful account of the first Euro-American
 impressions of the valley (see Lafayette Houghton
 Bunnell, *Discovery of the Yosemite: And the Indian
 War Which Led to That Event* [Chicago: Flemming H.
 Revell, 1880]).

2. John Muir, *The Yosemite* (Boston: Houghton Mifflin,
 1912; reprint San Francisco: Sierra Club Books, 1988),
 chapter 11: "The Ancient Glaciers: How the Valley Was
 Formed."

3. See Wallace Stegner, *Beyond the Hundredth Meridian:
 John Wesley Powell and the Second Opening of the West*
 (1954; New York: Penguin Books, 1992), illustration
 insert following 92.

4. M. Kat Anderson, *Tending the Wild: Native American
 Knowledge and the Management of California's Natural
 Resources* (Berkeley: University of California Press,
 2005), 3, 156, 171, 334.

5. Georgia O'Keeffe to Ansel Adams, 8 July 1958, Cen-
 ter for Creative Photography, University of Arizona,
 Tucson.

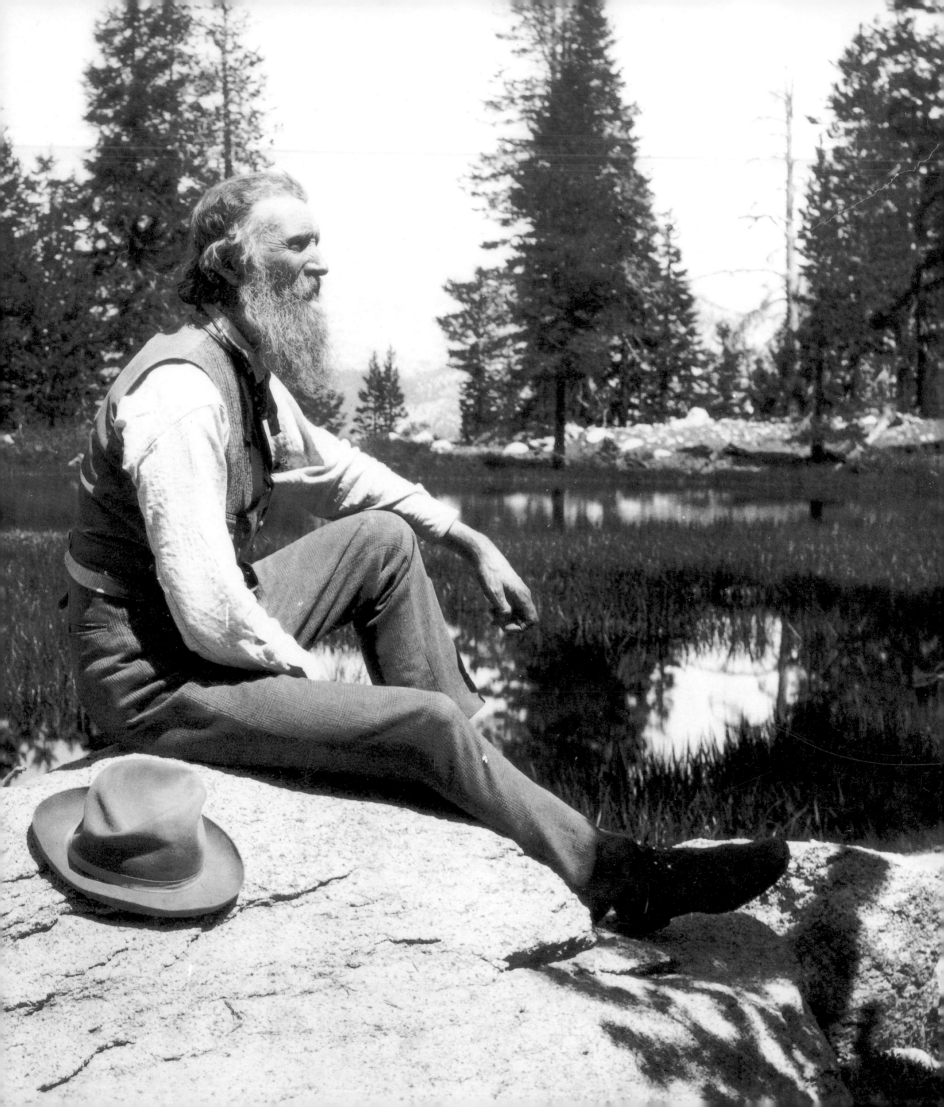

WILLIAM DEVERELL

"NIAGARA MAGNIFIED"

FINDING EMERSON, MUIR, AND ADAMS IN YOSEMITE

I pressed Yosemite upon him like a missionary offering the gospel.

—John Muir, *My First Summer in the Sierra*

IN THE SPRING OF 1871, the sage of Concord crossed the length of America and met the hermit of Yosemite. Ralph Waldo Emerson, frail and nearing seventy, took the new transcontinental railroad all the way to California, then traveled on to Yosemite, where John Muir, then thirty-three and at the peak of his physical and mental powers, was at work in the sawmill he had built himself. News of Emerson's presence in the vicinity thrilled Muir, and he marveled that the two might meet. "I was excited as I had never been excited before," he later wrote, "and my heart throbbed as if an angel direct from heaven had alighted on the Sierran rocks."[1]

Muir quickly sent Emerson a note beseeching him to linger long enough for the two to become acquainted face-to-face and maybe even venture out for a "months [*sic*] worship with Nature."[2] Struck by the intensity and emotion of the request, Emerson and his party visited the sawmill. Muir was captivated, as he knew he would be, by their brief time together. He taught Emerson about evergreen trees, offered plant specimens and drawings, and tried—without success—to convince Emerson to camp out overnight beneath a canopy of giant Sierra redwoods. "You," Muir famously said to Emerson, "are yourself a Sequoia. Stop and get acquainted with your big brethren."[3] But Emerson's companions and caretakers insisted (much to Muir's disappointment) that the older man required a warm bed to ward off the chill of the mountain night.

John Muir, ca. 1902
Library of Congress, Prints and Photographs Division

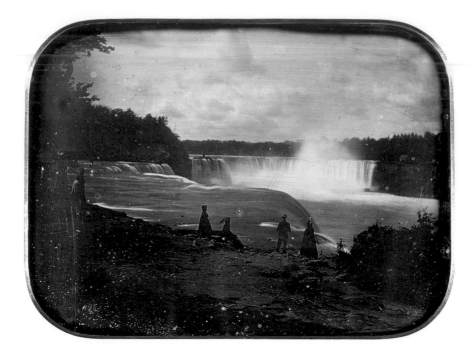

PLATT D. BABBITT
Tourists at Niagara Falls,
1854, whole-plate daguerreotype
Collection of Jim Farber

had assumed the role of teacher during their time together—and it was about nature that he taught Emerson. After their farewell, Muir would go on to succeed Emerson as the nation's representative thinker on nature.

Emerson's visit also signals the highly significant rise of Yosemite as the representative emblem, the heart, of American nature. It is remarkable that Emerson traveled west at all—not because of his infirmity, but rather because he was so closely identified with the Atlantic seaboard. Muir, on the other hand, was assuredly of the West, at least by the time he and Emerson met; a wanderer, he had nonetheless adopted the region (especially the Sierra Nevada) as his home upon his arrival in California shortly after the close of the Civil War. Symbolically at least, the meeting of Emerson and Muir meant that the New England woods and ponds would no longer fully represent the American environment. Following the directive of his ingenious protégé Henry David Thoreau, Emerson had gone "westward as into the future"[5]: in discovering Muir's Walden, he found the future of American nature.

Muir was delighted to the point of giddiness by his meeting with Emerson, but he just as clearly impressed the transcendentalist. Emerson was struck by Muir's intellect and tried to lure him back east, both because he wished for him to become known in the intellectual circles in which he traveled and, one suspects, because he felt the stirrings of a mentor's regard for the rough-hewn naturalist. Were Muir to come east, Emerson could teach *him*. "I have everywhere testified to my friends, who should also be yours, my happiness in finding you," Emerson wrote Muir upon his return to Concord. The time had come, he continued, for Muir to end his "probation and sequestration in the solitudes and snows" and "bring your ripe fruits so rare and precious into waiting Society."[6]

Emerson likely imagined that Muir would fill intellectual and other voids in his transcendentalist world. Thoreau had died a decade earlier. The Universalist and Unitarian preacher Thomas Starr King had left New England for a San Francisco pulpit, thereafter becoming enraptured by Yosemite.[7] It is possible

Even so, Emerson, ever curious, wished to learn about the things that Muir knew so well. Muir eagerly obliged, describing to Emerson the plant and animal life, as well as the geological complexities, of Yosemite Valley and the adjacent environs. The two men got along. And while it is perhaps too neat an equation to suggest that Emerson passed a torch to his younger companion, there is nonetheless that kind of significance woven into their meeting. We can see it especially well by virtue of the hindsight gained through more than a century's passing, knowing what we now know about the legacies of Emerson, Muir, and Yosemite itself.

They seem to have sensed the power of their meeting as well. As the Emerson group rode out of Yosemite Valley, Muir followed them south to the edge of the Mariposa Grove and watched them depart. Emerson, he later wrote, "lingered in the rear"; as he crested the summit, silhouetted alone against the skyline, the aging intellectual giant of nineteenth-century America turned his horse, took off his hat, and "waved me a last goodbye."[4]

That farewell bespeaks a profoundly symbolic moment in American history. Emerson, the embodiment of American transcendentalism, had met Muir, who would embody what came to be called American environmentalism. Muir

that Muir's spiritual bearing and his magnetic attraction to Yosemite reminded Emerson of King.[8] In any case, Emerson may have imagined that Muir could somehow assuage the sad loss of Thoreau and King.

Emerson pressed upon what he correctly divined as Muir's own loneliness in attempting to lure him east. "There are drawbacks also to Solitude, who is a sublime mistress, but an intolerable wife," he wrote. "So I pray you to bring to an early closure your absolute contracts with any yet unvisited glaciers or volcanoes, roll up your drawings, herbariums and poems, and come to the Atlantic coast."[9]

Despite Emerson's pleas, Muir did not go east during the poet's remaining ten years of life. Nor did Emerson again come west, despite Muir's equally elegant pleas that he do so. "You cannot be content with last year's baptism," Muir wrote. "'Twas only a sprinkle. Come be immersed."[10]

Chief among the reasons for Muir's resistance to Emerson's requests were the Sierras, especially the landscape of Yosemite Valley and its surrounding ridges, peaks, and valleys.[11] He would not leave Yosemite for another two years after Emerson's visit—and only in 1893 would he make a pilgrimage to Concord's Sleepy Hollow Cemetery to visit the graves of Emerson and Thoreau. Despite his coaxing, Emerson seems to have understood Muir's reluctance; having seen for himself the West's environmental wonders, Yosemite first among them, Emerson had earlier admitted that, once in California, "no young man would come back from it."[12]

Had Muir's meeting with Emerson taken place in the writer's Concord study, their encounter would have meant, and would have symbolized, far less. For their meeting to represent such a critical cultural and symbolic shift in American ideas about nature, it *had* to take place in Yosemite. Few other places in the United States play such a crucial role in the American imagination as Yosemite. The origins of its exceptional cultural power rest in the life and passion of John Muir. But they also lie in Emerson's visit and meeting with Muir.

Emerson's meeting with Muir in Yosemite is the stuff of novels, something that would have been wished for or imagined had it not happened for real. Their encounter is also an exclamation point of sorts, highlighting Yosemite's rise in importance and stature across the nation during the post–Civil War period. The New England editor Samuel Bowles perfectly captured what Yosemite would rapidly come to mean when he described it, in 1866, as "Niagara, magnified."[13] Whereas Niagara's grand falls had been central to the conception of American nature prior to the Civil War, Yosemite usurped this position in the national psyche in the postwar years, and it did so very quickly.[14]

The "magnification" of Yosemite's meaning began in the early 1860s, when photographers, painters, and writers produced a wealth of Yosemite narratives and images that were distributed nationally. The responsive awe rippled east almost audibly. By 1864, President Abraham Lincoln had signed a bill granting the Mariposa Big Tree Grove and Yosemite Valley to the state of California with the requirement that the "premises shall be held for public use, resort, and recreation" forever.

That Yosemite was the nation's first wilderness preserve—indeed, the first environmental set-aside *anywhere* in the world—is remarkable, for at that time it was still relatively unknown on a national scale. It had, however, become the focus of Californians eager to convince the federal government of the uniqueness and vulnerability of the region's landscape, and the successful effort to render Yosemite as a state preserve undoubtedly began to pull it toward the center of American environmental thinking. Also critical in this regard were the photographic images—magnifying and magnificent all at once—of Carleton E. Watkins and Charles Weed; the artworks of Thomas Ayres, Albert Bierstadt, and their peers; and the trickle of personal narratives just beginning to appear that extolled the sublimity of "the Yo Semite."

Without doubt, the political context of a nation ripping itself apart in fratricidal conflict had an equally profound effect on Yosemite's rise. How better to initiate an entire nation's healing from the wounds of war than to emphasize parks over battlefields, resplendent repose over killing?

When Frederick Law Olmsted, author of the first important Yosemite treatise, walked in Yosemite Valley, he saw a park all around him. He viewed the valley floor as a place ideally suited for contemplation, not unlike the New England landscapes of transcendental, Emersonian reverie or his own Central Park (though he did not recognize that regular burning by the Miwok had made the floor look as it did). Invited by the state of California to oversee the first Yosemite Commission, which was to offer ideas as to what ought to be done with the reserved Yosemite landscape, Olmsted obliged with ideas that were by then familiar to those who knew his work—ideas concerning the necessity of melding democracy with nature in order to preserve both. Olmsted asserted that the trauma of the Civil War heightened the nation's "susceptibility" to aesthetic and therapeutic contemplation. "It is a fact of much significance with reference to the temper and spirit which ruled the loyal people of the United States during the war of the great rebellion," he wrote in his treatise "Yosemite and the Mariposa Grove," "that a livelier susceptibility to the influence of art was apparent, and greater progress in the manifestations of

Frederick Law Olmsted, ca. 1860

Courtesy of the National Park Service, Frederick Law Olmsted National Historic Site, Brookline, Massachusetts

artistic talent was made, than in any similar period before in the history of the country."[15] Clearly, Yosemite was part of that aesthetic awakening. As scholar Scott Herring has noted, Olmsted defined Yosemite "as a literal work of art" during a war-induced artistic renaissance born of trauma, need, and longing.[16]

Olmsted's arguments emphasize the point that Yosemite's arrival into the American consciousness, whether by way of photographs, paintings, or floridly descriptive writings, was about national healing and convalescence—physical and psychic—as well as neo-romanticist exuberance over the sublime qualities of Far Western "Sierra scenes."[17] A shattered nation looked west, well beyond the conflagration, to peaceful environments not torn asunder by war. The battlefields themselves would later have a role to play in healing, but in the war's immediate aftermath, it was nature, especially Western nature, that served as a balm for the wounds of national division.

Ironically, Olmsted's commission report languished for decades, a victim of its author's keen vision. Olmsted's preservationist stance toward Yosemite ran counter to other commissioners' hopes for development of the park.[18] Not until the last decade of the century, after the valley floor and parts of the surrounding landscape had fallen to commercial use by farmers and ranchers, was Yosemite freed from the grasp of such interests, when it came under full environmental protection as a national park. Muir's instrumental campaign to effect this measure channeled Olmsted's earlier ideas regarding the preservation of Yosemite. What Olmsted launched, albeit quietly, Muir guided to success.

Muir loved the Sierra Nevada landscape with a passion akin to obsession, calling it "the Range of Light, the most divinely beautiful of all the mountain-chains I have seen."[19] His enthusiasm was firmly tied to his faith and religiosity, which Emerson recognized immediately; he would later make reference to Muir's "mountain tabernacle" in a letter.[20] But Muir was every bit as much physically drawn to the mountains as he was spiritually. He had walked the North American continent by the time he met Emerson, and in Yosemite he was at home.[21]

Muir's religious excitement with regard to Yosemite is perhaps easier for us to understand than his physical exuberance, for it better corresponds with present-day presumptions about the religious bent of nineteenth-century America. Muir's upbringing hammered a robust, deeply ascetic brand of Presbyterianism into heart and head—as a boy, he could recite the New Testament from memory. The language he used in describing the prayerful solemnity and grandeur of the Sierra Nevada—and of Yosemite in particular—is not so different from the vaunted phrases of the age. Samuel Bowles, never at a loss for a sharp turn of phrase, remarked that seeing Yosemite was "the confrontal of God face to face."[22]

There is, too, a hint of Manifest Destiny in Muir's writing about Yosemite's glories—not a sanguinary gloating over fulfilled national promise so much as a supplicant gratitude for the sublime natural gifts granted by God to the westering young nation. Muir's language is not, at core, a political rhetoric about national destiny, but is, rather, that of the truly devout. He believed that God's work was powerfully inscribed in Yosemite, and his wanderings around the park were inextricably tied to his devotional life: in the Yosemite landscape, he saw a conduit to the divine and, increasingly, the divine itself. His searches for God's handiwork, joyous in their abandon, are recorded in his writings. His ecstatic discoveries replenished his passion.

As many have pointed out, looking was, to Muir, a version of reading: in looking at nature in Yosemite, he was reading God's writings on the rocks, trees, and waterfalls. He saw religious power narrated all around him. Yosemite may indeed be a sacred site in the United States today—it is surely California's most sacred site—but, ironically, that "sacredness" has been leeched of the religiosity its most important guardian saw in it; it is a place both sacred and secular. Muir could not have understood this irony, for it was his religious fervor about Yosemite that galvanized him. The sublimity he found in the landscape had a profoundly religious import.[23] Present-day visitors who find religious or deeply spiritual solace, inspiration, or meaning in Yosemite's landscape are following in Muir's tradition.

While Muir's religiosity is perhaps more easily reconciled with current notions of nineteenth-century norms than are his physicality and stamina, we cannot ignore Muir the hiker in favor of Muir the supplicant, for his physical exploits played a vital role in making Yosemite the key representation of American wilderness. Muir possessed, one suspects, something of the physiological needs of modern-day extreme sports participants, the hard-to-quench need for a physical "rush" that only derrings-do in nature would satisfy. In this respect, Muir seems well ahead of his time; we almost expect to find him outfitted in Gore-Tex on his excursions through the Yosemite backcountry. Whereas Thoreau walked and looked, Muir walked, looked, and climbed. He clambered up tall trees blowing to and fro in ferocious winds, tossed himself into avalanches, and climbed rock faces with fingers and toes. Following Muir's (steep) trail nearly a century later, the poet Gary Snyder made a succinct little journal entry: "John Muir certainly had guts."[24]

In his four years of solitude in Yosemite, Muir was engaged in an extended wilderness experiment, or set of experiments. Influenced by transcendentalism and, no doubt, Emerson, he tried to free himself from his body in experiential fervor, hoping, we can imagine, to become Emerson's transparent eyeball. But at the same time, he was trying to experience Yosemite with every part of his body for the tingling excitement of it. There is in Muir's experiences both the transcendental repose of Emerson—the looking—and the ferocious revelry of immersion in nature, something Thoreau, if not Emerson, would have well understood. While living in his small cabin alongside Walden Pond, where he conducted his own experiments in living, Thoreau had a sudden impulse to devour a woodchuck "for that wildness which he represented." In Yosemite, Muir wanted to eat a squirrel "for the lightning he holds."[25]

Muir's writings on Yosemite, like Thoreau's on Walden, are attempts to narrate experience and to fathom nature. Muir was every bit as severe as Thoreau in the ways he went about working and reworking his voluminous notes into published form. He labored to describe his experi-

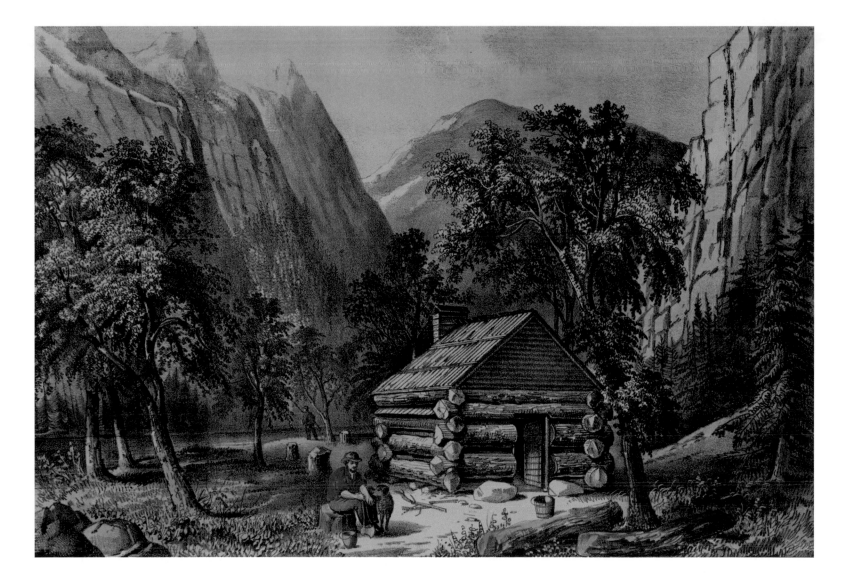

ences and their wilderness setting—through sketches and drawings as well as firsthand accounts—though he understood the limits of his reach. At a time in which stereographic photography was claiming to render actual travel unnecessary—and Yosemite was a favorite subject of the nineteenth-century American stereographer—Muir knew otherwise. He insisted that Yosemite could not be experienced in a parlor while looking at a stereographic rendering; it could only be truly experienced in situ. Muir also insisted that, in Yosemite, visitors ought to search for the landscape's lessons and teachings as he did. Muir did not mind tourists per se (though by many accounts he loathed crowds), but he did take exception to those who did not humble themselves before the park and its glories.[26]

Muir well understood the duality of Yosemite—as a place of both repose and physical challenges. The purpose of both, for Muir, was the same: proximity to God's handiwork and to God. Herein lies the greatest irony of Muir's legacy. Reports of his exploits among the landscape's peaks, ridges, and rocks introduced Yosemite to the imagination of others and popularized the place, but this popularization inevitably led to greater pressures on Yosemite's wilderness. Muir's ambivalence toward tourists never abated; he could not abide the sedentary and irreverent postures so many of them assumed.[27] But his example, in person and in print, helped them to believe they were in the American wild when they came to Yosemite, regardless of what they did or where they went

The Pioneer Cabin of the Yo-Semite Valley, n.d., lithograph published by Currier & Ives

Courtesy of The Bancroft Library, University of California, Berkeley

JAMES J. REILLY
Hutchings' Hotel, Yosemite Valley,
n.d., stereo albumen print
Courtesy of The Bancroft Library,
University of California, Berkeley

WALKER AND FARGERSTEIN
[FAGERSTEEN]
From Glacier Point,
n.d., stereo albumen print
Courtesy of The Bancroft Library,
University of California, Berkeley

JAMES J. REILLY
View in Yosemite,
n.d., stereo albumen print
Courtesy of The Bancroft Library,
University of California, Berkeley

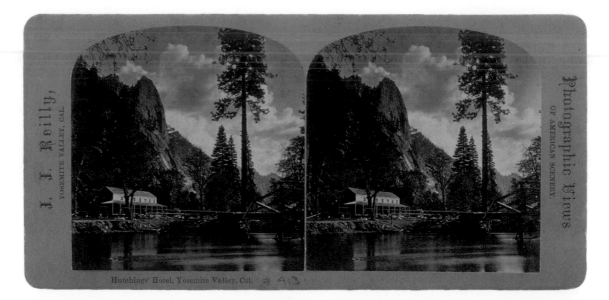

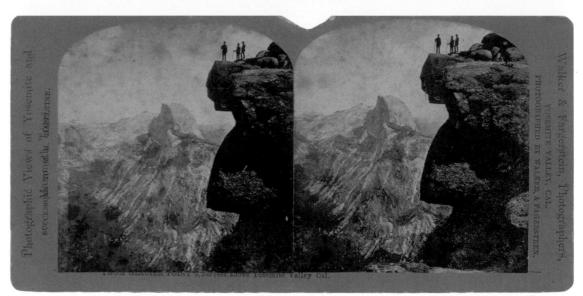

while there. That certainty, and whatever psychic or other comforts it engendered, encouraged others to follow suit, and the resultant stream inevitably threatened, and still threatens, the very wildness they come to see (if not to experience in ways more Muiresque).

What is often forgotten about Muir is that he saw, during his long sojourn in Yosemite, the end of its wildness approaching. Once he left Yosemite, he did not return for a long stretch of time, traveling instead to Alaska and elsewhere in the world. When he did come back, it was to save it, as Yosemite had saved him in the late 1860s. Despite the federal government having offered Yosemite to the state of California to be set aside as an environmental preserve, this impulse was not borne out. By the time Muir returned, in the late 1880s, he found a despoiled temple awash in money changers. Now, however, he could count on garnering

more allies in his quest to drive them out, in large measure because his writings had brought much broader attention to Yosemite.

Key to the campaign for federal protection of Yosemite was Robert Underwood Johnson, editor of *Century Magazine*. Much of the credit for the 1890 establishment of Yosemite National Park belongs to the literary and philosophical partnership of Johnson and Muir.[28] Critical to the park's protection, too, was the 1892 establishment of the Sierra Club, which formalized an environmentalist institution out of those whom Muir and Johnson galvanized in the campaign to save Yosemite.

In 1903, Muir met President Theodore Roosevelt in Yosemite—a meeting that was nearly as significant, and perhaps every bit as symbolic, as the meeting of Muir and Emerson a generation earlier. Muir was now nearly the same age as Emerson had been when he had come west

in 1871, while Roosevelt was in his mid-forties. As he had with Emerson, Muir told Roosevelt about the glories of Yosemite, and about its troubles. Its national park status had protected the landscape to some degree, but Muir feared further exploitation and damage. Muir's passion won the day, and Roosevelt did what Emerson could not—he headed off with Muir for that "worship with nature." The two went deep into the backcountry together, and when they came out Roosevelt was a Yosemite champion; he had become convinced that the valley had to be more fully protected by the federal government.

Within a few years, at Muir's and the Sierra Club's urgings and with Roosevelt's blessing, Congress had transferred the Mariposa Grove and Yosemite Valley—which had remained under the supervision of the state of California since 1864—to the national park and out

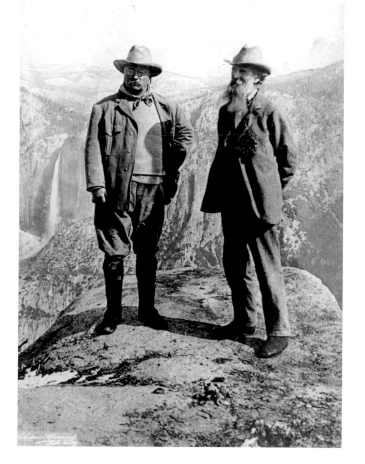

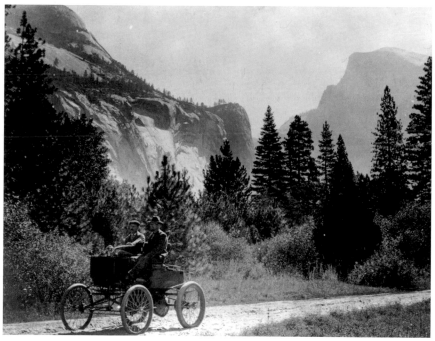

LEFT: Roosevelt and Muir at Glacier Point, 1903
The Yosemite Museum, Yosemite National Park

ABOVE: Holmes Brothers in Stanley Steamer, Yosemite
The Yosemite Museum, Yosemite National Park

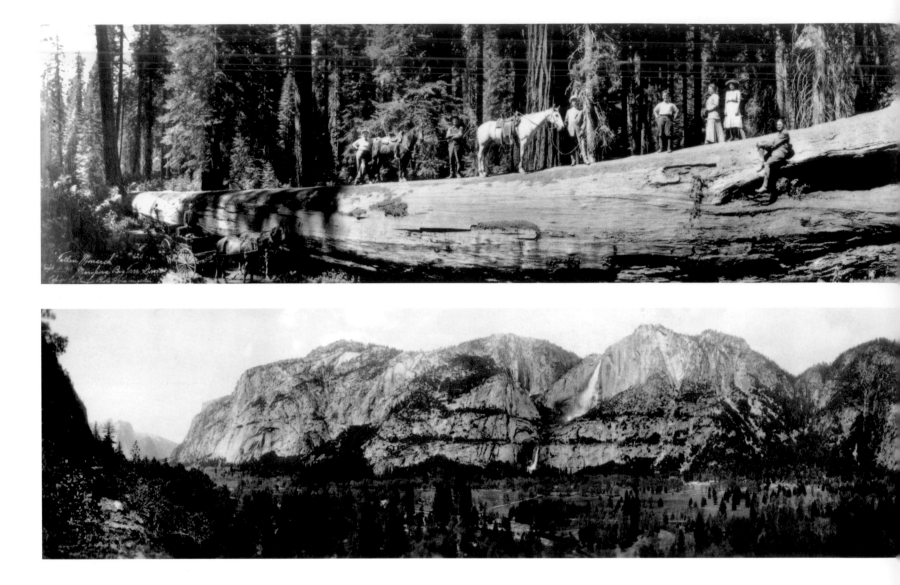

PHOTOGRAPHERS UNKNOWN
Fallen Monarch, Sept. 15, 1911,
Mariposa Big Tree Grove, 1911, gelatin silver print

Panorama of Yosemite Valley,
ca. 1915, gelatin silver print
Both: Library of Congress, Prints and Photographs Division

of state management. In 1914, civilian park rangers took over the management of the park from the United States Army, which had filled that role since the 1890s. (Muir applauded the army's stewardship of Yosemite.) Soon thereafter, Congress created the National Park Service to administer all national parks.

By that time, Muir was gone. He had thrown himself into a fight to keep Hetch Hetchy Valley, a smaller version of Yosemite Valley, also located inside the park's boundaries, from being dammed by the city of San Francisco to ensure its water supply. He and his allies lost, and Muir died not long after. But he is remembered, deservedly so, not for his defeats but for his victories.

Muir's enduring legacy is a national vision of Yosemite. The vantage often offered in his writings is an iconic one: Yosemite seen from above, the valley arrayed below in the majesty of a sweeping panorama. Looking down and in and from afar is a familiar view. Ansel Adams's *Clearing Winter Storm, Yosemite National Park* (ca. 1935, p. 116) is probably the single most recognizable image ever produced of an already familiar vista. Muir had traversed the trails and granite faces enough to know the power of this vantage point: "Nature as a poet, an enthusiastic workingman, becomes more and more visible the farther and higher we go."[29] This viewpoint, which addresses landscape and sky in considerable length and breadth, introduces a key theme regarding the national perception of Yosemite: the place holds still, or at least it seems to.

It was this glacial progression of time (as well as the glaciers themselves) that Muir sought in Yosemite. He knew that Yosemite, like the entire Sierra Nevada range, is always changing; the dynamism of geological change may be hard to observe at a human scale, yet it is anything but static. Beyond the frame of human, plant, and animal movement, however, the park's geological features are infinitely slowed. This reduction to geological time is a critical feature of the park's enduring power as an environmental touchstone in American culture.

It is yet another Yosemite irony that the seemingly static geological landscape emerged as *the* descriptive imagery of the park just as its rising popularity in the early twentieth century increasingly warranted human diversions

sprinkled amidst the natural grandeur of the valley floor (see p. 18). "Living in the Yosemite is extremely comfortable," the National Park Service pointed out in 1920. "The camps are fitted with good beds. The board is good. The camps have swimming pools. There are evening lectures for those who want them. One can hear lectures. One can dance. One can play tennis, even at night by electric light."[30]

Such diversions, one imagines, would have been of little concern to Muir, as long as tourists availed themselves of the park as well. Adams, however, eradicated such distractions, deliberately removing people and their paraphernalia from the landscape as he photographed it.[31] What Muir had sought in his lonely sojourns, Adams created: a Yosemite free from distracting mediation or mundane intrusions.[32] This removal, of course, has nothing in common with the grim removal of Yosemite's Native American inhabitants from the park in the nineteenth century, except, perhaps, on a metaphorical level; Adams erased people simply by aiming his camera above and beyond them.

The Yosemite of Adams's eye and camera—the Yosemite that has become the world's Yosemite—is a geological artifact existing as if in an earlier time. Adams's work exhibits none of Muir's ambivalence toward Yosemite tourists, none of Muir's alternately welcoming and standoffish behavior, for there is no one to welcome or to banish. No tourists, no National Park Service employees, no hoteliers, no photographers, no vendors, no campers—no one inhabits this idealized Yosemite.[33] (Ironically, Adams needed tourists. His commercial photographs of visitors in Yosemite supported his true legacy, the fine art landscape photographs.)

Over the course of more than a half-century's work, Adams became the Emersonian all-seeing eyeball Muir had labored so hard and successfully to become. His photographic genius magnified Yosemite into nothing less than American Nature. As Muir had done in the previous century, in other words, Adams did for his. He built his pictures atop Muir's foundation of exploits and words, aiming at conveying, as Jonathan Spaulding reminds us, "the essence of Yosemite. His photographs would

convey the wonder and renewal he found there, all the moods of nature—from quiet details of the forest to the sublime power of the thunder clouds above the valley walls."[34] Along the way, Adams became the twentieth century's most important interpreter of American nature.

Adams's ability to remove people from the Yosemite he created (*curated* is perhaps the more apt verb) is the key to making his images so remarkably seductive. The American wild—that wildness that Muir and Thoreau worshipped—beckons in Adams's Yosemite, awe-inspiring and even frightening in its majesty, as if nature, art, and God have coalesced amidst the granite, snow, and evergreens of an astonishing California landscape. Adams's images are like a shout answering Manifest Destiny's whispered promise: Americans shall inherit the West, and God is both mighty and pleased. Sublime nature returned in Adams's viewfinder (and, especially, in his darkroom), freed from the domestications of time, tourism, and the National Park Service.

Adams never met Muir—he was gone by the time the young Adams began to express an interest in photography, but the two might as well have met. Their lives and their work seem to carry on a dialogue. Over his long life, Adams inherited Muir's environmental mantle and was every bit as much (if not more) identified with Yosemite as was Muir. "I *knew* my destiny when I first experienced Yosemite," Adams wrote in his autobiography.[35] Muir appears to narrate Adams's images in his writings, and the Yosemite he genuflected before in exuberant faith is the Yosemite Adams pictured: the Yosemite Muir popularized through his writings as the place of God's music, His handiwork, and His vistas is the Yosemite Adams saw when he photographed.

The sons and daughters of those who answered Muir's call followed Adams into the park, looking for the Yosemite he knew and saw. All came because Yosemite looked like empty nature. What irony—visions of uninhabited space begetting exponential tourism!

For every story and every picture of Yosemite's grandeur, there is an accompanying story of crowds, roads, trash, and trouble. Debts must

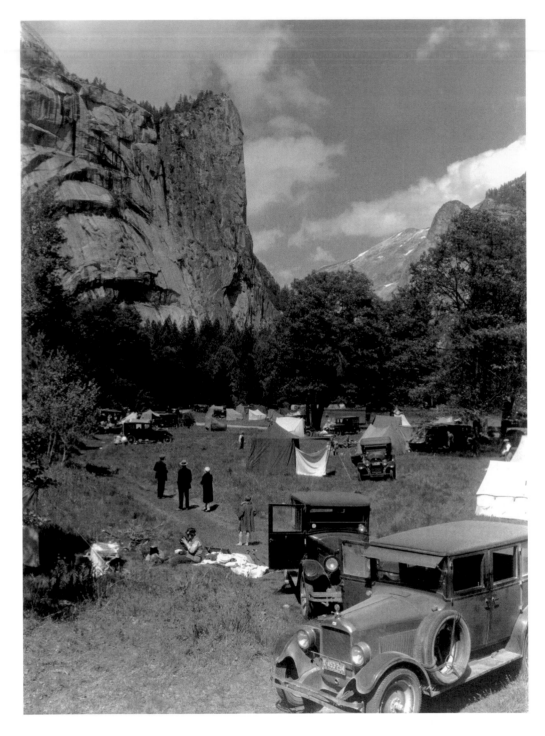

PHOTOGRAPHER UNKNOWN
Camping in Stoneman Meadow, Yosemite,
1927, black-and-white photograph
The Yosemite Museum, Yosemite National Park

be paid for imagining a place as empty when it is not, or for naively believing that its emptiness could be sustained. The environmental consequences exacted upon a landscape that must absorb the encroachment of so many are severe. What this means, beyond the infrastructural and governance challenges faced by Yosemite's stewards, is that the place also means something very different than it once did. "The Yo-Semite" came to fame as being synonymous with nature. Olmsted imagined it as such, and Muir both immersed himself in this Yosemite and guarded it from detractors and despoilers. Yosemite's enduring renown is a throwback to the post–Civil War period, when the nation mixed together ideas of the West and wilderness through the alchemy of national destiny and pride and lauded Yosemite as the product of that experiment.

But tourist crowds forever altered that reality. It would be difficult to pinpoint exactly when this happened, though it seems likely that it was sometime in the last generation. Yosemite topped a million annual visitors as long ago as the mid-1950s. In 1955, Gary Snyder, then a Yosemite trail worker in his twenties, made laconic haiku-like journal entries noting "hordes of campers" and "fires, camps, bears; this crowded valley."[36] By 1957, Adams noted that Yosemite's "material values and qualities" had "improved," while its "emotional, 'magical,' and inspirational moods" had regressed.[37] Or perhaps Yosemite changed as recently as 1976: in the year of the United States Bicentennial, four million people visited Yosemite.

Whereas Yosemite was at one time a symbol of the health, meaning, and purpose of American nature, it is now something quite different— more an identifier of the state of national parks these days than being about bigger ideas of the American environment. "The Yo-Semite" has become Yosemite National Park, and the two places are not synonymous: nature has receded from Yosemite's meaning, despite the fact that the overwhelming bulk of the park—over ninety-five percent—is wilderness area. While much of Yosemite is still largely empty of people twelve months of every year, the disproportionate impact of *too many* people atop the roads and trails of the valley has become

Yosemite's reality. The National Park Service, in fact, often refers to Yosemite as a city. Attempting to sustain Yosemite's role as representative of American nature in the midst of its own rapid urbanization is thus a heavy burden.

Visualizing or enshrining Yosemite as imagined emptiness not only comes at an ecological cost, but it also exacts a toll from the soul. The writer Rebecca Solnit points out that "Yosemite has been defined in terms of geological time scales and natural wonders; it has become easy to believe that Yosemite has no significant human history; and thereby that human history is not part of the landscape."[38] Where Adams pondered vistas, bringing granite and grandeur into the sharp focus of black against white, Solnit sees expulsion and blood. She hears cries above the sounds of falling water. Her book *Savage Dreams* keens with lament over the awful irony: Yosemite is the Garden of Eden only because of its habitation by—and bloody removal of—Native American residents, most assuredly not at the hands of an angry God. There is loss in Yosemite, and Solnit wishes that Americans contemplate, if not atone for, this.

Damaged landscape that it is, Yosemite still has the power to provoke real epiphany in those who witness it. The place has fundamentally shaped the environmental consciousness and convictions of some of the greatest of American thinkers on nature: Olmsted, Muir, Adams, Snyder, and Solnit, and also the environmentalist David Brower and the photographer Galen Rowell (whose backcountry exploits with his camera in the second half of the twentieth century embodied something of a cross between Muir and Edward Weston). All were moved by Yosemite and fundamentally changed by it.

Were he transported from his time to ours, Muir would likely not think well of the ways in which his beloved Yosemite must bear up against the press of millions of visitors each year. But as the park's fame within the realm of "destination tourism" shows few signs of fading, so too does the enduring importance of its first and most important guardian. As the "father of American environmentalism," Muir only becomes more significant as time passes.

This could not have happened without Muir in Yosemite—his years of peregrinations in its landscape, punctuated by heroic athleticism and contemplative reverie, changed Muir, they changed Yosemite, and they changed American history.

While the Yosemite Muir reveled in no longer exists, bemoaning loss and inevitable change threatens to discount what Yosemite yet remains: the keystone of the national park system, a managed environment still capable of provoking happiness, if not wonderment, awe, and epiphany. The very heart of California, Yosemite retains its extraordinary importance as an environmental touchstone. Yosemite may no longer epitomize American Nature the way it once did (it has paid the price for bearing that burden), but its significance cannot be denied.

———

Almost a century and a half ago, Ralph Waldo Emerson took off his hat and waved a Yosemite good-bye to John Muir. The impact of that simple, poignant gesture—of respect and friendship, if not something more profound—reverberates still. Emerson recognized Muir's power, and he recognized the ways in which Muir drew much of that power from Yosemite. From that moment on, Muir's significance grew, and Yosemite's significance grew accordingly. Muir set an example for those that came after him—most important among them Ansel Adams, whose photographs are an homage to Muir's vision.

Curiously, Muir's legacy and stature are only increasing now that he has been gone nearly a century. In the spring of 2004, California governor Arnold Schwarzenegger unveiled his choice for the state's new commemorative quarter: Standing beneath a soaring California condor, Muir is the coin's central figure. This commemoration of Muir as California's notable son represents a high-water mark in the accelerating sensibility of his influence. Muir's honorific mantle as the "father of American environmentalism" is just and well deserved, but what is curious about his expanding legacy and influence is the way in which Yosemite may be uncoupled from him. Yosemite was

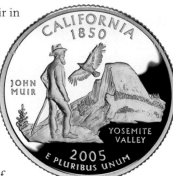

2005 California quarter, United States Mint image

once more famous than Muir—its fame and its ascension into cultural significance predated Muir's arrival—but their roles seem almost to have been reversed. While Yosemite is no longer the place it was in Muir's time there, its historical significance cannot be denied. Muir would have made an impact on American environmental thought without Yosemite, but it would have been a more muted impact, and it would have been stripped of much of his exuberance and passion. Yosemite and Muir are, and should be, inextricably linked.

Muir and the California condor are not the only depictions on the new state quarter: balancing the scene is Yosemite itself. Half Dome looms.

NOTES

1. William Frederic Badè, *The Life and Letters of John Muir,* vol. 1 (Boston: Houghton Mifflin, 1924), 253.

2. Ralph L. Rusk, ed., *The Letters of Ralph Waldo Emerson,* vol. 6 (New York: Columbia University Press, 1939), 154–55.

3. John Muir, *Our National Parks* (Boston: Houghton Mifflin, 1901), 135.

4. Quoted in Robert D. Richardson, Jr., *Emerson: The Mind on Fire* (Berkeley: University of California Press, 1995), 565.

5. Henry David Thoreau, "Walking," in *Excursions* (Boston: Ticknor and Fields, 1863), 177.

6. Joel Myerson, ed., *The Selected Letters of Ralph Waldo Emerson* (New York: Columbia University Press, 1997), 442.

7. King referred to Beethoven's Ninth Symphony, for example, as "the Yo-Semite of music." See King's correspondence in John A. Hussey, ed., *A Vacation among the Sierras: Yosemite in 1860* (San Francisco: Book Club of California, 1962), letter 6 (December 1860). Mt. Starr King, overlooking the Yosemite Valley, is named in King's memory.

8. Certainly, there was little physical resemblance: the tall and muscular Muir would have towered over the slight, five-foot-tall King.

9. Myerson, ed., *Selected Letters of Emerson,* 442.

10. Rusk, ed., *Letters of Emerson,* 202–4.

11. Muir also hated crowds, however, and the thought of being paraded about to Emerson's undoubtedly large social and intellectual circle likely did not interest him.

12. Quoted in Richardson, *Emerson: Mind on Fire,* 565. Muir found immediate solace in nature upon Emerson's departure, which, he wrote, made him lonely for the first (and not the last) time in Yosemite. "I quickly took heart again— the trees had not gone to Boston, nor the birds; and as I sat by the fire, Emerson was still with me in spirit, though I never again saw him in the flesh" (Muir, *Our National Parks,* 136).

13. Bowles wrote this in his influential *Across the Continent* (Springfield, Mass.: Samuel Bowles, 1866), 223. He had traveled to Yosemite in 1865 as Frederick Law Olmsted's guest.

14. See John F. Sears's insightful book *Sacred Places: American Tourist Attractions in the Nineteenth Century* (Amherst: University of Massachusetts Press, 1989), especially chapters 1 and 6. I am indebted to both chapters for helping shape my own thinking in this essay.

15. Quoted in Scott Herring, *Lines on the Land: Writers, Art, and the National Parks* (Charlottesville: University of Virginia Press, 2004), 19. Olmsted scholar Victoria Post Ranney rightly calls Olmsted's Yosemite pamphlet "the first comprehensive statement on the preservation of natural scenery in America." See Victoria Post Ranney, Gerard Rauluk, and Carolyn Hoffman, eds., *The Papers of Frederick Law Olmsted,* vol. 5: *The California Frontier, 1863–1865* (Baltimore: Johns Hopkins University Press, 1990), 3.

16. Herring, *Lines on the Land,* 19. More recently, the landscape architect Laurie Olin has called Olmsted's Central Park the greatest work of art in American history. See Greg Hise and William Deverell, *Eden by Design: The 1930 Olmsted-Bartholomew Plan for the Los Angeles Region* (Berkeley: University of California Press, 2000), 287.

17. "If we analyze the operation of scenes of beauty upon the mind," Olmsted wrote, "and consider the intimate relation of the mind upon the nervous system and the whole physical economy, the action and reaction which constantly occur between bodily and mental conditions, the reinvigoration which results from such scenes is readily comprehended. Few persons can see such scenery as that of the Yosemite and not be impressed by it in some slight degree" (from "Yosemite and the Mariposa Grove," quoted in Linda W. Greene, *Yosemite: The Park and Its Resources,* vol. 1 [Washington, D.C.: U.S. Department of the Interior, National Park Service, 1987], 56. "Yosemite and the Mariposa Grove" was first published in the October 1952 issue of *Landscape Architecture,* with introductory material by Laura Wood Roper, and is reprinted in Ranney, Rauluk, Hoffman, eds., *Papers of Olmsted,* 488–516).

18. Yosemite scholar Alfred Runte has written that "of all the might-have-beens in national park history, the suppression of Olmsted's report was among the most significant." See Alfred Runte, *Yosemite: The Embattled Wilderness* (Lincoln: University of Nebraska Press, 1990), 29.

19. Quoted in Tim Duane, *Shaping the Sierra: Nature, Culture, and Conflict in the Changing West* (Berkeley: University of California Press, 1999), 8.

20. Ralph Waldo Emerson to John Muir, February 5, 1872, in Myerson, ed., *Selected Letters of Emerson,* 442.

21. Myerson, ed., *Selected Letters of Emerson,* 442.

22. Quoted in Sears, *Sacred Places,* 123.

23. While he might have winced at the over-the-top prose, Muir would probably have applauded the response of one eastern tourist writing of his Yosemite experiences in 1892: "Now all is lost and swallowed up in the sublimity of the scene that breaks from the floor of the vale. El Capitan; one bristling solid tower of rock without a break, or bush, the earth rises up majestically 3300 feet, the monarch of them all . . . it speaks of the Almighty; it lifts up our hearts in praise to God our Heavenly Father who made them all . . . it is God's own handiwork, marvelous indeed" (Steven Merritt, quoted in Marguerite Shaffer, *See America First: Tourism and National Identity, 1880–1940* [Washington, D.C.: Smithsonian Institution Press, 2001], 278).

24. Gary Snyder, journal entry, August 24, 1955, in Gary Snyder and Tom Killion, *The High Sierra of California* (Berkeley, Calif.: Heyday Press, 2002), 74.

25. Thoreau wrote in *Walden:* "As I came home through the woods with my string of fish, trailing my pole, it being now quite dark, I caught a glimpse of a woodchuck stealing across my path, and felt a strange thrill of savage delight, and was strongly tempted to seize and devour him raw; not that I was hungry then, except for that wildness which he represented" (Henry David Thoreau, *Walden* [Boston: Beacon Press, 1997], 197). Muir, writing to his close friend Jeanne Carr, commented: "One of the little lions ran across my feet the other day as I lay resting under a fir, and the effect was a thrill like a battery shock. I would eat him no matter how rosiny for the lightning he holds. I wish I could eat wilder things" (Badè, *Life and Letters of Muir,* 272).

26. Of course, not everyone responded to Yosemite with Muir-like reverence. For often-comical recitations of Yosemite as being nothing particularly special, see David Robertson, *Yosemite As We Saw It* (Yosemite National Park, Calif.: Yosemite Association, 1990), esp. 41–48. Tourist Olive Logan represents the best of these laments (47–48): "By another day some of us are well enough to mount again and begin our search after Beauty. We find an occasional rattlesnake, unlimited fatigue, and the tombstone of a man who was kicked to death by his horse."

27. "They climb sprawlingly," he wrote, "to their saddles like overgrown frogs" (quoted in Stephen Fox, *John Muir and His Legacy: The American Conservation Movement* [Boston: Little, Brown, 1981], 14).

28. Of importance, too, as historian Richard Orsi has pointed out, was the role of the Southern Pacific Railroad. See Orsi, *Sunset Limited: The Southern Pacific Railroad and the Development of the American West, 1850–1930* (Berkeley: University of California Press, 2005), especially part 5.

29. Muir, quoted in Herring, *Lines on the Land,* 59.

30. *Rules and Regulations: Yosemite National Park* (Washington, D.C.: Government Printing Office, 1920), 15–16.

31. "I go to Yosemite not because of the attractions of the firefall, dancing, vaudeville and popular music, urban cocktail lounges and food services, hideous curios, slick roads, and a general holiday spirit—and somewhere back of this smokescreen of resortism the real Valley can be seen (but usually through a thick haze of campfire and incinerator smoke)" (Ansel Adams to Horace Albright, July 11, 1957, in Mary Street Alinder and Andrea Gray Stillman, eds., *Ansel Adams: Letters, 1916–1984* [Boston: Little, Brown, 1988], 254).

32. A Yosemite representing, in the words of Olmsted, "this union of the deepest sublimity with the deepest beauty of nature" (Ranney, Rauluk, and Hoffman, eds., *Papers of Olmsted,* 500).

33. Gary Snyder expressed a similar longing for uninhabited wilderness in a journal entry of summer 1955, in which he declared that "200,000 years ago the Sierras would have been nice" (Snyder and Killion, *High Sierra of California,* 67).

34. Jonathan Spaulding, *Ansel Adams and the American Landscape* (Berkeley: University of California Press, 1995), 168.

35. Ansel Adams with Mary Street Alinder, *Ansel Adams: An Autobiography* (Boston: Little, Brown, 1985), 67. Spaulding discusses Adams's first Yosemite trip and the "deep psychic connection" it forged between the artist and the place (see Spaulding, *Ansel Adams and the American Landscape*, chapter 2).

36. Snyder and Killion, *High Sierra of California,* 65.

37. Ansel Adams to Horace Albright, July 1, 1957, in Alinder and Stillman, eds., *Adams: Letters,* 253.

38. Rebecca Solnit, *Savage Dreams: A Journey into the Landscape Wars of the American West* (1994; Berkeley: University of California Press, 1999), 230.

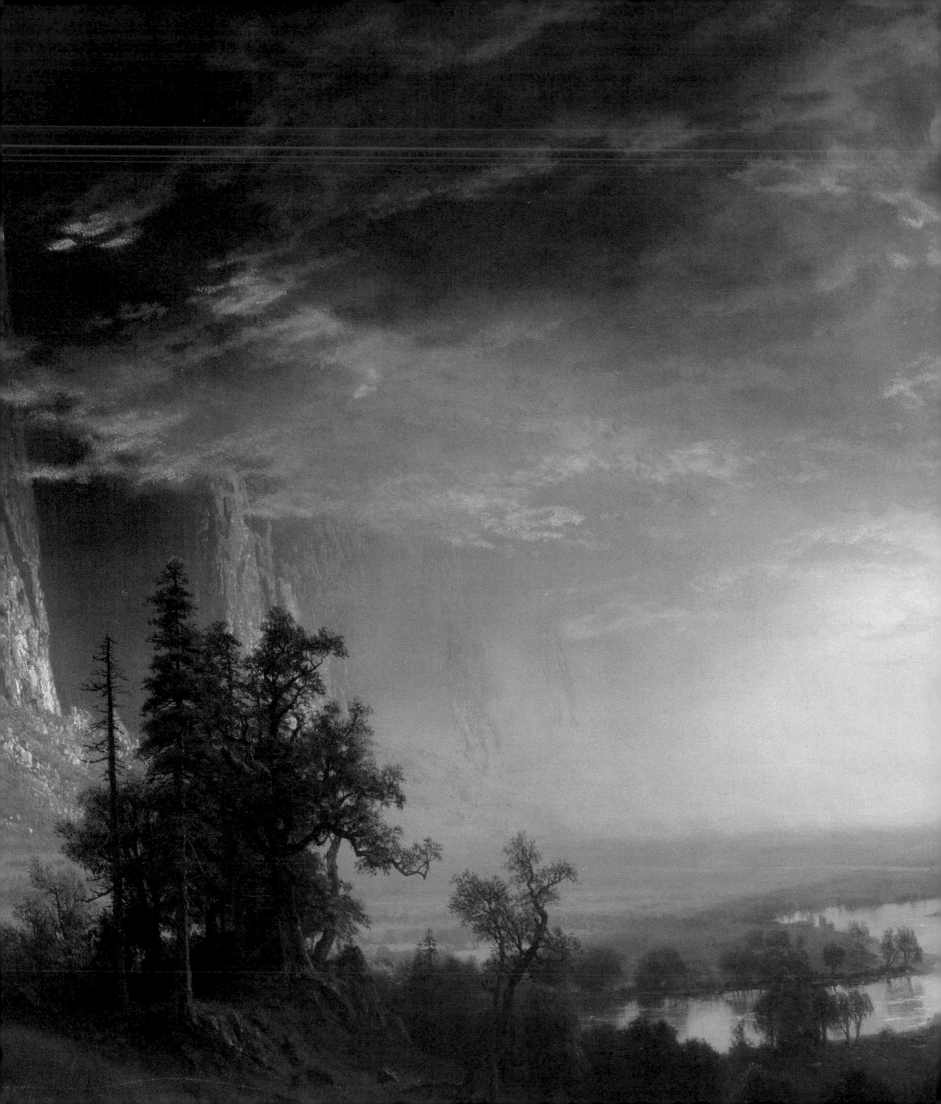

KATE NEARPASS OGDEN

CALIFORNIA AS KINGDOM COME

It is as if the auriferous treasures of the earth were fused into the sky in one superb triumph of pigmentary perfection.
—*Catalogue of James H. Stebbins' Private Collection of Modern Paintings* (1889)

WITH A DISTINCTLY PRIMORDIAL FEEL to its atmospheric haze, Albert Bierstadt's *Sunset in the Yosemite Valley* (1868) is a painting of an ancient place. Isolated, immense, and bathed in the glowing light of a setting sun, the natural architecture of Yosemite appears like a Gothic cathedral, a biblical Eden on American soil. At the same time that it references the past, the painting also speaks of things to come. The setting sun presages the dawn of a new era, a shining and golden future awaiting the populace of the distant West.

To a nation that was both insecure about the brevity of its history and struggling to rebuild following a brutal civil war, Yosemite was worth its weight in artistic metaphors. If California was "a second Canaan for the impoverished and oppressed,"[1] then Yosemite Valley was the symbolic heart of the new Promised Land. As a natural symbol of Eden, the valley drew together several ideological interests: nationalist pride in the riches of the New World, local devotion to the region as a particularly blessed American paradise, and religious justification of the country's Manifest Destiny of westward expansion. State pride also played a role, as the wealthy men whose fortunes had been founded on California industry, railroads, and banking chose to decorate their mansions and businesses with large paintings of the state's leading scenic locale. Yosemite, as Kevin Starr has observed, "was the one adequate symbol for all that California promised: beauty, grandeur, expansiveness, a sense of power, and a sense—this in the

ALBERT BIERSTADT
Sunset in the Yosemite Valley (detail; see p. 24)
The Haggin Museum, Haggin Collection, Stockton, California

geological history—of titanic preparation for an assured and magnificent future."[2]

Yosemite Valley could not have assumed this ideological role were it not for paintings like *Sunset in the Yosemite Valley*. Depictions of Yosemite's grandeur by Bierstadt and contemporaries such as Thomas Hill and William Keith put the power of visual imagery to work in elevating the valley from mere place to compelling symbol. These paintings, and the prints made from them, allowed members of the public, from barons of commerce to middle-class shop owners, to visualize Yosemite without visiting it and compelled them to see it in a specific way.

The romantic vision of Yosemite—timeless, simultaneously wild and pastoral, relatively unpeopled, suggestive of divine endorsement of American progress—became itself a historical force, shaping the valley's development as a park, tourist destination, artistic subject, and icon of American wilderness generally. As a counterargument to those who viewed nature as a source of raw materials to be consumed by burgeoning cities and industry, the idealized nature of Yosemite proved attractive to a broad range of the public longing not just for respite but for a spiritual experience in the equivalent of a mountain cathedral. They came in increasing numbers, and in so doing they radically transformed the valley.

Yet while tourism created a reality that increasingly diverged from the ideal depicted on canvas, it also ensured the future of artistic production in Yosemite. Tourists were a ready market for paintings, sketches, and prints of the valley's grand scenery, and tourism, by increasing the park's fame, enhanced its popularity as an artistic subject in the broader art market. Yosemite's nineteenth-century painters by necessity promoted their work in the commercial realm, but in so doing they also helped transform Yosemite into something that could be possessed or consumed—as an inexpensive print, original oil painting, or tourist experience.

In many ways, the catalytic event for this phenomenon was the arrival of Bierstadt and his traveling companions at Yosemite Valley in 1863. Having trekked into Yosemite for several weeks' stay, they saw the valley for the first time from Inspiration Point at sunset, witnessing "an unspeakable suffusion of glory created from the phoenix-pile of the dying sun."[3] This vision of Yosemite, and others Bierstadt encountered over the following weeks, would be utilized when he painted *Sunset in the Yosemite Valley* five years later. For Bierstadt, an artist of considerable artistic and entrepreneurial skill, the timing could not have been better. In Yosemite, he sought—and found—nature on a grand scale, a landscape that could further his growing reputation for paintings of spectacular scenery at a time when large paintings of dramatic vistas were especially valued by art patrons.

With Bierstadt on his Yosemite excursion were Fitz Hugh Ludlow, a writer who would send reports of their adventures to newspapers back in New York, and the painters Virgil Williams and Enoch Wood Perry, friends of Bierstadt's from their student days in Europe. To help the artists with questions of science, John Huston, a "highly scientific metallurgist and physicist generally," accompanied them.[4] Together, the combined talents of the party created a "large little world," with each specialist contributing to the others' understanding of the astonishing environment in which they found themselves.

A visual account of the expedition, complementing Ludlow's written reports, can be found in Bierstadt's painting *Cho-looke, the Yosemite Fall* (1864). The group camped in the open instead of staying in the decidedly plain accommodations of the valley's two early hotels. Their campsite, visible at the lower right in the painting, is notably rustic, with bedrolls rather than tents or cabins, testifying to the rugged nature of the trip. Artists' tools, including paint boxes, a folding easel, and a parasol, are arranged on a rock in the foreground, signifying the expedition's purpose. A rifle for hunting and protection rests on a stool nearby. Dwarfed by the size and power of Yosemite Falls behind them, the group enjoys a leisurely moment of camaraderie as members pitch in to stoke their campfire. In the process of depicting a pastoral and idyllic moment, Bier-

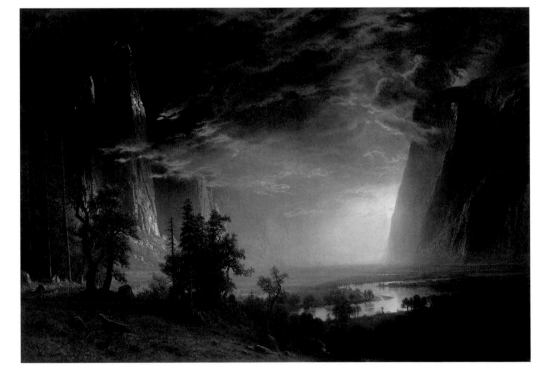

ALBERT BIERSTADT
Sunset in the Yosemite Valley, 1868, oil on canvas
The Haggin Museum, Haggin Collection, Stockton, California

stadt took artistic liberty with Yosemite itself—the height of the cliffs has been exaggerated, and the waterfall has significantly more volume than it would have had during their late summer visit. As is evident from other canvases recording this expedition, the group's painters often worked side by side; Williams's *Along the Mariposa Trail* (1863, p. 26), for example, is similar to Perry's *Cathedral Rock, Yosemite Valley* (1866, p. 27).[5] Using parasols to keep the sun off them as they worked, the three set up their easels and camp stools directly in view of nature's wonders.

Before departing with Ludlow for Oregon's Mount Hood on the second leg of their Western excursion, Bierstadt dropped off some of his Yosemite sketches at a San Francisco newspaper, which published descriptions of some of the works and whetted public appetite for the finished paintings. After Bierstadt finally returned to his New York studio in December, *Cho-looke, the Yosemite Fall* was one of the first paintings he completed, capitalizing on the wave of interest in the artistic and expeditionary nature of his California trip. Combining scenery of staggering proportions with signs of abundant natural resources, *Cho-looke, the Yosemite Fall* helped position Yosemite as the visual and symbolic heir to Niagara Falls. That eastern monument had captured the American imagination in 1857 when Bierstadt's rival, Frederic Edwin Church, debuted his iconic canvas of the falls viewed from the Canadian side. Unlike Niagara, however, which had been considerably developed as a resort by 1863, Yosemite was still relatively remote, especially to Easterners. Prior to the 1869 completion of the transcontinental railroad, traveling to Yosemite from New York required either a train ride to St. Louis, followed by a "tedious and dangerous"[6] overland journey by stage to San Francisco, or a voyage by ship to California; from San Francisco, travelers then took a steamboat or another train to Stockton, a stage to Mariposa or another jumping-off point, and finally a horseback journey into the valley by one of three routes—the Mariposa, Big Oak Flat, or Coulterville trails. This last, grueling leg of the trip sometimes took as long as four days and involved maneuvering steep trails, sheer drop-offs, and dust so thick that travelers

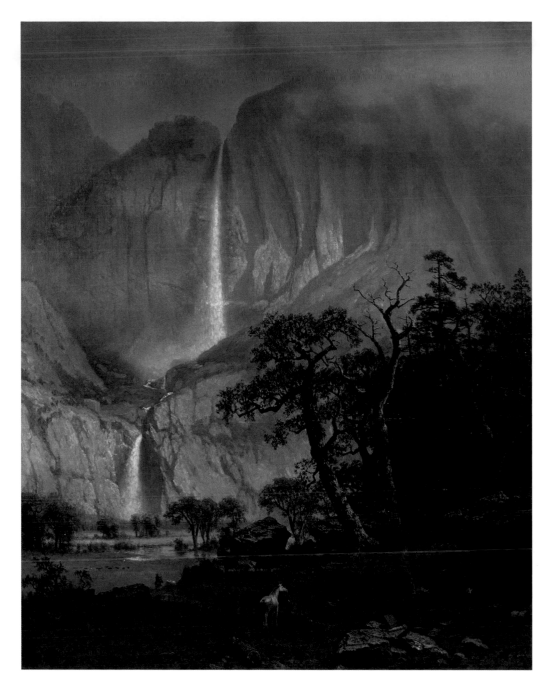

ALBERT BIERSTADT
Cho-looke, the Yosemite Fall, 1864, oil on canvas
The Putnam Foundation, Timken Museum of Art, San Diego

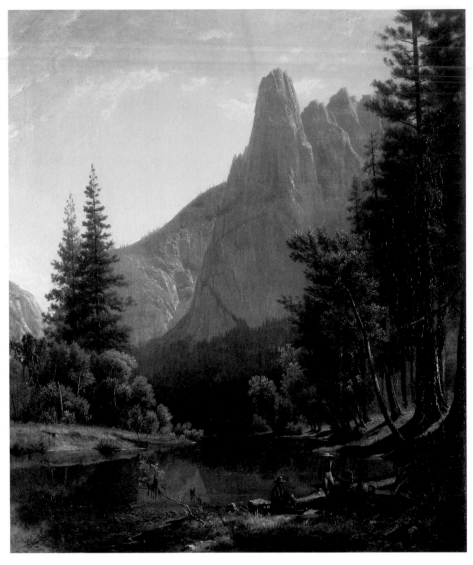

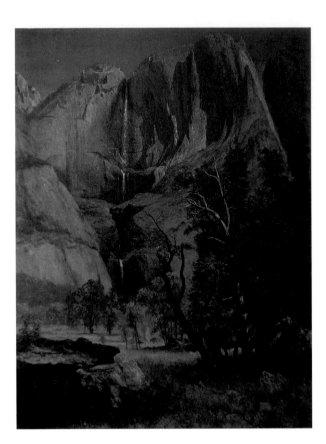

ALBERT BIERSTADT
View in the Yosemite, ca. 1863,
oil on paper mounted on canvas
Collection of A. A. Phillips, M.D., Newark, New Jersey

VIRGIL WILLIAMS
Along the Mariposa Trail, 1863, oil on canvas
California Historical Society, Gift of A. K. Brown;
California Historical Society Collections at the
Autry National Center, Los Angeles

were advised to wear canvas "dusters" or "dust-coats" to protect their clothing. Though multiple routes existed prior to 1874, when stage roads reached the valley, there is nothing to suggest one was more comfortable than another. By undertaking this rugged trek—and "documenting" it in his paintings, as Ludlow did in his letters—Bierstadt was self-consciously casting himself as an artist-explorer, a peculiarly Western mantle that suggested the intrepid character necessary for such endeavors as well as the exotic nature of Western subjects of the frontier era.

Yet if the artist-explorer's subjects were exotic, they were also transient: painted just before the completion of the transcontinental railroad, Bierstadt's Yosemite paintings were of a place about to be inherently, and irrevocably,

changed. Similarly, images from the expeditionary Missouri River voyages of George Catlin, Alfred Jacob Miller, and Karl Bodmer, all undertaken before 1838 in search of Western Indian tribes, were intended as records of the Native peoples of the West before their traditional culture was lost to advancing "civilization."[7] While Catlin's dreams of realizing fame and fortune from his Indian portraits never fully materialized, Bierstadt achieved both through his artistic discovery of Yosemite.

By framing his efforts in a spirit of discovery and exploration, Bierstadt was promoting his work to the elite group of capitalists, mostly railroad moguls and other industrial barons, who made up his top clientele. His doing so also suggests his considerable savvy when it came to the market for large-scale pictures of

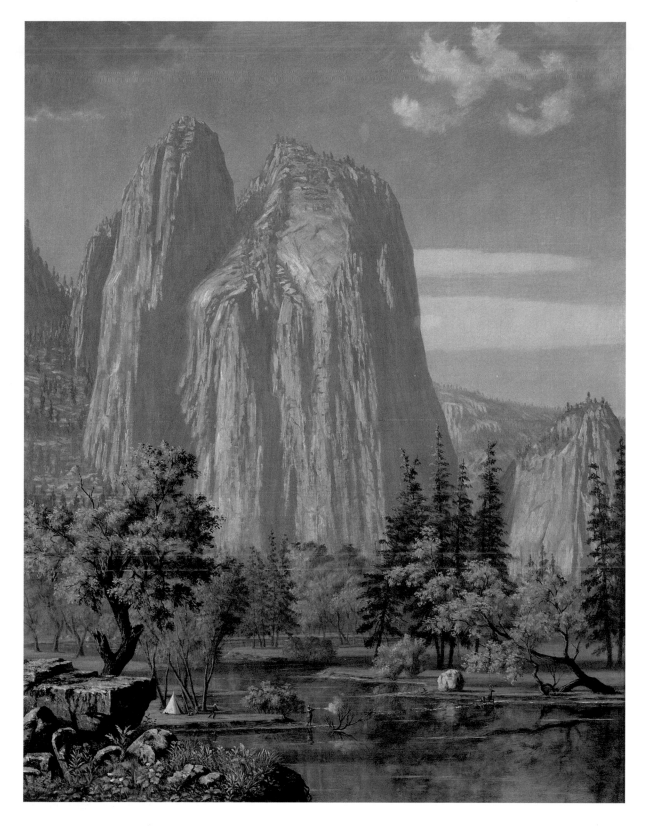

ENOCH WOOD PERRY

Cathedral Rock, Yosemite Valley, 1866, oil on canvas

Oakland Museum of California, Gift of Mr. Warren Howell

natural monuments. The enterprise of painting "Great Pictures"—large works that toured multiple cities as self-contained exhibitions to attract critical attention and wealthy buyers—had been pioneered by Church with *Niagara*. By 1863, Church had debuted two other large pictures as well, canvases of the South American Andes and Newfoundland icebergs, which he sold for $10,000 each. In traveling great distances for the opportunity to paint scenery that was both more impressive and less despoiled than Niagara, Bierstadt was effectively engaging Church in a game of artistic one-upmanship. Even as Bierstadt was en route to Yosemite, the first of his Great Pictures still extant,[8] *The Rocky Mountains, Lander's Peak* (1863), was already making the rounds of museums and galleries in Boston, New York, Washington, D.C., Chicago, and London. The painting was typically shown in its own room, flanked by potted plants and lit with gas lamps; visitors paid an admission charge of about

twenty-five cents to see it dramatically revealed from behind a velvet curtain.[9] By touring *The Rocky Mountains, Lander's Peak* as a self-contained theatrical spectacle, Bierstadt made the painting itself, and not just the landscape it depicted, a star. This status was confirmed by its 1865 sale to an English railroad entrepreneur for the staggering sum of $25,000, which shattered Church's sales record and made Bierstadt one of the richest artists in the country.

Bierstadt completed several major Yosemite works, including *Sunset in the Yosemite Valley*, by 1868, effectively staking out the valley as his artistic turf. At 5 by 8 feet in size, *Looking Down Yosemite Valley, California* (1865) was his first Great Picture of Yosemite. Based on the little canvas *Valley of the Yosemite* (1864), *Looking Down Yosemite Valley, California* was introduced to the public at the National Academy of Design's annual exhibition in New York in 1865. The following year, in a manner befitting a

ALBERT BIERSTADT
The Rocky Mountains, Lander's Peak,
1863, oil on canvas
The Metropolitan Museum of Art, Rogers Fund, 1907 (07.123).
Photograph © 1984 The Metropolitan Museum of Art

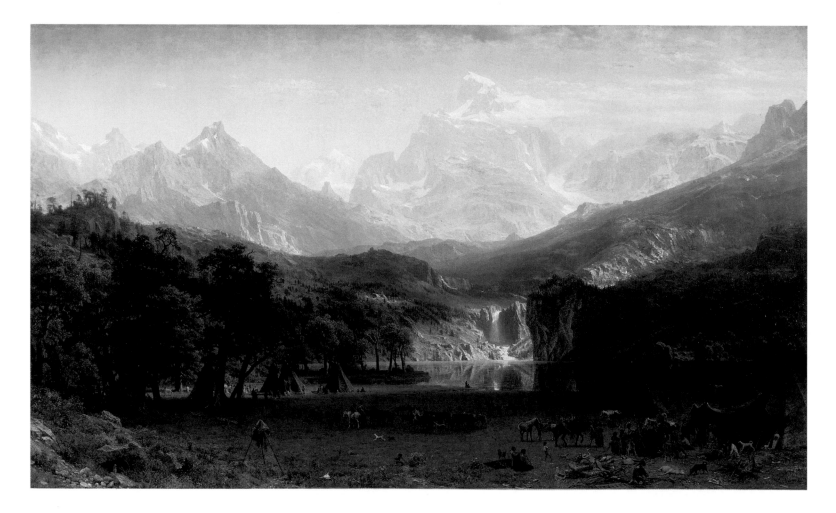

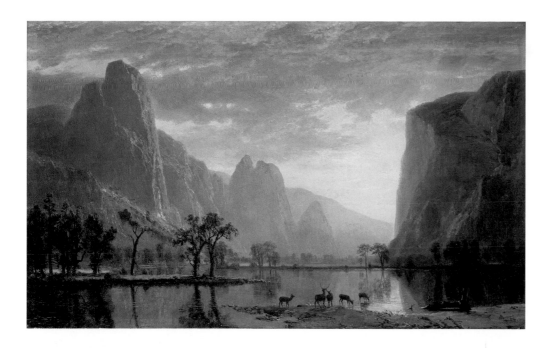

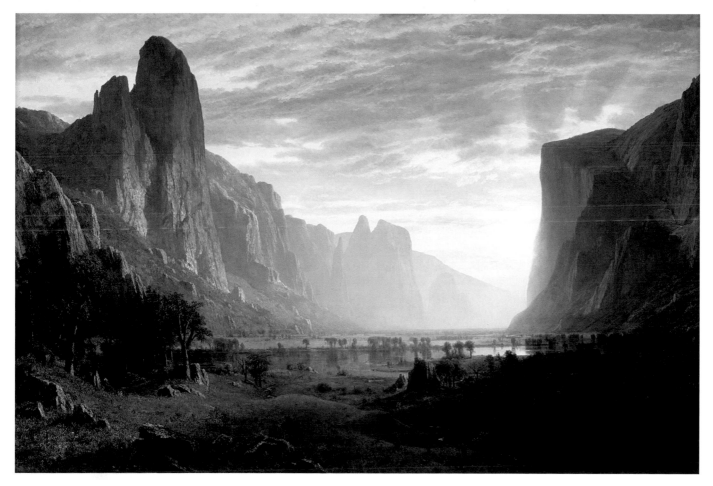

TOP: **ALBERT BIERSTADT**

Valley of the Yosemite, 1864, oil on paperboard

Museum of Fine Arts, Boston, Gift of Martha C. Karolik
for the M. and M. Karolik Collection of American Paintings,
1815–1865. Photograph © Museum of Fine Arts, Boston

BOTTOM: **ALBERT BIERSTADT**

Looking Down Yosemite Valley, California, 1865, oil on canvas

Birmingham Museum of Art, Birmingham, Alabama,
Gift of the Birmingham Public Library, 1991.879

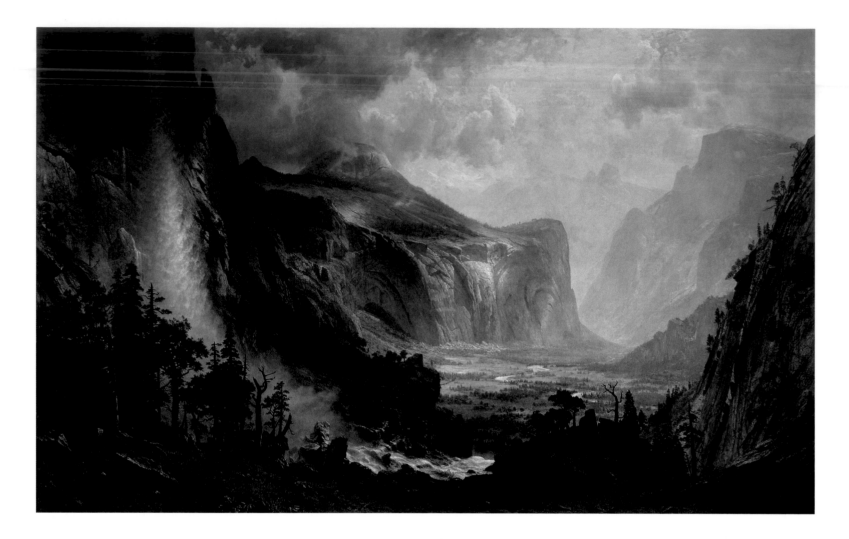

ALBERT BIERSTADT
The Domes of the Yosemite, 1867, oil on canvas
Collection of St. Johnsbury Athenaeum,
St. Johnsbury, Vermont

major work, it was sent to Milwaukee, Cincinnati, and Philadelphia, where it amazed its audience and confirmed Bierstadt's position as America's top painter of grand Western scenery. The correspondence between the quantity of canvas covered by such paintings and the monumental scale of the site reinforced the symbolism of westward expansion; as one British visitor to the United States, Constance Gordon-Cumming, noted, "everything in America is done on a large scale."[10] The dimensions of such paintings also gratified well-heeled prospective patrons, such as the financier LeGrand Lockwood, who commissioned Bierstadt's second truly monumental Yosemite work, *The Domes of the Yosemite*, for $25,000 in 1867.

Not everyone agreed with Bierstadt's version of Western providence, however. Nine-and-a-half feet high and 15 feet long, *The Domes of the Yosemite* was Bierstadt's largest canvas; it also sparked the biggest controversy of his career.

When it made its debut at the Tenth Street Studio Building in New York, it inspired a heated critical debate. Some judged the painting Bierstadt's "greatest success," whereas others were merciless in their attacks; among the latter was the critic Clarence Cook. Known for his "slashing and scalping" style, Cook targeted Bierstadt—and *The Domes of the Yosemite* in particular—as evidence of all that was wrong with American painting. Cook found the painting especially vulgar—a result he ascribed to Bierstadt's tendency to favor surface effects over subtlety and his "little accurate knowledge of nature."[11] Such reviews kept some away from Bierstadt's studio, among them Mark Twain, who at first avoided the painting, having heard it was not worth the effort. When Twain did see it, however, he declared it "beautiful"—indeed, "considerably more beautiful than the original." The atmosphere, in particular, he saw as "altogether

too gorgeous . . . more the atmosphere of Kingdom-Come than of California."[12]

Bierstadt's vision of Yosemite as Kingdom Come resonated with Lockwood, who installed the painting in his Norwalk, Connecticut, mansion in a private miniature temple to art, an octagonal rotunda based on Bramante's design for St. Peter's Basilica in Rome.[13] There it hung adjacent to an Annunciation by the Belgian painter Petrus van Schendel, which it dominated, slightly, in size. This pairing suggested a similarity in the spiritual resonance of the two works and gave equal weight to the images, one a depiction of America's natural beauty and the other an expression of Europe's more deeply rooted fine art heritage. Though retired from public view, *The Domes* was made accessible as an elegantly printed chromolithograph. Measuring 22 by 33 inches, the print was suitably impressive in size and quality for the reproduction of such a monumental canvas. While his major oils were affordable only to an elite few, Bierstadt made sure his vision of Yosemite as the Promised Land was publicly accessible through reproductions. Prints of his *Sunset: California Scenery* (1868) were also popular and no doubt graced many a parlor in Victorian San Francisco.

Despite the contentious debate some of his larger paintings inspired, Bierstadt's Yosemite work had widespread resonance. It also had precedents: prior to Bierstadt, at least a handful of artists had tried to capture the valley, beginning with Thomas Ayres, a self-taught draftsman who had come to California with the Gold Rush.[14] Ayres explored the valley in July 1855 with James Mason Hutchings, a writer, publisher, and Yosemite's first promoter, who later operated a hotel on the valley floor. Hutchings knew the market for scenic views and the publicity value of having an artist along with him as he traveled to Yosemite. On July 27, Hutchings and Ayres arrived in the valley, surprised to find it "almost unknown" to residents of the towns en route.[15] They explored the valley for two days, with Ayres making detailed drawings of the scenery (p. 32), before departing on July 30 for the long trip home.

An important early Yosemite entrepreneur, Hutchings provided several of the valley's first

artist-explorers with inspiration and commissions. He published Ayres's drawing of Yosemite Falls as a large-format lithograph in 1855 (p. 32), and engravings after four of Ayres's Yosemite sketches appeared in the first issue of *Hutchings' California Magazine,* a monthly periodical Hutchings launched in July 1856. Drawings by Adolph Schwartz, George Tirrell, Joseph Lamson, and others appeared in subsequent issues.[16] While their illustrations were of sites outside Yosemite, these artists had all explored the valley and its surroundings in Hutchings's company, and Yosemite had served as their artistic training ground.

Although Bierstadt would make the panoramic sweep of the valley the most famous view of Yosemite by the late 1860s, it was Yosemite Falls that drew the attention of these early draftsmen. Its unusual three-tiered configuration was distinctive and easily recognized. When depicted in a vertical format, the falls resembled a natural altar, which reinforced

the Christian symbolism of the place and conveyed an iconic power that more expansive vistas from Inspiration Point and Glacier Point did not. Water was an extremely important resource in the West, where it was frequently in short supply; mountain water, in particular, was believed to possess healing powers and was often recommended as a cure for a variety of joint and respiratory ailments. The depiction of a multitiered waterfall well over two thousand feet high would have thus had a particularly dramatic impact. Ayres's drawing, published by Hutchings, was the most widely disseminated of these early black-and-white views.

Other than Ayres's drawings, few of these early Yosemite sketches have survived. An undated sketch by Adolph Schwartz—*Yosemite Falls, Yosemite*—has recently come to light, along with several drawings of other Western subjects by the artist. A friend of Johann Augustus Sutter and James W. Marshall of Gold Rush fame, Schwartz may have been

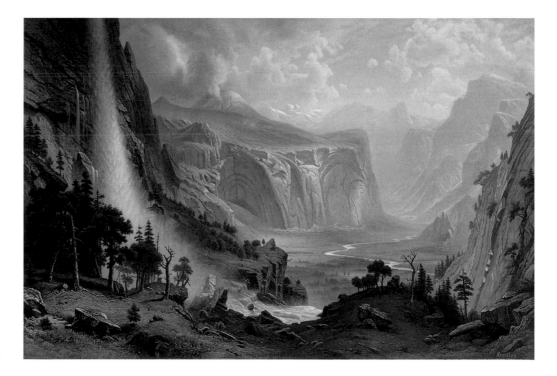

ALBERT BIERSTADT
The Domes of the Yosemite, 1870, chromolithograph
Amon Carter Museum, Fort Worth, Texas

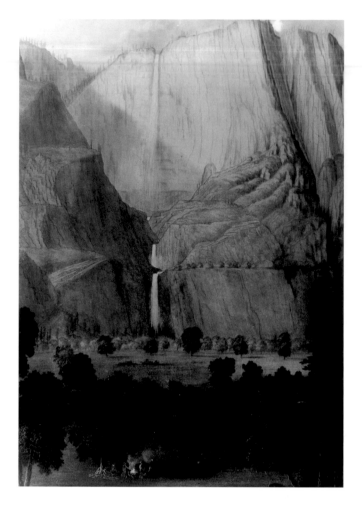

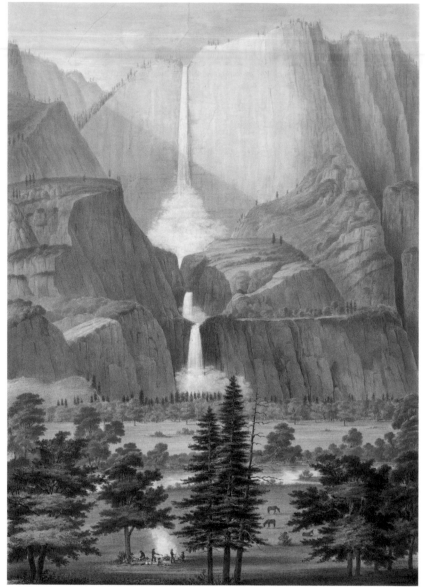

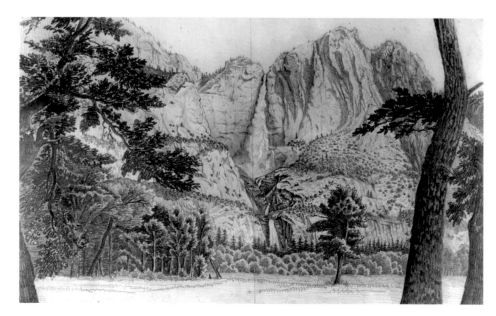

commissioned to sketch local scenery by Colonel John Charles Frémont, owner of the mining estate Las Mariposas near Yosemite.[17] Another intriguing early image is Lamson's *Mount Broderick and the Nevada Fall, Yo-Semite Valley, California* (1859). The mountain it depicts (now called the Cap of Liberty) had been christened in honor of David Colbreth Broderick, a U.S. senator from California who died in a duel over political differences with David S. Terry, chief justice of the California Supreme Court—a reminder of the degree to which California was governed by a frontier code. Lamson's notation on the drawing, "Respectfully inscribed to the members of the Broderick Monument Association," suggests that the sketch was made on commission or in hopes of making a sale.

By 1859, Yosemite's popularity caused Hutchings to remark on "the painters of California, who now make their annual pilgrimage to this Art Gallery of Nature, to receive inspiration among its sublime pictures."[18] While expeditionary draftsmen such as Ayres and Schwartz delineated Yosemite's topography in pencil on paper, artists with higher artistic aspirations were also beginning to capture its beauties in oil on canvas. Like Ayres, they usually selected Yosemite Falls as their first subject (see pp. 34–35). Among the first to render the falls on canvas were Frederick A. Butman and Antoine Claveau, both of whom probably visited the valley in 1857.[19] Yosemite Falls was such a compelling subject that even William S. Jewett, well on his way to becoming "the fashionable portrait-painter of the eighteen sixties,"[20] felt the need to try his hand at painting it, as did George Henry Burgess, who painted the falls in both watercolor and oils. Grafton Tyler Brown, a draftsman and lithographer as well as California's first African American landscape painter, would feel similarly compelled two decades later, as would the French-born Bohemian Club artist Jules Tavernier.

Yosemite's dramatic artistic potential would not be fully realized, however, until after Bierstadt's 1863 visit. Indeed, a San Francisco chronicler noted that Bierstadt's presence

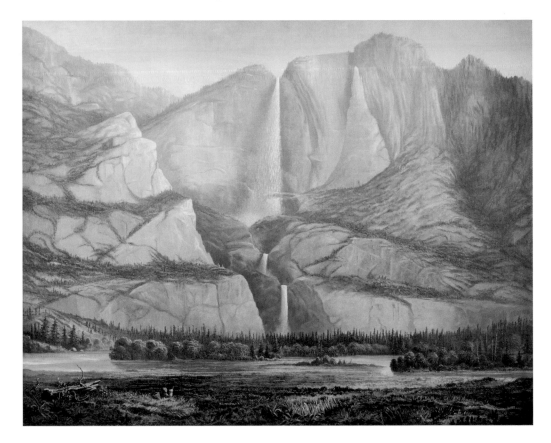

and work in Yosemite had so galvanized local artists that "a violent outbreak of Yosemite views, good, bad and indifferent" was unleashed upon the city.[21] Also directly following Bierstadt's visit, the Yosemite Grant of 1864 set aside the valley and the Mariposa Grove under the protection and administration of the state of California. Whether the Yosemite Grant was in part a response to Bierstadt's work is not clear, but his shining vision of California as the Promised Land would have resonated with President Abraham Lincoln amidst the turmoil of civil war. Predating the creation of Yellowstone National Park by eight years, the Yosemite Grant is still considered by many to be the first concrete expression of the national park idea.[22]

Yosemite's newly acquired official status helped crystallize its conceptual importance within the national landscape, and for California painters in particular. Among San Francisco artists, it was Thomas Hill and William Keith,

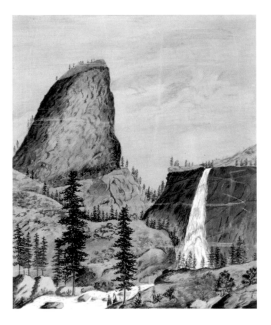

FREDERICK A. BUTMAN
Yosemite Falls, 1859, oil on canvas
Collection of Eldon and Susan Grupp

JOSEPH LAMSON
Mount Broderick and the Nevada Fall, Yo-Semite Valley, California, 1859, watercolor and gouache on paper
California Historical Society, FN-31908

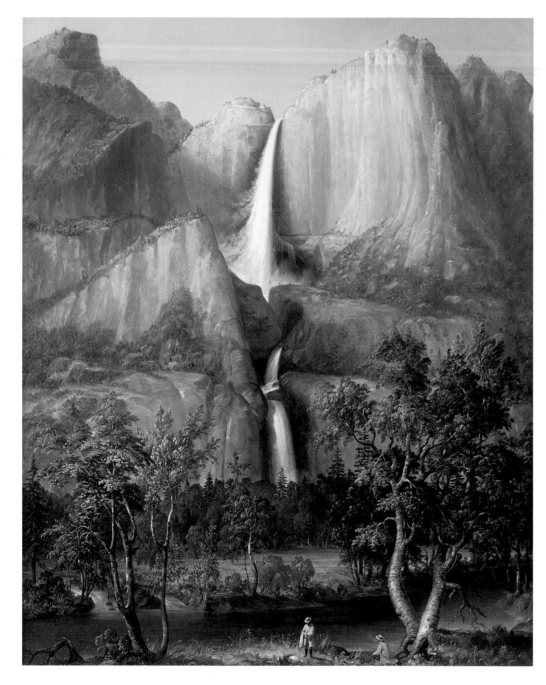

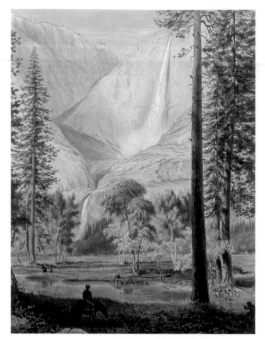

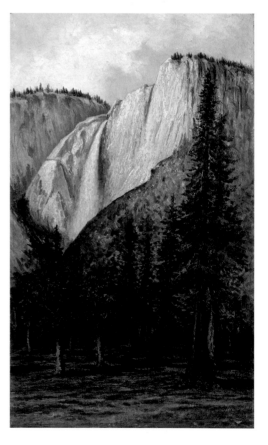

WILLIAM S. JEWETT
Yosemite Falls, 1859, oil on canvas

The Collection of The Newark Museum, Newark, New Jersey,
Gift of Mrs. Charles W. Engelhard, 1977. Photograph
© The Newark Museum

GEORGE HENRY BURGESS
Yosemite, n.d., oil on canvas

The Yosemite Museum, Yosemite National Park.
Photography by Robert Woolard

GRAFTON TYLER BROWN
Yosemite Falls, 1888, oil on canvas

Collection of Mr. and Mrs. Lester H. McKeever

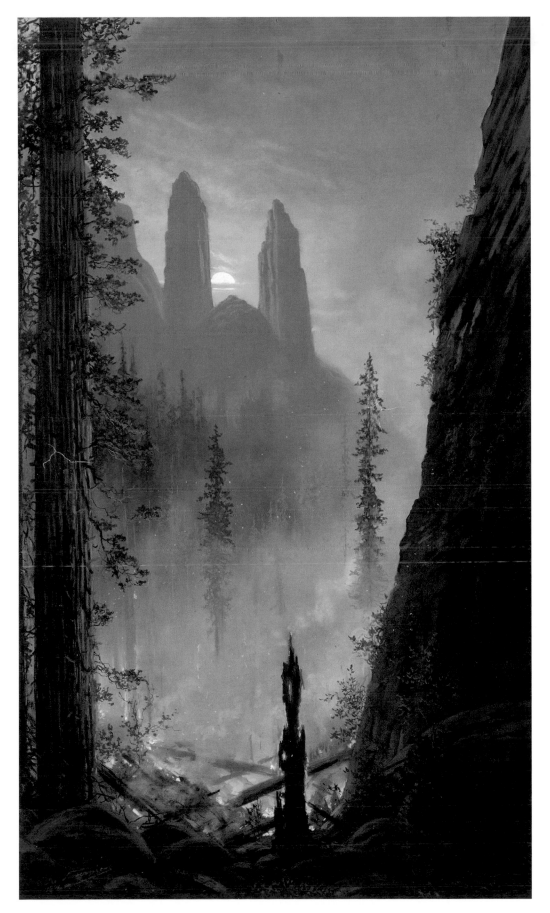

JULES TAVERNIER

*Yosemite (Forest Fire in Moonlit
Landscape)*, 1886, pastel on paper

Oakland Museum of California, Gift of
Mrs. Mary C. Hanchette

"local stars" in the memoirs of one socialite,[23] who would become most closely associated with Yosemite in the 1870s, as the new park gradually opened to tourism. Unlike Bierstadt, Hill and Keith were based in California; although both gained recognition in the New York art world, they achieved their greatest success in the Golden State. With improved access to Yosemite generating a larger audience for their work, and with Bierstadt's sensationalizing style in decline, Hill and Keith would also enjoy a connection to the park long after their predecessor had slipped from public view.

From the beginning, Hill in particular enjoyed a unique relationship with Yosemite Valley. Although he may have visited Yosemite before 1865,[24] his trip to the valley that year was important for multiple reasons: he traveled and worked with Virgil Williams, who had painted Yosemite with Bierstadt two years earlier, and with the photographer Carleton E. Watkins, who documented their campsite. Further, all three artists were consulted on aesthetic aspects of park management by the landscape architect Frederick Law Olmsted, who was then working as manager of Frémont's Las Mariposas estate. When the valley was declared a state park in 1864, Olmsted wrote to the artists as a member of the Yosemite Park Commission. Although the artists' response is unknown, Olmsted's letter requesting their input may document the first instance in which American artists were asked to serve as consultants on landscape aesthetics.[25]

By the time Hill had resettled in San Francisco from Boston for health reasons in 1872, he had been to Yosemite at least twice. He was already known on the West Coast for his exquisite, sunlit landscapes such as *Yosemite Valley* (1867, p. 38). This work shares many similarities with Watkins's photograph *Up the Valley, Yosemite* (ca. 1861–66, p. 38), suggesting that Hill might have consulted his friend's photographs when painting his studio canvases. The close relationship between Watkins's photo and Hill's painting also likely resulted from the particularly long distance between artist and subject; Hill finished the painting in Paris, during an additional period of study. After his time in Paris, Hill returned not to San Francisco but to Boston, where he painted two 6-by-10-foot Yosemite canvases between 1868 and 1871—first *Yo-Semite Valley* (present location unknown) and then *Great Canyon of the Sierras* (1871, p. 39). The latter is more broadly handled than Hill's paintings of the 1860s; his earlier work

CARLETON E. WATKINS
In Camp [Virgil Williams and Thomas Hill in Yosemite Valley], 1865, stereo albumen print
The Yosemite Museum, Yosemite National Park

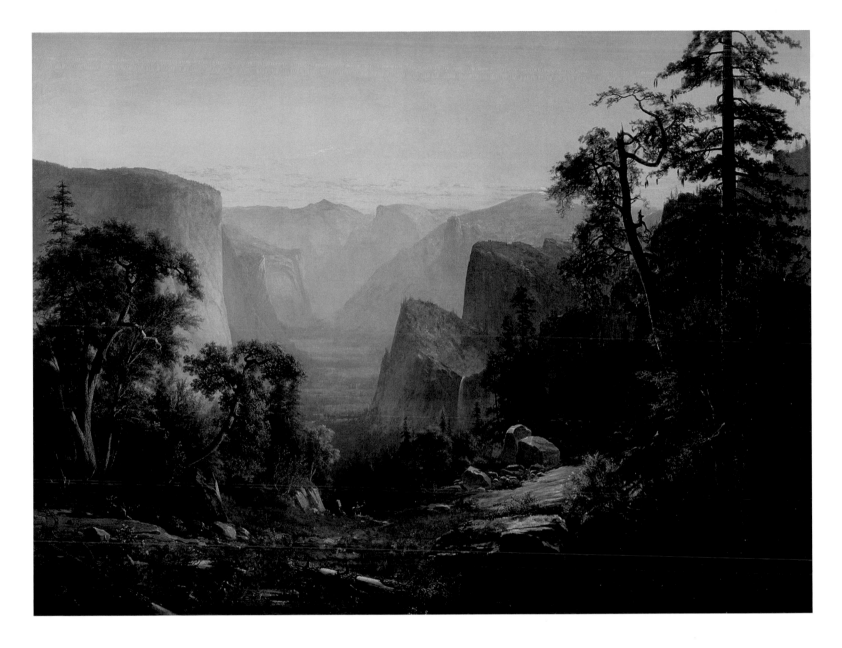

THOMAS HILL

View of the Yosemite Valley, 1865, oil on canvas

Collection of The New-York Historical Society, 1897.2

was usually smaller and more detailed, in keeping with his Hudson River School training. In an era that stigmatized painters for copying too directly from photographs, Hill's critics complained not about his use of artistic license (as they had about Bierstadt), but about his having "essayed large Yosemite views from points which [he had] never visited, but which [his] friend the photographer had."[26] Hill's large Yosemite canvases of 1868 and 1871 helped to promote his name in the Boston area, where he received a great deal of publicity. The first also brought him to the attention of the publisher Louis Prang, who was so inspired by Hill's vision of the valley that he

issued a series of Yosemite chromolithographs based on small oil sketches by the painter John Ross Key. Prang was also motivated to take his family to see the valley in person in 1872.[27]

The competition among painters shifted in the 1870s. Whereas Bierstadt had vied with Church for the national spotlight, Hill, Keith, and their contemporaries courted an audience that was more familiar both with their work and with Yosemite itself. This competition operated at several levels: on one were the large-scale epics painted for the barons of industry by art world celebrities such as Bierstadt and (in California) Hill and Keith; next were the

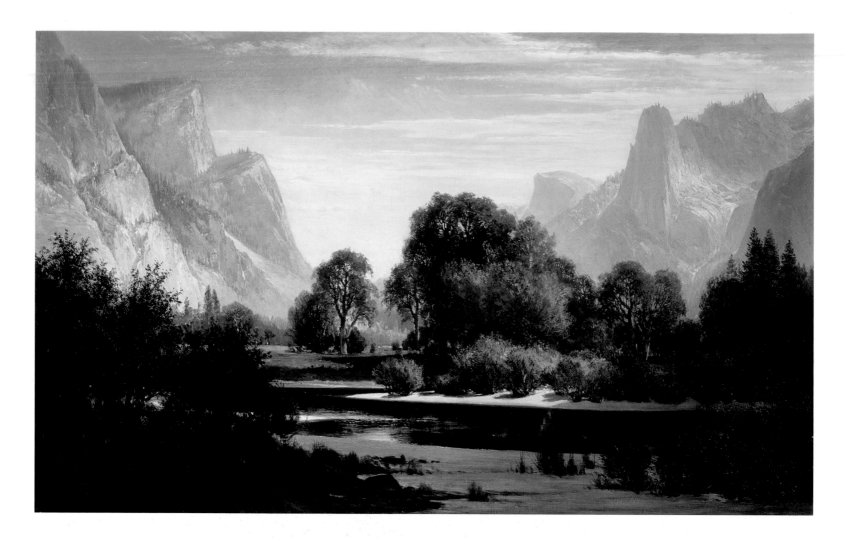

THOMAS HILL
Yosemite Valley, 1867, oil on canvas
Private collection of Thomas Kinkade

CARLETON E. WATKINS
Up the Valley, Yosemite,
ca. 1861–66, albumen print

Photography Collection, Miriam and Ira D. Wallach
Division of Art, Prints and Photographs, The New York
Public Library, Astor, Lenox and Tilden Foundations

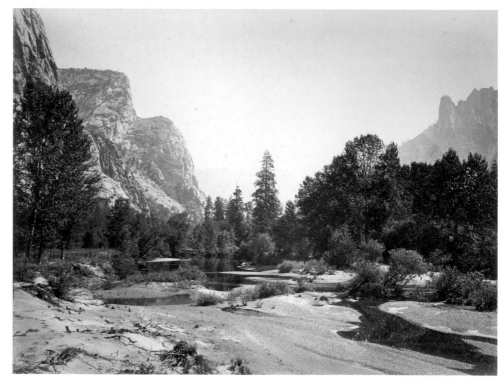

exquisite small oils by these and other painters, which were affordable to a broader clientele and filled a different niche in the market; and by the early 1870s, there was also an increasingly brisk trade in the low end of the market, with lithographs, chromolithographs, and engravings made available to more middle-class patrons, many of whom were also participants in the growing industry of Western tourism and had actually been to Yosemite. Comparable in price with stereographs and cabinet-card photographs, chromolithographs were sold for a few cents apiece.[28] Yosemite prints thus fulfilled the needs of tourists looking for inexpensive souvenirs as well as local residents who wanted attractive decorations for their homes.

The increasing availability of chromolithographs and other affordable souvenir images was directly related to the rising numbers of tourists visiting the valley after completion of the transcontinental railroad. Both Louis Prang in Boston and the Currier and Ives firm in New York City produced series of small- to medium-sized Yosemite prints. Prang published two such series of chromos, one based on oil sketches by John Ross Key and the other replicating images by the relatively unknown artist Robert Wilkie. Currier and Ives's uncolored lithographs, most of which were never credited to a particular artist, contain a number of topographical inaccuracies and were certainly the work of a draftsman who had never been to the valley in person.[29]

Hill is closely identified with the monumental Yosemite panoramas sold to the captains of California commerce, such as his 6-by-10-foot *Yosemite Valley (From Below Sentinel Dome, as Seen from Artist's Point)* (1876, p. 40). Exhibited at the Centennial Exhibition in Philadelphia, it was one of three canvases that earned the artist a gold medal for landscape—an accomplishment placing him, at least briefly, on a par with fellow exhibitors such as Bierstadt and Thomas Moran. Like Bierstadt, Hill adapted the subject and size of his Yosemite epics of the 1870s to serve the civic and personal aggrandizement agendas of his clientele. Unlike Bierstadt, however, Hill was patronized primarily by Californians, including affluent railroad entrepreneurs and businessmen with new mansions built to impress. His *Yosemite Valley* of 1876 was purchased by Leland Stanford, former governor of California, for display in the painting gallery of his Nob Hill home. Hill's clientele also included the railroad magnate Charles Crocker and his brother, Judge Edwin Bryant Crocker, both of whom purchased large Yosemite panoramas; the wealthy Santa Anita rancher Elias J. "Lucky" Baldwin, who bought a canvas titled *In the Heart of the Sierra* (1875); and the banker William C. Ralston, who acquired *The Royal Arches of Yosemite* (1872) for his lavish neo-Renaissance palace at Belmont. Some of these sales brought Hill as much as $10,000 per canvas. That all of these men purchased

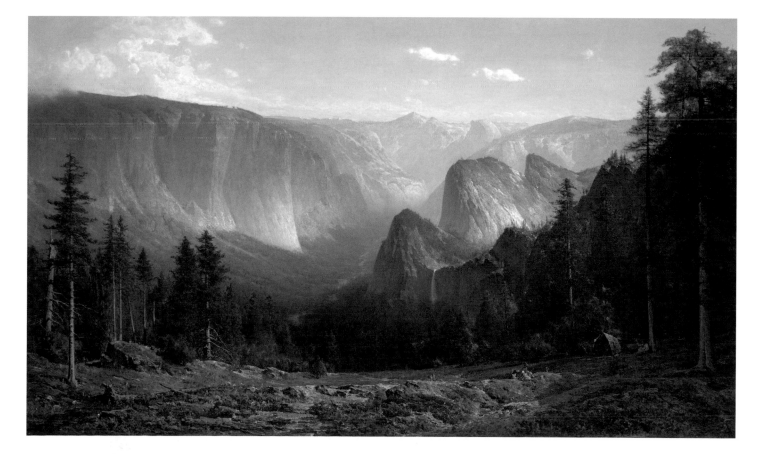

THOMAS HILL
Great Canyon of the Sierras, 1871, oil on canvas
Crocker Art Museum, E. B. Crocker Collection

large canvases by Hill within a few years' time suggests a strong element of competition among them. In 1871, the San Francisco *Daily Evening Bulletin* noticed the collecting tendency among California's nouveau riche, reporting that "Our California railroad magnates are all gathering collections of paintings."[30]

The choice of Hill's work by California's financial moguls was eminently logical at the time, and of mutual benefit. By the early 1870s, Hill was one of the older, more established painters of California; he was a success in his field, just as they were in theirs. The artist's wealthy patrons also provided a much more public arena for Hill's Yosemite imagery by displaying large canvases in their businesses, where the paintings served as both tasteful decoration and travel advertisements. William C. Ralston ex-

hibited Yosemite canvases by Hill at the Bank of California, and the hotelier James Lick decorated the dining hall of the Lick House hotel with large paintings of Yosemite and other California subjects. The owners of the Palace Hotel also purchased a large Yosemite scene by Hill.

Hill's premier status within the market for California paintings, especially among those whose fortunes were founded in the Golden State, suggests also the degree to which he was associated with Yosemite. Although Charles Dorman Robinson and Christian Jörgensen would give him a run for his money by the end of the century, during the 1870s and 1880s Hill dominated not only the high end but also the lower end of the market for Yosemite paintings by selling to tourists directly from his Yosemite studio. Recent research indicates

that Hill's first studio was built in the spring of 1883 "between the Cosmopolitan [Hotel] and Cook's Hotel, near the walk connecting the two places," and that by the end of the same year a second studio was constructed for him at the Wawona Hotel.[31] By 1886, he had moved into the Wawona Hotel, where his daughter Estella lived with her husband, John S. Washburn, one of the hotel's proprietors; Hill occupied "rooms 10 and 11 upstairs in the rear of the main hotel."[32] By the late 1880s, the Yosemite tourist trade was strong enough that Hill made his living primarily through sales to tourists. Although his production of enormous epics had nearly stopped, he was still selling paintings to a wealthy clientele, including British aristocrats and well-to-do Americans who came to the valley on the grand tour.[33]

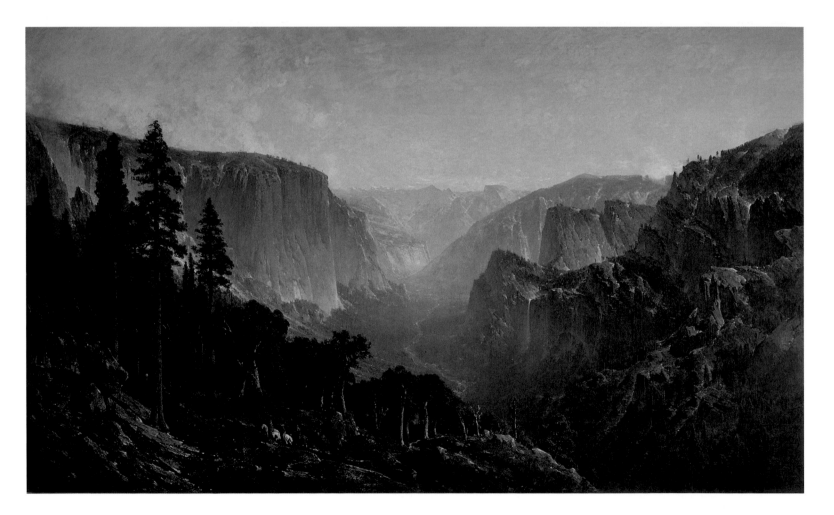

THOMAS HILL
Yosemite Valley (From Below Sentinel Dome, as Seen from Artist's Point), 1876, oil on canvas
Oakland Museum of California, Oakland Museum Kahn Collection

In addition to his panoramic epics of the 1870s and his huge output of souvenir paintings in the 1880s, Hill's oeuvre also includes several icons unique in style and format to the history of Yosemite art. Among these are his elongated vertical images of waterfalls and mammoth trees painted on wood, such as the undated *Wawona Tree* and *Waterfall, Yosemite* (p. 42). The art historian Nancy Anderson has commented on the irony of Hill's use of sequoia planks for his paintings of the giant redwoods. "In the most literal sense," she notes, "the subject of the painting had been consumed in the production of the image."[34] *The Wawona Hotel* (ca. 1885, p. 43) depicts its place of origin— Hill's studio building—at the left edge of the scene. When Hill painted the hotel, he added the fountain in front in a moment of artistic license; after the image was broadly disseminated as an engraving in Hutchings's 1886 book *In the Heart of the Sierras,* many visitors to Wawona were disappointed not to find the fountain there, prompting the proprietors to add one in 1889.[35] As an illustration in Hutchings's book, Hill's image spoke to potential visitors of the amenities available near the Yosemite Valley. Nearly a century later, in the late 1970s and early 1980s, the engraving was used on the Wawona Hotel's menu, where its presence now conveyed a more historical

CARLETON E. WATKINS (Photographer)
GEORGE HENRY BURGESS (Artist)

W. C. Ralston and the Directors of the Bank of California,
ca. 1875, albumen print
California Historical Society, FN-23312

PHOTOGRAPHER UNKNOWN

Thomas Hill's Studio at Wawona, ca. 1880s, albumen print
Oakland Museum of California, Gift of Cherene Holsinger and
James W. Cravagan III

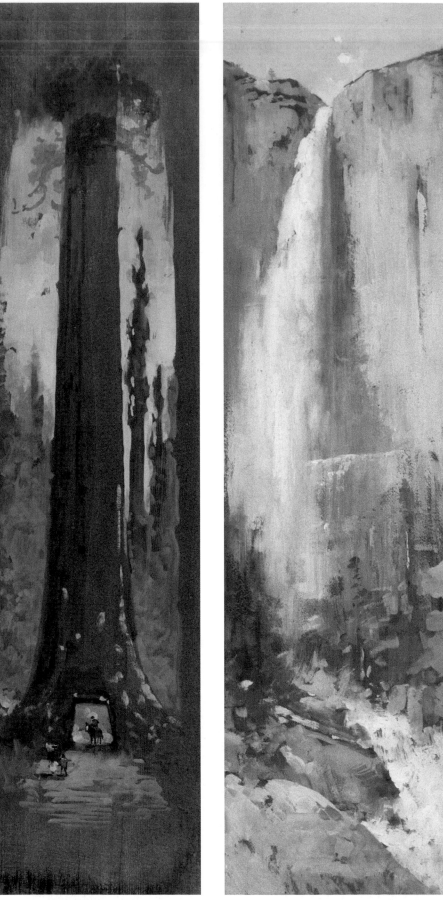

message to modern viewers regarding the continuity of Yosemite tourism.[36] In providing an outlet for sales of paintings, tourism was an important source of revenue for Hill and his competitors, including Robinson, whose *Advertisement for Barnard's Hotel and Cottages, Yosemite, Cal.* (ca. 1881–93) is blatantly commercial in origin. In their willingness to blend images of Yosemite scenery with hotel vignettes, both artists were clearly catering to the growing tourist market that their landscapes had helped create.

Hill's leading competitor in California's nascent art world was San Francisco's other "local star," William Keith. Keith exhibited watercolor studies of Yosemite subjects following a trip there in July 1866 and may have visited the valley even earlier in the decade.[37] His first oil paintings, like Hill's, were cast in the Hudson River School mold, although both artists, after studying abroad, acquired a looser, more painterly style as time progressed. Given the intense competition of the era, with first Bierstadt and then Hill linking their names to Yosemite, Keith sought his own artistic turf, painting the valley but also taking on a wide range of California mountain landscape subjects. Keith was also the artist most closely connected with John Muir. His Scottish origins and enthusiasm for California scenery—traits he shared with Muir—helped to solidify their friendship.

Describing their first meeting, when Keith and another painter, the San Francisco portraitist Benoni Irwin, approached him in Yosemite in 1872, Muir wrote that the artists "inquired whether in the course of my explorations in the adjacent mountains I had ever come upon a landscape suitable for a large painting."

THOMAS HILL
The Wawona Hotel, ca. 1885, oil on canvas
Collection of Mr. and Mrs. Gene Quintana

CHARLES DORMAN ROBINSON
Advertisement for Barnard's Hotel and Cottages, Yosemite, Cal., ca. 1881–93, oil on canvas
The Yosemite Museum, Yosemite National Park.
Photography by Robert Woolard

Keith and Irwin happily accompanied Muir into the high country of the Sierra Nevada. After they had rejected various landscape possibilities, the crown of the Sierra range came into view, and the artists were "excited beyond bounds." According to Muir, "the more impulsive of the two, a young Scotsman, dashed ahead, shouting and gesticulating and tossing his arms in the air like a madman. Here, at last, was a typical alpine landscape."[38] Keith's choice of subject was clearly influenced by the German mountain paintings he had seen during his studies abroad.

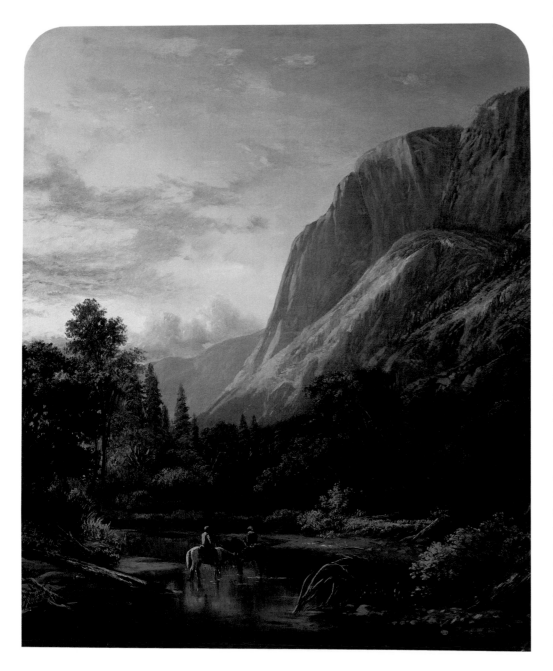

WILLIAM KEITH
Glacier Rock, Yosemite, 1869, oil on canvas
Oakland Museum of California, Gift of Judge O. D. Hamlin

Keith's *Yosemite Valley* (1875) sets the transience of human habitation against the timeless backdrop of the valley's granite walls. Both Natives and Anglo-American tourists are represented in the foreground, as seen in the Indian camp at the left and the riders at the river's edge. The camp itself contains the conical wooden dwellings of the Miwok Indians, who had lived in the Yosemite region long before its discovery by white settlers. Women in riding habits seated on horses testify to the increasing numbers of tourists visiting Yosemite after the completion of the railroad in 1869. In 1875, the year Keith painted this view of Yosemite, Muir complained about the "ungovernable avalanche of tourists" coming to the valley every spring, "flooding the hotels, and chafing and grinding against one another like rough-angled bowlders [sic] in a pothole."[39]

Due in large part to its accessible coastal location and perhaps not incidentally to its scenic setting, San Francisco was the first important art center of the American West. The Gold Rush of 1849 had attracted a major influx of immigrants, including artists, to the area. At first, the painters' productions were exhibited in shop windows and at the Mechanics' Institute fairs of the 1850s. As artistic activity increased during the following decade, art galleries were established, along with two short-lived artists' associations (the California Art Union and the San Francisco Artists' Union). More influential and long-lasting was the San Francisco Art Association, founded in 1871, which even opened an academy—the California School of Design—three years later.[40]

The growing San Francisco art world of the 1870s attracted a variety of artists, including Bierstadt, who returned to California for a second, longer stay between July 1871 and October 1873. An art world celebrity by this time, Bierstadt involved himself with the artistic institutions that had been established in the city since his 1863 visit; on August 7, 1871, he was elected the first honorary member of the San Francisco Art Association. Bierstadt returned to Yosemite several times, adding snow scenes, such as *Yosemite Winter Scene* (1872), to his repertoire. He also explored the High Sierra with the geologist Clarence King; the two men

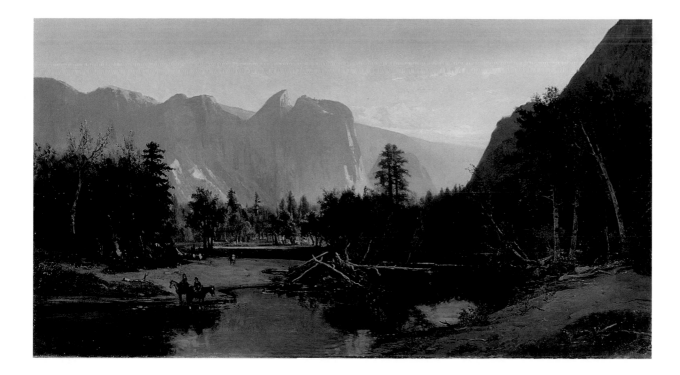

were photographed by Eadweard J. Muybridge during an 1872 outing to the Tuolumne River watershed above Yosemite (p. 46).

An art collector himself, King knew many of Yosemite's painters socially and worked with several of them in the field.[41] The landscape painter Gilbert Munger joined King's field crew in Utah in 1869; continuing west to California, he sketched Yosemite several times over the next few years. Although Munger usually painted with his fellow artist and close friend John Ross Key, on one occasion he joined Bierstadt in the Sierra Nevada, "camping in the snow sketching snow storms and snow effects."[42] Bierstadt's influence is obvious in the glowing sky of Munger's undated *Yosemite Valley* (p. 46). The activities of painters, both in San Francisco and during their wilderness sketching trips, were frequently discussed in the local press. A writer of 1870 complimented Munger for "doing more to bring to public notice the artistic resources in California scenery than any landscape painter whose pictures have been shown here."[43]

While many Yosemite painters produced large canvases, few besides Hill and Keith attempted to echo the scale of Bierstadt's epic works of the 1860s. Indeed, Bierstadt's largest Yosemite

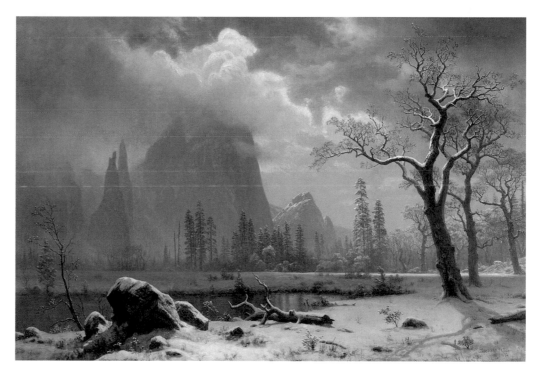

TOP: **WILLIAM KEITH**
Yosemite Valley, 1875, oil on canvas
Los Angeles County Museum of Art, A. T. Jergins Bequest, M.71.115. Photograph © 2006 Museum Associates/LACMA

BOTTOM: **ALBERT BIERSTADT**
Yosemite Winter Scene, 1872, oil on canvas
University of California, Berkeley Art Museum, Gift of Henry D. Bacon. Photograph by Benjamin Blackwell

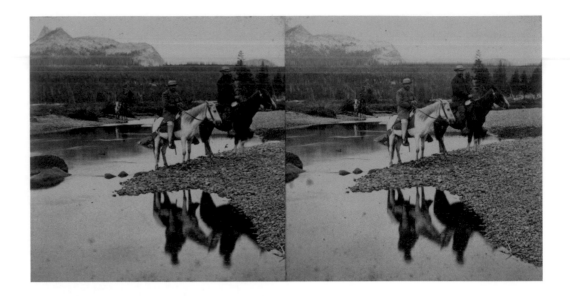

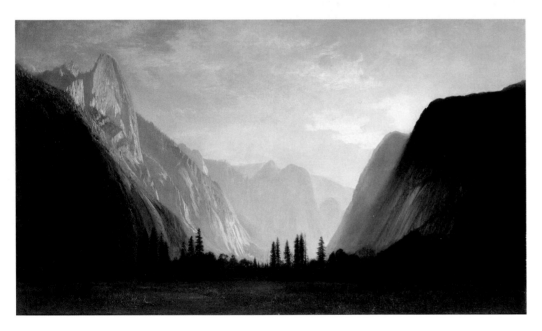

painting was surpassed in size only once: by Robinson's 50-by-380-foot circular panorama depicting the view from Inspiration Point. Lacking Bierstadt's network of patrons, Robinson had to undertake his ambitious canvas without a commission. In what was perhaps the most blatant demonstration of nationalistic pride associated with Yosemite imagery, he took his panorama to the Paris Exposition of 1900. His hopes of displaying it were disappointed, however, as the painting's size ultimately prevented its exhibition. To finance his trip home, Robinson was forced to sell the work in pieces, the whereabouts of which are unknown today.[44] Though Robinson's Yosemite venture ultimately yielded more disappoint-ment than riches, its ambition embodies what can be called the "Bierstadt effect": Bierstadt's work had turned Yosemite into a spectacle with the power to make artistic reputations and personal fortunes.

With the completion of the transcontinental railroad in 1869 came an increase in competition among artists as they sought new vantage points, new subjects, and new patrons. After Bierstadt, Thomas Moran was the most illustrious Eastern painter to visit Yosemite in the early 1870s. Having just returned from Yellowstone in Wyoming Territory a few months previous, Moran was hired to illustrate an article on Yosemite Valley for the January 1872 issue of *Scribner's Monthly*. During his summer stay, he made a series of drawings and watercolors, some of which he later reused as engravings, but the trip inspired no major canvases. Perhaps because he wished to avoid direct comparison with Bierstadt, most of Moran's Yosemite oils were not created until after his second visit, in 1904, two years after Bierstadt's death and long after the competitive atmosphere among grand landscape painters had subsided.

Moran's Yosemite imagery of the mid-1870s, while not grand in scale, nonetheless suggests the park's iconic status. *A Vision of the Golden Country*, an engraving he designed for Henry T. Williams's travel book *The Pacific Tourist*,[45] includes flowers and succulent fruits in front of a Yosemite landscape, with high, snow-capped mountains in the background. This

242 THE PACIFIC TOURIST.

A VISION OF THE GOLDEN COUNTRY.

BY THOMAS MORAN.

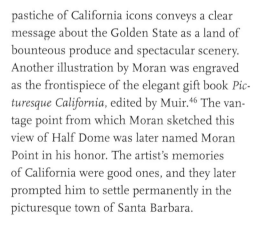

pastiche of California icons conveys a clear message about the Golden State as a land of bounteous produce and spectacular scenery. Another illustration by Moran was engraved as the frontispiece of the elegant gift book *Picturesque California*, edited by Muir.[46] The vantage point from which Moran sketched this view of Half Dome was later named Moran Point in his honor. The artist's memories of California were good ones, and they later prompted him to settle permanently in the picturesque town of Santa Barbara.

The lure of the Golden State brought dozens of artists to Yosemite after 1869, some visiting for a few months or years, others, like Moran, settling permanently in California. William Bradford, familiar to many as a painter of icebergs, found so much to paint on the West Coast that he used San Francisco as his base of operations for several years. Living at the Palace Hotel for much of that time, Bradford took over Bierstadt's old studio and living quarters on the top floor.[47] Like Bierstadt, he was

CLOCKWISE
FROM ABOVE LEFT:

THOMAS MORAN
A Vision of the Golden Country, engraving in Henry T. Williams, *The Pacific Tourist: Williams' Illustrated Trans-Continental Guide of Travel, from the Atlantic to the Pacific Ocean* (New York: Henry T. Williams, 1877), 242
Courtesy of The Bancroft Library, University of California, Berkeley

THOMAS MORAN
Frontispiece in *Picturesque California,* ed. John Muir (New York: J. Dewing Publishing, 1888)
Courtesy of The Bancroft Library, University of California, Berkeley

Photograph by George Reed in *The Overland Monthly* 22, second series, no. 129 (September 1893)
Courtesy of The Bancroft Library, University of California, Berkeley

active in San Francisco's social and artistic circles. The two also shared an interest in painting Yosemite in snowy winter conditions, but with only a few Yosemite canvases to his credit, it seems that the valley and its mountain setting were not Bradford's most successful subjects. In contrast, the German-born Herman Herzog made only one trip to Yosemite, but his visit in June 1874 provided him with source material for numerous paintings over the years, including *Nevada Falls* (1878).[48]

Just as Yosemite lured a wealth of artists from varied backgrounds, Yosemite paintings of the 1870s and 1880s attracted an increasingly diverse clientele. Thomas Hill's business notebook for the years 1884–87 indicates that although most of his clients during this period were from New York and San Francisco, a good number were British—several of them titled aristocrats—and a scattered few came from such distant points as Germany, India, New Zealand, and Australia. Gilbert Munger was commissioned to paint California scenery by Lord Skelmersdale (Edward Bootle-Wilbraham) and two other English gentlemen, who reputedly offered him $10,000 for his efforts.[49] William Bradford received a request for two Yosemite paintings from Earl Grosvenor (Victor Alexander Grosvenor), son of the Duke of Westminster, after both stayed at Leidig's Hotel in the valley. By his own account, Charles Dorman Robinson sold some eighty-four canvases to British clients, including baronets, earls, and lords.[50] An exceptional case was Lady Constance Gordon-Cumming, a painter and writer, whose 1878 display of watercolors on the porch of her hotel was probably the first art exhibition held in the valley by a nonresident artist.[51]

Tourists not only served as the patrons of Yosemite artists; they were also subjects in their paintings. Although tourists appeared in Yosemite landscapes as early as 1858, with Antoine Claveau's *Yosemite Falls*, they were most often depicted as small but intrepid figures whose presence added a human focal point and narrative element to the otherwise overwhelming scenery. The first painting to deal directly with tourism was William Hahn's 1874 *Yosemite Valley from Glacier Point* (p. 50), a painting that is emblematic of the emerging interest in Yosemite as a leisure destination. Hahn was a friend of William Keith's from their student days in Germany and from time spent together in the Boston area; like Keith, he settled permanently in California in 1872.[52] Known primarily as a genre painter—a specialist in

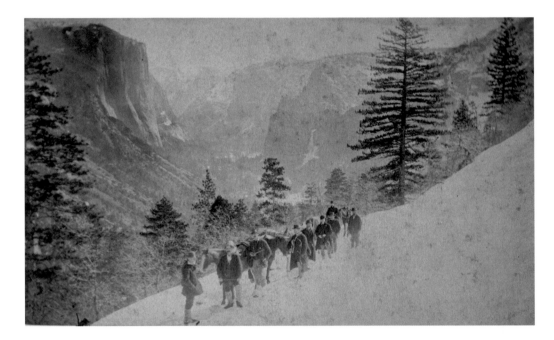

GEORGE FISKE
William Bradford with His Camping Outfit in the Yosemite Valley, 1878–80
Courtesy of The New Bedford Whaling Museum, New Bedford, Massachusetts. © The New Bedford Whaling Museum

WILLIAM BRADFORD
Sunset in the Yosemite Valley, n.d., oil on canvas
Marsh-Billings-Rockefeller National Historical Park

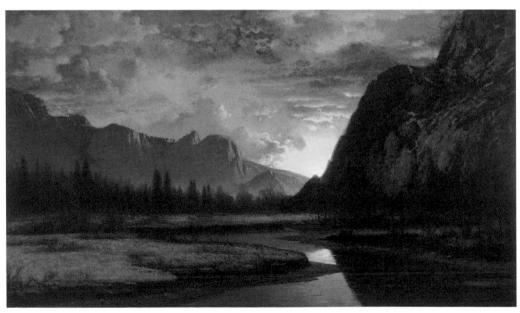

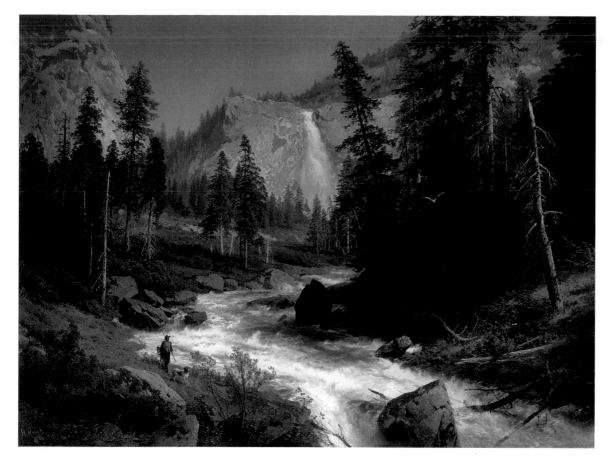

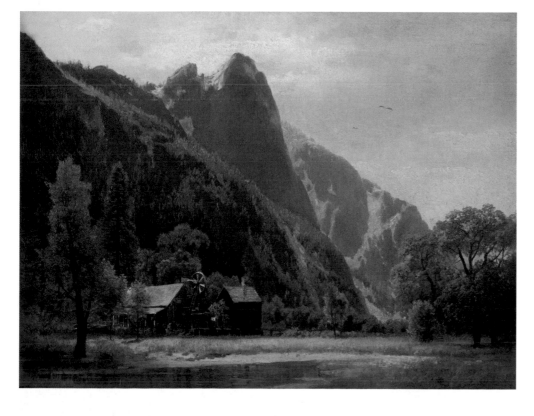

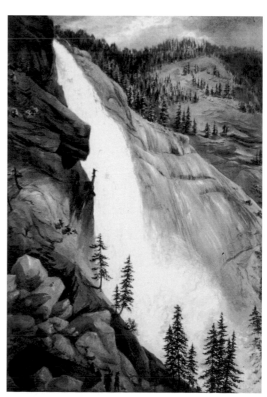

COUNTERCLOCKWISE FROM LEFT:

HERMAN HERZOG
Nevada Falls, Yosemite, 1878, oil on canvas
Courtesy of The Anschutz Collection.
Photograph by William J. O'Connor

HERMAN HERZOG
Yosemite Valley, 1874, oil on canvas
Collection of Eldor and Susan Grupp

CONSTANCE GORDON-CUMMING
Nevada Falls, 1878, watercolor
The Yosemite Museum, Yosemite National Park

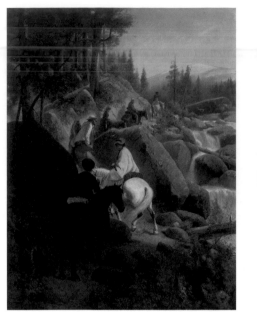

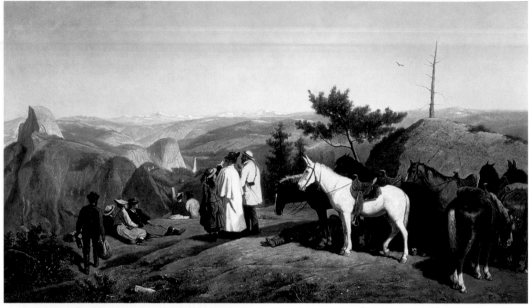

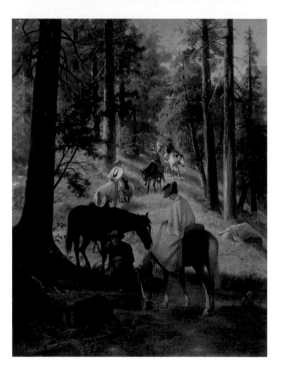

WILLIAM HAHN
The Trip to Glacier Point (The Excursion Party),
Yosemite Valley from Glacier Point, and
The Return from Glacier Point, all 1874, oil on canvas

First panel: Private collection; middle panel: California Historical
Society, Gift of Albert M. Bender; California Historical Society
Collections at Autry National Center, Los Angeles; last panel:
courtesy of Garzoli Gallery, San Rafael, California

scenes of everyday life—Hahn was the first artist to give human figures equal emphasis with Yosemite scenery. *Yosemite Valley from Glacier Point* documents the horse trail to the summit that had been opened in 1872, two years before Hahn painted the view. With its fashionable travelers admiring the vista from Glacier Point, the canvas celebrates their enjoyment of Yosemite's impressive scenery. Once the centerpiece of a three-part series that featured the steep trail and horseback journey to and from the outlook, the painting is a celebration of the rugged, outdoor aspects of a Yosemite adventure; at the same time, it also presents the trip as a leisurely one, with well-dressed ladies partaking in the journey and the discarded remnants of the group's picnic lunch visible in the left foreground. The inclusion of not only tourists but also their trash makes Hahn's *Yosemite Valley from Glacier Point* the first Yosemite image to comment on the environmental implications of increasing visitation.

The litter that appears in the foreground of Hahn's painting was just the beginning of the troubled relationship between Yosemite's visitors and the environment that artists came to paint. By the time Yosemite achieved national park status in 1890, access had increased considerably, rendering sublime landscapes of the

type Bierstadt had painted in the 1860s obsolete. Indeed, so well known was the main valley, so numerous the paintings already produced, that many considered it trite as a subject for serious landscape artists. Although Bierstadt's reputation and prices had declined considerably, the artist was still active, traveling and exhibiting in the United States and abroad; in 1885, he even returned to Yosemite for a final, and little-publicized, farewell visit.[53] Around 1890, Hill was spending his summers churning out smaller paintings for sale to wealthy tourists, which he continued to do on a seasonal basis until 1905. Keith, still active in San Francisco, was giving painting lessons, as well as selling portraits and landscapes.[54] Of this Yosemite triumvirate, Bierstadt—once the most celebrated—had also faced the harshest criticism, clinging tenaciously to his dramatic and detailed painting style despite severely declining finances in the mid-1890s. Hill and Keith, having adopted a softer style influenced by the French, continued to make a living as artists and enjoyed a great deal of respect from their California colleagues.

By 1890, increased access and visitation had considerably changed public perception of Yosemite from a sublime wilderness to a playground for the people. That year, approximately 1,500 square miles of territory surrounding the valley were placed under federal stewardship, creating a large national park with a small state park (the valley itself) at its center.[55] The valley would be "receded" to the federal government in 1906, at which point it became part of the larger national park. Bierstadt, Hill, and Keith—along with a host of their colleagues—had done their best to capture this Mecca of the Mountains in its pristine state. Their paintings were informed by notions of sublimity and the divine, by nationalism and geological inquiry, and by ideologies of destiny and progress that lie at the root of many of Yosemite's present-day problems. Nevertheless, their visions of the valley still resonate for viewers today.

PHOTOGRAPHER UNKNOWN
William Keith at Yosemite, California, 1891
Courtesy of The Bancroft Library,
University of California, Berkeley

NOTES

The epigraph is from *Catalogue of James H. Stebbins' Private Collection of Modern Paintings* (New York: American Art Galleries, 1889), 4. I am grateful to Amy Scott and Stephen Aron for their invaluable guidance and suggestions for this essay.

1. Bayard Taylor, "A Trip to the Big Trees," *North Pacific Review* 1, no. 1 (October 1862), 19.

2. Kevin Starr, *Americans and the California Dream* (New York: Oxford University Press, 1973), 183.

3. Fitz Hugh Ludlow, *The Heart of the Continent: A Record of Travel across the Plains and in Oregon, with an Examination of the Mormon Principle* (New York: Hurd and Houghton, 1870), 431–32.

4. Ludlow, *Heart of the Continent*, 419.

5. Even closer in subject are Williams's *Along the Mariposa Trail* (1863, California Historical Society Collections at the Autry National Center, Los Angeles) and Perry's *Sentinel Rock, Yosemite* (1865, private collection). For illustrations, see Nancy K. Anderson, *Cho-looke, the Yosemite Fall* (San Diego: Timken Art Gallery, 1986), unpaginated. Another similar pair is Bierstadt's *Yosemite Valley* (1866; Sotheby's New York, sale catalogue 7950, December 3, 2003) and Perry's *Sentinel Rock, Yosemite* (n.d., private collection).

6. Albert Bierstadt to John Hay, August 22, 1863, John Hay Collection, John Hay Library, Brown University, Providence, R.I.; cited in Nancy K. Anderson and Linda S. Ferber, *Albert Bierstadt: Art and Enterprise* (New York: Hudson Hills Press, 1990), 178.

7. Many of the tribes that Catlin encountered during his four major western expeditions between 1832 and 1836 had already been forcibly removed from their ancestral homelands in the southwestern United States. Their culture had therefore already been significantly changed by contact with Euro-Americans.

8. Anderson and Ferber, *Bierstadt: Art and Enterprise*, 24–25.

9. Ibid., 172, 182.

10. Constance Gordon-Cumming, *Granite Crags* (Edinburgh and London: William Blackwood, 1884), 258.

11. Quoted in Anderson and Ferber, *Bierstadt: Art and Enterprise*, 30.

12. Quoted in ibid., 91.

13. See Gordon Hendricks, "Bierstadt's *The Domes of the Yosemite*," *American Art Journal* 3, no. 2 (Fall 1971), 26–27.

14. See Nancy K. Anderson, "Thomas A. Ayres and His Early Views of San Francisco: Five Newly Discovered Drawings," *American Art Journal* 19, no. 3 (1987), 19–28.

15. "How the Yo-Semite Valley Was Discovered and Named," *Hutchings' California Magazine* 35 (May 1859), 504. Details of Ayres and Hutchings's travels have been taken from Hutchings's diary entries for June 26–July 30, 1855, Library of Congress, Washington, D.C.; typescript copy made by Cosie Hutchings Mills, Yosemite Museum, 99–112.

16. Ayres's drawings appeared in the July 1856 issue of *Hutchings' California Magazine*; Schwartz's in September 1859; Tirrell's and Lamson's in May 1860.

17. "Adolph Schwartz (1829–1872)," typescript, courtesy of M. P. Naud, Hirschl and Adler Galleries, New York.

18. "The Great Yo-Semite Valley," *Hutchings' California Magazine* 4, no. 9 (December 1859), 250.

19. For Claveau, see Sotheby Parke-Bernet, New York, sale catalogue 6400, March 10, 1993, lot 16, and the San Francisco *Daily Evening Bulletin*, October 27, 1857. An 1857 Yosemite painting by Butman is mentioned in the artist's file in the Oakland Museum of California Library, though the location of the painting is unknown.

20. Amelia Ransome Neville, *The Fantastic City: Memoirs of the Social and Romantic Life of Old San Francisco* (Boston: Houghton Mifflin, 1932), 96.

21. Benjamin Parke Avery, "Art Beginnings on the Pacific II," *Overland Monthly* 1, no. 2 (August 1868), 114.

22. While the Yosemite Grant set aside some 36,000 acres of Yosemite Valley for protection by the state of California, it was Yellowstone, in Wyoming Territory, that became the first national park in 1872; Yosemite would receive this status in 1890.

23. Neville, *Fantastic City*, 96.

24. For 1862 as the date of Hill's first visit, see David Jacks, "Diary from California to Ithaca, New York, May to September 1885," David Jacks's Family Papers, Box I, Huntington Library, San Marino, California, 15. I am grateful to Peter Blodgett for unearthing Jacks's diary. For 1865, see Janice T. Driesbach, *Direct from Nature: The Oil Sketches of Thomas Hill* (Yosemite National Park, Calif.: Yosemite Association; Sacramento, Calif.: Crocker Art Museum, 1997), 91n. 18.

25. See Hans Huth, "Yosemite: The Story of an Idea," *Sierra Club Bulletin* 33, no. 3 (March 1948), 70.

26. "Art Jottings," *California Mail Bag* 7 (June 1875), 116–17.

27. Prang's Yosemite visit is documented by an entry in Snow's La Casa Nevada hotel register, Yosemite Museum. Dated September 1, 1872, it reads: "Louis Prang, Boston, Mass., Mrs. L. Prang, Rosa M. Prang, Mrs. B. Bergmann."

28. Harry T. Peters, *California on Stone* (1935; reprint, New York: Arno Press, 1976), 7.

29. See Kate Nearpass Ogden, "Yosemite in Nineteenth Century Prints," *Magazine Antiques* 152, no. 5 (November 1997), 717–18; and Richard Holmer, "Currier and Ives Do California," *The Californians* 12, no. 6 (1995), 9.

30. Quoted in Gordon Hendricks, "The First Three Western Journeys of Albert Bierstadt," *Art Bulletin* 46, no. 3 (September 1964), 349.

31. *Mariposa Gazette*, April 28, 1883, and January 19, 1884. Information courtesy of Tom Bopp, Wawona Hotel, Wawona.

32. Wawona Washburn Hartwig and Jay Guerber, "Thomas Hill" (chronology), typescript in the author's collection, 5. See also Driesbach, *Direct from Nature*, 72, 75.

33. See Thomas Hill, business notebook, 1884–87, Crocker Art Museum archives, Sacramento.

34. Nancy K. Anderson, "The Kiss of Enterprise: The Western Landscape as Symbol and Resource," in William H. Truettner and Nancy K. Anderson, eds., *The West as America: Reinterpreting Images of the Frontier, 1820–1920* (Washington, D.C.: Smithsonian Institution Press for the National Museum of American Art, 1991), 277.

35. See James Mason Hutchings, *In the Heart of the Sierras, Tourists' Edition: The Yo Semite Valley, Both Historical and Descriptive; and Scenes by the Way* (Oakland, Calif.: Pacific Press, 1886), 255. See also *The Mariposa Gazette,* May 25, 1889.

36. Information courtesy of Tom Bopp.

37. Alfred C. Harrison, Jr., *William Keith, The Saint Mary's College Collection* (Moraga, Calif.: Hearst Art Gallery, Saint Mary's College of California, 1988), 5.

38. John Muir, "A Near View of the High Sierra," *Scribner's Monthly* (1880); reprinted in *The Mountains of California* (New York: Century, 1894, 1913), 51, 52.

39. John Muir, "The Summer Flood of Tourists," San Francisco *Daily Evening Bulletin,* June 14, 1875.

40. Nancy Dustin Wall Moure, *California Art: 450 Years of Painting and Other Media* (Los Angeles: Dustin Publications, 1998), 39.

41. Two catalogues of King's estate are held by the New York Public Library.

42. Munger, in a letter to his brother, quoted in "A St. Paul Artist High Up in the World Sketching," St. Paul, Minn., *Daily Pioneer,* November 15, 1872, 4; quoted in Michael D. Schroeder, "Chronology," Gilbert Munger Web Site, Tweed Museum of Art, University of Minnesota, Duluth, http://www.d .umn.edu/tma/MungerSite.

43. "Local Art Items," San Francisco *Alta California,* August 28, 1870, 1.

44. See Kent L. Seavey, *Charles Dorman Robinson (1847–1933)* (San Francisco: California Historical Society, 1965), unpaginated.

45. Henry T. Williams, *The Pacific Tourist: Williams' Illustrated Trans-Continental Guide of Travel, from the Atlantic to the Pacific Ocean* (New York: Henry T. Williams, 1876), 242.

46. John Muir, ed., *Picturesque California and the Region West of the Rocky Mountains, from Alaska to Mexico* (San Francisco and New York: J. Dewing, 1888).

47. Richard C. Kugler, *William Bradford: Sailing Ships and Arctic Seas* (New Bedford, Mass.: New Bedford Whaling Museum in association with the University of Washington Press, Seattle, 2003), 35.

48. See Donald S. Lewis, Jr., *American Paintings of Herman Herzog* (Chadds Ford, Penn.: Brandywine River Museum, 1992). Herzog's Yosemite trip was documented in the local press, as well as in Yosemite hotel registers.

49. Thomas Hill, business notebook, 1884–87; and Michael D. Schroeder and J. Gray Sweeney, *Gilbert Munger: Quest for Distinction* (Afton, Minn.: Afton Historical Society Press, 2003), 60.

50. See "Art Notes," San Francisco *Morning Call,* January 18, 1880; and Leidig's Hotel register, entry for November 22, 1879, Yosemite Museum. See also Charles Dorman Robinson, "The Artists of California," list enclosed in a letter to Mr. Newbegin, San Rafael, August 8, 1927, Bancroft Library, University of California, Berkeley; typescript copy at the Oakland Museum of California.

51. Gordon-Cumming, *Granite Crags,* 282–83.

52. Harrison, *William Keith,* 16. For more on Hahn, see Marjorie Dakin Arkelian, *William Hahn, Genre Painter, 1829–1887* (Oakland, Calif.: Oakland Museum, Art Department, 1976).

53. Bierstadt's final visit is documented in the Yosemite Falls Hotel register, entry for July 30, 1885, Yosemite Museum; and "Fortnightly Art Review," San Francisco *Chronicle,* August 9, 1885, 9. *Chronicle* reference courtesy of Alfred C. Harrison, Jr.

54. Driesbach, *Direct from Nature,* 88; Harrison, *William Keith,* 33.

55. Alfred Runte, *Yosemite: The Embattled Wilderness* (Lincoln: University of Nebraska Press, 1990), 55.

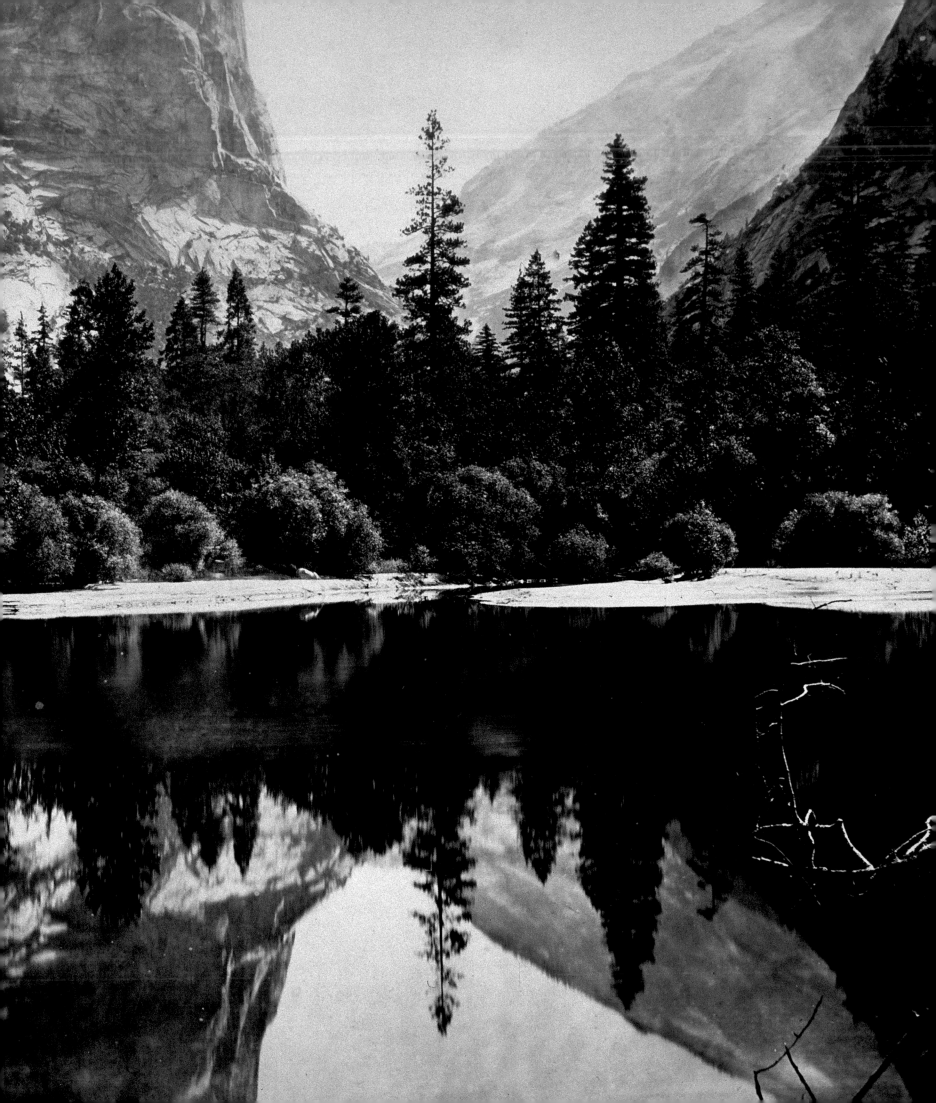

GARY F. KURUTZ

YOSEMITE ON GLASS

ON THE NIGHT OF JUNE 17, 1859, a party of San Francisco notables arrived at the newly constructed Hite Hotel in Yosemite Valley after a long journey on horseback over steep, rugged trails. Among them was the publisher James Mason Hutchings, keenly interested in promoting California's "scenes of wonder and curiosity" and there to collect images of Yosemite for his pictorial *Hutchings' California Magazine*.[1] Hutchings had with him several companions, including the influential Reverend Ferdinand C. Ewer, former publisher of the *Pioneer,* and Charles Leander Weed, the first photographer to enter the valley.

Charged by Hutchings with creating the images for a "Yosemite Panorama,"[2] Weed set up his dark tent the following day, mounted his forty-pound, wood-and-metal camera on its awkward nonfolding tripod, and pointed the instrument at what would become one of the most photographed sites in the world, Yosemite Falls.[3] According to Yosemite historian Mary Hood, Weed removed the lens cap and made this photograph—the first ever in the valley—at 11:25 in the morning. From there, Weed spent the next several days touring the valley with Hutchings and friends, recording now familiar landmarks such as the Three Brothers, Bridalveil Fall, El Capitan, and scenes along the Merced River as it cascaded and flowed through the valley floor. On June 21, Weed took a photograph of the two-story hotel, creating the first photographic image of a Yosemite building. He also viewed that neighboring wonder of majestic sequoias, the Mariposa Big Tree Grove. By the time Hutchings's party had finished its thirteen-day tour, Weed had successfully secured approximately twenty 10-by-14-inch and forty stereographic negatives. During his wilderness excursion, this photographic pioneer had

CHARLES LEANDER WEED
Mirror Lake (detail; see p. 58)
The Yosemite Museum, Yosemite National Park

55

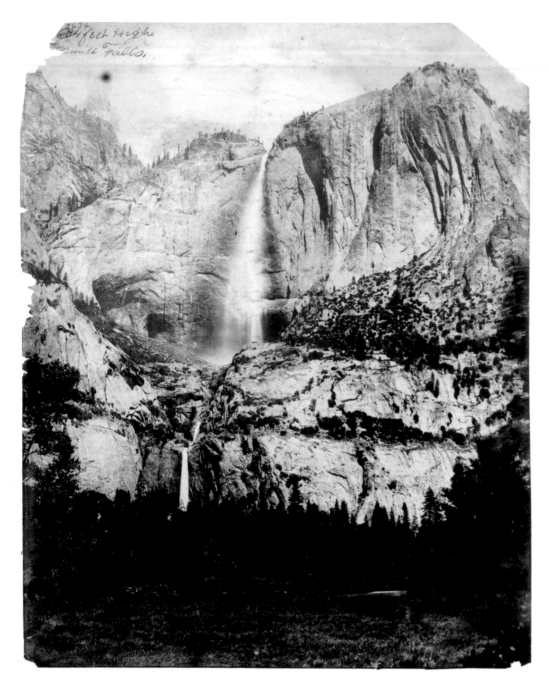

CHARLES LEANDER WEED
Yosemite Falls, June 1859, salt print
Courtesy of The Bancroft Library, University of California, Berkeley

exposed the first negative and had made the first stereo wet plates in Yosemite's great granite chasm.[4]

Over the next four decades, Yosemite Valley would play a major role in shaping pioneer landscape photography of the American West. Its wide central valley ringed with towering peaks, domes, and spectacular waterfalls challenged and inspired such leaders of the genre as Carleton E. Watkins and Eadweard J. Muybridge.[5] More than any other place, Yosemite became the basis of their careers and reputations. In turn, their images called international attention to this awesome natural wonder, coming at a time when technological advances in the new medium of photography had made possible the production of photographic prints in quantity. A more widely disseminated art form than painting, photography conveyed Yosemite's stunning beauty and exotic wilderness appeal to a mass audience, bringing the valley iconic fame and setting a standard for aspiring landscape and tourist photographers across the country.

In many respects, the black-and-white photography of the nineteenth century was the perfect medium for conveying the power and majesty of this geological masterpiece. As art historian David Robertson points out, Yosemite Valley is dominated color-wise by gray granite walls and boulders, white waterfalls, and dark green trees.[6] The lack of color, in other words, did not detract from the impact of the photographer's craft. Nonetheless, the valley's relatively remote location and its vertiginous terrain presented a huge challenge. Cumbersome glass negatives, enormous cameras, portable dark tents, and fragile chemicals all had to be laboriously brought in by pack animals. Setting up a camera holding an 18-by-24-inch wet-plate negative, thousands of feet above the valley floor, tested the determination and courage of these intrepid early photographers. Their reward proved worth the risk: the stunningly clear mammoth-plate albumen images created in the 1860s and 1870s are not just visual documents but true works of art that arguably remain unsurpassed.

Following its auspicious beginning in 1859, Yosemite photography evolved into a thriving

genre before the end of the nineteenth century. By the 1870s, three-dimensional stereographic prints, small in size and cheaply produced, appeared in countless homes. As the dry-plate negative came into widespread use in the 1880s, photographers enjoyed a new freedom: its shorter exposure time enabled them to instantaneously capture the furious motion of the valley's breathtaking waterfalls, rivers, and streams. Technological innovation also permitted the photographer to produce on-the-spot images that could be sold as souvenirs, while greater accessibility and widening fame brought increasing numbers of tourists to Yosemite.

Yosemite, through the photographer's lens, emerged as a wilderness shrine, becoming, among other marvels of nature, the New World's answer to the Old World's man-made monuments. Photographs of the valley and its environs, viewed in a gallery or through a stereo viewer, proved that Yosemite's splendor was indeed unparalleled and gave credence to the words of the writer and the canvases of the painter. Images of this Eden-like valley further bolstered the beliefs of nature worshippers like Ralph Waldo Emerson and Henry David Thoreau, giving them a new deity to add to their naturalistic pantheon. Most significantly, the works of these camera artists played a crucial role in demonstrating to the federal government the need to preserve this scenic wonder before it became despoiled by developers and overrun by waves of sightseers.

By the turn of the twentieth century, more than 150 photographers and publishers of photographs had recorded the valley, making it the most visible landscape icon and tourist destination in the American West.[7] For many of these Yosemite photographers, the products of their cameras became the means for both demonstrating their artistic skill and making money, but their careers were also fraught with the perils of working with new technology and a new artistic medium. Despite the massive effort and artistry involved in the production of mammoth-plate images, pioneer photographers often received little credit; competitors, dealers, and publishers pirated their images, ensuring that the economics of making a liv-

ing by landscape photography were problematic at best. Furthermore, as these "sun artists" churned out thousands of Yosemite photographs, the buying public did not always distinguish between the artfully composed image and the hackneyed tourist shot. Yet as nineteenth-century Yosemite photographers negotiated this tension between the dictates of commerce and the creative motives of art, the images they produced helped define Yosemite as a symbol of wilderness in a rapidly industrializing America.

——

In 1859, when the Hutchings party journeyed to Yosemite and Weed made his historic first images, photographic technology had recently made a great leap forward, evolving from one-of-a-kind daguerreotypes and ambrotypes preserved in decorative cases to paper prints that could be reproduced in quantity from wet-plate glass negatives.[8] Weed had mastered working in the field with a wet-plate camera as an em-

ployee of San Francisco's leading photographer, Robert H. Vance.[9] At the time, Yosemite was still unknown to most, located 150 miles east of San Francisco and having only been "discovered" by whites a few years earlier. It was therefore still a place of mystery to most Victorians, and preparation for a photographic trip into the wilderness in the late 1850s must have been daunting. Transportation alone represented a considerable challenge, with heavy equipment carried by stage, then packed into the valley by mule teams over long and difficult trails. In addition to his massive camera, Weed had to lug to Yosemite numerous 10-by-14-inch sheets of glass, each weighing at least a pound and a half.[10] Furthermore, he had to prepare and develop his negatives in a stuffy dark tent on the spot, where a blast of wind, drop of sweat, or wayward insect could ruin his plate. He also took with him a smaller, dual-lens stereoscopic camera for creating three-dimensional views that would be mounted on cards.[11]

CHARLES LEANDER WEED
Hite's Hotel, June 21, 1859, salt print
Courtesy of The Bancroft Library, University of California, Berkeley

262. Three Brothers—Yosemite Valley.

CHARLES LEANDER WEED
Three Brothers—Yosemite Valley, 1864,
stereo albumen print (published by
Lawrence and Houseworth, San Francisco)
Courtesy California State Library, Sacramento

CHARLES LEANDER WEED
Mirror Lake, 1864, mammoth-plate albumen print
The Yosemite Museum, Yosemite National Park.
Photography by Robert Woolard

Weed made it safely back to Vance's studio in
San Francisco with his treasure trove of pic-
tures. When the gallery produced contact prints
from his negatives, a new audience could see
for themselves the astonishing wonder of
Yosemite's soaring monoliths, towering water-
falls, and giant trees with the verisimilitude
afforded by photography. Vance apparently
printed the stereos first. Peering into a viewer
to see these scenes in three dimensions must

have prompted gasps of disbelief and delight
at nature's handiwork. The imperial-size salt
prints similarly evoked expressions of awe.
An impressed reporter from the San Francisco
Times, having seen the stereos through a me-
chanical viewing machine, wrote a glowing re-
view, pronouncing the images to be "admirable
specimens of the art."[12]

Although prints of Weed's images could be
seen free of charge at Vance's establishment,
the photographs had been intended as illustra-
tions for *Hutchings' California Magazine.*
To this end, artists created nineteen engraved
wood blocks from the photographs for repro-
duction in the periodical.[13] At a time before
photomechanical processes, this represented
the only method of presenting photographic
images to a mass audience. The October 1859
issue of Hutchings's magazine featured the
Yosemite trip in its lead article, and the first
page carried a rendering of Weed's historic
photograph of Yosemite Falls, with the credit
line "From a Photograph by C. L. Weed." En-
gravings based on Weed's images appeared in
three subsequent issues of *Hutchings' Califor-
nia Magazine,* and Hutchings further exploited
Weed's work by recycling these engravings in
multiple editions of his books *Scenes and Won-
ders of Curiosity in California* (1860) and *In the
Heart of the Sierras* (1886).[14]

Weed's views gained further notice when Vance
sold the rights to the stereos to the well-known
New York gallery Edward Anthony and Com-
pany. In this way, these first-ever views of the

great gorge would reach a national and even international market. Their distribution, however, demonstrated an early economic and artistic downside of the photography business: nowhere did Anthony credit Weed on the company's imprint.[15] Likewise, when Weed's photographs received a special award at the 1859 California State Fair, it was Vance's gallery and not Weed that received the accolades.[16]

In the summer of 1864, the enterprising San Francisco gallery of Lawrence and Houseworth hired Weed to return to Yosemite. This time, he was equipped with an even larger camera, capable of holding 17-by-22-inch glass-plate negatives, and of course a stereo instrument. From this campaign deep into Yosemite backcountry, penetrating as far as Bunnell Cascade in Little Yosemite, Weed obtained another impressive series of views. Demonstrating Weed's improving style, these images were of a quality far superior to that of his 1859 views. Moreover, printed as gold-toned albumen prints, a new medium, the images had a richness and clarity lacking in the flat-looking salt prints. Gallery advertising promoted these latest photographs as "crowning achievements of art." However, in the nascent genre of photography-acclaimed-as-art, Weed's employers, who footed the bill, did not include his name in their printed captions or in their catalogues.[17]

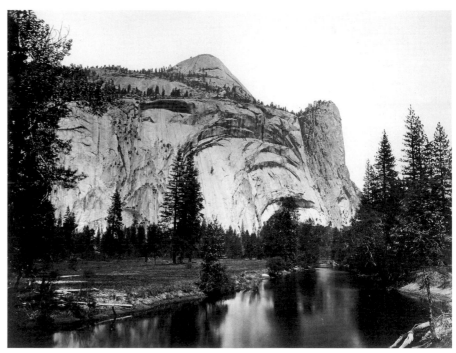

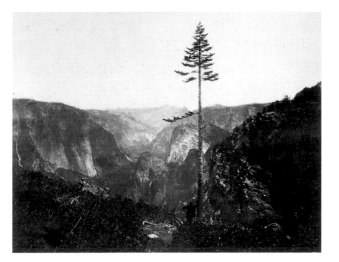

CHARLES LEANDER WEED
Yo-Semite Valley from the Mariposa Trail, 1864, mammoth-plate albumen print (published by Thomas Houseworth and Company)
Oakland Museum of California, Gift of the Women's Board

CHARLES LEANDER WEED
South Dome, South Side, 1864, albumen print
Photography Collection, Miriam and Ira D. Wallach Division of Art, Prints and Photographs, The New York Public Library, Astor, Lenox and Tilden Foundations

CHARLES LEANDER WEED
The North Dome, 3,725 Feet High, Royal Arch and Washington Tower, Yosemite Valley, 1864, albumen print
Museum of the American West Collection, Autry National Center, Los Angeles; purchase made possible by the Gold Acquisitions Committee, 2003

Lack of artistic credit for early photographers also contributed to a related problem, which was that their work was sometimes confused with one another's. When Lawrence and House-worth sent a selection of Weed's prints (without credit) to the prestigious Paris Exposition of 1867, including twenty-six of his 1864 mammoth plates of Yosemite, it was the gallery, not the artist, who came away with a bronze medal, the highest award. (The gallery then capitalized on the prize's promotional value by reproducing the medal on the backs of their mounts.) To make matters worse, the San Francisco *Alta California* credited Weed's rival photographer Carleton E. Watkins with

the award. Although the paper quickly corrected the error, giving Weed proper recognition, such mistakes were all too common.[18]

As landscape photography became an increasingly competitive endeavor, problems of artistic license as well as the economic realities of creating large-scale works based on a remote locale would also plague Watkins's career. Influenced perhaps by Weed's first set of images or by the inspirational words of Unitarian preacher Thomas Starr King, Watkins realized that this convulsion-rent valley presented him with the scale of scenery and artistic challenge that would make his reputation. In 1861, two

CARLETON E. WATKINS
Mt. Broderick and Nevada Falls, 1861, mammoth-plate albumen print
Courtesy California State Library, Sacramento

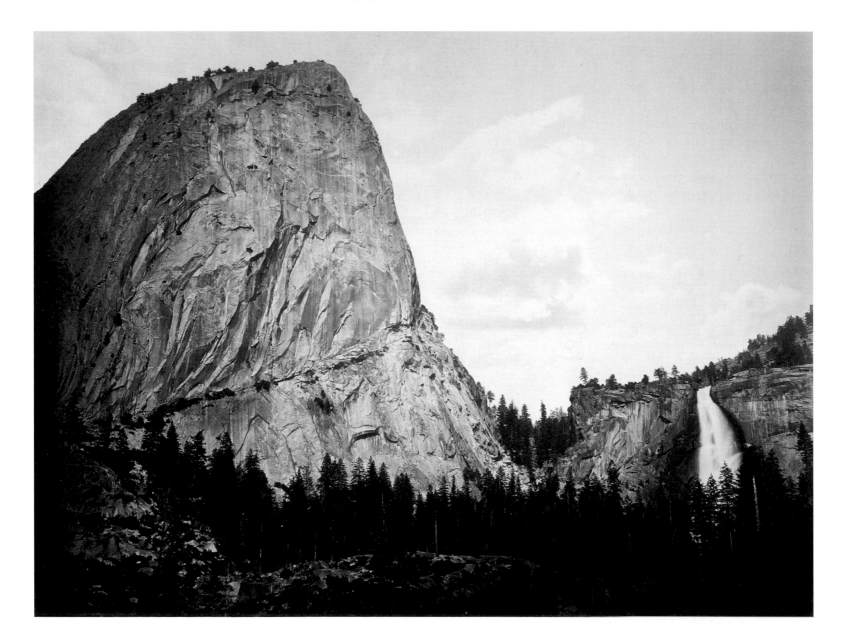

years after Weed's historic first trip, Watkins became the second artist to venture into the great valley with a wet-plate camera, creating a series of images that would establish him as one of the giants of American landscape photography. As his friend and biographer Charles B. Turrill noted, Watkins would forever after be linked to Yosemite.[19]

Recognizing the artistic potential and perhaps a ready market for large-scale images of Yosemite, Watkins hired a San Francisco cabinetmaker to create a leviathan camera capable of holding an 18-by-22-inch glass-plate negative. Equipped with a new wide-angle lens, the larger camera would allow Watkins to capture more of Yosemite's expansive landscape in each image.[20] Like Weed, he also took a much smaller stereoscopic camera. In so doing, he would capitalize on a dual market by creating impressive albumen mammoth plates for exhibition and sale to the wealthy, and smaller and cheaper stereos for popular consumption. Unlike Weed, however, Watkins did not have the advantage of an influential figure like Hutchings to pave the way and secure guides for him. Also unlike Weed, Watkins operated his own gallery and all expenses were his. It was financially risky to embark on such an undertaking without a commission or guaranteed sales.

Watkins's first stop, prior to dropping down into the valley, was the shade-shrouded Mariposa Grove, where he took full-length and close-up views of the noble sequoia known as the Grizzly Giant. Thereafter, he set up a base camp in the valley, using a team of mules to bear his equipment as he sought out the best vantage points each day. Photographing in this remote wilderness arena, Watkins faced many of the same challenges Weed had two years earlier. Over the course of the summer, he packed and unpacked his cameras, dark tent, and chemicals dozens of times before securing thirty acceptable mammoth plates and one hundred stereo negatives. What a patience-taxing effort it must have been to perfectly coat a four-pound sheet of glass with viscous collodion while squatting in a cramped, stuffy dark tent. Bugs, dust, and grit were constant foes, and the angry summer sun could warp his delicate equipment. Using wet-plate negatives, he

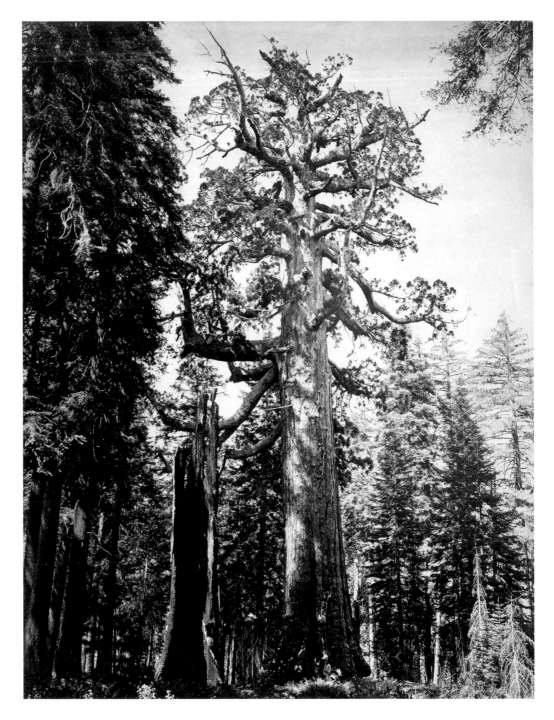

CARLETON E. WATKINS
Grizzly Giant, before 1864, mammoth-plate albumen print
Courtesy California State Library, Sacramento

worked in the still of the morning to prevent wind from distorting tree branches. An entire day could be occupied obtaining just one satisfactory mammoth plate.[21]

The output from Watkins's initial Yosemite campaign generated paeans of praise in the press and from the intellectual and artistic community, including Emerson and Oliver Wendell Holmes.[22] Due to his superior equipment, as well as his aesthetic sensibilities, his prints stood out against Weed's comparatively flat pioneer images of 1859. The Reverend H. J. Morton, a frequent contributor to the powerful *Philadelphia Photographer,* conveyed the singular immediacy of Watkins's images when he wrote, "We are able to step, as it were, from our study into the wonders of the wondrous valley, and gaze at our leisure on its amazing features."[23] Pioneer photographer C. R. Savage of Utah called Watkins's images "the most advanced in the photographic art." Watkins's standing soared further when the prestigious Goupil's Art Gallery in New York City put on a display of his prints in 1863. The painter Albert Bierstadt viewed his work there, and was so taken by what he saw that he determined to visit Yosemite himself. As demonstrated by the oils that resulted from Bierstadt's 1863 trip, Watkins would have a considerable influence on landscape painting; indeed, he frequently worked alongside other artists, including Thomas Hill and Virgil Williams, on subsequent visits to Yosemite.[24]

Watkins's Yosemite photographs influenced how people saw Yosemite in other ways as well, and for decades to come. Combined with Weed's photographs, they provided the visual evidence to support the effort to preserve Yosemite and the Mariposa Grove. In 1864, President Abraham Lincoln signed the bill that set aside the great valley and grove "for public use, resort, and recreation . . . inalienable for all time." With the Civil War raging, these striking photographs reminded the nation of the precious and peaceful assets under its stewardship.[25] Watkins's majestic Yosemite views also attracted the attention of three eminent scientists, Josiah D. Whitney, William Henry Brewer, and Clarence King of the Geological Survey of California. Led by Whitney, the survey began a serious investigation of the Golden State's incredible geology, with Yosemite and its environs as the principal target. Photography would form an essential component of their work. Always struggling to make ends meet, Watkins had a financial incentive to collaborate with Whitney and revisit the valley, but his motivation was personal as well: the competitive fire to surpass Weed's 1864 views and capitalize on the newfound national and scientific interest in Yosemite.[26]

In late July 1865, Watkins made his second foray to Yosemite, secure in the knowledge that he had in Whitney and his survey at least one client waiting. Consequently, he came heavily equipped, with a mule train carrying over a ton of baggage, including one hundred mammoth sheets of glass for wet-plate nega-

BOTH: **CARLETON E. WATKINS**
Under the Upper Yosemite Fall, no. 72, 1861, stereo albumen print

Tip Top of the Sentinel Dome, stereo no. 1142, ca. 1866, stereo albumen print
Both courtesy California State Library, Sacramento

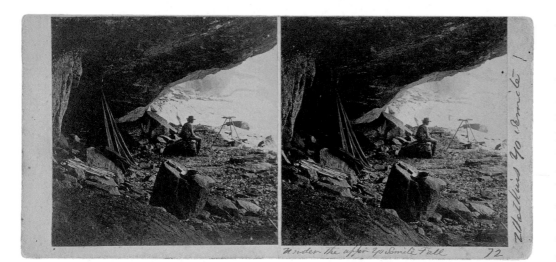

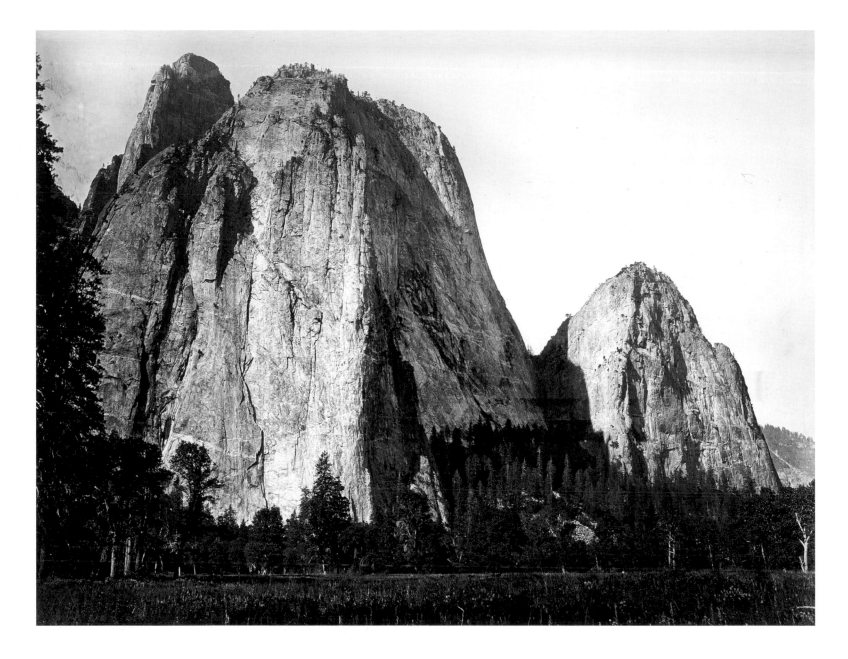

tives and a camera fitted with a wide-angle Globe lens that allowed for less distortion at the edges of his prints.[27] Seeking to improve upon his 1861 work, he revisited many of the same locations, including the Mariposa Grove and its gnarled Grizzly Giant. New angles, different times of the day, and close-ups of rock formations and waterfalls provided a rich reward.

A year later, Clarence King led Whitney's survey back to Yosemite for the summer season. Watkins also returned, this time armed with four cameras. As Watkins's biographer Peter Palmquist has pointed out, his use of multiple cameras with the necessary support equipment was a marvel of coordination. The expedition blazed trails into the high country, obtaining vertigo-inducing views from such heights as Glacier Point. One of the glories of this mid-decade campaign was a three-part panorama of the valley, known as the Lyle Group; photographed from Sentinel Dome, it provided a geological portrait as never seen before. Whitney and Brewer were ecstatic with the results. In a singular tribute to their photographer's genius, the state geologist named a Yosemite peak in his honor.[28] Watkins also produced six thousand original prints at a cost of $1,500 to illustrate Whitney's magnum opus,

CARLETON E. WATKINS
Cathedral Rock, ca. 1866, mammoth-plate albumen print
Courtesy California State Library, Sacramento

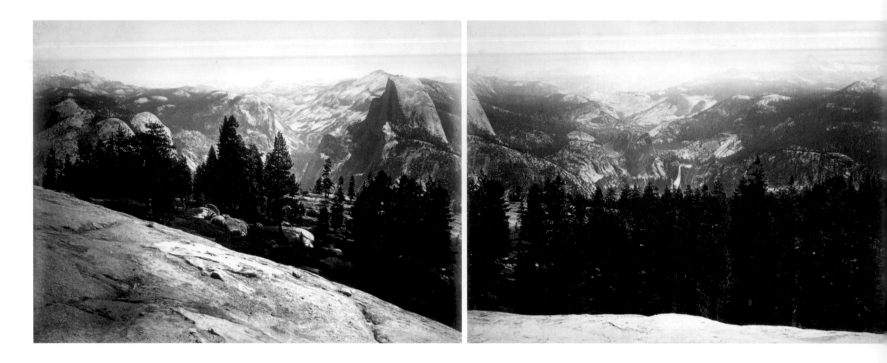

The Yosemite Book. In 1868, Julius Bien of New York published the handsome quarto, embellished with actual mounted photographs, in an edition of 250 copies.[29]

Back in San Francisco, Watkins grappled with the highly competitive business side of photography. Three expeditions had given him an unsurpassed inventory of views in various sizes. To solidify name recognition and subject ownership, he bestowed the name Yo-Semite Gallery on his downtown Montgomery Street business and his photographer's wagon. He adorned the gallery, which was strategically located near the leading hotels and business blocks, with mammoth plates stylishly presented in gilt-edged walnut frames. Single mammoth plates sold for five dollars each. His patrons and customers could also select groups of images to be placed in portfolios or in sumptuously bound large folio albums. Many of these prints he signed and captioned in his own hand. These were indeed works of art and much more affordable than a landscape painting by Bierstadt or Hill. Stereos could be purchased as single cards for a dollar each or packaged in boxed sets.[30]

Despite the flood of recognition and rising visibility of landscape photography as an art form, selling scenic views of Yosemite and the West remained a tough business. While most of his competitors relied on portraiture as a stable source of income, Watkins persistently entered his Yosemite views in local, national, and international exhibitions, and his advertising in newspapers, directories, guidebooks, and on the backs of his card mounts touted the many accolades he had garnered. Winning

PARIS INTERNATIONAL EXPOSITION, 1868
The First Prize
AWARDED TO THE UNITED STATES
BY THE
Committee on Photographic Landscapes,
RECEIVED BY
C. E. Watkins,
AND THE
ONLY MEDAL FOR CALIFORNIA VIEWS
425 MONTGOMERY STREET, SAN FRANCISCO.

EXPOSITION UNIVERSELLE DE MDCCCLXVII A PARIS
C.E. WATKINS
RECOMPENSES

NAPOLEON III EMPEREUR

Advertisement from the *San Francisco Directory* (1870), p. cxi
Courtesy California State Library, Sacramento

CARLETON E. WATKINS
Yosemite Valley Panorama, 1865–66, three-part panorama, mammoth-plate albumen prints
The J. Paul Getty Museum, Los Angeles

BELOW: Advertisement for Carleton E. Watkins's Yo-Semite Gallery from the *San Francisco Directory* (1867–68), p. xxvi
Courtesy California State Library, Sacramento

awards still did not always translate into dollars, however, and the confusion that resulted from piracy and mix-ups diluted both his income potential and artistic visibility. Such was the case in 1867, when Watkins was credited with the award-winning images actually created by Weed,[31] or when Watkins's 1861 views were reprinted without credit by the New York publisher D. Appleton and others, robbing him of potential income before copyright was enforced.[32] Even worse, sometime around 1876 Watkins lost his entire negative collection to Isaiah Taber for defaulting on a debt; seizing this bonanza, Taber aggressively marketed Watkins's landscape photographs, including many of his Yosemite views, under his own name.[33]

Showing the same indomitable will and energy that first took him to the Yosemite wilderness in 1861, Watkins returned again in 1878, determined to rebuild his inventory and his livelihood. Marketed as "Watkins' New Series," the photographs that resulted from this trip included some memorable images, such as *Agassiz Rock and the Yosemite Falls, from Union Point* (p. 66), a relatively unique composition that featured a dramatic granite obelisk overlooking the valley. Though Watkins returned to the valley several more times after the 1860s, creating brilliant images in a variety of for-

mats, his 1860s views were the ones that established him as the preeminent landscape photographer of California and the West. By the 1880s and 1890s, the valley was filled with tourists and other photographers who aimed their more portable cameras at the same vantage points laboriously selected by the master.[34] As Nanelle Sexton notes, "Yosemite, the birthplace of his personal aesthetic and the wellspring of his inspiration, had become a visual cliché."[35]

Watkins was not solely responsible for popularizing Yosemite as a photographic destination, however. As early as 1867, he already had a serious challenger to his role as Yosemite's preeminent photographer. That fall, Eadweard J. Muybridge returned from the valley with a superb series of views that dazzled the local press and art community.[36] Without doubt, the English-born Muybridge, who would later achieve immortality through his studies of figures in motion, was among the most innovative and famous photographers at work in the Far West during the pioneer era, eclipsing many of his contemporaries.[37] Success in Western landscape photography meant conquering Yosemite; the theater-like setting of the valley, with its easily recognizable landmarks, made it the ultimate proving ground.

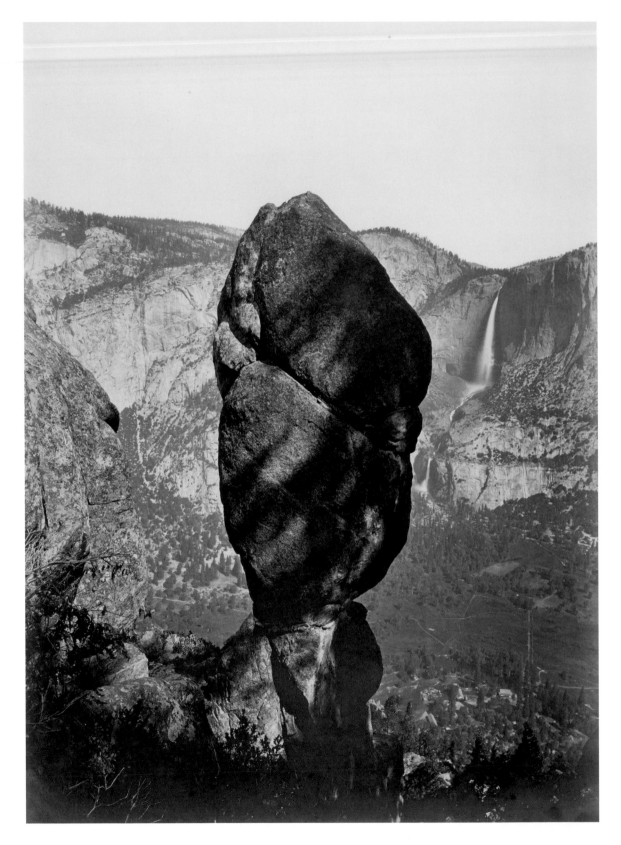

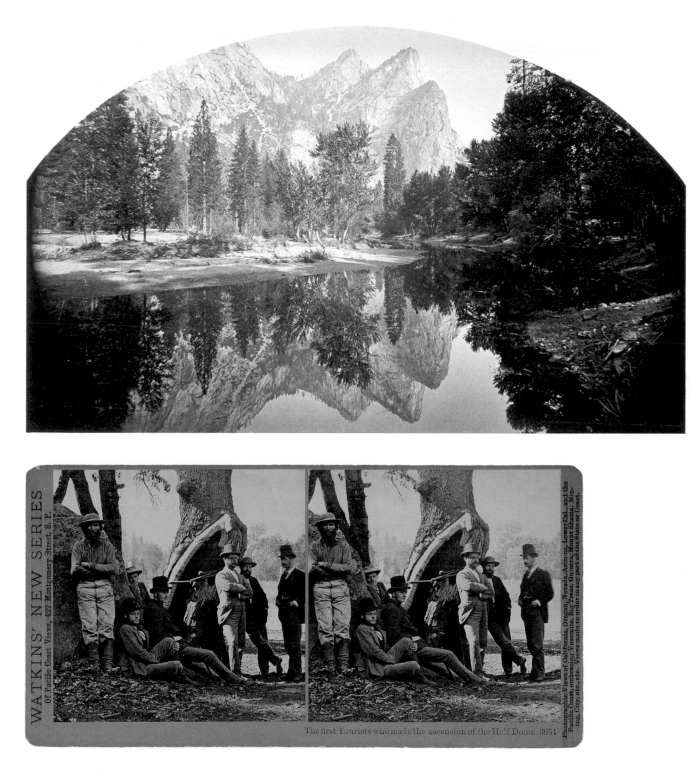

BOTH: **CARLETON E. WATKINS**

Mirror View of the Three Brothers, Yo Semite, B3013,
ca. 1875–77, albumen print

"The first Tourists who made the ascension
of the Half Dome," 3051, n.d., stereo albumen print

Both courtesy California State Library, Sacramento

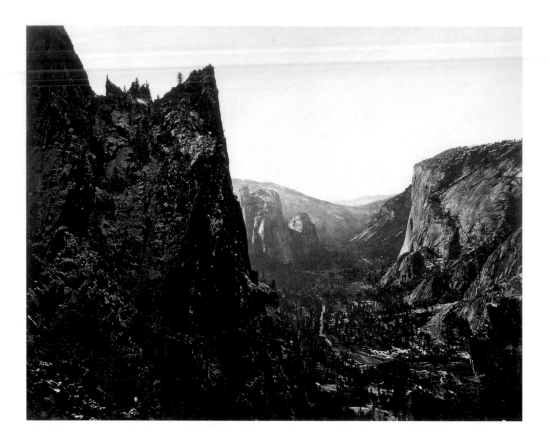

EADWEARD J. MUYBRIDGE
Valley of the Yosemite from Union Point, 1872,
mammoth-plate albumen print
Courtesy California State Library, Sacramento

Affiliated with Silas Selleck's Cosmopolitan Gallery of Photographic Art in San Francisco, the mercurial Muybridge headed to Yosemite in the spring of 1867, lugging the now requisite stereo camera, together with a larger, 5-by-8-inch glass-plate camera. Along with photographing the many heralded geological landmarks of Yosemite, he also pushed into the Merced River Canyon and rim of the valley. During this initial campaign, he came away with seventy-two large views and 114 stereos. In his approach, he did not entirely replicate the work of Weed and Watkins, but rather concentrated on different vantage points and times of the day, capturing the "mood" and drama of the valley by including mist, reflections, clouds, and even a rainbow. Locations such as the shimmering Mirror Lake naturally caught his inventive attention. Ever resourceful, he either painted clouds on his negatives or made a separate negative of clouds and then superimposed this on another to make a print.[38] As a further innovation, "he invented and patented the 'Sky Shade,' a device for 'holding back' the sky areas in his negatives, to prevent their becoming overexposed and washed out."[39] Thus his images, like a painter's, often took

advantage of atmospheric effects, exhibiting a romantic flare not previously seen in Western landscape photography.

In aesthetic terms, Muybridge's work is often compared to that of Watkins, though his more painterly approach represents a considerable departure from his competitor's highly structured, classical style. When it came to the business skills of the two competitors, however, there is little to compare. Whereas Watkins long struggled to support himself and his family, Muybridge showed considerable market savvy, some of it gleaned perhaps from witnessing Watkins's troubles. In February 1868, Muybridge issued a flyer from the Cosmopolitan Gallery of Photographic Art, announcing the publication of twenty Yosemite prints. Rather than promote his own name, he hid his identity under the picturesque, mythological nom de plume "Helios," the Greek god of the sun. Furthermore, he ingeniously wrote his pseudonym directly into the glass negatives, thereby thwarting pictorial pirates. As he modestly stated in his flyer: "For artistic effect, and careful manipulation, they are pronounced by all the best landscape painters and photographers in the city to be the most exquisite views ever produced on this coast."[40] The local press and *Philadelphia Photographer* were effusive in their praise. In addition, the photographer received a further boost when John S. Hittell illustrated the first-ever Yosemite guidebook, published in 1868, with twenty tiny original Muybridge photographs. Hittell eloquently stated the value of photography in conveying the awesomeness of Yosemite, writing: "The illustrations are photographs because no engravings could do justice to the scenes."[41] Muybridge sold his larger, 6-by-8-inch prints mounted on 14-by-18-inch Indian-tinted boards for $1.25 each and his stereos for $4.50 a dozen, generally less than Watkins's Yosemite Art Gallery prices had been.[42] As a further touch, he appealed to his audience's fascination with exotic wilderness by using Native American names in his letterpress captions: Nevada Fall became Yu-wo-hah; Bridalveil Fall was Pohono; and El Capitan was Tutokanula.

With his "Flying Studio," Muybridge returned to the valley in 1872, the same pivotal year that

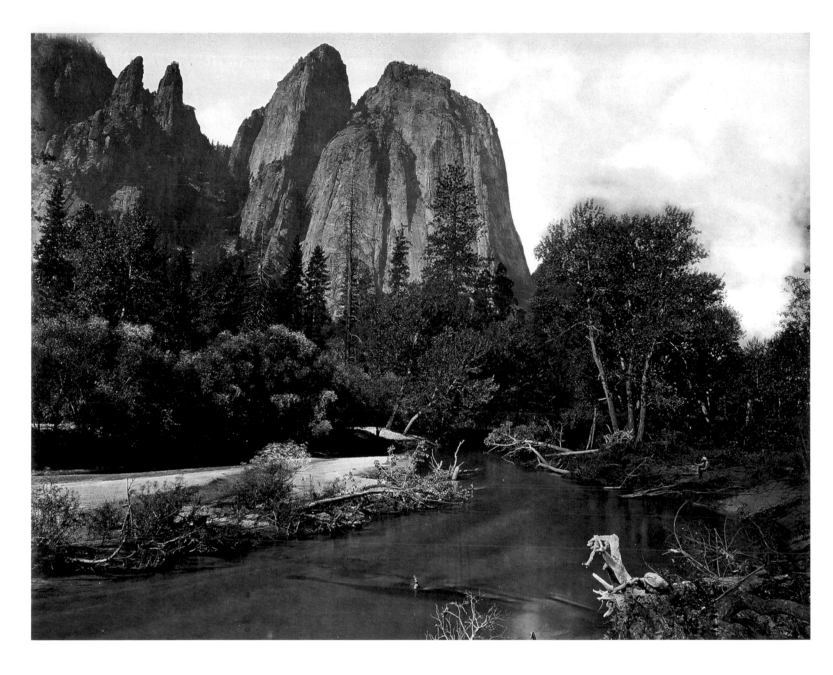

he married the young and beautiful Flora Stone and agreed to work with Leland Stanford, former governor of California, in photographing the racehorse Occident in full stride. On this second trip, Muybridge planned to take a mammoth-plate camera, thereby increasing the competition with Watkins, whose enormous Yosemite prints were still considered the grand standard of landscape photography. He also took the unusual but entrepreneurial step of issuing a prospectus, soliciting subscribers, and listing the names of the city's financial and cultural elite as early supporters. Muybridge also upped his prices: "The size of my proposed negatives will be 20 × 24 inches, and

the prints about 18 × 22, of which subscribers for each *one hundred dollars* subscribed will be entitled to select forty from the whole series."[43]

Leaving his new bride at home in San Francisco, Muybridge spent the next six months, from June to November, photographing the valley from top to bottom. Seemingly, he captured every possible marketable view. This latest campaign took him into areas previously unrecorded and produced startling and breathtaking images from the valley's rim and on top of and under Yosemite Falls. One stereograph depicted the death-defying artist confidently sitting at the edge of Contemplation Rock at

EADWEARD J. MUYBRIDGE
Cathedral Rocks, 1872,
mammoth-plate albumen print
Collection of Jim Farber

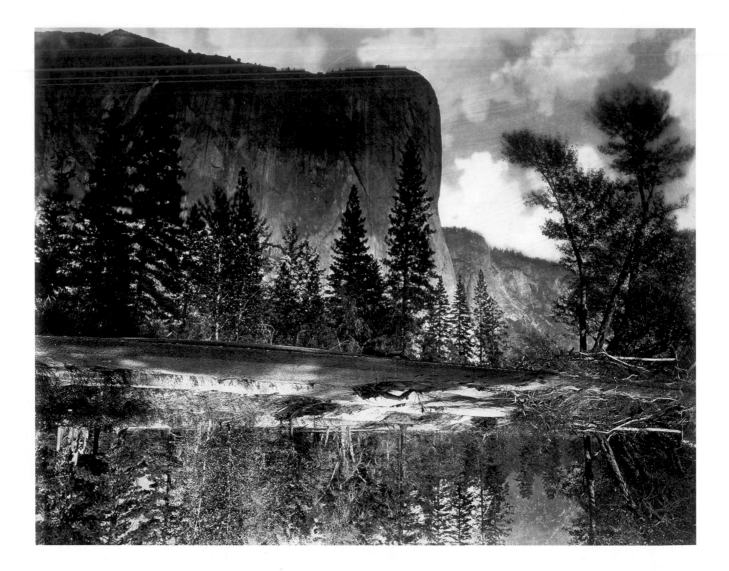

BOTH: **EADWEARD J. MUYBRIDGE**
Tutokanula (El Capitan), 1872,
mammoth-plate albumen print

The Flying Studio, 1867,
stereo albumen print

Both courtesy California State
Library, Sacramento

Glacier Point, peering down at the valley floor three thousand feet below. [44] As reported in the *Alta California for April 7, 1873*, nothing would stop Muybridge from obtaining the best possible views, including cutting down trees by the score and hauling his heavy camera to such high and dangerous places that his guides sometimes refused to follow.[45] Back on the secure valley floor, Muybridge also obtained many views showing human presence, including hotels, tourists enjoying themselves, and Albert Bierstadt at work in his outdoor studio.

Muybridge's work, especially that made from the valley floor, demonstrates many of the same compositional principles and artistic concerns that can be seen in Bierstadt's canvases, and painter and photographer likely exchanged ideas. Among their shared interests was Yosemite's resident Native community. At Bierstadt's suggestion, Muybridge made a series of seventeen candid stereos of Yosemite Indians, including two now famous views of the painter at work flanked by Native peoples and their cedar-bark dwellings. This grouping,

probably the first to seriously study the Indians along the Merced River, was published under the general title *The Indians of California*.[46]

When an exhausted Muybridge left the valley in November, he came away with an incredible cache of over five hundred negatives, highlighted by forty-five stunning mammoth plates. The marketing of these new views demonstrated the vagaries of working with a celebrity photographer: though Muybridge had left San Francisco under the sponsorship of Thomas

EADWEARD J. MUYBRIDGE
Ancient Glacier Channel at Lake Tenaya, Yosemite,
1872, mammoth-plate albumen print
Courtesy California State Library, Sacramento

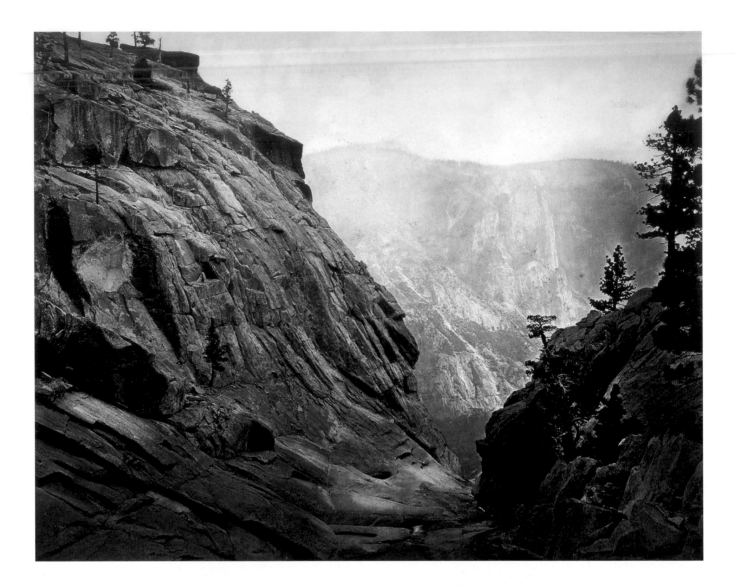

BOTH: **EADWEARD J. MUYBRIDGE**

Yosemite Creek: Summit of Falls at Low Water,
1872, mammoth-plate albumen print

Courtesy California State Library, Sacramento

Tuloowack Grotto, ca. 1867–72,
stereo albumen print

Courtesy of The Bancroft Library, University
of California, Berkeley

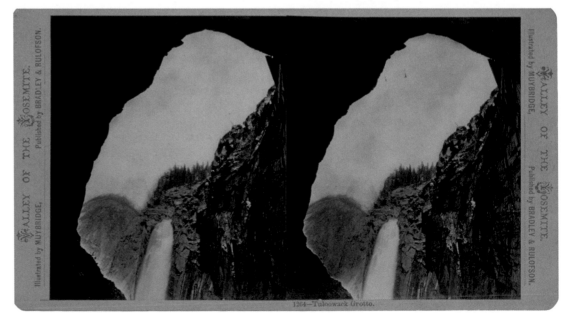

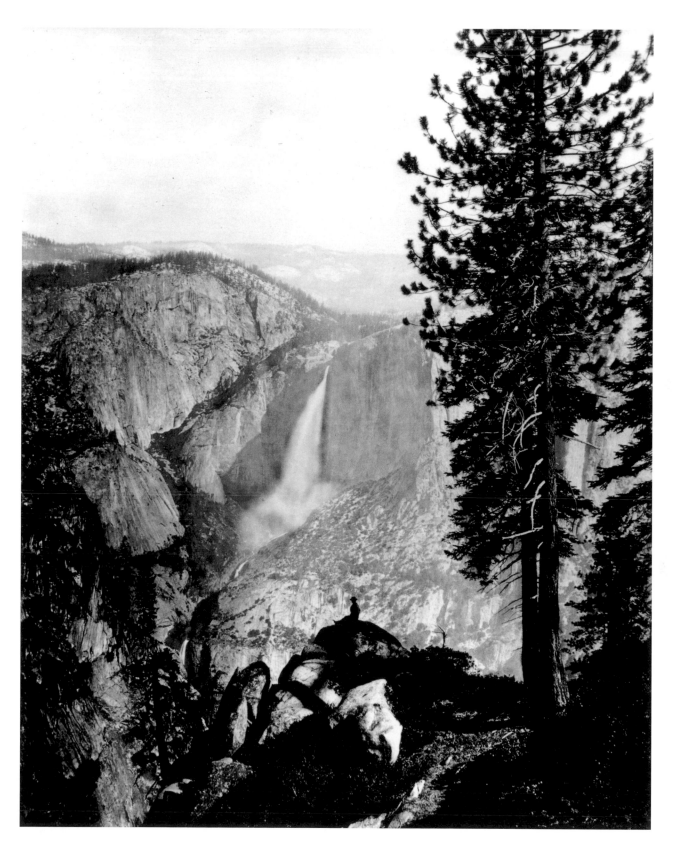

EADWEARD J. MUYBRIDGE
Falls of the Yosemite from Glacier Rock, 1872,
mammoth-plate albumen print

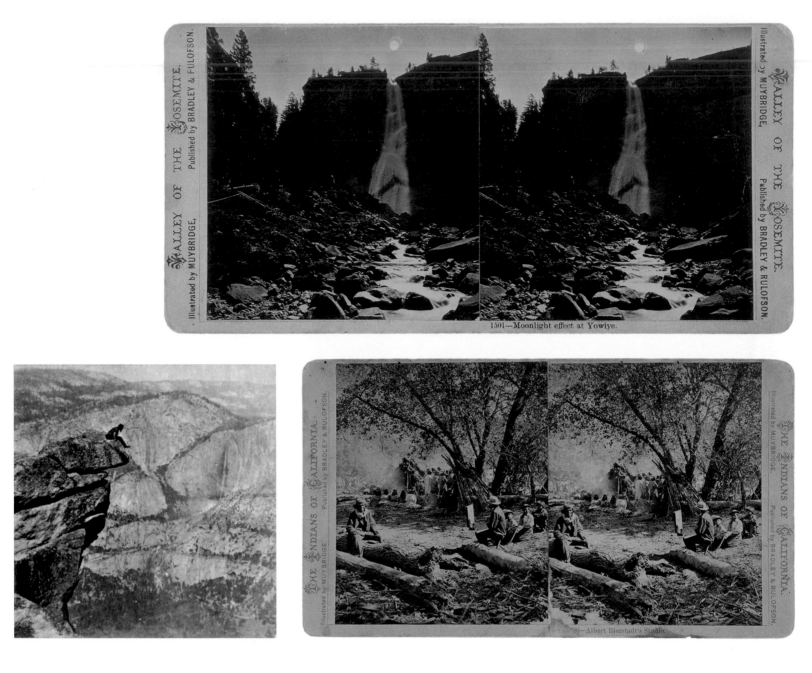

1501—Moonlight effect at Yowiye.

—Albert Bierstadt's Studio.

ALL: **EADWEARD J. MUYBRIDGE**
Moonlight Effect at Yowiye (Nevada Falls),
1872, stereo albumen print
Courtesy California State Library, Sacramento

Contemplation Rock, Glacier Point,
ca. 1867–72, half of stereo albumen print
California Historical Society, FN-18893

Albert Bierstadt's Studio (from the series
The Indians of California), ca. 1872, stereo albumen
print (published by Bradley and Rulofson)
California Historical Society, TN-0060

Houseworth and Company, when his views were published, they carried the imprint of the rival gallery Bradley and Rulofson, who apparently offered him a better deal that included the latest and most expensive printing and mounting equipment.[47] In June 1873, Bradley and Rulofson printed an extensive fifty-three-page catalogue of Muybridge's work that included not only his images of Yosemite and the Mariposa Grove, but also everything else he had to offer.[48] It worked out to be a mutually satisfying relationship, as Muybridge netted more than $20,000. In 1873, a selection of his Yosemite views of the previous year won

the International Gold Medal for Landscape Photography at the Vienna Exhibition. The *Alta California* predicted his images would attract tourists to California and that the railroads would place the photographs in the leading hotels of the eastern United States and Europe.[49]

With the completion of the transcontinental railroad, development of better stage and wagon roads, and consequent influx of tourists, photographers saw a tremendous commercial opportunity in the valley. Yosemite in the 1870s became the Western equivalent of Niagara Falls and a must-visit for the upper-crust trav-

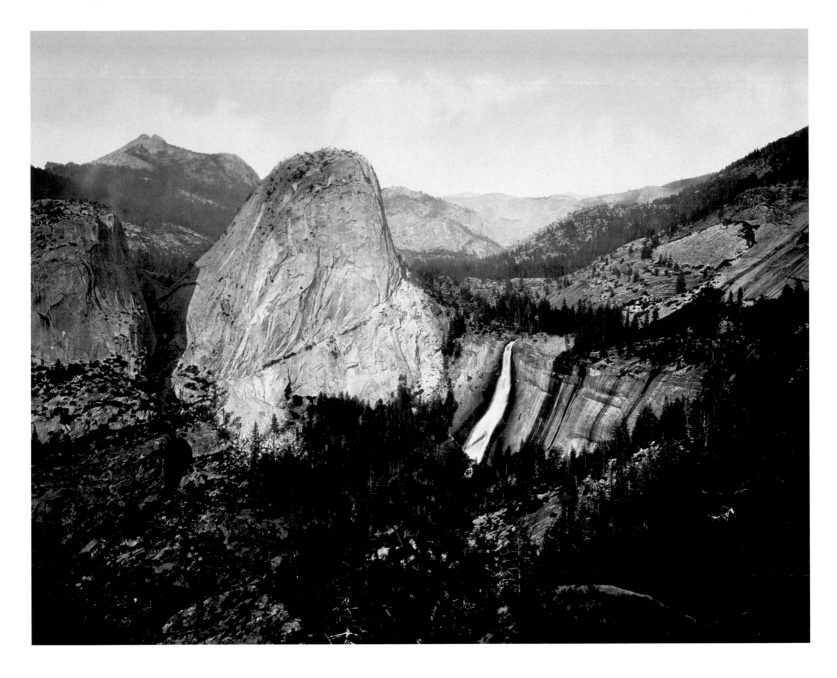

eler. Some came as nature worshippers, while others "came to see and be seen by their kind." Having one's likeness recorded with the great falls in the background or dancing at the edge of Glacier Point served not only as a precious memento, but also as proof of having done something fashionable with a touch of high adventure.[50] To respond to the sightseer, photographers relied much more on the cheaper and portable stereo view and the smaller card-mounted photograph. Like paintings, expensive gilt-framed mammoth plates and elephant folio albums appealed primarily to the *beau monde*. In contrast, stereo cards printed in se-

ries with such eye-catching general titles as *The Glories of Yosemite* could be packed into compact boxed sets and comfortably placed in the parlors of the well-informed general public. Some stereo photographers even had their captions printed in multiple languages, while others listed additional prints in the series. In many respects, the dual images pasted on colorful stereo cards did more to call attention to the wonders of Yosemite than the gold medal–winning mammoth prints. Guidebooks to California and Yosemite frequently came illustrated with engravings and lithographs reproduced from these photographs.

EADWEARD J. MUYBRIDGE
Cloud's Rest, Valley of the Yosemite, No. 40,
1872, mammoth-plate albumen print
The Yosemite Museum, Yosemite National Park.
Photography by Robert Woolard

CHARLES BIERSTADT
Our Party—Yo Semite Valley, Cal.,
1870, stereo albumen print
Courtesy California State Library, Sacramento

JAMES J. REILLY
Snow's Hotel and Nevada Fall, Yosemite Valley,
Cal., ca. 1870–76, stereo albumen print
Courtesy California State Library, Sacramento

JAMES J. REILLY
Cloud's Rest and Thunder Clouds, Yo Semite
Valley, Cal., ca. 1870–76, stereo albumen print
Courtesy California State Library, Sacramento

Two types of stereo photographers entered the valley in addition to the aforementioned pioneers: those who traveled west to build an inventory of popular landscapes and those who saw Yosemite as a primary focus of their livelihood. For example, Charles Bierstadt of Niagara Falls—the older brother of the famous landscape painter—toured the valley in 1870, returned to New York, and published a number of views under his imprint. Two others from New York State, Thomas C. Roche of Brooklyn and Charles L. Pond of Buffalo, also brought their double-barreled cameras to Yosemite in the early 1870s and created an impressive body of three-dimensional work, each with a distinctive style. Photographers and publishers such as John P. Soule of Boston, Kilburn Brothers of Littleton, New Hampshire, and Thomas Houseworth of San Francisco merely purchased negatives from itinerant cameramen or from those who worked in the valley during the spring and summer months. As was commonplace practice, these publishers did not credit the original artist.[51]

One of the most devoted and accomplished Yosemite photographers during the stereo era was James J. Reilly.[52] After five years of photographing visitors to the most famous tourist spot in America, Niagara Falls, the native of Scotland traveled overland to California in 1870 and, in May, found himself in the valley for the "visiting season." He became the first to set up a photographic establishment in the valley. Importing supplies and equipment from San Francisco, he erected a long canvas tent on the valley floor, with a sign reading "J. J. Reilly's Stereoscopic View Manufactory & Groups Taken" running its entire length.[53] Every spring and summer until 1876, Reilly returned to the valley and created an incomparable record of stereo views, many of which he sold to other photographers and publishers.

During those seven productive seasons, Reilly constantly scouted for new locations. As a result, he possessed an understanding of the valley's terrain that few could match. The yawning chasm was, to him, more than a curiosity presented in a photographer's sales album; it was his passion. On several occasions, he explored the Yosemite wilderness and backcountry with John Muir, the soon-to-be-famous naturalist. On one trip in 1871, Muir and Reilly prowled the Sierra for three weeks, allowing the photographer to obtain views of previously undocumented locations, including Lake Tenaya, Cathedral Valley, and the Upper Tuolumne. Water for his wet plates had to be carried up to two miles; on one high-country expedition, he even resorted to melting snow filtered through his socks. These long excursions allowed Reilly to perfect his skills. Possessing a practiced eye, he excelled with mirror effects, dramatic use of shadow, and unconventional camera angles. The inclusion of clouds (even thunderclouds) in many of his stereos rivaled in brilliance Muybridge's images.[54]

Selling views to tourists in the valley and to publishers of pictures remained Reilly's stable source of income. The consistent acclaim he received in the professional journals and newspapers for the superiority and artistry of his

PHELPS. BOLTON. PERKINS. PROF. LE CONTE. SOULÉ. LINDERMAN. COBB.
STONE. HAWKINS. POMEROY.

GREAT YOSEMITE FALL.
2,634 FEET HIGH.

JAMES J. REILLY
Great Yosemite Fall, from Joseph LeConte's *A Journal of Ramblings Through the High Sierras of California by the "University Excursion Party"* (San Francisco: Francis and Valentine, 1875)
Courtesy California State Library, Sacramento

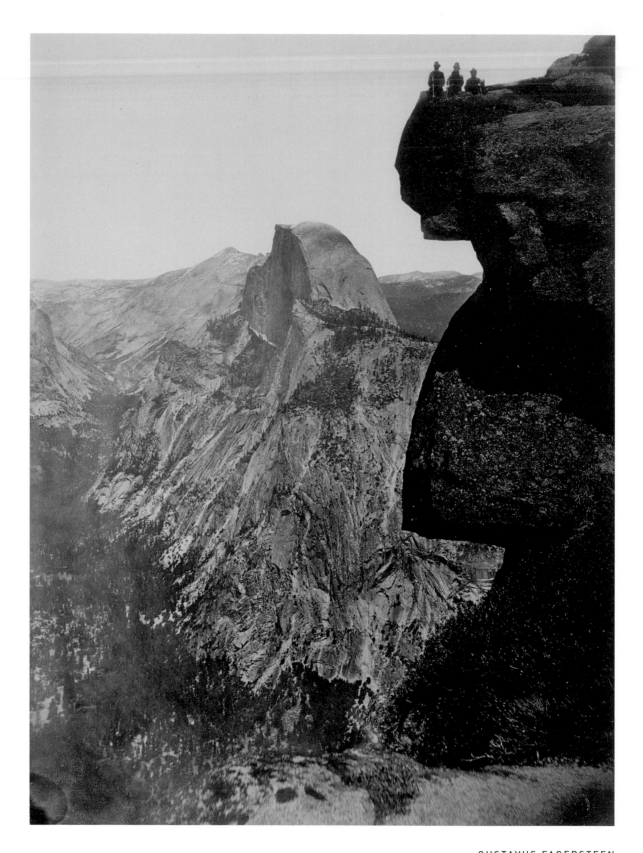

GUSTAVUS FAGERSTEEN
Untitled (Overhanging Rock, Glacier Point, Yosemite), 1883, albumen print

work further bolstered his reputation with the tourist crowd. Among his clients were such prestige-enhancing names as Theresa Yelverton, the Viscountess of Avonmore; entertainer P. T. Barnum; and the eminent scientist Joseph LeConte of the University of California Excursion Party. For LeConte, Reilly printed 1,080 4-by-3-inch prints from nine negatives to illustrate his *Journal of Ramblings,* a delightful travel account published in 1875 in an edition of only 120 copies.[55] Frequently, Reilly photographed parties of excursionists and campers enjoying the sublime wilderness scenery fully attired in their layers of Victorian clothing.

Such photographs served as irrefutable proof that they had visited "the greatest valley in the world."[56]

Catering to tourists did have its downside, however. Stereographs of Yosemite were flooding the market in the 1870s, and the general public did not always distinguish quality views from low-grade cheap productions. Reilly, writing for the *Philadelphia Photographer* in 1876, expressed the universal frustration of all artists who made a living selling to a large, nondiscriminating audience: "Our art is beautiful, but . . . the man who can furnish the cheapest sells [the] most without regard to quality."[57]

Competition for the tourist dollar also intensified when another photographer of uncommon artistic abilities, Martin Mason Hazeltine, set up shop in the valley.[58] The Vermont native, like Reilly, produced spectacular views and sold stereo prints and negatives to publishers in San Francisco and the eastern United States. After several competitive seasons, the rivals wisely decided to join forces, hiring as their assistants S. C. Walker and Gustavus Fagersteen, among others. Under the tutelage of Reilly and Hazeltine, Walker and Fagersteen created superior work first for their employers and later on their own.

In 1877, in need of diversifying his business, Reilly left the valley for Marysville, but he long continued to publish and sell Yosemite views under his own imprint and that of others. Hazeltine continued the business they had established, publishing stereo cards under the new imprint of "M. M. Hazeltine, Photographer, successors to J. J. Reilly and M. M. Hazeltine." In a rare display of recognition, the stereo cards credited assistants Walker and Fagersteen as the photographers.[59]

By the mid-1880s, the glass dry plate had superseded the collodion negative, allowing cameramen much greater freedom and consistency than the cumbersome wet-plate technology had. No longer would each sheet of glass have to be individually prepared and fixed in the field, and exposure time was dramatically reduced. Developing tents, boxes of chemicals, and the tricky manipulation of wet sheets of glass became a thing of the past.[60]

George Fiske became the first significant dry-plate photographer to work in Yosemite Valley.[61] Taking an unusual step, the photographer and his wife, Elmira, moved to Yosemite in the fall of 1879, when most were abandoning the Sierra with the onslaught of winter. The hardy couple remained through the fall of 1881. In so doing, Fiske became the first cameraman to live in the park year-round. Seeing economic potential and enraptured by the valley's magni-

ficence, especially during its volatile winter months, Fiske and his wife returned permanently in 1883 and built their home and studio in the heart of paradise across from the Yo Semite Chapel. From their backyard, the couple enjoyed an unobstructed view of Yosemite Falls and from the front, Sentinel Rock.[62]

While expert in handling collodion negatives, Fiske quickly adapted to pre-prepared gelatin dry plates and roamed the Yosemite region with two primary cameras: one for making "boudoir" prints (5 by 8 inches) and another for imperial-size, 11-by-14-inch plates. Nattily attired, the bearded artist presented quite a sight to tourists as he transported his camera, tripod, and dry plates in a wheelbarrow he affectionately dubbed the "Cloud-Chasing Chariot." Such a spectacle charmed campers, who would often become customers. At other times, Fiske could be seen in a buggy drawn by his horse Sailor Boy, or on one of his trusty donkeys, Honest John and Bake. During the winter months, when snow enveloped the valley, he would haul his instruments on a sled dragged by snowshoe-shod Honest John.[63]

These pictorial ramblings over the course of forty years allowed Fiske to produce an unprecedented visual record of the valley. The art historian Thomas Curran noted what differentiated Fiske's approach from that of his competitors: "Fiske photographed Yosemite in a highly personal, expressive style, making photographs of the Valley not as a dispassionate observer, but as one deeply and emotionally involved with his subject."[64] His spirit of adventure took him to remote corners, where he captured not only grand views, but also comely details of boulders, trees, and debris caused by nature's storms. He loved to create contrast by photographing the same spot at different times of the day or during different seasons. Light and shadow became his props. However, Fiske is best remembered for his dramatic and unique winter views. He proudly advertised the fact that he had created the "only series of Winter and Storm Views of the Yosemite Valley ever taken." His pictures of the various falls flanked by ghostly sheets of ice, trees covered in snow, and the furious winter storms that swept through the valley were unsurpassed.[65]

PHOTOGRAPHER UNKNOWN
Untitled (George Fiske and His "Cloud-Chasing Chariot"), ca. 1901–18, gelatin silver print
Collection Center for Creative Photography,
The University of Arizona, Tucson

GEORGE FISKE
Honest John, ca. 1885, albumen print
Courtesy California State Library, Sacramento

GEORGE FISKE

Upper Yosemite Falls, with Ice Cone at Base, 1879, albumen print

Courtesy California State Library, Sacramento

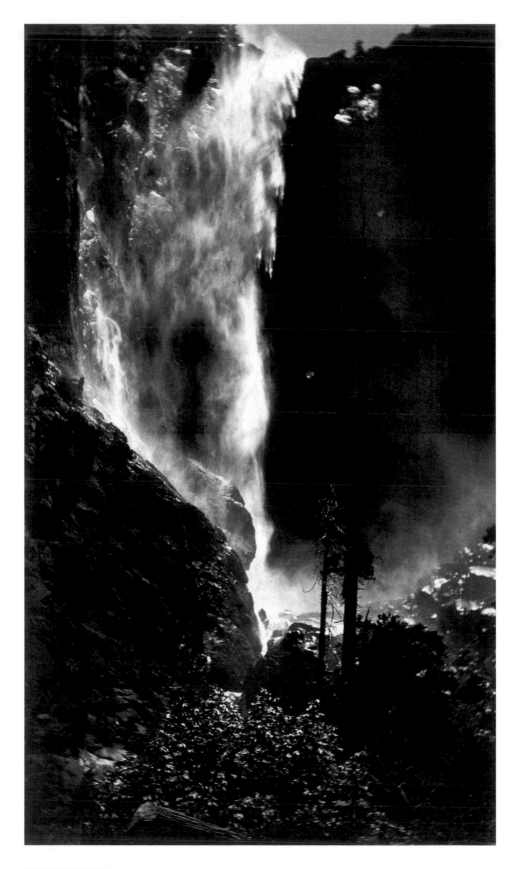

GEORGE FISKE

Wind Playing with Bridal Veil Falls, n.d., albumen print

Courtesy California State Library, Sacramento

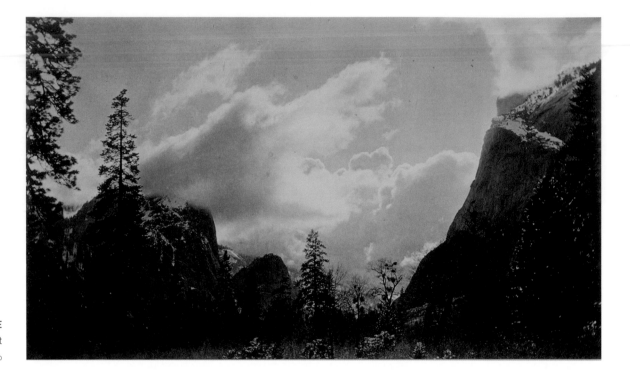

GEORGE FISKE
Storm in Yosemite, n.d., albumen print
Courtesy California State Library, Sacramento

As a commercial photographer relying primarily on images of a specific natural wonder, Fiske naturally supplemented his art with views designed for the popular market, and he eagerly displayed prints and albums in the valley's posh hotels. Described as "blatantly sentimental and commercial," these images nonetheless provided a steady income. *Kitty Tatch and Friend on Overhanging Rock,* popularly known as *Dancing Girls at Glacier Point* (ca. 1895–1905), *Prince on Snowshoes* (n.d.), *Big Tree Room, Barnard's Hotel* (ca. 1884), and *Jack Frost's Visit to Yosemite* (ca. 1884) all had universal appeal and generated brisk sales. In short, Fiske mixed a little mirth with the monumental.[66] He further developed his repertoire by adding "instantaneous" views that captured the powerful motion of water as it cascaded down Yosemite's precipices. The appearance of his images in various publications—including E. S. Denison's *Yosemite and the Big Trees of California* (1886) and Hutchings's *In the Heart of the Sierras*—further added to his fame. The latter came embellished with collotype reproductions, the first use of photomechanical illustrations in a major Yosemite book.[67]

Certainly, Fiske's most lasting impact was the influence of his photographs in making Yosemite a national park, thereby ensuring its preservation. Since 1864, the natural wonder had been governed by the state-controlled Yosemite Valley Commission, which had suffered from mismanagement and overcommercialization. Fiske's photographs depicting environmental destruction, combined with the passionate words of Muir and others, motivated Congress in 1890 to place this wilderness jewel under the stewardship of the federal government and secretary of the interior.[68]

While Californians naturally dominated photography in Yosemite, artists of national reputation made pilgrimages in quest of building their stock of scenic views. Recalling the 1860s and early 1870s, William Henry Jackson, the great Colorado photographer, took a series of mammoth-plate views in 1888 or 1889 (see p. 86).[69] John K. Hillers, the celebrated photographer who accompanied John Wesley Powell down the Colorado River in 1871, likewise took his large-format equipment into Yosemite. Collaborating with Powell again, Hillers in 1892

revisited many of the same spots made famous by Weed and Watkins, taking photographs apparently intended for a display of Powell's U.S. Geological Survey at the Chicago World's Columbian Exposition. Perhaps reflecting his feelings of humility while traversing the valley, Hillers captioned one of his images "Yosemite, Home of the Storm Gods."[70]

By the 1890s, serious amateurs carrying easy-to-manipulate cameras surged into the valley, attracted by the same awe that first brought in the pioneer "cloud chasers." Yosemite and Bridalveil Fall, Half Dome, Glacier Point, El Capitan, and Mirror Lake became true Western icons and an unmatched setting to practice the art of landscape photography. Many other professional photographers trooped into the valley, but none surpassed the body of work produced by Weed, Watkins, Muybridge, Reilly, Hazeltine, and Fiske. Through their art and love of the wilderness, America—and indeed the world—came to know the "Great Yo-Semite Valley" as a symbol of nature's grandeur.

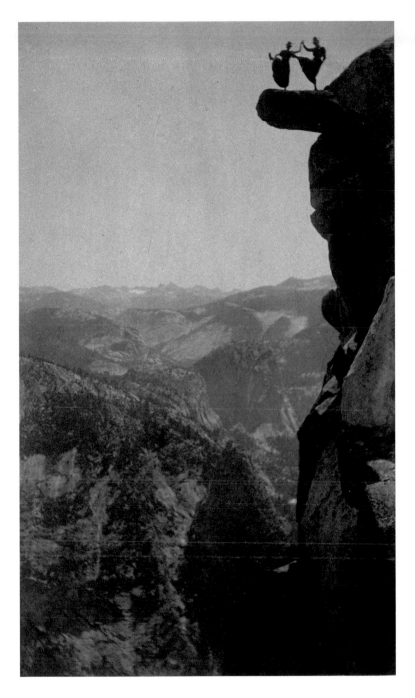

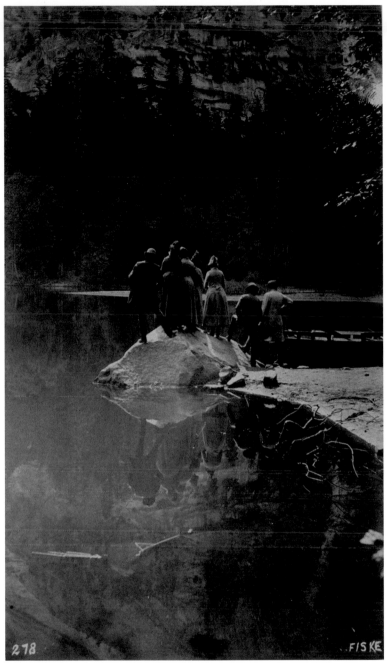

BOTH: **GEORGE FISKE**

Kitty Tatch and Friend on Overhanging Rock, Glacier Point,
Yosemite, California, ca. 1895–1905, albumen print

Watching the Sun Rise in Mirror Lake,
ca. 1870–1900, albumen print

Both: The Yosemite Museum, Yosemite National Park

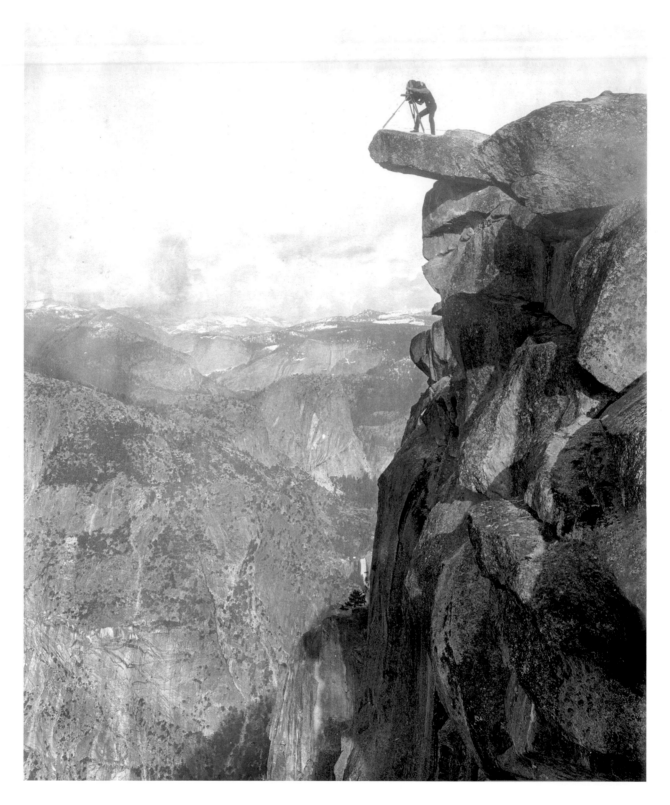

WILLIAM HENRY JACKSON
Yosemite Valley, Rock at Glacier Point,
ca. 1888–89, mammoth-plate albumen print
Courtesy Colorado Historical Society, CHSJ 2239

NOTES

1. For a short biography of Hutchings, see Peter E. Palmquist and Thomas R. Kailbourn, *Pioneer Photographers of the Far West: A Biographical Dictionary, 1840–1865* (Stanford, Calif.: Stanford University Press, 2000), 312–16.

2. Mary V. Hood, "Charles L. Weed, Yosemite's First Photographer," *Yosemite Nature Notes* 38, no. 6 (June 1959), 76–87; and Peter E. Palmquist, "California's Peripatetic Photographer: Charles Leander Weed," *California History* 58, no. 3 (Fall 1979), 194–219.

3. In an era before camera shutters, the operator would simply remove the lens cap to expose the negative. Likewise, during that pioneering era, the size of the negative dictated the size of the print; enlargers did not exist.

4. Palmquist, "California's Peripatetic Photographer," 201.

5. The literature concerning early photography in Yosemite is voluminous, and the late Peter E. Palmquist dominates the subject as much as El Capitan dominates the topography of the valley. His books and articles on Watkins, Weed, Reilly, and the San Francisco gallery Lawrence and Houseworth are essential, as is his *Pioneer Photographers of the Far West*, co-authored with Kailbourn (see n. 1). For more on early Yosemite photography, see Paul Hickman, "Art, Information, and Evidence: Early Photographs of the Yosemite Region," *Exposure* 22 (Spring 1984), 26–29; Bill Hood and Mary Hood, "Yosemite's First Photographers," in Jack Gyer, ed., *Yosemite: Saga of a Century, 1864–1964* (Oakhurst, Calif.: Sierra Star Print, 1964), 49–52; Weston J. Naef and James N. Wood, *Era of Exploration: The Rise of Landscape Photography in the American West, 1860–1885* (Buffalo, N.Y.: Albright-Knox Art Gallery; New York: Metropolitan Museum of Art, 1975), Kate Nearpass Ogden, "Sublime Vistas and Scenic Backdrops: Nineteenth-Century Painters and Photographers at Yosemite," *California History* 69, no. 2 (Summer 1990), 137, 139–40, 142, 147–49, 151–52; and David Robertson, *West of Eden: A History of the Art and Literature of Yosemite* (Yosemite National Park, Calif.: Yosemite Natural History Association and Wilderness Press, 1984), 12–16, 53–91.

6. Robertson, *West of Eden*, 53–54.

7. Hickman, "Art, Information, and Evidence," 26.

8. The British inventor Frederick Scott Archer produced the first usable glass photographic negatives in 1851.

9. Palmquist, "California's Peripatetic Photographer," 199–200.

10. Hood, "Charles L. Weed, Yosemite's First Photographer," 85.

11. Ibid., 83–84.

12. Quoted in Palmquist, "California's Peripatetic Photographer," 202.

13. Hood, "Charles L. Weed, Yosemite's First Photographer," 76–78; and Palmquist, "California's Peripatetic Photographer," 200–201.

14. Hood, "Charles L. Weed, Yosemite's First Photographer," 78–79; Hickman, "Art, Information, and Evidence," 28.

15. Palmquist, "California's Peripatetic Photographer," 204.

16. Palmquist and Kailbourn, *Pioneer Photographers of the Far West*, 585.

17. Palmquist, "California's Peripatetic Photographer," 208. In a rare instance, J. L. Wiseley, in his article "The Yosemite Valley," *Harper's New Monthly Magazine* 32, no. 192 (May 1866), 697–708, not only credited Weed but also asked his permission to have his photographs rendered as engravings.

18. Palmquist, "California's Peripatetic Photographer," 208–11; and Peter E. Palmquist, *Lawrence and Houseworth, Thomas Houseworth and Co.: A Unique View of the West, 1860–1886* (Columbus, Ohio: National Stereoscopic Association, 1980), 12–14, 23–27.

19. Charles B. Turrill, "An Early California Photographer: C. E. Watkins," *News Notes of California Libraries* 13, no. 1 (January 1918), 32.

20. Nannette Margaret Sexton writes that in all likelihood it was a Grubb-C Aplanatic Landscape lens; see Sexton, "Carleton E. Watkins: Pioneer California Photographer (1829–1916), A Study in the Evolution of Photographic Style during the First Decade" (Ph.D. diss., Harvard University, 1982), 137–38. See also Peter E. Palmquist, *Carleton E. Watkins, Photographer of the American West* (Albuquerque: Amon Carter Museum and University of New Mexico Press, 1983), 12. The above works, as well as the special issue "Carleton E. Watkins: Pioneer Photographer," *California History* 57, no. 3 (Fall 1978), are essential for the study of Watkins.

21. Turrill, "An Early California Photographer," 32–33; and Palmquist, *Watkins*, 16–18. Collodion negatives had many limitations. Long exposures caused running water to lose its detail. They also made the sky appear featureless and pale; in

essence, exposure of the negative for the foreground overexposed the sky. Muybridge overcame this with the invention of his "Sky Shade" (see the discussion of Muybridge later in this essay).

22. Palmquist, *Watkins*, 18–19.

23. Quoted in ibid., 19.

24. Ibid.; Nancy K. Anderson, "Wondrously Full of Invention: The Western Landscapes of Albert Bierstadt," in Nancy K. Anderson and Linda S. Ferber, *Albert Bierstadt: Art and Enterprise* (New York: Hudson Hills Press, 1990), 79; and Janice T. Driesbach, *Direct from Nature: The Oil Sketches of Thomas Hill* (Yosemite National Park, Calif.: Yosemite Association; Sacramento, Calif.: Crocker Art Museum, 1997), 17, 21–23, 28.

25. Palmquist, *Watkins*, 19–20; and Hickman, "Art, Information, and Evidence," 28.

26. Palmquist, *Watkins*, 23; and Sexton, "Watkins," 231.

27. As explained by Sexton, Watkins's earlier lens had caused the edges of the prints to be distorted or blurred; the Grubb-C lens was stretched beyond its capability for a mammoth plate, but the dome-top edges masked this defect. Sexton, "Watkins," 235–38.

28. Palmquist, *Watkins*, 24–30; Nannette Margaret Sexton, "Watkins' Style and Technique in the Early Photographs," *California History* 57, no. 3 (Fall 1978), 242–51.

29. Palmquist, *Watkins*, 30; and James B. Snyder, in the electronic edition of *The Yosemite Book, New York, 1868* (Berkeley: Bancroft Library, University of California, 2003), 3–8.

30. Palmquist, *Watkins*, 31–32, 36–37, 45–46, 52–53; Sexton, "Watkins," 189; and Turrill, "An Early California Photographer," 33.

31. Palmquist, *Watkins*, 32.

32. Ibid., 26; and Sexton, "Watkins," 266.

33. Taber dearly loved Yosemite and made many trips to the valley in the 1870s and 1880s. See Linda and Wayne Bonnett, *Taber: A Photographic Legacy, 1870–1900* (Sausalito, Calif.: Windgate Press, 2004).

34. According to Palmquist, "By 1878 Watkins was a legendary figure in the valley." Palmquist, *Watkins*, 58.

35. Sexton, "Watkins," 345.

36. For Muybridge, see Mary V. Jessup Hood and Robert Bartlett Haas, "Eadweard Muybridge's Yosemite Valley Photographs, 1867–1872," *The California Historical Society Quarterly* 42, no. 1 (March 1963), 5–26; Robert Bartlett Haas, *Muybridge: Man in Motion* (Berkeley: University of California Press, 1976); Gordon Hendricks, *Eadweard Muybridge: The Father of the Motion Picture* (New York: Grossman, 1975); Naef and Wood, *Era of Exploration*, 37–41, 65, 167–75; and Rebecca Solnit, *River of Shadows: Eadweard Muybridge and the Technological Wild West* (New York: Viking, 2003).

37. Hendricks, *Muybridge*, 5–7; Haas, *Muybridge*, 7–14; Hood and Haas, "Muybridge's Yosemite Valley Photographs," 6–7.

38. Haas, *Muybridge*, 18; Solnit, *River of Shadows*, 47–50.

39. Haas, *Muybridge*, 18.

40. Eadweard J. Muybridge, *Yo-Sem-i-te Valley* (San Francisco: Cosmopolitan Gallery of Photographic Art, 1868, prospectus), North Baker Library, California Historical Society, San Francisco; Hood and Haas, "Muybridge's Yosemite Valley Photographs," 10–11; Hendricks, *Muybridge*, 18–19.

41. John S. Hittell, *Yosemite: Its Wonders and Its Beauties* (San Francisco: H. H. Bancroft, 1868), iv.

42. Muybridge advertisement in Hittell, *Yosemite*, second leaf of backmatter advertisements.

43. Hood and Haas, "Muybridge's Yosemite Valley Photographs," 17.

44. The title of the stereograph is *Contemplation Rock, Glacier Point*. It was published by Bradley and Rulofson.

45. "Photograph Studies: Eight Hundred Views of Yosemite Valley and the Big Trees," San Francisco *Alta California*, April 7, 1873.

46. For his 1872 campaign, see Solnit, *River of Shadows*, 83–96.

47. Haas, *Muybridge*, 43; Hood and Haas, "Muybridge's Yosemite Valley Photographs," 20–21; Palmquist, *Lawrence and Houseworth*, 36–37, 39.

48. *Catalogue of Photographic Views by Muybridge* (San Francisco: Bradley and Rulofson, 1873), 1–53.

49. "Photograph Studies" (see n. 45).

50. Paul Hickman and Peter Palmquist, "J. J. Reilly, Part III: Views of American Scenery," *Stereo World* 12, no. 3 (July–August 1985), 7–9; Stanford E. Demars, *The Tourist in Yosemite, 1855–1985* (Salt Lake City: University of Utah Press, 1991), 27–48; Robertson, *West of Eden*, 87–90.

51. Hickman, "Art, Information, and Evidence," 26–27; Hood and Hood, "Yosemite's First Photographers," 50–51; Robertson, *West of Eden*, 89–90.

52. For information on Reilly, see Hickman and Palmquist, "J. J. Reilly," 4–23; and Peter Palmquist, *J. J. Reilly: A Stereoscopic Odyssey, 1831–1894* (Yuba City, Calif.: Community Memorial Museum, 1989).

53. Palmquist, *J. J. Reilly*, 12–13.

54. For a description of Reilly's techniques, see ibid., 15–16.

55. Ibid., 10–11; and Joseph LeConte, *A Journal of Ramblings through the High Sierras of California by the "University Excursion Party"* (San Francisco: Francis and Valentine, 1875). LeConte did not credit Reilly in his text.

56. Quoted in Palmquist, *J. J. Reilly*, 18.

57. Quoted in ibid., 15.

58. For a description of Hazeltine's career, see Paul Hickman, "Martin Mason Hazeltine, 1827–1903: A Chronology," *Stereo World* 20, no. 6 (January–February 1994), 4–13; and Palmquist and Kailbourn, *Pioneer Photographers of the Far West*, 283–86.

59. Palmquist, *J. J. Reilly*, 17–18; and Hickman and Palmquist, "J. J. Reilly," 10–11. The Oakland Museum of California possesses a superior collection of Fagersteen's Yosemite photographs.

60. For a history of the dry plate, see Helmut and Alison Gernsheim, *The History of Photography, 1685–1914* (New York: McGraw-Hill, 1969), 329–32.

61. Paul Hickman and Terence Pitts, *George Fiske: Yosemite Photographer* (Flagstaff, Ariz.: Northland Press, 1980). See also Palmquist and Kailbourn, *Pioneer Photographers*, 229–31.

62. Hickman and Pitts, *Fiske*, 1–6; Palmquist, *Watkins*, 27; and Palmquist and Kailbourn, *Pioneer Photographers of the Far West*, 229–30.

63. Hickman and Pitts, *Fiske*, 23–26; Palmquist and Kailbourn, *Pioneer Photographers of the Far West*, 230.

64. Thomas Curran, untitled essay in *Fiske the Cloud Chaser: Twelve Yosemite Photographs by George Fiske (1837–1918)* (Oakland: Oakland Museum of California; Yosemite National Park, Calif.: Yosemite Natural History Association, 1981), unpaginated.

65. Palmquist and Kailbourn, *Pioneer Photographers of the Far West*, 230; Hood and Hood, "Yosemite's First Photographers," 51–52; and Hickman and Pitts, *Fiske*, 54–61.

66. Hickman and Pitts, *Fiske*, 45–49.

67. Ibid., 24–25, 45–48. Fiske albums may be seen at the Oakland Museum of California, the Yosemite Museum, and the California State Library. The Yosemite Museum possesses the largest collection of Fiske prints and albums.

68. Hickman, "Art, Information, and Evidence," 29.

69. Peter B. Hales, *William Henry Jackson and the Transformation of the American Landscape* (Philadelphia: Temple University Press), 199–200; Naef and Wood, *Era of Exploration*, 89; and Ogden, "Sublime Vistas and Scenic Backdrops," 148.

70. Don D. Fowler, *The Western Photographs of John K. Hillers: "Myself in the Water"* (Washington, D.C.: Smithsonian Institution Press, 1989), 134, 141–46; Ogden, "Sublime Vistas and Scenic Backdrops," 148.

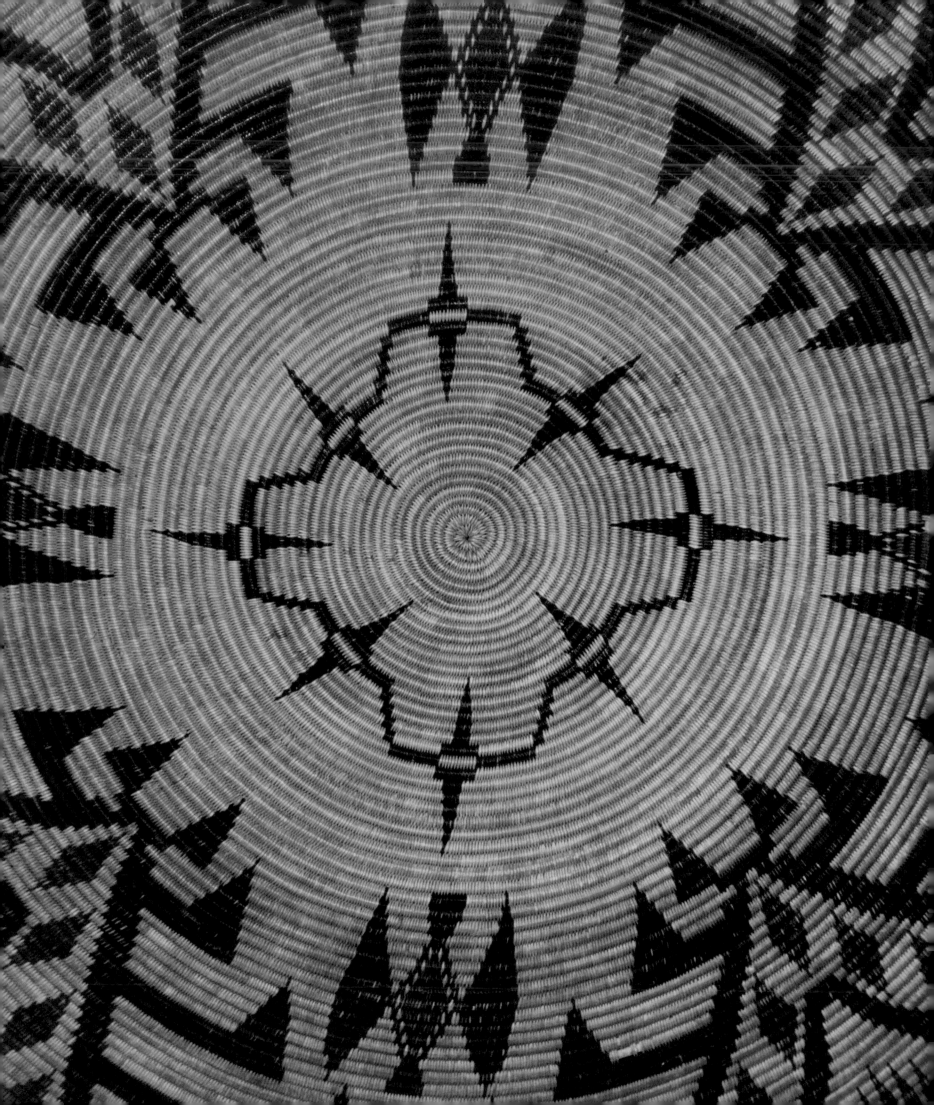

BRIAN BIBBY

NATIVE AMERICAN ART
OF THE YOSEMITE REGION

There was a large bonfire, and around this the dancers ranged themselves in a circle. Each dancer had a basket, some of them being exceedingly fine ones—heirlooms that had been kept hidden from all vulgar eyes for just such an important event. To the low singing of the medicine man—there being no drum—the dance began. Gradually the song increased in power, and as it did so the dance increased in speed, fury, and frenzy. The baskets were used in rhythmic movement with the motions of the dancers. Down to the feet, across the hips, before each breast in turn, then above the head. All this time the wailing was kept up, and tears rolled down the cheeks of the best mourners. At the height of the dance, at a signal from the leader, all the baskets were thrown into the fire, and, as the last flame from them expired, the dance was brought to a conclusion. —Thomas Hill, describing a funeral ceremony he witnessed in Yosemite Valley during the 1870s

THE ORIGINAL ARTISTS OF YOSEMITE were its indigenous people, who created finely woven baskets, mostly for the utilitarian purposes of collecting, processing, transporting, and storing the seeds, bulbs, greens, acorns, and pine nuts that comprised much of their diet.[1] Although they may not have thought of their basketry as art (in the Western sense), many examples are widely viewed as such today.

The coming of Euro-Americans to the Yosemite area in the middle of the nineteenth century—and the ensuing influx of non-Indians and appropriation of Native land—resulted in the gradual erosion of the traditional Native economy on which basket weaving was based.[2] The transformation of Yosemite into a "wilderness" mecca for tourists and artists had significant

CARRIE BETHEL
Basket (detail, see p. 102)
Autry National Center, Los Angeles,
Promised Gift of Mrs. Gene Autry

91

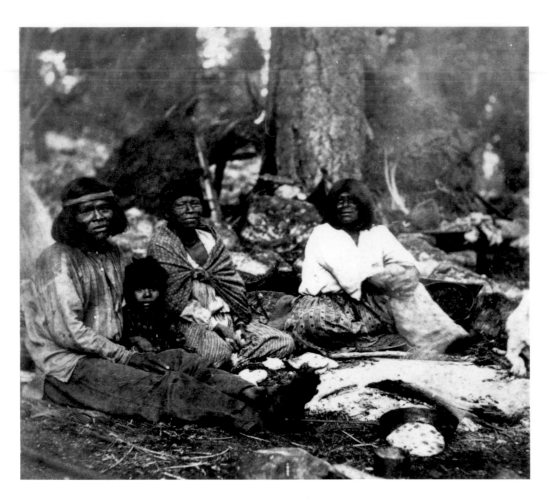

JAMES J. REILLY
Indian Group, Yosemite Valley, ca. 1875,
half of stereo albumen print
The Yosemite Museum, Yosemite National Park

consequences for its indigenous inhabitants, yet it also had a paradoxical result: by establishing a market and sources of patronage for weavers, it eventually allowed Native people to be recognized as artists in their own right.

The area now encompassed by Yosemite National Park once included the homelands of several Native American peoples, although the relatively high elevation made most of the region—including Yosemite Valley—impractical for year-round residence.[3] Miwok-speaking people, indigenous to the western slope of the Sierra Nevada, were likely the most consistent occupants of Yosemite before 1850, particularly in the valley and Hetch Hetchy (a name derived from the Miwok *hetch-hetchi*, a variety of grass seed).[4] The Mono Lake Paiute—entering from east of the Sierra crest—also had a history of seasonal occupation in Yosemite.[5] Along the southern portions of the park, the Chukchansi and Western Mono likely hunted and gathered seasonal foods and other materials. These Native groups inhabited Yosemite over countless generations; large granite boulders still exhibit the depressions left by women who pounded acorns into flour over a span of at least 3,500 years.[6]

Native peoples utilized Yosemite's physical environment in part to feed themselves. Yosemite Valley, Hetch Hetchy, and adjacent areas contained seasonal food resources unavailable at the lower elevations where most Miwok people maintained their primary villages. The same was true for Paiute people, living in the high desert environment east of the Sierra. Yosemite was also a place to collect the raw materials for basketry, ceremonial regalia, hunting equipment, and other everyday tools and objects. Native people had a symbiotic relationship with the landscape, and they practiced a way of life that did not separate artistic creation from everyday existence. The objects they created that we view today as "art" were born of necessity, as the essential tools of a food-collecting society.

By the 1870s, when large-scale, romantic paintings and photographs of Yosemite Valley were raising international awareness of and interest in the region, its original Miwok and Paiute

inhabitants were already living in a radically transformed world. Increasing visitation disrupted some traditional practices, such as hunting, but it also provided new means of subsistence as Native people integrated themselves into the developing cash economy, usually as domestics and laborers. This work supplemented their traditional lifestyle at first, and then gradually replaced it.

Although Yosemite's Indian community was of considerable interest to some, Euro-American resort owners, ranchers, miners, tourists, and artists in the area were likely not aware that their activities were essentially and irrevocably changing the foundations of a culture with roots extending back for millennia. To the painters and photographers of the romantic era, Yosemite's Indians were useful for adding scale and exotic flare to the otherwise uninhabited vistas they painted and photographed. Many late-nineteenth-century images of Yosemite—photographs by Carleton E. Watkins, Eadweard J. Muybridge, and Martin Mason Hazeltine and paintings by Thomas Hill,

Christian Jörgensen, and Constance Gordon-Cumming, among others—included Native people. Some of the photographs evince a casual feel and the honesty of a spontaneous snapshot—such as James J. Reilly's *Indian Group, Yosemite Valley* (ca. 1875), which shows a family sitting around a spent campfire. A metal frying pan and a tortilla appear in the foreground of this photograph, and a few baskets are seen in the background. Often the most obvious Native element in these early photographs, baskets are similarly strewn about in a Hazeltine albumen print, *Miwok Family in Yosemite Valley* (ca. 1875). Images such as these presented an exotic people who appeared to exist within the grandeur of Yosemite independently of tourist culture and the hotels, roads, and campsites that punctuated the scenery. To enhance this effect and to create an air of authenticity, artists and photographers often collected Native basketry to display in their studios, and sometimes used Indian names as titles for their works. By depicting Indians and borrowing Indian names, romantic-era artists

and photographers helped position Native people as an important part of Yosemite's wilderness ambiance.

In this context, Native culture was appreciated primarily for what it could add to Yosemite's wild and exotic atmosphere, not for what it really was. Native history and culture, and Native people's relationship to the land, were therefore much misunderstood. Contrasting Yosemite to urban and industrial landscapes, most Euro-Americans saw it as a sublime wilderness free of all the corrupting influences of civilization. Most Euro-Americans in Yosemite during the romantic era thus remained largely ignorant of the ways in which Native people had actively shaped the landscape of Yosemite Valley and the surrounding region, mainly through burning, long before the arrival of whites.[7] Nineteenth-century artists and photographers had flower-filled meadows, clear vistas, and parklike forests to capture on their canvases and glass negatives thanks in part to Native management of the valley's ecosystems. Most early Yosemite visitors believed that the

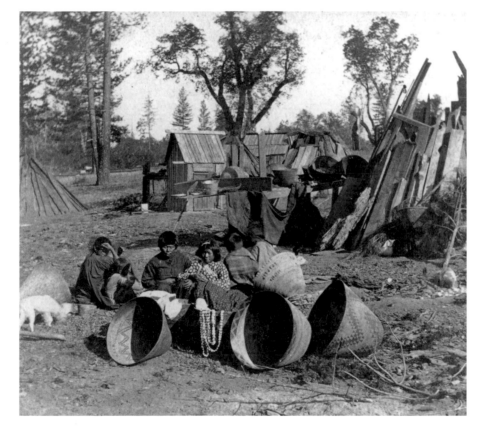

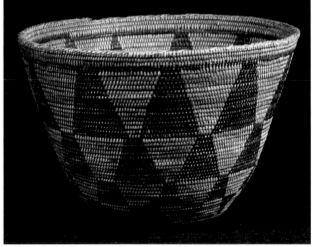

LEFT: **MARTIN MASON HAZELTINE**
Miwok Family in Yosemite Valley, 1870, albumen print
The Yosemite Museum, Yosemite National Park

ABOVE: **NANCY WILSON**
Miwok cooking basket, ca. 1900, collected by Christian Jörgensen
The Yosemite Museum, Yosemite National Park.
Photography by Robert Woolard

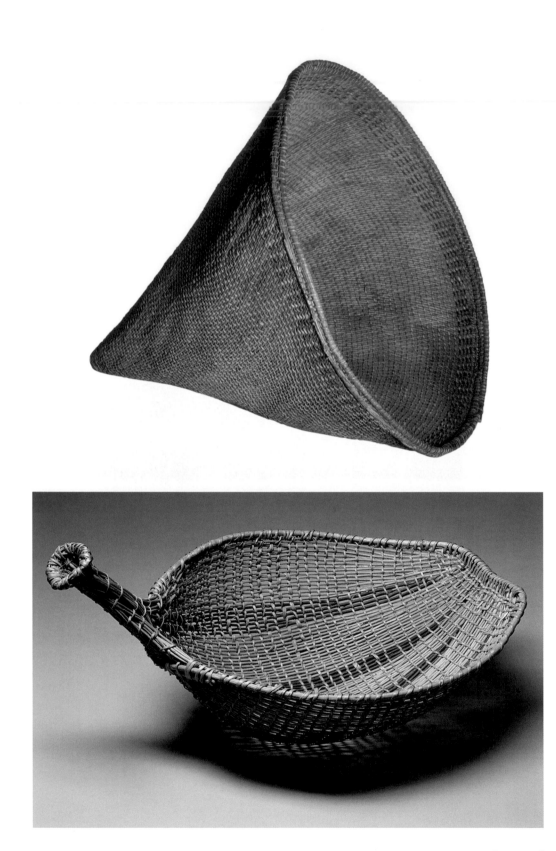

SARAH PRIEST (attributed)
Miwok burden basket, ca. 1890
The Yosemite Museum, Yosemite National Park.
Photography by Robert Woolard

Miwok seed beater, ca. 1900
Southwest Museum of the American Indian Collection,
Autry National Center, Los Angeles

valley was purely a product of ancient geological forces (or divine intervention), however, and this was fundamental to its allure as a destination and subject.[8]

Through centuries, if not millennia, of experience, Native people had come to understand that nature needed human assistance in providing the food and other materials they collected in the valley. Some shrubs required pruning; many plants benefited from harvesting of their bulbs and corms. Above all, the land needed periodic burning to keep meadows from becoming forests. This encouraged valued plants to produce long, straight shoots for baskets. It also created favorable conditions for the cultivation of grass seeds, greater visibility of potential enemies, and browsing by deer and other game.[9] Although the appropriation of Yosemite Valley by Euro-Americans curtailed most of these management practices during the latter part of the nineteenth century,[10] their effects remained an indelible imprint on the landscape well into the twentieth century.

At about the same time that traditional management practices became unsustainable in the valley and elsewhere in the region, Native people began to see other opportunities. Partly as a result of the popularization of Yosemite by artists and photographers, the valley and environs were becoming a prime tourist destination. The growing waves of tourists were hungry for exotic curios from the wilds of Yosemite, and Native weavers, largely cut off from the food-collecting environment for which baskets were originally developed, accommodated the demand by shifting basket weaving into the commercial sphere. By the end of the nineteenth century, basket collecting was a rage in California and throughout much of the country, and Native weaving traditions came under economic and artistic influences that ultimately transformed baskets from functional necessities to art for export. By 1920, large and elaborate baskets by Native weavers could be found alongside paintings and photographs in artists' studios in the valley, in retail galleries in San Francisco, and prominently displayed in homes across California and the United States.[11]

Before considering Miwok and Mono Lake Paiute baskets as objects of both art and commerce, it is important to understand their basis in traditional culture. Each basket had its beginning in the management practices that created the ideal basketry materials—long, straight, flexible shoots of willow, redbud, creek dogwood, and deerbrush; abundant stalks of bunchgrass; long roots of sedge and bracken fern. Weavers were regular observers of plant communities, collecting materials within specific seasonal windows determined by the growth patterns of the host plants. For example, redbud shoots were pruned in winter, soon after the first freeze turned the bark an attractive red-brown, whereas deerbrush shoots were cut in the spring, when the sap rises and the bark can be cleanly separated to expose the shiny surface of the wood underneath. Each material possessed its own qualities; strength and flexibility were the main concern, but tone and color were also important as they enabled the weaver to create decorative patterns.

After collection, basket materials were processed according to their intended use—either as foundation rods (warps) or as sewing strands (wefts). Warp materials were stripped of their outer bark, while weft materials were split twice, with the outer section of the material being retained. During this stage, weavers might continue to trim their material into finer strands. The splitting and trimming of basket materials was a meticulous process involving great skill and an eye for uniformity. Most materials were then cured (dried) for several weeks. Introduction to water brought the dry strands back to a flexible state for weaving.

Basket design was originally intimately connected with function. In all, Miwok and Paiute households utilized approximately ten types of baskets, each serving a specific purpose in the gathering and processing of food resources, and each exhibiting distinctive features that reflected their intended use. The baskets' forms also suggest the problem-solving capacity of their creators. For example, the wide opening of a conical burden basket was designed for easily filling; its shape also allowed most of the weight to be distributed above the shoulders when the basket was transported on the back. The seed beater was used to knock grass seeds

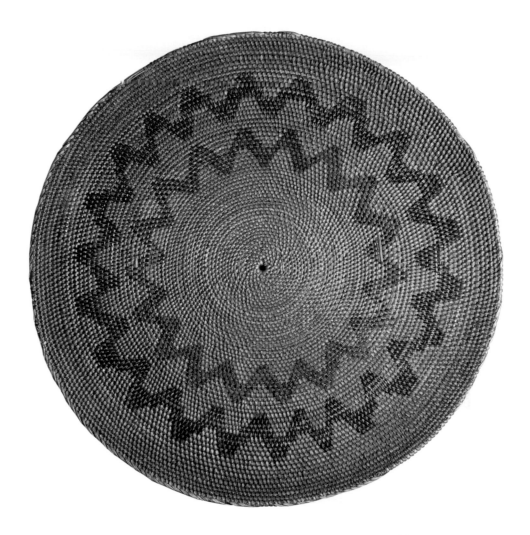

ABOVE: Miwok sifting tray, ca. 1900
The Yosemite Museum, Yosemite National Park.
Photography by Robert Woolard

loose from their stocks, sending them straight into the open mouth of the burden basket held in the opposite hand; the tiny seeds were then winnowed and parched in shallow trays. Among the Miwok, flat, circular trays were designed to sift acorn flour, the finely pounded flour settling into the corrugations of the coiled weave while the coarse granules rolled off the edge. The truncated shape of a Miwok cooking basket allowed for easy access when adding hot stones to boil acorn soup. Globular, closed-form baskets often served as storage receptacles for personal property. Twined caps protected a Paiute woman's head from the chafing of a burden basket's pack strap, shielded her face from the sun, and helped keep her hair free of pine resin as she gathered pine nuts. Cradles were woven to hold, protect, and transport infants.

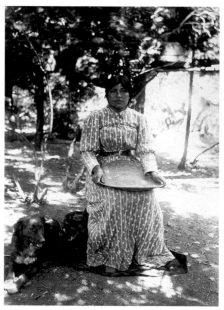

GEORGE WHARTON JAMES
Woman with Sifting Tray, Yosemite Valley,
1900–1902, gelatin silver print
Southwest Museum of the American Indian
Collection, Autry National Center, Los Angeles

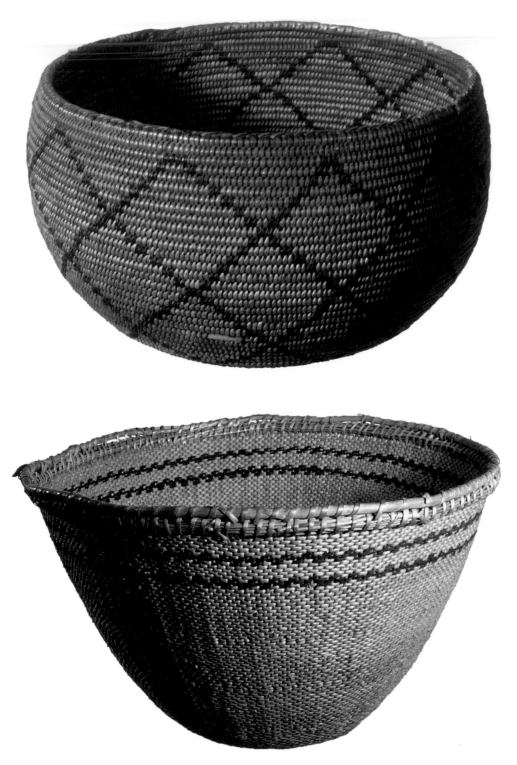

Miwok basket, ca. 1900

The Yosemite Museum, Yosemite National Park.
Photography by Robert Woolard

Paiute cooking basket, ca. 1900

The Yosemite Museum, Yosemite National Park.
Photography by Robert Woolard

Consistent with their practical purpose, traditional baskets were generally conservative in their decorative motifs. For example, traditional Mono Lake Paiute cooking baskets created prior to 1900 were mostly diagonally twined, with a rim that included a willow rod stitched onto the top selvedge; designs, often consisting of two or perhaps three plain horizontal bands of bracken fern, were nearly always placed only in the upper half of this type of basket. Miwok cooking baskets likewise featured minimal designs. Some examples were completely undecorated,[12] but most displayed a basic pattern created by weaving in split redbud shoots or black bracken fern roots to contrast with the buff tone of the primary weaving material of split willow, maple, deerbrush, or sedge.

Though utilitarian, baskets typically reflected great weaving skill and often had beautiful sculptural forms, traits that allowed them to stand as works of art, as valuable commodities to Native and non-Native people alike. Finely woven pieces, which were particularly prized, were often buried with the dead or burned in honor at mourning ceremonies.[13] As property, baskets denoted wealth and were often included in dowries, given as gifts, and used in feasting ceremonies.[14] Although there are examples of innovation and individual creativity in baskets created prior to 1900, weavers were generally guided by the conventions of traditions established by their communities over many generations, producing well-crafted, functional works with a recognized cultural aesthetic that enhanced daily life and familial status.

This all began to change in the late nineteenth century when tourists, artists, and concessionaires started buying baskets in Yosemite, sparking both a wider market for their production and a flurry of creative activity that would have profound implications for Native art and life. As hotels were built and baskets became increasingly salable commodities, concessionaires and tourists became employers and patrons of Native people, who shifted away from their subsistence existence as they began to participate in Yosemite's developing cash economy.

In the 1890s, Galen Clark wrote that young Native women "find it easier to make money by washing and sewing or almost any other [domestic] work," and he later added that "any labor of this kind pays them better than making baskets for sale."[15] Nonetheless, as the demand for Native souvenirs grew and the traditional need for basketry declined, the weaving of baskets for sale did become an important source of income for a number of (mainly older) Native women.[16] By 1900, baskets were often made expressly for sale to the ever-increasing waves of tourists. Clark observed four years later that "during the past few years a rapidly growing interest in the native Indian has been manifested by a large majority of visitors to the Yosemite Valley. They have evinced a great desire . . . to purchase some articles of their artistic basket and bead work, to take away as highly prized souvenirs."[17] Since these baskets were not intended for use within the Native community, weavers may have no longer felt bound to the aesthetic conventions and rules associated with traditional basketry. Likely responding to the demand for "prettier" baskets by non-Indian consumers, they experimented with new design ideas and shapes, often exotic in origin.[18]

Growing competition among weavers prompted them to seek new materials for their baskets, while increased mobility brought about greater access to a wider range of plant products. Mono Lake Paiute weavers, for example, increased their use of sedge root and redbud. The addition of redbud—when combined with the black bracken fern—gave rise to polychrome works and new, stimulating visual effects, while sedge root—a product of the Sierra foothills and San Joaquin Valley—was easier to split and trim than willow and thus accelerated the weaving process. By 1919, some Mono Lake weavers had begun to receive sedge root through the mail from relatives living west of Yosemite.[19] Access to automobiles, particularly by the 1920s, also helped spread the use of redbud. Ida Bishop, a Western Mono weaver from Northfork, periodically visited Yosemite Valley to sell sedge root and redbud to the Paiute / Miwok weaver Lucy (Tom) Telles and

others. The trunk of Bishop's car was filled with rolls of the materials, split, cleaned, and ready to use.[20]

Baskets made for sale differed in many ways from their functional precedents. Salable baskets were often smaller replicas of traditional ones, with embellishments not found on pieces made for personal use. The Miwok weaver Indian Mary, an original Yosemite resident, often included additional woven bands of redbud in her small seed beaters, also cross-sectioning the reddish stripes of creek dogwood in the basket's foundation. Twining a small seed beater was quite cost-effective for the weaver as the work went quickly, requiring about six hours' time.[21]

Entirely new forms of baskets also began to appear. Globular baskets with lids and baskets with pedestals imitating the form of a goblet or fruit compote were popular adaptations by the 1890s. By the turn of the century, human figures and animals—previously unknown or extremely rare in Miwok and Paiute basketry—had also become popular design motifs.[22] Local weavers were exposed to new design ideas through Native art imported from outside the Yosemite region into the homes and galleries of photographers and artists, and as inventory in Salter's Yosemite Store and the Indian Curio Corner at Camp Curry. Native basketry from outside the Yosemite region, Navajo textiles, Plains and Plateau beadwork, manufactured blankets with "Indian" patterns, and finely woven Washoe baskets already popular in the Tahoe region were all sold as curios in the valley at the turn of the century.[23]

This broader market affected basket design in other ways as well. Around 1908, E. W. Billeb, superintendent of a large lumber mill on the south shore of Mono Lake, ordered a shipment of Czechoslovakian seed beads and gave them to the wives of his Paiute mill workers, encouraging them to use the beads to decorate their willow baskets.[24] Already proficient in the production of loom-woven beaded belts, they devised a netlike technique to cover the surface of the baskets with beads, using a needle and thread to connect them.[25] The beaded basket, with its bright colors and new texture, represented a radical departure from the traditional two-tone Paiute basket. This freedom

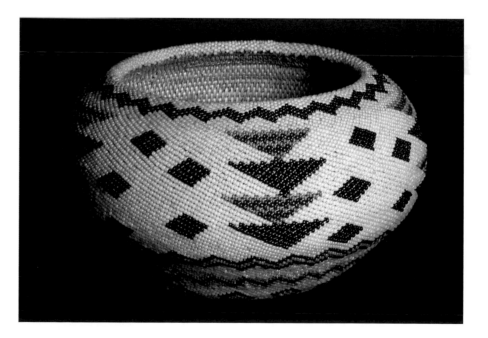

NELLIE CHARLIE
Beaded basket, ca. 1920–50

The Yosemite Museum, Yosemite National Park.
Photography by Robert Woolard

Mary Wilson, Donald Tressider,
and Chris Brown at Indian Field Days,
Yosemite Valley, ca. 1925

Southwest Museum of the American Indian
Collection, Autry National Center, Los Angeles

Promotional poster for
Indian Field Days, ca. 1929

The Yosemite Museum, Yosemite National Park

Indian Field Days

September 6 and 7, 1929

A military band and a troop of United States Cavalry are expected to join with hundreds of Indians, Rangers and Cowboys to make these the best Indian Field Days ever held in Yosemite.

$1500 IN PRIZES

Indians wearing their own costumes that meet requirements of the judges (war bonnet or feather headdress; buckskin jacket, pants and moccasins or buckskin dress and moccasins) will receive an additional $5 for the two days. Indian men stripped and painted as warriors will receive $2 for the two days.

EXCITING HORSE RACES

Including Mounted Potato Races; Roman Races; Musical Chairs; Bending Races, etc., etc. Trick Roping.

BASKET AND BEADWORK EXHIBITION

A special half-day will be devoted to judging, showing and sale of Indian Baskets and Beadwork. Buyers from San Francisco and other cities have been invited to attend this big sale. Small baskets, watch fobs, necklaces will be the best sellers.

Indian Ceremonial and War Dances

A most interesting program has been arranged by the well-known Directors:

FOREST S. TOWNSLEY HERBERT EARL WILSON
Chief Ranger Chief Lecturer

YOSEMITE NATIONAL PARK

SUN-STAR PRINT

to experiment carried over into Miwok and Paiute coiled basketry traditions, which also began to evidence significant changes.[26] By the early twentieth century, making baskets expressly for sale had become a worthwhile enterprise, with some weavers' prices having risen substantially.[27]

In 1916, Native arts in Yosemite received a big boost when the newly established National Park Service, working with concessionaires, instituted Indian Field Days. This event—repeated nearly every year until 1929—would have a profound effect on the design and role of baskets in Native society. Created to draw even more visitors to Yosemite and capitalize on tourists' interest in Native people—and baskets in particular—Indian Field Days was an annual rodeo and fair held in the valley during the late summer and early fall, when the waterfalls were at their least impressive. Native participants joined with park employees and tourists in a series of contests that included potato races and tugs-of-war, sometimes on horseback. Local Native people, wearing fringed buckskin, feathered headdresses, and beadwork reminiscent of Plains Indian culture, performed parades and exhibition dances. Among the Native performers was the great

Paiute / Miwok cowboy and horseman Harry Tom, who performed feats of trick riding. Indian Field Days encouraged Native participants to modify their appearance, their behavior, and (often) their artwork to resemble tourist stereotypes of how Indians dressed and behaved. As Craig Bates has pointed out, Indian Field Days transformed its participants into "living spectacles to be photographed and romanticized along with the natural wonders."[28]

Native people were often induced to participate in these events by cash prizes. A total of $150, a significant sum in 1922, was awarded for the three best displays of baskets, and another $150 for the three best individual works. By

1924, first prize for the best basket alone had grown to $50. The publicity associated with the contest often resulted in residual benefits as well: during the 1924 Indian Field Days, Lucy Telles won first and fifth places with her two entries; she then sold each basket for $100 before the end of the celebration.[29]

By providing lucrative incentives, emphasizing basketry as a competitive endeavor, and creating a ready market, Indian Field Days soon established a new environment for weavers. Indian Field Days was responsible for both a greater appreciation for Native arts in Yosemite and an economic base that allowed weavers to create grand, extraordinary works that rivaled

in ambition and artistry the monumental oils and mammoth-plate albumen prints of Yosemite's "Golden Era." It also generated a new group of collectors, of whom James H. Schwabacher was the most important. Schwabacher provided patronage for Yosemite weavers for more than thirty years; today, his extensive collection is a major part of the Yosemite Museum.[30]

Within the competitive atmosphere encouraged by Indian Field Days, a handful of talented individuals developed recognizable styles and motifs and were elevated to near celebrity status within the valley. Over a forty-year period, from 1920 through 1960, several

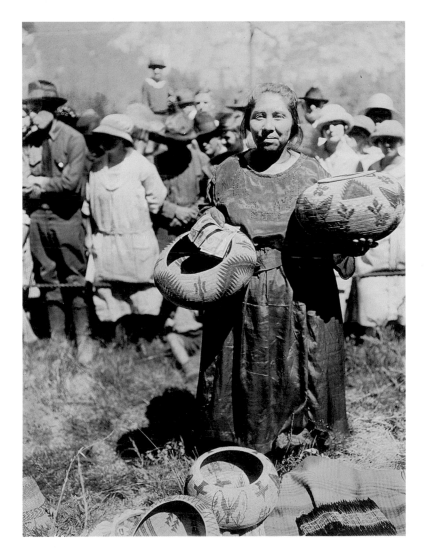

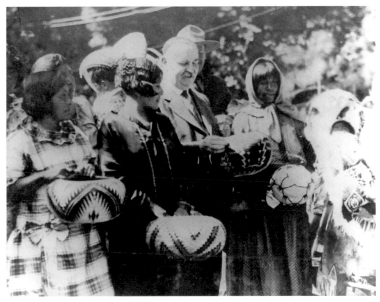

LEFT: Lucy Telles at Indian Field Days, Yosemite Valley, 1924

Southwest Museum of the American Indian Collection, Autry National Center, Los Angeles

ABOVE: Lucy Telles, Carrie Bethel, California Governor Friend Richardson, and Tina Charlie during the basket competition at Indian Field Days, Yosemite Valley, 1926

The Yosemite Museum, Yosemite National Park

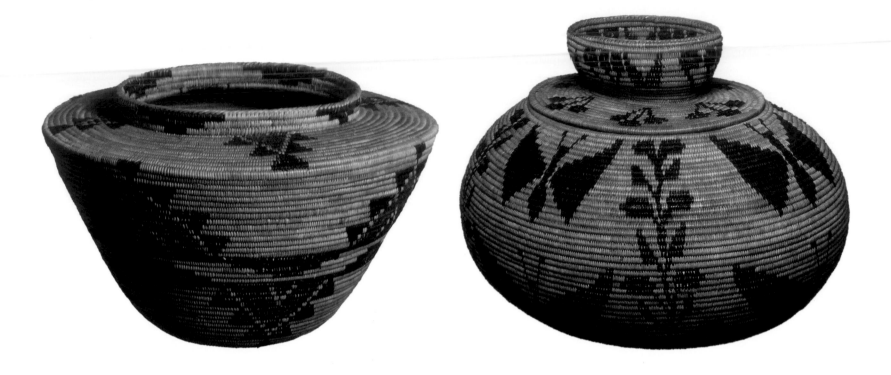

LUCY TELLES
Bottleneck basket (left), ca. 1930,
and lidded basket, ca. 1930
Both: The Yosemite Museum, Yosemite
National Park. Photography by Robert Woolard

Paiute / Miwok women from the Mono Lake–Yosemite region became known for their exceedingly fine, visually stunning, and complex polychrome baskets. These weavers included sisters Nellie and Tina Charlie, Leanna Tom and her nieces Lucy Telles and Alice James Wilson, sisters Carrie (McGowan) Bethel and Minnie (McGowan) Mike, Daisy (Charlie) Mallory, and Nellie Jameson. Although the parades and dances of Indian Field Days ended with the last event in 1929, the market for baskets continued to thrive during the 1930s (and is ongoing in various forms today). By that time, some baskets had also become astonishingly large, most famously Telles's "big basket," which took her four years to finish. Thirty-six inches wide and 20 inches high, it was the subject of numerous publicity photographs and was featured at the Golden Gate International Exposition in 1939 (see page 5).[31]

The new genre of basketry pioneered by these women represented a rapidly changing creative movement in which each new piece seemed to push the limits of what had previously been accomplished. Although individual artistic expression and experimentation were no doubt ingredients of the new basketry, it is also apparent that weavers created works they felt would appeal to their non-Indian patrons, and thus the weavers likely used motifs or shapes

they may not have cared for themselves. Certainly, since these baskets were not made for internal use, functionality was not a determining factor in their design. Regardless of the external influences, however, each of these innovative creations represents an uncommon technical mastery anchored in an ancient weaving heritage. They are exceptional, at times phenomenal, and their level of skill and beauty has not been duplicated since.

A bottleneck basket by Lucy Telles of ca. 1930 represents a form borrowed from Yokuts basketry traditions of the region southwest of Yosemite. Telles made at least three such baskets, all with very similar patterns. She appears to have been the only Yosemite–Mono Lake weaver to make this style of basket, although bottlenecks became popular among Owens Valley Paiute and Panamint Shoshone weavers. Telles also made several baskets fitted with lids, an anomaly within Miwok and Paiute basketry traditions. One such piece, also of ca. 1930, is oval in form and includes a small basket woven into the lid. Its design motifs include butterflies and a rosebush. This attempt at realist representation was a departure from traditional Native basketry and is another innovation that would have appealed to non-Indian buyers. It may also have been something fun for the weaver to try. Butterflies were a popular

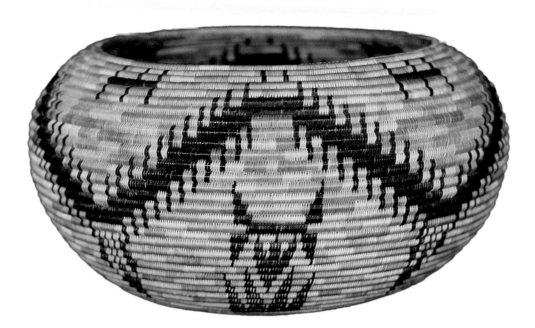

NELLIE CHARLIE
Basket, ca. 1940
Collection of Margaret R. and Robert R. Bayuk

CARRIE BETHEL
Basket, 1929
The Yosemite Museum, Yosemite National Park.
Photography by Robert Woolard

motif for Telles, and she included them in several of her large Field Days–era baskets.

One of Nellie Charlie's fancy baskets (ca. 1940) exhibits an interesting feature: the distinctly mottled background of her large polychrome bowl was created by using several different lots of sedge root, ranging in tone from nearly white to dark tan. Its effect is to make the polychrome design appear to lift off the surface of the basket. It is not known if this was intentional. A basket by Carrie Bethel woven for the 1929 Indian Field Days competition represents one of the finest examples of basketry anywhere. This modestly sized piece, created at a time when many weavers were making large and overtly ornate baskets, is distinguished by its graceful shape, the fineness and impeccable, even quality of its weave, and the interplay of its serrated black motif with its red filler motifs, which provides the basket with perfect balance.

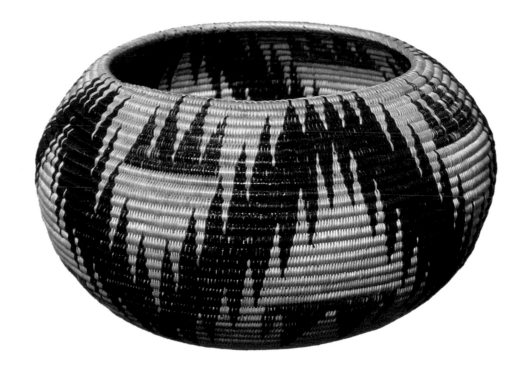

Bethel was not opposed to making oversized baskets, however, completing at least four large pieces during the 1930s. One of these exhibits a feature uncommon in older Paiute coiled ware: a separate design scheme on the bottom of the basket (p. 102). The design layout that covers the basket's sides overlaps much of the bottom, meeting the complex base pattern at four equally distanced points, thus cre-

ating visual excitement when the basket is viewed from the base (or from above, the pattern on the bottom of the basket being visible through its opening). Bethel was not immune to competition, either. Seeing the considerable attention that Telles's "big basket" drew, Bethel produced a big basket of her own. Completed about 1936 and also four years in the making, this piece seems to mark an apex in the history of basketry from the region. Although Bethel

would proceed to weave at least four more exceedingly fine oversized baskets, she never attempted a work this large again. The basket is embellished with a flourish of ornate patterns—mainly isolated motifs repeated throughout the basket. Although it does not have the flow or symmetry of Telles's big basket, its intricate use of multiple patterns represents a mind-numbing organizational challenge. Bethel may have sketched many of the motifs on paper

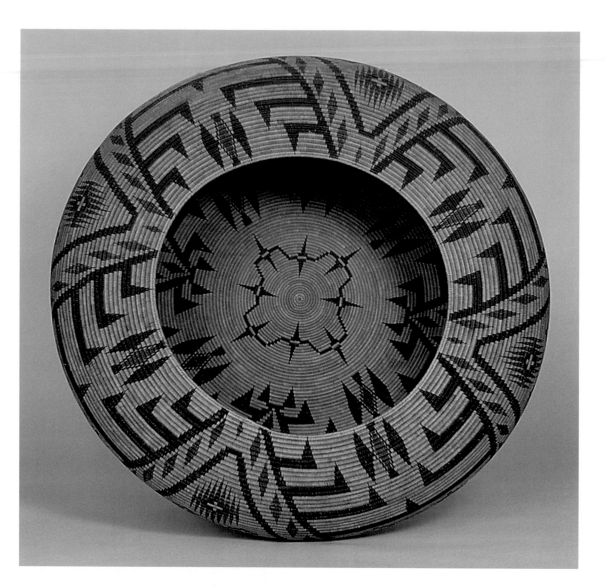

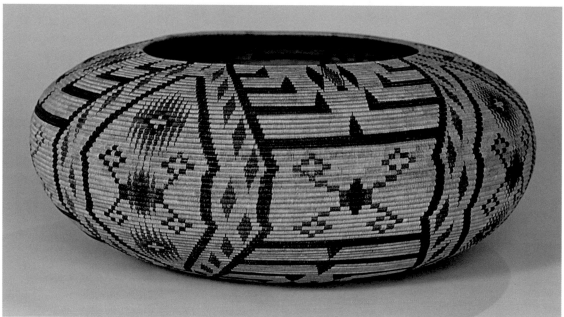

while planning the basket, but the complex math involved in organizing and spacing them during the process of weaving was done entirely in her head.[37]

Creating baskets on this scale was a huge challenge in other ways, too. They weighed a great deal, making structural integrity an issue; the immense size of Bethel's and Telles's big baskets was made possible by the inherent stability of three-rod coiling and the tensile strength of the weaving material. It is remarkable that such large works contained relatively fine weaving—more than twenty stitches per inch. In addition, the inclusion of polychrome motifs (red and black) within ornate patterns necessitated frequent splicing—terminating one material to insert and begin weaving with another—as the weaver switched her sewing strands from redbud to bracken fern to sedge. (Frequency of splicing may have reached its maximum in a large piece made by Bethel around 1933 that contains over a thousand elongated triangles, each outlined with a single stitch of contrasting color.[33]) The big baskets by Telles and Bethel seem all the more remarkable given the depressed economy of the day and the fact that the termination of Indian Field Days in 1929 had reduced tourist patronage.

Despite their impressive output and the widespread reputations both women developed, neither Telles nor Bethel was a full-time artist. During the 1930s, Bethel worked in the Tioga Lodge laundry at Mono Lake and labored in seasonal agriculture in the San Joaquin Valley.[34] Telles was a housewife and grandmother who rose before dawn to cook breakfast for her husband, did the laundry, took care of the grandchildren, and prepared dinner. She wove when she found the time and energy. Once, a park ranger became curious about a light left on in the Telles house past 1:00 A.M. Peering through the window, he saw Telles working on her basketry.[35]

It seems unlikely that Telles, Bethel, or any of their fellow weavers ever imagined themselves to be great artists. They belonged to relatively impoverished communities and their works had yet to grace the institutions where paintings by Albert Bierstadt, William Keith, and Thomas Hill were hung. The thriving market

for their work suggests, however, that even if these individuals didn't necessarily see themselves as great artists, their audience often did—and still does. In 1936, Bethel sold a large basket to Schwabacher for $600, at that time enough money to buy a new Pontiac; in 2005, a similar basket sold for $850,000.[36] One wonders what Bethel would have thought of her work commanding a price comparable to, and in many cases greater than, a major painting by Hill or Keith.

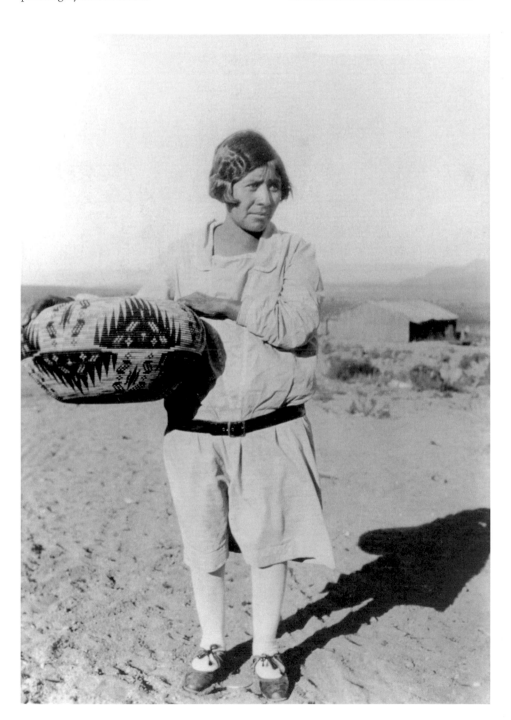

Carrie (McGowan) Bethel, ca. 1929
The Yosemite Museum, Yosemite National Park

About 1960, Bethel completed a basket reminiscent of her exquisite 1929 piece, only larger. The consistency of her weaving in these two baskets, created more than thirty years apart, is truly remarkable for such a physically demanding art form. Also in 1960, a young Kashaya Pomo / Coast Miwok woman, Julia (Domingues) Parker—married to Telles's grandson, Ralph Parker—began to demonstrate basket weaving in Yosemite National Park, continuing the role Telles had filled until her death in 1955. Parker had received her initial basketry instruction from Telles, and one of her early experiences in gathering basketry material had been in the company of Bethel, hiking along the sandy banks of Tenaya Creek above Mirror Lake to dig bracken fern roots. A miniature single-rod basket of sedge root, redbud, and bracken fern she made in 1985 is reminiscent of the globular polychrome bowls of both Telles and Bethel. Today, Parker—perhaps the most versatile, productive weaver in the state—continues to create basketry only fifty yards from the spot of her first demonstration forty-five years ago, continuing a tradition as old as the largest tree in the Mariposa Grove of sequoias.[37]

CARRIE BETHEL
Basket, ca. 1960
Collection of Mr. and Mrs. Gene Quintana, Carmichael, California

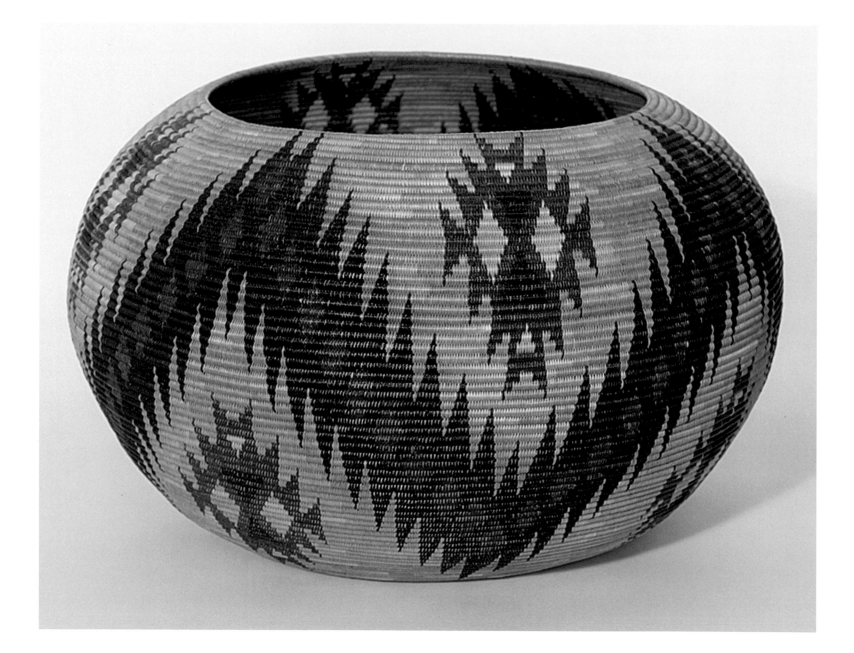

Basketry wasn't the only traditional Native art in which innovations took place in the twentieth century. Among the regular and more prominent Indian Field Days participants was a local Miwok man, Chris Brown (a.k.a. Chief Lemee). Brown appears in photographs from the 1929 Field Days wearing a Plains Indian–style war bonnet and various other pieces of exotic Indian garb donned for the annual presentation of "Indian Ceremonial and War Dances." After Indian Field Days came to an end, until the early 1950s, Brown performed Miwok songs and dances in interpretive programs held behind the Yosemite Museum.

Photographs of Brown performing during these programs (p. 106) show him wearing a temakkela, a traditional piece of Miwok ceremonial regalia. Worn across the forehead, the temakkela is tied to the dancer's head with strings attached to the band near the temples, so that each end of the band waves and flaps during the dancer's movement. As such, the temakkela is intended to be viewed in movement—not as a static piece of art. Made from the bright yellow-orange quills of red-shafted flicker feathers, the band is assembled by sewing three or four strings through the quills. The traditional Sierra Miwok temakkela differed from other flicker-quill bands in Northern California in its solid ruff of feathering along the upper and lower selvedges, accomplished by leaving a section of feathering at the tips of the stripped quills.

Brown's temakkela, made in the 1930s, differs from other extant examples in several ways. The band employs a sequence in which eight trimmed wing-feather quills alternate with two feather-tipped quills throughout the length of the band; as a result, the feathered edge appears serrated. Historically, this style is indicative of Maidu, Wintun, and Pomo traditions. The placement of "marks" on the outer surface of the band—the black opposing diamonds made from the trimmed tips of flicker feathers—is also an idea originating far to the north and west, and not evident on historical Miwok bands other than Brown's. Brown intended the band to be worn with the rounded outer surface of the quill facing outward. Nearly all flicker-quill bands made before 1910 were intended to have the inner side of the quill face

JULIA PARKER
Miniature basket, 1985
Collection of Dean and Maria Shenk

Chris Brown and friend at Indian Field Days, Yosemite Valley, 1929
The Yosemite Museum, Yosemite National Park

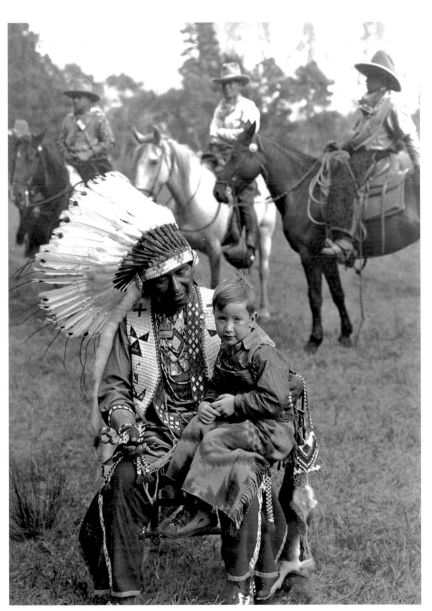

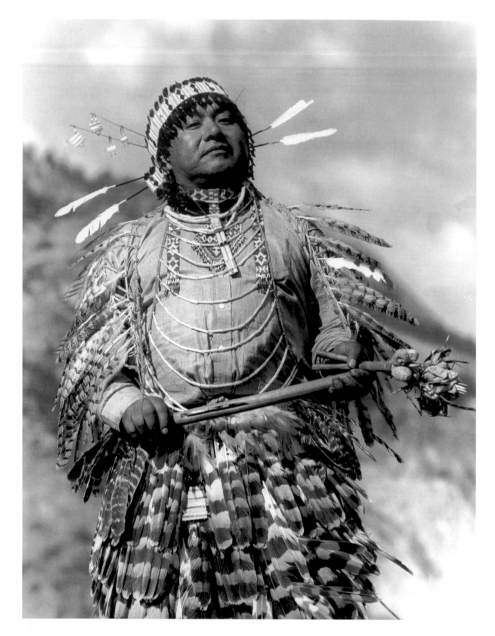

Chris Brown, ca. 1930

The Yosemite Museum, Yosemite National Park

CHRIS BROWN
Miwok flicker-quill headband, ca. 1930

The Yosemite Museum, Yosemite National Park

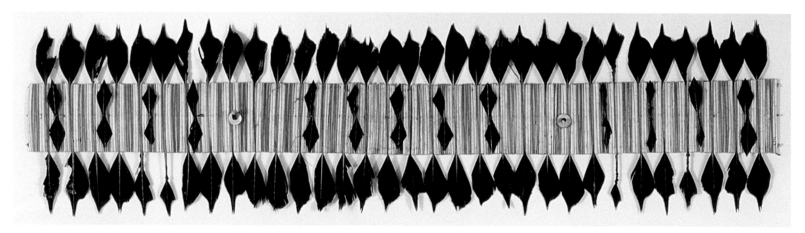

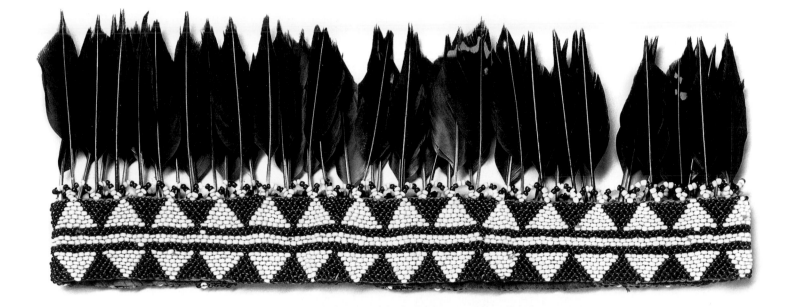

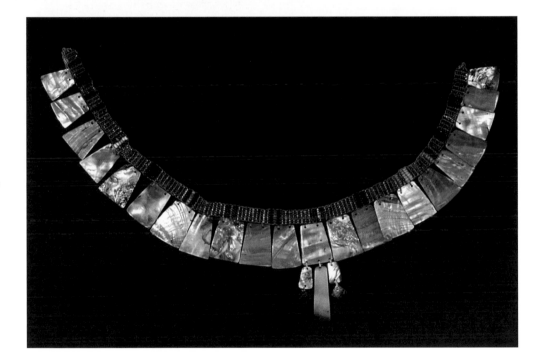

outward. A particularly innovative component of Brown's piece is the unusual creation of vertical stripes throughout the band, accomplished by alternating flicker quills with pairs of white—likely chicken—quills. It is not known whether Brown felt the inclusion of the white quills produced a desirable look, or if it was simply an issue of economy. Some historical bands include a few random stripes created with quills from yellow-shafted flickers, blue jays, or crows, but the regularity with which Brown alternated the orange and white throughout the length of the band carries the idea further.

Before the introduction of European glass beads, Native people in the Yosemite region utilized various shells, traded inland from the Pacific coast, in their regalia, as items of personal adornment, and as money. These were often worked into disc beads or shaped pendants. Abalone-shell pendants, for example, were arranged into pectoral necklaces. Pentagon-shaped pendants, such as those appearing on a necklace worn by the young man on the far right of the illustration on page 98, date from before 1850.

The weaving of European glass beads into headbands, necklaces, belts, and sashes involved both regional and introduced techniques. An

abalone necklace and collar of loom-woven glass beads in the Yosemite Museum (ca. 1910–40) is reminiscent of the old pectoral necklace. An unusual beaded headband collected from Mary Wilson in Yosemite Valley about 1925 is woven in blue and white glass pony beads using a brick stitch (see above and p. 98). The band is woven so that the ends are connected, resulting in a completed circle of beadwork. Loops of beads embellish the upper selvedge

Miwok beaded headband, ca. 1925
Southwest Museum of the American Indian collection, Autry National Center, Los Angeles

Miwok abalone-shell necklace, ca. 1910–40
The Yosemite Museum, Yosemite National Park. Photography by Robert Woolard

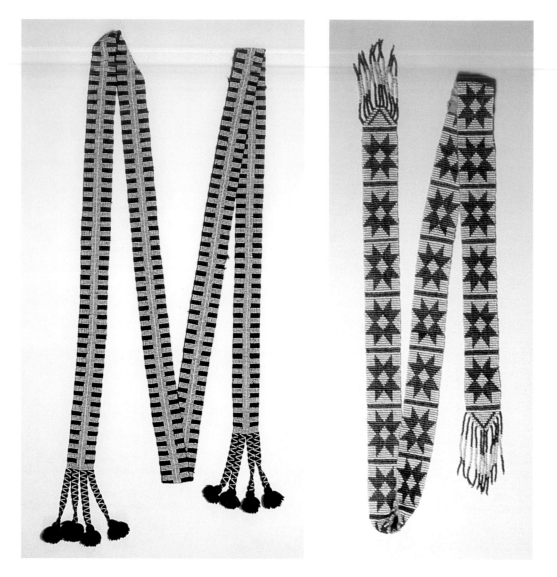

Bead and yarn sash, ca. 1910

The Yosemite Museum, Yosemite National Park.
Photography by Robert Woolard

Paiute beaded belt, ca. 1920

The Yosemite Museum, Yosemite National Park.
Photography by Robert Woolard

of the band, and acorn woodpecker tail feathers are inserted between the beadwork and a cloth backing. Photographs by Eadweard J. Muybridge show Native women in Yosemite wearing headbands of what appears to be woven beadwork with pendants of abalone shell in 1873, although some of the bands may be of cloth with glass beads sewn onto the material.

The weaving of glass beads into long belts was an introduced art form, entering the Mono Lake–Yosemite region via Paiute people to the north, who had acquired the technique from Native people of the Columbia River Plateau.[38] Local Native people also made long sashes woven of yarn and glass beads, using a technique similar to that of loom beadwork. It is not known when or where the idea originated,

though sashes appeared in photographs of Native people in Yosemite by 1900. Men normally wore the sash diagonally across the chest as a bandoleer, whereas women wrapped it around the waist as a belt. Designs found in beadwork sometimes transcended the medium. For example, a popular beadwork motif in the Mono Lake–Yosemite region was the eight-pointed star, which was frequently employed as a pattern in coiled basketry after about 1900.[39] A basket by Daisy Mallory (daughter of Nellie Charlie) illustrates the adaptation, although in this case the star contains six points rather than eight. A favorite device of both Mallory and her mother was to space four motifs around the basket, alternating their color (red and black) so they stood in equal opposition, as evident in a basket woven by Mallory sometime between 1920 and 1950.

Like seed beaters and sifting trays, cradle baskets had functional origins and were also woven for sale to non-Native collectors. All Native groups in California made cradle baskets. Among the Mono Lake Paiute, cradles were made exclusively of willow collected in the semi-arid country bordering the east face of the Sierra. The cradle was actually two separate pieces of basketry—a back and a hood. Children were swaddled in a blanket with their arms to their sides, and then laced in the cradle. Women carried the cradle on their backs, with a strap passing across the top of the forehead or shoulders. The construction of cradle baskets is the best-preserved weaving tradition in the eastern Sierra, as its use has never become obsolete.

Like most Paiute children of his generation, Raymond Andrews was raised in a cradle. He learned to make cradle baskets (p. 110) from his grandmother, Minnie Mike, and often observed his great-aunt Carrie Bethel cleaning and splitting her willow, a necessary skill in cradle-basket construction. Cradle baskets appear in several romantic images of Yosemite, including paintings by Thomas Hill and Christian Jörgensen, and in Julius T. Boysen's ca. 1901 photograph of Andrews's great-grandmother Suzie McGowan and her daughter Sadie with Yosemite Falls as a backdrop (p. 111). A cradle made by Andrews in 2005, displaying the diamond gender pattern used for girls, demonstrates the continued integrity of traditional standards, unadulterated by tourism.

For the Native people of Yosemite, the history and cultural legacy of their ancestors—both

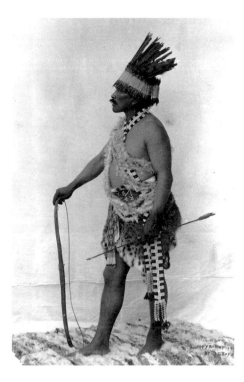

Francisco Georgely wearing a bead and yarn sash, photographed by Julius Boysen, 1903
The Yosemite Museum, Yosemite National Park

DAISY CHARLIE MALLORY
Basket, ca. 1930–50
Southwest Museum of the American Indian
Collection, Autry National Center, Los Angeles

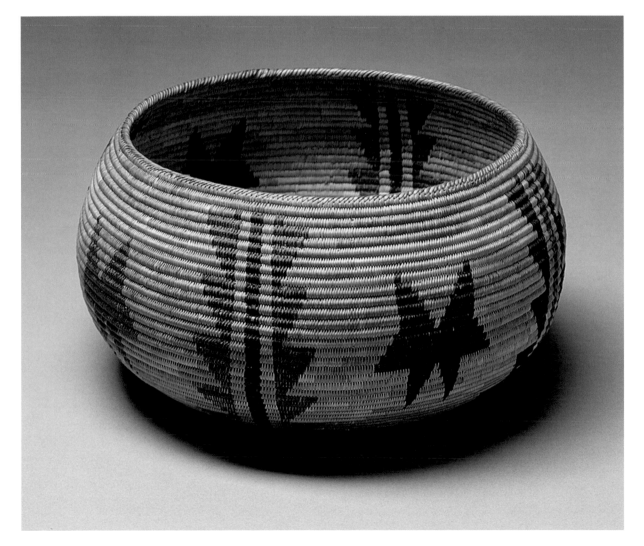

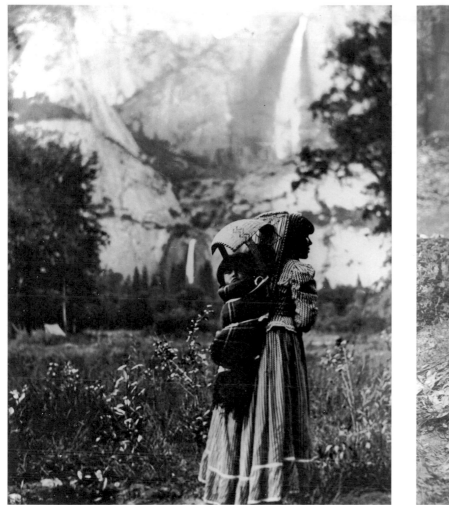

remote and immediate—continue to exist as personal experience, embedded in the granite that holds their myths and of which there is personal, tactile memory. Now, in the twenty-first century, Native artists continue to explore the relationship between their people and contemporary Yosemite, often with an eye to their history and traditions. Among the new mediums used by Native artists is photography, represented by the work of Dugan Aguilar, of Paiute / Maidu / Pit River descent. Although Native people have long been a subject of photography in the valley, Aguilar is among the first Native photographers to document Native life in Yosemite and California through his own vision. Whereas images of Native people by Muybridge, Hill, and others provoked curiosity about an exotic people, Aguilar's work is informed by familiarity and affiliation with his subject.

In the fall of 1997, Aguilar photographed several women raised at the "Indian village" in Yosemite, made up of thirteen homes built by the National Park Service in 1932 for Native residents who had formerly lived in makeshift tent cabins near the Ahwahnee Hotel.[40] (Ironically, the new "village"—located a quarter mile west of Yosemite Falls—was actually the old site of Wa-ha-ka, a village documented by Stephen Powers during his historic 1872–73 ethnographic survey of California.[41]) In one photograph from this series, Della Hern rests next to the bedrock mortar where her grandmother, Louisa Tom, pounded acorns until about 1955. Hern's memories of this activity are vivid: "Oh, you could hear the thud of the rock as it hit the acorn. . . . My grandma used to get [the pestle] and bring it down, just 'uh!' when she'd hit her acorn . . . 'uh!' "[42] Hern's aunt, Lucy Telles, taught her the nuances of sifting acorn flour in the traditional Paiute

JULIUS I. BOYSEN
Suzie McGowan and daughter Sadie, Yosemite Valley, ca. 1901
The Yosemite Museum, Yosemite National Park

DUGAN AGUILAR
Della Hern, 1997, gelatin silver print
Courtesy Dugan Aguilar

DUGAN AGUILAR
Helen Coats, 1997, gelatin silver print
Courtesy Dugan Aguilar

sifting tray on this spot. Hern is one of the few remaining speakers of Mono Lake Paiute and considers Yosemite her home. Her grandmother was the last Native person to be buried in the park, in 1956.

Aguilar also photographed Helen Coats, who lived in the enclave with approximately fifty other Miwok and Paiute residents during the 1930s and 1940s, atop a bedrock mortar where her grandmother, Lucy Telles, pounded acorns. Coats said her grandmother liked this particular pounding site because of the generous shade and its relative isolation, sitting at the base of the talus slope behind the village. Here, she and her sister Alice were less likely to be bothered by children while they went about their task. As a girl, Coats pulverized

sourberries in one of the deep cupules found on this rock. After pouring water into the granite hole and allowing it to mix with the red, sticky mass, she would lie on her chest, sipping the fresh, tart drink—a special treat on hot July afternoons.[43]

Like the painters and photographers who have been their contemporaries and their patrons, Native artists in Yosemite have created works that respond to their environment, to criteria established by their own community, and to outside influence, often in the form of market competition. Whereas European artists brought culturally sanctioned aesthetics to Yosemite from the outside, Native art was born within its borders, long before Yosemite became a destination or a pastime.

NOTES

The epigraph is from George Wharton James, *Indian Basketry, and How to Make Indian and Other Baskets*, 4th ed. (New York: Henry Malkan, 1909; rept., New York: Dover Publications, 1972), 47–48.

1. *Yosemeti* in the Central Sierra Miwok dialect (*Yohemeti* in the Southern Sierra Miwok dialect) translates as "they are killers" or "the killers" (see Sylvia M. Broadbent, "The Southern Sierra Miwok Language," *University of California Publications in Linguistics* 38 [1964], 240; L. S. Freeland and Sylvia M. Broadbent, "Central Sierra Miwok Dictionary with Texts," *University of California Publications in Linguistics* 23 [1960], 5). The term was used by Sierra Miwok speakers to identify a Native group living in or near Yosemite Valley during the mid-nineteenth century. It may have also served as a pejorative term to describe any Native group living outside one's territory with whom there had been conflict. However, baptismal records at Mission Santa Clara, dating from 1810 to 1812, identify two individuals as "Josmites." Their villages were located near the mouth of the Stanislaus River, south of present Manteca. These Josmites appear to have been Yokut-speaking people, thus adding further confusion to the use of "Yosemite" in the High Sierra (see James A. Bennyhoff, "Ethnography of the Plains Miwok," *Center for Archaelogical Research at Davis* [University of California] 5 [1977], 134, 164, 167; Randall Milliken, "Contact Period Ethnogeography of the Calaveras River Region [in The Taylors Bar Site, CA-CAL-1180/H: Archaeological and Ethnohistoric Investigations in Calaveras County, California]" [Davis, Calif.: Far Western Anthropological Research Group, 1997], 203). Yosemite Valley was known to the Miwok as Œawoni (i.e., Ahwahnee)—"place like a gaping mouth" (see Craig D. Bates, "Names and Meanings for Yosemite Valley," *Yosemite Nature Notes* 47, no. 3 [1978], 42–44).

2. The interaction between non-Indians (Spanish, Mexican, and Euro-Americans) and Indians had an early history of violence—beginning with capture and coercion in the recruitment of Native converts for the Spanish missions, and followed by the massive influx of miners during the rush for gold that began in 1848. After miners and settlers claimed their foothill territory, Indians made several attacks on the intruders; in the course of a response, the Mariposa Battalion entered Yosemite Valley in 1851—possibly the first white men to do so—and attacked the Indians, who were forcefully removed to the Fresno River Reservation (though they were allowed to return to Yosemite and Mono Lake after a year or so). See C. Gregory Crampton, *The Mariposa Indian War 1850–1851: Diaries of Robert Eccleston: The California Gold Rush, Yosemite, and the High Sierra* (Salt Lake City: University of Utah Press, 1957), 93, 109.

3. In years when there were mild winters, good crops of acorns, and other favorable conditions, some Native people may have stayed in Yosemite through the winter.

4. Samuel A. Barrett and Edward W. Gifford, "Miwok Material Culture," *Bulletin of the Public Museum of the City of Milwaukee* 2, no. 4 (1933), 155.

5. Ibid.

6. Richard G. Ervin, "Test Excavations in the Wawona Valley: Report of the 1983 and 1984 Wawona Archaeological Projects, Yosemite National Park, California," *Publications in Anthropology* 26 (Tucson: Western Archaeological and Conservation Center, National Park Service), 33–34; and Robert J. Fitzwater, "Final Report of Two Seasons' Excavations at El Portal, Mariposa, County, California," *Annual Report of the University of California Archaeological Survey* 4 (Los Angeles: University of California Archaeological Survey, 1962), 252.

7. A notable exception was Constance Gordon-Cumming, who wrote: "Indeed, there is a corner of danger, lest in the praiseworthy determination to preserve the valley from all ruthless 'improvers' and leave it wholly to nature, it may become an unmanageable wilderness. So long as the Indians had it to themselves, their frequent fires kept down the under-wood, which is now growing up everywhere in such dense thickets, that soon all the finest views will be altogether hidden, and a regiment of wood-cutters will be required to clear them" (Constance Gordon-Cumming, "Wild Tribes of the Sierra," *National Review* 2, no. 8 [1883], 415).

8. M. Kat Anderson, *Tending the Wild: Native American Knowledge and the Management of California's Natural Resources* (Berkeley: University of California Press, 2005), 3, 156, 171, 334.

9. Ibid.

10. Ibid., 157.

11. Craig D. Bates and Martha J. Lee, *Tradition and Innovation: A Basket History of the Indians of the Yosemite–Mono Lake Area* (Yosemite National Park, Calif.: Yosemite Association, 1990), 2–8; and Charles E. Holder, "A California Craze; the Latest Fad among Artistic People; Collections of Indian Baskets," *Placer Herald*, July 10, 1891, 7.

12. Bates and Lee, *Tradition and Innovation*, 56, 65.

13. Ibid., 39; M. E. Beatty, "The Last Indian Cremation in Yosemite," *Yosemite Nature Notes* 12, no. 9 (1933), 89–90; and James, *Indian Basketry*, 47–48.

14. Bates and Lee, *Tradition and Innovation*, 39.

15. Galen Clark to Mrs. Carr, Yosemite Valley, December 3, 1894, copy in Shirley Sargeant Collection; and Galen Clark, *Indians of the Yosemite Valley and Vicinity: Their History, Customs, and Traditions, with an Appendix of Useful Information for Yosemite Visitors* (Yosemite Valley, Calif.: Galen Clark, 1904), 71.

16. Bates and Lee, *Tradition and Innovation*, 75; and Clark to Mrs. Carr, December 3, 1894.

17. Clark, *Indians of the Yosemite Valley and Vicinity*, 1.

18. Bates and Lee, *Tradition and Innovation*, 76, 86.

19. Ibid., 86.

20. Julia Parker, interview with the author for the Native American Oral History Project, June 7 and 8, 1995, Research Library, Yosemite National Park.

21. Brian Bibby, *The Fine Art of California Indian Basketry* (Sacramento: Crocker Art Museum; Berkeley, Calif.: Heyday Books, 1996), 26.

22. Bates and Lee, *Tradition and Innovation*, 76, 78.

23. Ibid., 75–76, 86.

24. Ella M. Cain, *The Story of Early Mono County* (San Francisco: Fearon, 1961), 116.

25. Bates and Lee, *Tradition and Innovation*, 81.

26. Ibid., 82.

27. Ibid., 73; and C. Hart Merriam, field journal, 1900, Library of Congress, Washington, D.C., 72, 95.

28. Bates and Lee, *Tradition and Innovation*, 92.

29. Ibid., 97–98.

30. Ibid., 118.

31. Ibid., 116; Craig D. Bates, personal communication to the author, 2004.

32. Raymond Andrews, personal communication to the author, 2005.

33. Gene Quintana, personal communication to the author, 2004.

34. Andrews, personal communication, 2005.

35. Parker, interview, June 7 and 8, 1995.

36. Quintana, personal communication, 2004.

37. Fitzwater, "Final Report of Two Seasons' Excavations," 252.

38. Craig D. Bates, "Made for Sale: Baskets from the Yosemite–Mono Lake Region of California," *Moccasin Tracks* 7, no. 4 (1981), 4–9.

39. Bates and Lee, *Tradition and Innovation*, 80.

40. Harold Perry, "The Yosemite Story: A Drama of Chief Tenaya's People" (manuscript), Huntington Library, San Marino, Calif., 1949, 6.

41. Stephen Powers, *Tribes of California*, Contributions to North American Ethnology 3 (Washington, D.C.: U.S. Geological and Geographical Survey of the Rocky Mountain Region, 1877), 139.

42. Della Hern, interview with the author for the Native American Oral History Project, June 9, 1995, Research Library, Yosemite National Park.

43. Helen Coats, interview with the author for the Native American Oral History Project, May 12, 1995, Research Library, Yosemite National Park.

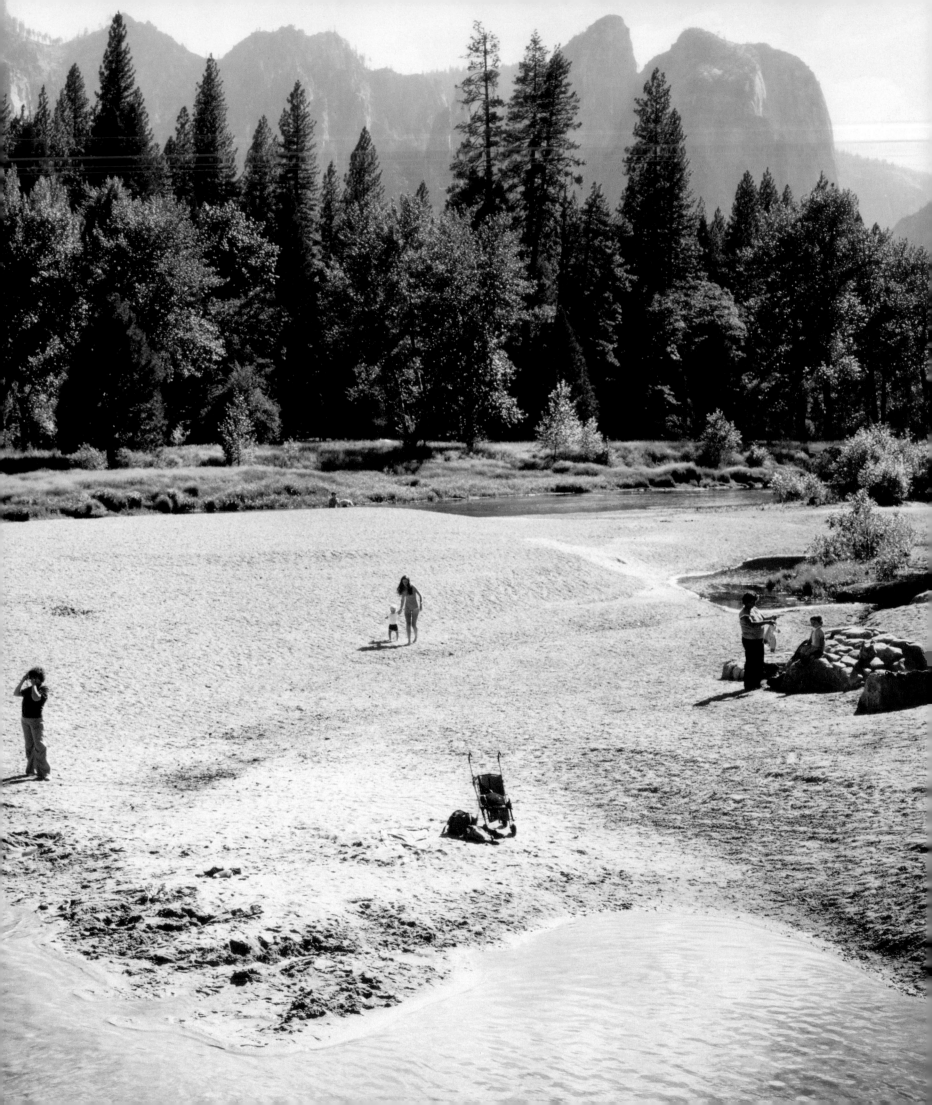

JENNIFER A. WATTS

PHOTOGRAPHY'S WORKSHOP

YOSEMITE IN THE MODERN ERA

ON A WINTRY JANUARY DAY IN 1935, Ansel Adams loaded his 8-by-10-inch view camera into a station wagon and drove the few miles from his darkroom to a roadside spot overlooking the panoramic sweep of Yosemite Valley. The morning's rainstorm had turned into a heavy wet snow by midday, and Adams had a picture in mind. "I had visualized for many years an image of Yosemite Valley from Inspiration Point," he later wrote. Once at his chosen location, the photographer quickly set up his camera. Storm clouds moved rapidly overhead. When "the Valley was revealed under a mixture of snow and clouds with a silver light gilding Bridalveil Fall," Adams tripped the shutter. The result was magical. *Clearing Winter Storm, Yosemite National Park* (p. 116) is the most enduring photograph of Yosemite ever made.[1]

Forty-five years later, Roger Minick drove to the large parking lot adjacent to the Wawona Tunnel exit. From that paved vantage, he could take in the view memorialized in Adams's picture. But Minick had very different intentions. In his photograph (p. 117), a woman, her back to the camera, stands squarely in center frame and gazes out to the valley below. Her head covering, a garish scarf emblazoned with the words "Yosemite National Park," marks her as a tourist.

If the twentieth century was the "photographic century," Yosemite was the genre's grand laboratory. In this singular critical space, myriad photographers expressed a dizzying range of artistic and cultural values over the course of a hundred years. Adams's monumental views of a pristine, unpeopled landscape offer one emblematic approach;

STEPHEN SHORE
Merced River, Yosemite National Park (detail; see p. 133)
Oakland Museum of California, anonymous gift with matching funds from the National Endowment for the Arts. © Stephen Shore

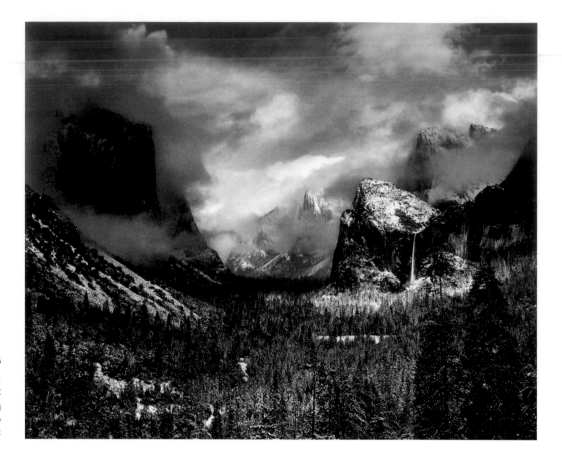

ANSEL ADAMS
Clearing Winter Storm, Yosemite National Park,
ca. 1935, printed 1980, gelatin silver print

Courtesy of the Huntington Library, Art Collections, and
Botanical Gardens, San Marino, California. Photograph by
Ansel Adams © 2006 The Ansel Adams Publishing Rights Trust

Minick's tourist at center stage offers another. Between these two temporal and conceptual poles, there exists a wide array of photographic responses to nature and American iconography. Yosemite thus serves as a case study for the evolution of the medium.

In turn, photography made Yosemite an exceptional place within American culture. Images created by generations of photographers, from Charles Weed in 1859 to Ansel Adams and beyond, have kept Yosemite in the public consciousness as a symbol of American Nature and a tourist destination par excellence for nearly 150 years. The history of photography in Yosemite is, at heart, a visual discourse about the role of the individual within Yosemite and within nature; this peculiarly American conversation is about the nation's unique relationship with its wilderness.

Ansel Adams is the loudest voice in this conversation. The preeminent Yosemite photographer for more than fifty years, Adams set the standard against which all others are measured, for good or ill. Adams earned his place alongside the likes of Ralph Waldo Emerson, Henry David Thoreau, John Muir, and Rachel Carson as an American nature thinker of extraordinary influence and reach. He determined, as one writer has put it, "not only how people saw the place, but how they imagined nature itself."[2]

Adams followed a path blazed by pioneering expeditionary photographers of the nineteenth century. What began as a trickle of images produced by the earliest Yosemite photographers had become a torrent by the turn of the century, thanks in part to George Eastman. Eastman's introduction in 1888 of a portable camera that required little more than pushing a button gave the means (if not the requisite skills) for picture making to a new generation. These "button pushers" came to Yosemite seeking the same sylvan views captured years before by Charles Weed, Carleton E. Watkins, Eadweard J. Muybridge, and others. The more dedicated of their ranks joined organizations like the California Camera Club, one of the largest and most active of such associations in the nation. Between 1899 and 1915, the club made at least seven Yosemite excursions. "There is, perhaps, no place in California more attractive to the photographer," wrote one editor in the club's journal, *Camera Craft*.[3]

The Sierra Club, founded in 1892 by John Muir, also embraced photography, though largely as a means of memorializing hikes and camping trips into the wild rather than for aesthetic purposes. The organization's commemoration of Yosemite through photography has roots in its very early years, as members made certain to document their outings, both large and small. In 1920, the eighteen-year-old Adams began his long and fruitful association with the Sierra Club, working as the summer caretaker of its Yosemite lodge. Adams's introduction to the Sierra backcountry that year set the course for his future career.

Women, too, joined the growing number of photographers drawn to Yosemite. By the end of the nineteenth century, practicing photography as a pastime was de rigueur for young women of leisure. The new, lighter equipment encouraged female participation, and advertisers capitalized on this, seeing a ready market in women with both the time and the money to spare.

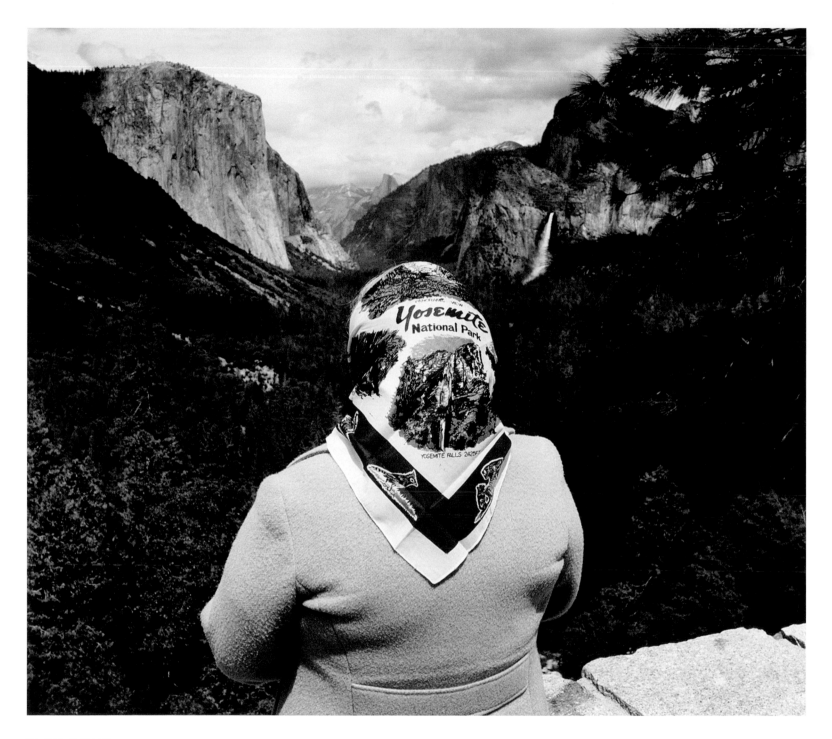

ROGER MINICK

Woman at Inspiration Point, Yosemite National Park,
1980, C-print

Oakland Museum of California, Prints and Photographs Fund.
© Roger Minick

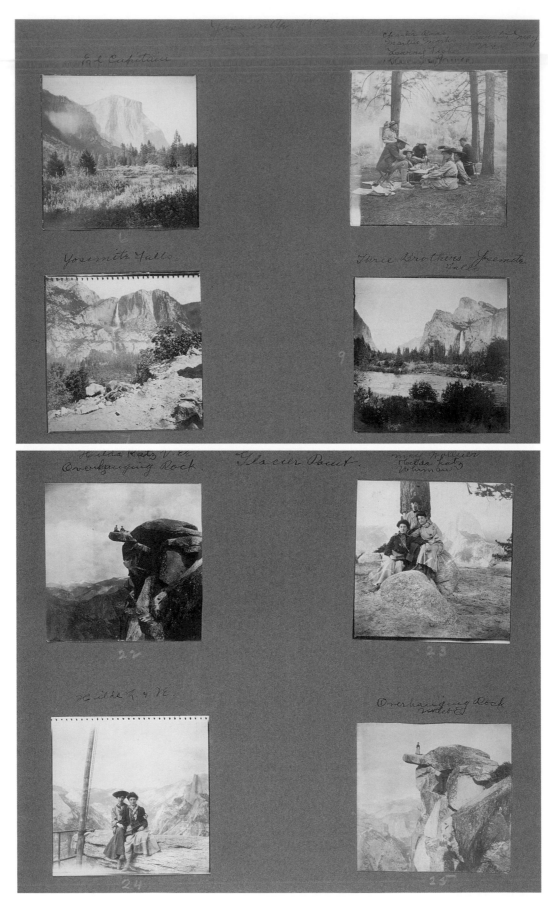

But what do the photographs of Yosemite taken by these early tourists and amateurs tell us? What do they say about their creators and the time in which they were made? Naturally, the photographs are as varied as their makers, but a few general principles apply. The objective of many, if not most, Yosemite visitors was to record the scene for later reflection and as a memory aid. Even Adams, writing of his early photographic forays with the Sierra Club, admitted that his images comprised a "visual diary" of the sites he encountered.[4] Some had artistic aims in mind. California Camera Club members, for example, wrote about the technical aspects of photographing waterfalls and flowers.[5] But many of the images in *Camera Craft*'s pages depict the photographers visiting the park's numerous attractions. In *The Yosemite Trip Book* (1926), a guide for the motoring tourist, F. J. Taylor listed some likely subjects for the camera lens: "A bear in a tree . . . a waterfall, a towering peak, a deer, a friendly squirrel, a chipmunk, or a panorama of Sierra peaks."[6]

Glaring in this banal litany of subjects is what is missing. The tourist of this era made little pretense of attempting to capture the magnificent, sweeping views made popular in the nineteenth century, nor did she feel the need to put forward a vision of nature untouched by human presence, as Adams and his countless mimics would later do. Much like today's vacation album, the tourist snapshots of the early twentieth century, taken together, represent a catalogue of sites encountered and duly noted.

Along with taking pictures of Yosemite, tourists also bought them. As early as the nineteenth century, a clutch of professional photographers operated studios in Yosemite Valley, selling photographs to visitors disembarking from train and car. These businessmen were not only supported by tourism; in turn, they helped fuel it, reinforcing, in the minds of visitors, the image of Yosemite as an untrammeled place of breathtaking vistas and tranquil Indians. George Fiske was the first to set up shop in the valley, settling in 1879 and making and selling pictures until his suicide in 1918. Fiske preferred the "view from below," not the lofty vantage points favored by so many of his professional peers. As the art historian David Robertson has noted, he also "brought time into the Yosemite picture," chronicling Yosem-

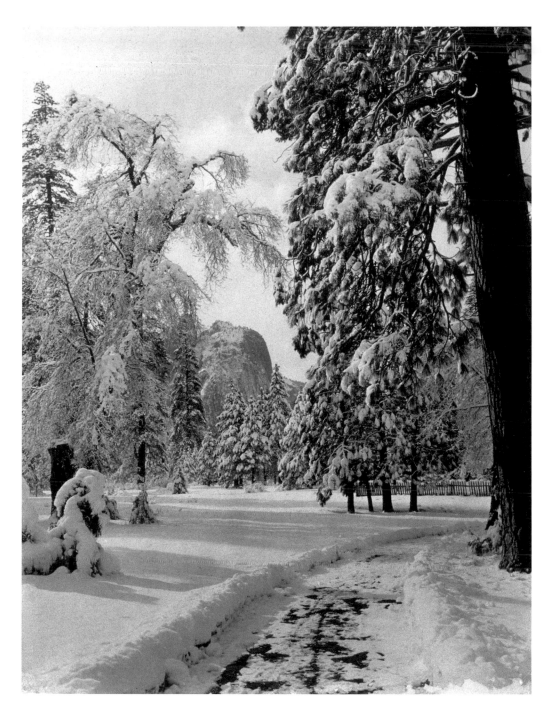

GEORGE FISKE
Untitled (Path in Snow), ca. 1900, albumen print
The Yosemite Museum, Yosemite National Park

ite's changing seasons in crystalline views of snow-encrusted trees or storm-charged skies.[7]

Studio photographs filled aesthetic and other gaps for the average visitor. They showed aspects of Yosemite that were either physically or temporally inaccessible to someone on a brief stay, and they demonstrated an artistry beyond the capabilities of the amateur's equipment or skills (or both). Professional photographers also encouraged tourists to wander into the frame to personalize their visit. Julius T. Boysen, who opened his studio in 1900,

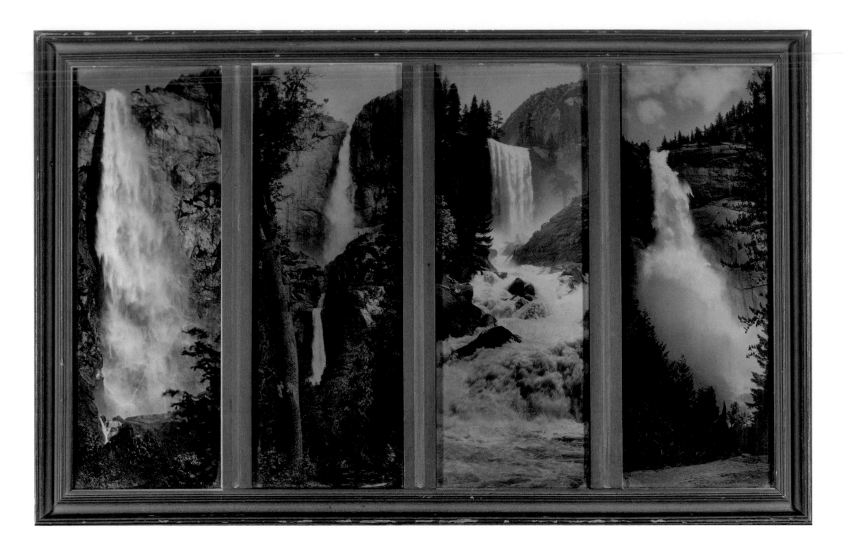

ARTHUR PILLSBURY
Four Falls, n.d., orotone
Collection of Jim Farber. Courtesy Arthur C. Pillsbury
Foundation (acpillsburyfoundation.com)

specialized in depicting tourists in spine-tingling acts of derring-do (or just plain foolishness), such as perching precariously atop Yosemite's highest points. Boysen's inventory also concentrated on less ubiquitous themes, such as the valley's small Native American population and the Mariposa Grove.

The studio photographer Arthur Pillsbury, who operated his Yosemite concession from 1906 to 1927, claimed to sell an average of five thousand photographic postcards a day during the height of the season.[8] He was known for his sparkling orotones—shimmering gold-toned creations depicting waterfalls and other natural features, housed in decorative period frames. Adams would later recall that his first roll of film had been developed by Pillsbury, who had also offered a few technical tips to the novice photographer.[9]

Other professional photographers of the period also came to Yosemite eager to try their hand at the subject. Arnold Genthe, a San Franciscan with a thriving portrait studio, visited Yosemite several times between 1903 and 1906. Perhaps best known for his artful depictions of San Francisco's Chinatown, Genthe made upward of seventy Yosemite negatives over the course of his visits. *Camera Craft* published his atmospheric *On the Rim of the Yosemite Valley* as the frontispiece of its August 1903 issue. Genthe's photograph of a mist-enshrouded Half Dome set against the gnarled limbs of a tree is a masterful example of the pictorialist school of photography then holding sway in fine art circles.

Yosemite enthralled the neo-romanticist pictorialists, a loose constellation of artists who sought to provide an antidote to the quotidian views of Yosemite made by tourists and the

slick documentary style of its studio operators. The pictorialists strove to elevate photography above the level of the "button pushers," the visual anthropologists, the documentarians, and the purely commercial into the realm of fine art.[10] Influenced by the Arts and Crafts movement's emphasis on handcraft, as well as the stylistic approaches of Japanese art and tonalist painting, many pictorialists sought to infuse their images with spiritual and emotional meaning. They employed various manipulations to achieve their artistic ends, such as draping their lenses with cheesecloth and painting or etching on their negatives, their finished prints, or both. William E. Dassonville, a photographer who traveled in San Francisco's bohemian circles, went to Yosemite on at least two occasions, in 1904 and 1907. His image *Twilight, Yosemite Valley* (1907), with its deep, brooding shadows cast in the valley's tranquil waters, captures a mood of quiet contemplation and reflection. It is a picture that evokes a feeling more than any specific sense of place.

The noted British photographer Alvin Langdon Coburn spent the summer months of 1911 camping in Yosemite, which he called "one of the world's finest beauty spots."[11] He returned home with a dramatic series of waterfall images (p. 122), showing rock walls and thundering water behind the silhouettes of dark, lacy leaves in the foreground, in homage to Japanese ideas of space and composition that were then in vogue.

The most prominent California pictorialist to claim Yosemite and the High Sierra as a creative backdrop was Anne Brigman.[12] Unlike her male contemporaries, Brigman made the body—in particular, the female body—the centerpiece of her artistic vision. Born in 1869 in Hawaii, Brigman attributed her deep love of nature to her mother, Mollie, "who gave me a sense of earth-beauty and color and rhythm even before I drew my first breath."[13] Moving to Northern California as a teenager only heightened Brigman's sensibilities. She began photographing herself and her friends outdoors in the nude, a radical choice for a woman of the day. An epiphany occurred on one such outing with her friends, when she experienced "the visualization of the human form as part of the tree and rock rhythms."[14] The rugged Sierra

wilderness, where she regularly camped for months at a time, became a powerful muse for Brigman's increasingly pantheistic vision. The female figure with her head thrown back, arm reaching to the heavens, or posed as if one with a rock or a tree (p. 123), symbolized Brigman's view of nature as a source of spiritual liberation and emotional strength.

Brigman made no secret of her fondness for altering images to achieve her desired outcome. She took few negatives, reworking them as the spirit moved her. "The etching tool," she wrote, "is one of my closest allies. . . . Even the effect of mystery steal [sic] through its keen edge, revealing itself in the finished print."[15]

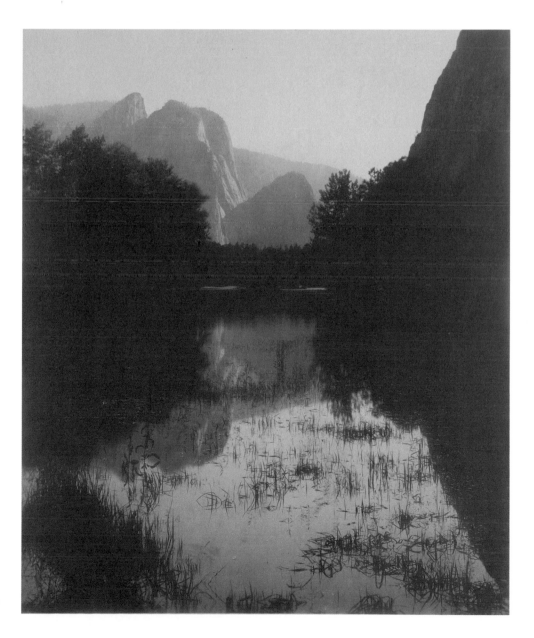

WILLIAM E. DASSONVILLE
Twilight, Yosemite Valley, ca. 1907, gum bichromate print

© The Estate of William Dassonville (represented by Paul M. Hertzmann, Inc., San Francisco). Photograph courtesy of the Barry Singer Gallery, Petaluma

ALVIN LANGDON COBURN
California, Yosemite Falls, 1911, platinum print
Oakland Museum of California, Burden Fund for Photography

ANNE BRIGMAN
The Lone Pine, 1908, gelatin silver print
Susan Ehrens Collection. © Mrs. Willard Nott

While Yosemite provided the setting for many of Brigman's musings, her aims were not documentary, but rather allegorical and emotive. Her daring subject matter left some viewers skeptical of the photographs' verisimilitude. When Alfred Stieglitz published five of Brigman's images in his journal, *Camera Work,* he provided the following caveat: "In order to correct a false impression which has gone abroad, we might add that these negatives are not produced in a studio 'fitted up with papier-maché trees and painted backgrounds,' but have been taken in the open, in the heart of the wilds of California."[16]

Not long after Brigman first went tramping through those California wilds, a young Ansel Adams discovered the "great earth-gesture" of the High Sierra.[17] Like Brigman, Adams came to believe that photography provided a window onto an inner world, yet whereas Brigman used the body as her focal point, Adams would make

people and their traces conspicuously absent from the natural landscape as his work evolved in service to his aesthetic and environmental ideals.

Adams's later celebrity would have seemed improbable to those who knew him as a hyperactive child.[18] At the age of thirteen, he received from his indulgent father a year-long pass to San Francisco's 1915 Panama-Pacific Exposition in lieu of more formal schooling. His eccentric education continued the following year with a family trip to Yosemite, where the precocious teenager was presented with his first camera, a Kodak Box Brownie. By Adams's own admission, his first efforts at photography were "very poor," but he was irretrievably hooked by Yosemite and his attempts to record his experiences on film. In the following years, though most of his energies were directed toward his consuming passion for music and the desire to become a concert pianist,

summers found Adams longing for a Sierra escape. Joining the Sierra Club in 1919, he began his lifelong tenure with the organization whose environmental mission he would later come to personify through his work as a board member and a photographer.[19]

At first, Adams was, in his own words, an "ardent hobbyist" who, like the vast sea of Yosemite tourists before and after him, made pictures for documentary rather than creative ends.[20] As he matured into a young adult, he refined both his technique and his eye, and he began to acquire a reputation as a photographer of promise among a coterie of San Francisco artists and patrons.[21] Adams later pinpointed one of his significant breakthroughs to a spring day in April 1927, when he made an image that irrevocably changed his understanding of photography. Adams and some friends, including his fiancée, Virginia Best, had hiked to a spot that promised a spectacular view of

ANSEL ADAMS
Monolith: The Face of Half Dome, 1927, gelatin silver print

Yosemite Valley. Lugging close to forty pounds of equipment, including a view camera, glass-plate negatives, filters, lenses, and a tripod, the group arrived only to find Half Dome engulfed in shadow. They decided to wait for better conditions, and Adams set up his camera. Realizing that he had but two negatives left in his holder, Adams chose to use a yellow filter in order to darken the sky. "As I replaced the slide," he wrote, "I began to think about how the print was to appear, and if it would transmit any of the feeling of the monumental shape before me in terms of its expressive-emotional quality. I began to see in my mind's eye the finished print I desired: the brooding cliff with a dark sky and the sharp rendition of distant snowy Tenaya Peak."[22] With his last remaining negative, Adams changed his yellow filter to a red one and increased the exposure. The resulting image—*Monolith: The Face of Half Dome*—is one of Adams's signature works.

Adams's epiphany came when he realized that he could translate onto the finished print how he *felt* when looking through the camera's ground glass. In what seemed a single moment, Adams had moved his art beyond the sphere of the merely documentary, into the realm of the interpretive and emotional. He termed this telepathic exercise "visualization," a concept that would come to define his photographic approach.[23]

Adams married Best in 1928, and the couple soon took over her father's Yosemite Valley art concession, Best's Studio. The timing was propitious: all the nineteenth-century studios had folded, and their gallery could operate virtually uncontested on the valley floor. Through his twenties, however, Adams continued to equivocate between photography and music. The tension was exacerbated by his need to perform commercial work in order to support his growing family and to underwrite his creative photography. A 1930 meeting with the photographer Paul Strand resolved Adams's career ambivalence; he realized then that "the camera, not the piano, would shape my destiny."[24] But the strain of balancing photography for hire with photography for love would trouble Adams until his death.

At about the same time that Adams had his "Monolith revelation," he also made *Half Dome from the Glacier Point Hotel* to satisfy his financial obligations. While both images exhibit Adams's trademark technical virtuosity, they could hardly be more different in tone and intent, revealing the gulf between the worlds of commerce and art that Adams already straddled. In *Monolith*, with its dramatic upward gaze and hulking rock wall set against an inky black sky, Half Dome is the psychological equivalent of the superego, a site of inner, unshakable power and human conscience. In the Glacier Point Hotel image, by contrast, Half Dome is but a picturesque center point in a neatly symmetrical composition celebrating the hotel's wondrous views. Using the hotel architecture to frame the scene, one of many spectacular Yosemite sights available to the tourist, Adams rendered the landscape controlled, accessible, and utterly nonthreatening (if the nonchalant expressions of the two "dudes" in the photograph are any indication). Though Adams's commercial imagery is either overlooked entirely or glibly dismissed in the context of his entire oeuvre, it is important to

remember that pictures like *Half Dome* provided the bread-and-butter income that supported his creative work.

Adams soon fell in with a group of like-minded San Francisco–area photographers. Coming together for a time under the moniker Group f/64, they rejected the misty-eyed sentimentality of pictorialism, embracing a straight investigation of (mostly) natural forms. According to Edward Weston, one of the group's more celebrated members, they made photographs free of "the fog of impressionism." Adams and Weston met in 1928 at the home of San Francisco arts patron Albert Maurice Bender, and though that first encounter left neither man impressed, the two soon forged a powerful creative and personal allegiance that lasted throughout their lives. The younger Adams, a gregarious partygoer and inveterate bon vivant with legendary energy, provided a study in contrast to the reserved and abstemious Weston, but the two shared a deep mutual respect as well as a slavish dedication to their craft.

In 1937, Weston became the first photographer to win a prestigious Guggenheim Fellowship,

and he embarked on a journey across California and the American West that opened his eyes to landscape photography. Adams introduced Weston to Yosemite, and he visited the park four times over the course of the following two years. The sinuous forms of the juniper trees at Lake Tenaya captivated him (p. 126), as did the effects of freshly fallen snow on rocks and branches. Whereas Adams's landscapes tended toward the bold and breathtaking, Weston concentrated on textures and subtle forms, favoring close-up investigations of nature's mysteries.

While Adams and Weston differed in style, they concurred in their subject matter and approach, and both endured criticism for their insistence on photographing the natural world in the midst of the Great Depression. Both photographers were liberal supporters of the New Deal, but they resisted the social-documentary path followed by so many of their peers in the 1930s—the new wave of photographers committed to documenting the ravages of economic catastrophe for the Farm Security Administration and other federal

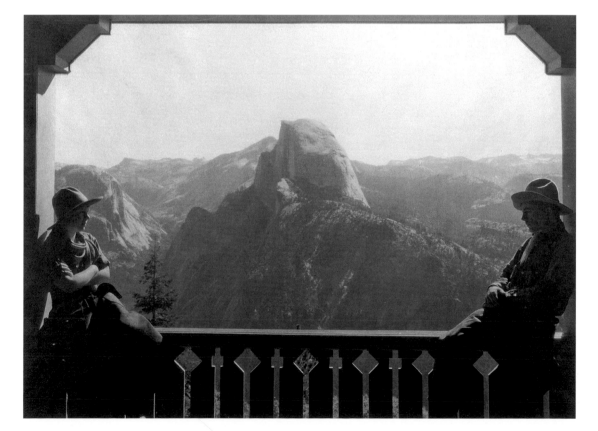

ANSEL ADAMS
Half Dome from the Glacier Point Hotel,
1929, gelatin silver print

Museum of the American West Collection, Autry National Center, Los Angeles; purchase made possible by the Gold Acquisitions Committee, 2001. Photograph by Ansel Adams © 2006 The Ansel Adams Publishing Rights Trust

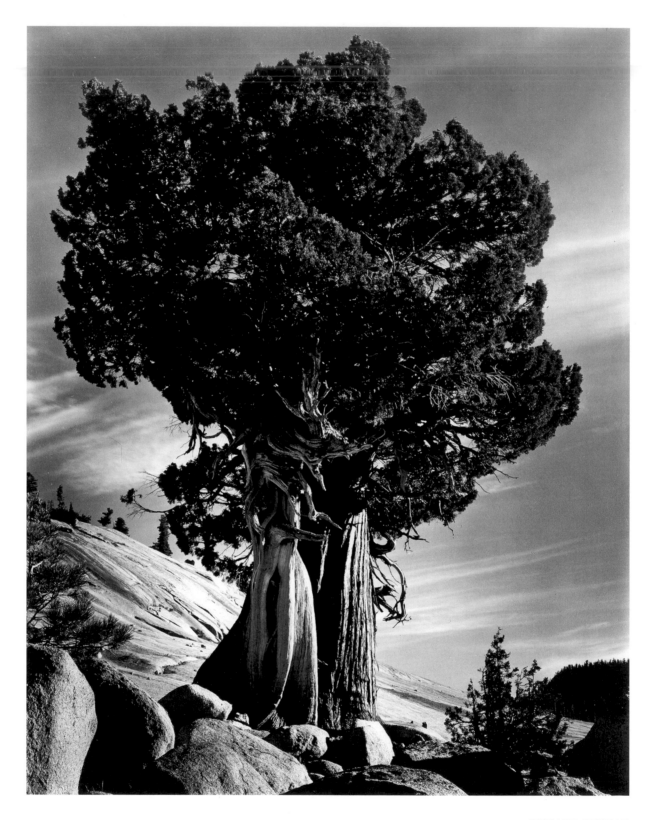

agencies. Writing to Weston in 1934, Adams put forth a private apologia for their actions: "Our objective [in photography] is about the same—to express with our cameras what cannot be expressed in other ways, to trust our intuition in respect to what is beautiful and significant, to believe that humanity needs the purely aesthetic just as much as it needs the material."[25]

Through the 1930s and 1940s, men continued to dominate the world of landscape photography in general and Yosemite imagery in particular. Adams's friend Dorothea Lange concentrated on the Depression's human subjects, and his fellow Group f/64 member Imogen Cunningham created studies of her family and botanical specimens. Cunningham made a single trip to Yosemite, in 1939, and the result of this visit offers a telling contrast to Adams. Her *Self-Portrait with Jane Foster* pays homage to Brigman's studies of the female nude in the landscape, though Cunningham's approach is less theatrical: Foster floats ethereally in water, with Cunningham visible only as a shadow as she makes the exposure. The photographer's inclusion of herself in this way is as old as the medium itself. Unlike most such images, however, her shadow appears not as a signature element, but is coequal with the photograph's other human subject; Cunningham is present here as a participant-observer.

The marked difference between Cunningham's and Adams's Yosemite photographs suggests their complicated, albeit respectful, relationship. Cunningham found Adams's brash commercial enterprises repugnant; for instance, she spoofed his willingness to let Hills Brothers use one of his Yosemite images on their coffee cans by sending him the offending container planted with a marijuana seedling. For his part, Adams remarked that Cunningham had "acetic acid" running through her veins.[26]

After a 1937 darkroom fire destroyed many of his important negatives, Adams embarked on an extensive program of writing, teaching, and expressly creative (as opposed to commercial) photography in an effort to realize his twin ambitions in art and environmental conservation. He held the first of his annual Yosemite photography workshops, the brainchild of

U.S. Camera editor Tom Maloney, in 1940. Intended as a vehicle for bringing his photography and environmental consciousness to a wider public audience, the workshops would attract numerous photographers, both professionals and serious amateurs, to Yosemite over the years.

During the first workshop, Adams and Weston taught twelve students in a series of informal sessions with a hands-on approach. When the workshops resumed in 1946 after a five-year

IMOGEN CUNNINGHAM
Self-Portrait with Jane Foster, 1939, gelatin silver print

Photograph by Imogen Cunningham
© The Imogen Cunningham Trust

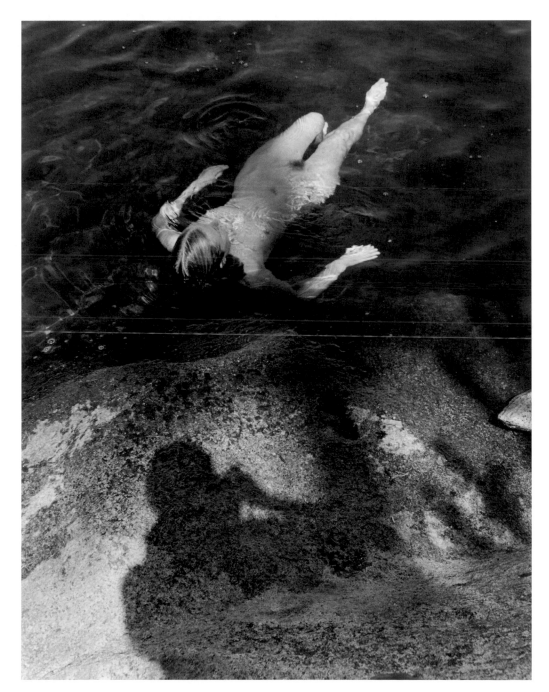

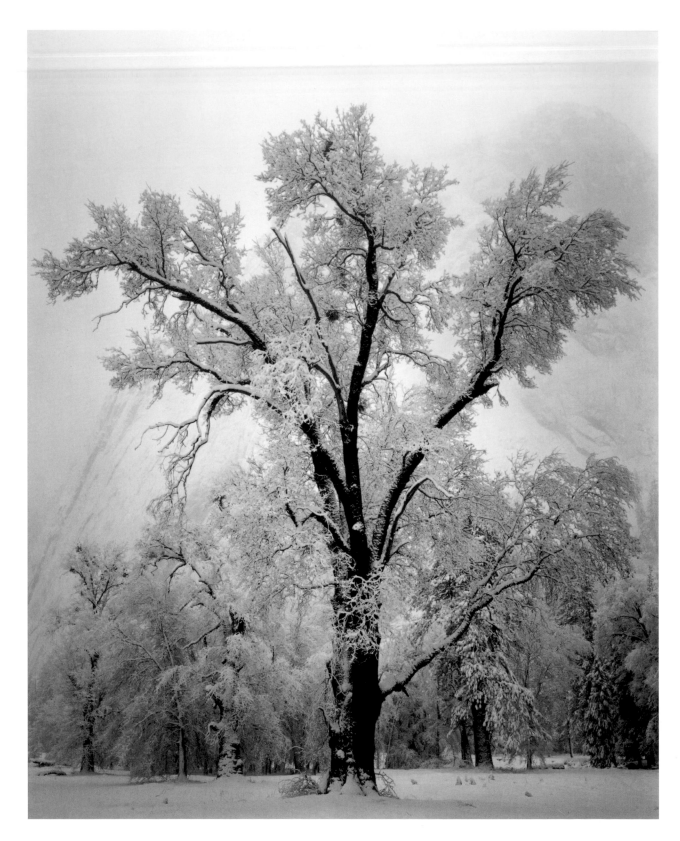

hiatus because of the war, Adams continued to stress fieldwork over classroom instruction, a formula he employed for the next thirty-five years. By the time he handed over the workshop reins in 1981, he had drawn dozens of notable instructors to Yosemite—photographers as diverse as Wynn Bullock, Paul Caponigro, Lucien Clergue, Linda Connor, Judy Dater, William Garnett, Robert Heinecken, Eikoh Hosoe, Mary Ellen Mark, Barbara Morgan, Wright Morris, George Tice, and Brett Weston, to name a few.[27] Some of his longtime assistants, the photographers Al Weber, Morley Baer, John Sexton, and Don Worth, continued in the fine-art black-and-white tradition for which Adams was known, carving out their own niches in the photography world. Others, such as Philip Hyde, became recognized for their photography in support of conservation ideals. Yet perhaps the most potent aspect of the workshops was the international visibility they afforded Adams and, to an even larger extent, Yosemite.

By sheer force of Adams's work and reputation, Yosemite became a mecca for eager disciples. Some came wanting to experience Adams's epic scenes for themselves, while others wanted to learn at the hand of the master. His books, exhibitions, and workshops, as well as his trips to Washington, D.C., on behalf of the Sierra Club and allied environmental organizations, all made Adams familiar to legions of diverse fans. Just as Adams brought widespread attention to Yosemite, so Yosemite increased Adams's fame. "Ansel has a really extraordinary personal public," the photographic historian Nancy Newhall remarked in a 1960 letter to Sierra Club president David Brower. "I have never yet walked with him down any main street, from Fifth Avenue to the most lost and forgotten desert town, that somebody didn't yell, "HI, ANSEL!"[28]

Adams was indeed the most famous photographer of his day. Solo exhibitions of his photographs appeared in prestigious museums around the world; he lobbied Congress and met with heads of state, including Presidents Johnson, Ford, Carter, and Reagan; his celebrity was enshrined in a 1979 cover story in *Time*. His larger-than-life persona was a perfect complement to the outsized spaces of Yosemite, and his growing fame was reflected in his work: by the early 1970s, Adams was translating his earlier negatives into bold, large-scale prints with lunar blacks and blinding whites that could be viewed from across a room, in marked contrast to his more intimate works that owed a debt to pictorialism.

Together, Adams's photographs present a straightforward visual narrative that promotes the grandeur, beauty, and spiritually restorative powers of parkland. The tale they tell excludes the troubling realities of crowds, unsightly infrastructure, and automobiles; Adams's flawless, unpeopled landscapes offer a transcendental experience revelatory of an idealized inner world. Adams routinely lectured workshop participants about Yosemite's purpose as a reserve—a place for recreation, certainly, but first and foremost one for personal "*recreation*." As he explained to an audience at the Metropolitan Museum of Art in New York City in 1975, "I work with the natural scene in both spectacular and tender modes. I think (I hope) I have added personal qualities to my images which transcend—for better or worse—the impact of the external reality."[29]

By the time Adams made this remark at the Metropolitan Museum, a new generation of up-and-coming photographers was redefining photography's function in Yosemite. "Is there life after Ansel Adams for Yosemite photographers?" one writer mused.[30] The answer is yes, though the weight of Adams's legacy is perhaps most evocatively pictured in a whimsical photograph by Jerry Uelsmann, depicting Adams's disembodied—albeit congenial—head superimposed on the face of Half Dome.

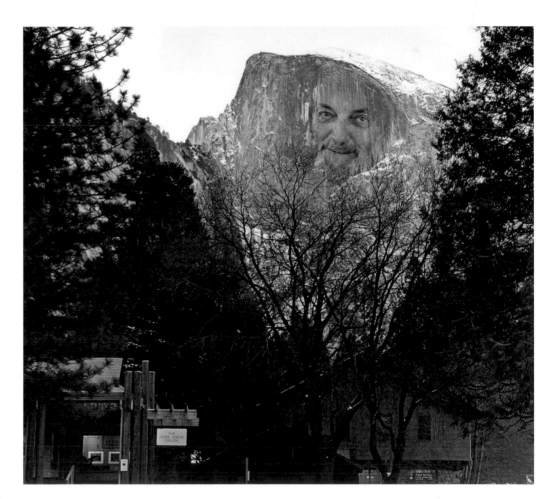

JERRY UELSMANN
Ansel Adams in Half Dome, 1973, gelatin silver print
© Jerry N. Uelsmann

Certainly, by the 1960s no photographer could attempt image-making in Yosemite without acknowledging Adams's looming presence. The world was a vastly different place from the one in which Adams had begun making pictures some four decades prior, however. The 1950s had seen a rise in the photojournalistic style. Popularized by Robert Frank and others, this approach privileged a social and biographical agenda over the craftsmanship associated with Adams and his compatriots. A decade later, the upheavals of the civil rights movement and the Vietnam War made nature photography seem quaint and old-fashioned. Two divergent sensibilities began to prevail: the irreverent, mocking stance that informed Pop Art, and (particularly in the photography world) a mys-

tical, self-expressive attitude. The era also witnessed the spread of fine art photography programs on college campuses, where curricula tended toward a personal, intuitive approach to the medium rather than the technical stance associated with the professional schools of an earlier period. All of this, added to the tremendous changes that had occurred within Yosemite itself, made Adams's work seem out of step to the art school–trained neophytes who sought distinctive voices of their own.

This new school of photographers discovered and depicted a Yosemite unimagined by Adams. They framed their shots on the valley floor rather than the craggy vistas favored by Adams, and many turned their cameras to the crowding that had by then become endemic. Artists

BRUCE DAVIDSON
Campground No. 4, Yosemite National Park, 1966, gelatin silver print
Museum of the American West Collection, Autry National Center, Los Angeles. © Bruce Davidson / Magnum Photos

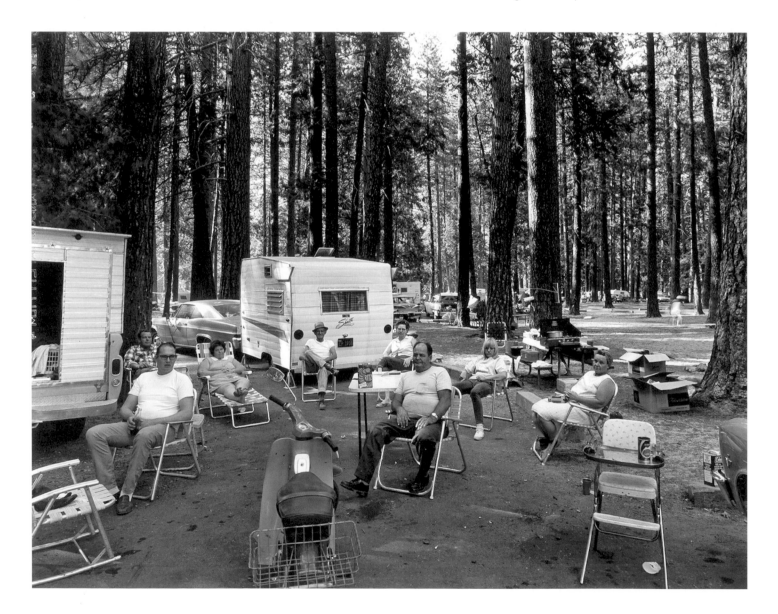

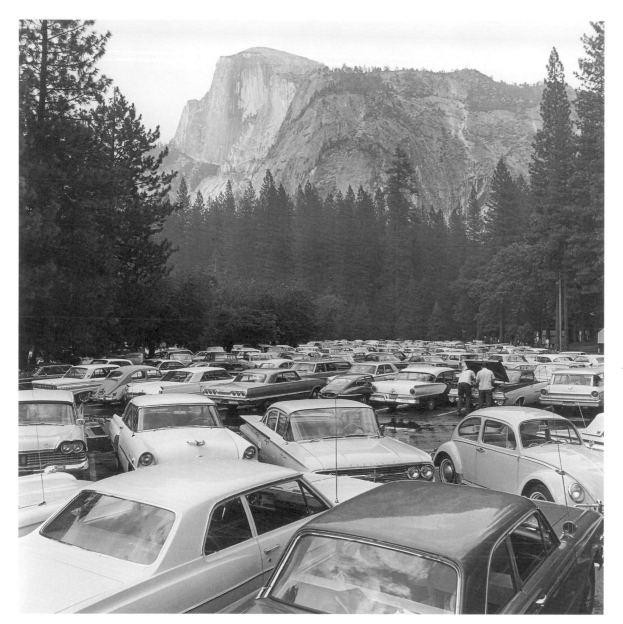

RONDAL PARTRIDGE
Pave It and Paint It Green, ca. 1965,
gelatin silver print

Museum of the American West Collection,
Autry National Center, Los Angeles;
purchase made possible by Jennifer and
James R. Parks. © 2003 Rondal Partridge

like Bruce Davidson consciously highlighted the population density of campgrounds clogged by vehicles and visitors bored by their excursion to the woods. Rondal Partridge, Imogen Cunningham's son, took much the same approach in *Pave It and Paint It Green* (ca. 1965), in which the distinction between city and wilderness has disappeared. To be sure, an "Adams School" of practitioners continued to make pristine black-and-white views showcasing an untrammeled wilderness landscape—but by the late 1960s such images had essentially been shouted down by the cacophony of photographs foregrounding the

park's tourist experience, which for all intents and purposes had become the predominant experience of most visitors to Yosemite.

Just as he had during the Great Depression, Adams ignored the rising trend. "I have a great love and attachment for that vague property of nature and of man which some call 'beauty,'" he wrote to Alvin Langdon Coburn in 1964. "I am not interested in turning over stones to find unhealthy critters proliferating, no matter what the 'shock' value may turn out to be."[31] Yosemite's "unhealthy critters"—the crowds, the traffic jams, the litter—were precisely what

held the new generation of photographers in thrall. Ted Orland's *One and a Half Domes, Yosemite* (1975, p. 132), for example, assumes the vantage of the twentieth-century tourist while also paying homage to its photographic precedents. In this sepia-toned view, the ancient landscape recorded by Watkins and Adams is overshadowed by the "half-domed" trash can and a luridly hand-colored map explaining the site's geology. A former Yosemite workshop participant and Adams's assistant for a number of years, Orland wryly called this image part of his "Ansel Adams Memorial Equivalent Series."[32]

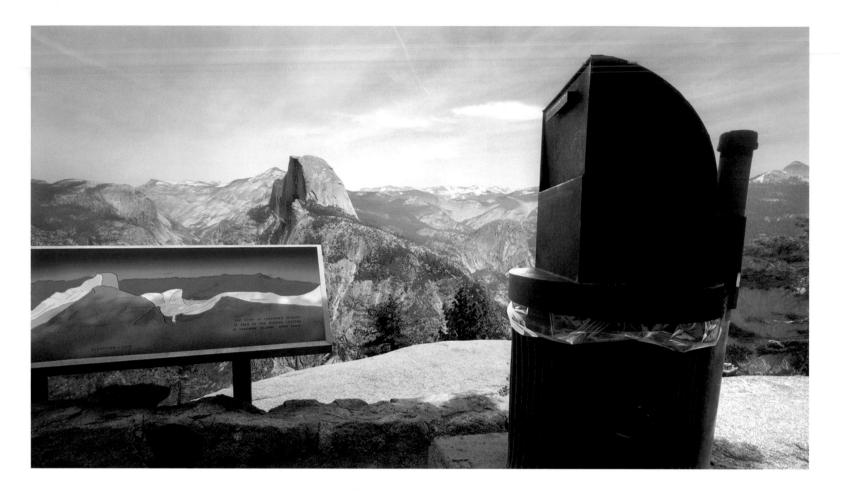

TED ORLAND

One and a Half Domes, Yosemite,
1975, digital print 2005

Museum of the American West Collection, Autry National
Center, Los Angeles, Gift of the artist. © Ted Orland

Orland is representative of a school of landscape imagery that developed during the 1970s. The New Topographics featured Adams's much-lamented "unhealthy critters"—the banal, pedestrian, or otherwise unlovely aspects of human incursions on the land.[33] While Orland and others rephotographed sites depicted by nineteenth-century photographers, Stephen Shore's *Merced River, Yosemite National Park* (1979) shows a summer day's recreation on the river's banks. The animating argument behind such images was consistent: any presumably objective view of a Yosemite absent humans or human traces is, and always has been, a fiction.

At the same time, skilled photographers continued in the sublime tradition enshrined by Adams. Galen Rowell embraced technological advances in portable cameras and color film to produce a wildly popular brand of kamikaze wilderness photography. Trekking into backcountry inaccessible to the rank and file,

Rowell often risked life and limb to create improbably beautiful—even surreal—imagery. He called this "participatory photography" or "the difference between a landscape viewed as scenery from a highway turnout and a portrait of the earth as a living, breathing being that will never look the same twice."[34] Like Adams, he wanted to show the mystical, evanescent moment that epitomized his inner emotions, "to make images that exceeded the normal perception before my eyes."[35] *Last Light on Horsetail Fall, Yosemite, California* (1973, p. 134), for example, makes no pretense of depicting the landscape as it really is; rather, it presents the landscape in its Platonic, idealized form, in a singular perfect moment.[36]

In 1986, the Yosemite Museum inaugurated its artist-in-residence program, which has brought many notable photographers to the park.[37] One participant, Jerry Uelsmann, an instructor at Adams's workshops for many years, returned to the park in 1992. In a playful jab at Adams's

evangelistic promotion of his "visualization" technique, Uelsmann terms his working method "post-visualization". His alchemy happens not in the field but in the darkroom, where he selects any number of elements from thousands of negatives and combines them in a montage. Often symbolic and mystical, the resulting photographs explore the inner universe of the psyche. While some of Uelsmann's Yosemite-based imagery pokes fun at modern conceptions of nature, most of it hearkens back to the pantheistic symbolism first explored photographically by Anne Brigman. In *Tree Goddess* (1994, p. 135), Uelsmann turns Edward Weston's formalist study of the juniper tree at Lake Tenaya on its ear, making it a stand-in for Mother Earth. Uelsmann's photographs claim no agenda beyond the self-expressive and personal: "ultimately my hope is to amaze myself."[38]

STEPHEN SHORE
Merced River, Yosemite National Park, 1979,
dye coupler print

Oakland Museum of California, anonymous gift with matching funds from the National Endowment for the Arts.
© Stephen Shore

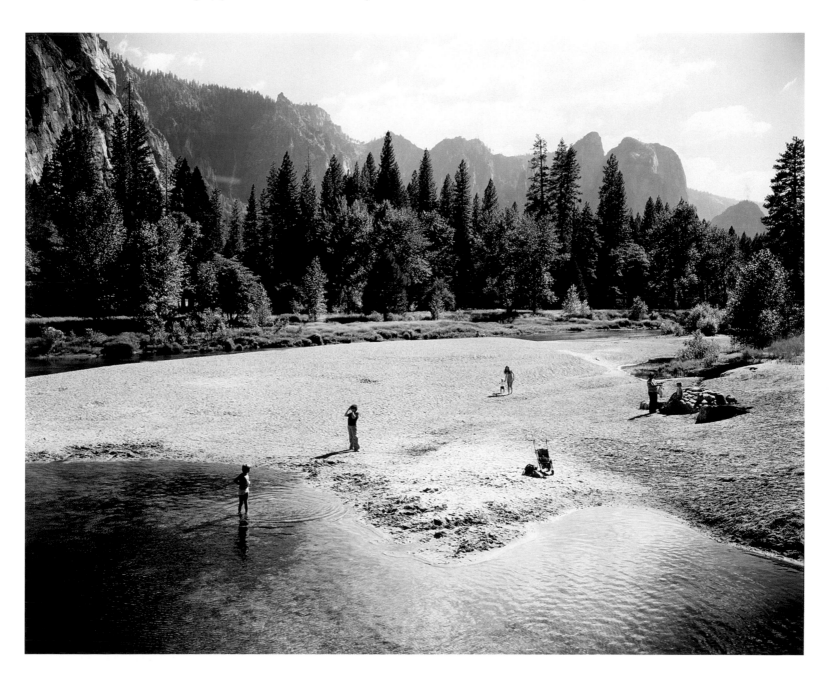

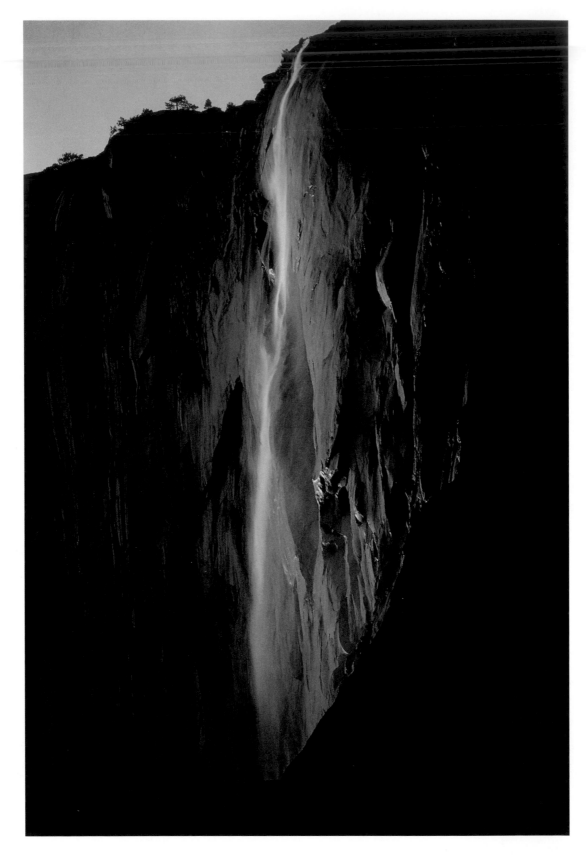

JERRY UELSMANN

Tree Goddess, 1994, gelatin silver print

Museum of the American West Collection, Autry National
Center, Los Angeles; purchase made possible by Gary
and Sandra Gordon. © Jerry N. Uelsmann

GUS FOSTER

Mt. Dana, 1990, panoramic photograph

Museum of the American West Collection,
Autry National Center, Los Angeles. © Gus Foster

Following Adams's death in 1984, Yosemite photography became increasingly diverse. During the 1980s and 1990s, a more multivalent, less sardonic approach emerged. Like Uelsmann, many artists used the park as a canvas to express personal, inner convictions rather than for conservation or preservation ends. Color photography ruled the day, and toward the end of the twentieth century photographic prints became ever larger—even gargantuan in the case of artists like Thomas Struth and Gus Foster—in line with trends in the broader photography world.

As has been the case historically, men continued to dominate Yosemite's photographic terrain. Despite many female instructors and students participating in park workshops, few women chose Yosemite as a significant subject for their work. One of the park's most widely known contemporary images, Judy Dater's *Imogen and Twinka at Yosemite* (1974, p. 138), shows the model Twinka (the daughter of artist Wayne Thiebaud, who has made notable paint-ings of Yosemite) coyly posed against a tree, subjected to Imogen Cunningham's appraising scrutiny; the work bears no overt markers of Yosemite except in its title. While Adams drew many women artists to Yosemite, few seemed interested in taking on the park itself. Geraldine Sharpe and Liliane DeCock, who served as Adams's assistants, are possible exceptions, but their work concentrates on nature's details rather than Yosemite's landscape per se. Wanda Hammerbeck admits to feeling somewhat intimidated by Adams's hold on Yosemite, noting that she sought to distance herself from him upon tackling the topic.[39] Her *HOW IT RISES TOWARDS THE SKY* and *HOW IT RESTS ON THE GROUND* (both 1992, p. 139) concentrate on solid, earthbound objects rather than the light, air, and sky that predominate in Adams's views.

A place as geologically ancient and as unremittingly popular as Yosemite continues to prove tantalizing to artists. The park and its millions of visitors offer a rich opportunity to explore the interstices of time and humanity's relation-ship to nature. In 1996, Don Suggs positioned his camera at the Half Dome overlook, photographing the thousands of visitors who streamed past. *High Sierra* (p. 140), a dense composite of images taken during this "stake-out," captures bits and pieces of the flow of spectators passing before the static, seemingly immutable view. These are not contemplative witnesses to nature's grandeur, but a jostling throng checking off a long list of things to see and no doubt taking a memorializing snapshot before hurrying along to the next site. Fourteen years earlier, David Hockney also used a multiple-image approach to investigate the flow of time along the Merced River (p. 141). John Divola's *Occupied Landscapes* (1989–92, pp. 142–43), each of which shows a single figure or a small pair embedded in the landscape, evoke what Divola interprets as the natural human inclination to "get away from it all" and seek solitude in nature, even amidst the crowds.

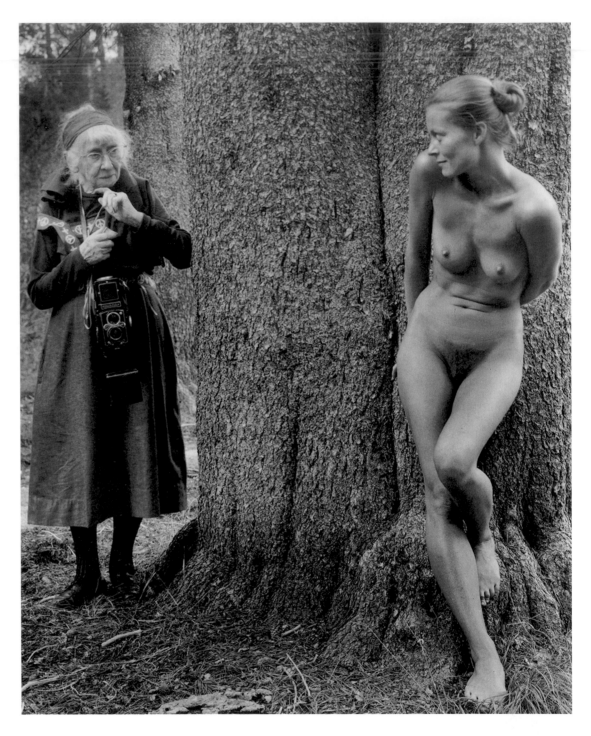

WANDA HAMMERBECK
HOW IT RISES TOWARDS THE SKY
and *HOW IT RESTS ON THE GROUND*,
both 1992 (photographed 1983),
Ektacolor prints with silkscreened text

Museum of the American West Collection, Autry
National Center, Los Angeles; purchase made
possible by the Gold Acquisitions Committee
and an Anonymous Donor, 2006.

© Wanda Hammerbeck

HOW IT RISES TOWARDS THE SKY

HOW IT RESTS ON THE GROUND

DON SUGGS
High Sierra, 1996, gelatin silver print "composite"
photograph and acrylic varnish on wood panel
Courtesy L.A. Louver Gallery, Venice, California.
© Don Suggs

DAVID HOCKNEY
Merced River, Yosemite Valley, Sept. 1982,
1982, photographic collage, edition of 20
© David Hockney

JOHN DIVOLA

Occupied Landscape #1 (Yosemite), 1989–92
Occupied Landscape #3 (Yosemite), 1991–92
Occupied Landscape #4 (Yosemite), 1991–92
Occupied Landscape #5 (Yosemite), 1991–92
black-and-white photographs

MARK KLETT AND BYRON WOLFE
Above Lake Tenaya, Connecting Views from
Edward Weston to Eadweard Muybridge, 2002, digital print

Museum of the American West Collection, Autry National Center,
Los Angeles; purchase made possible by Jennifer and James R. Parks.
© 2002 Mark Klett and Byron Wolfe. Left: Edward Weston, *Juniper,* 1936;
© Center for Creative Photography. Right: Eadweard Muybridge,
Ancient Glacier Channel, at Lake Tenaya, Mammoth Plate No. 47, 1872;
courtesy of The Bancroft Library, University of California, Berkeley.

At the dawn of the new century, Mark Klett's photographs of Yosemite bring the last hundred years full circle. Klett became known in the 1970s for his rephotography projects in which he explored iconic sites depicted by an earlier era's expeditionary photographers; recently, he has turned his lens to Yosemite.[40] Armed with copy photographs, maps, and the latest camera and global-positioning equipment, Klett and his colleague Byron Wolfe set out to find the exact location and vantage of "first view" photographs made by earlier photographers such as Muybridge, Weed, Weston, and Adams. These masterworks provide the stepping-off point for new commentary on Yosemite's celebrated spaces. One panoramic composite of images, *Above Lake Tenaya, Connecting Views from Edward Weston to Eadweard Muybridge* (2002), for example, anchors contemporary views between Weston's famous

Tenaya Lake juniper tree at one end and a nineteenth-century Muybridge photograph at the other, providing, as Klett aptly remarks, the vertiginous sensation of "time flowing backward."[41] Klett and Wolfe's blending of old and new calls into question the presumptive trajectory from pure to sullied or utopic to embattled. In *Clearing Autumn Smoke, Controlled Burn* (2002, p. 147), Klett and Wolfe create the modern-day equivalent of Adams's *Clearing Winter Storm*. Owing its artistic legacy to Adams and its hazy atmosphere to the forestry policies of the National Park Service, the image represents a fitting tribute to two of the most powerful entities to shape perceptions about Yosemite, if not Yosemite itself.

A survey of photography in Yosemite in the twentieth century must naturally begin and end with Ansel Adams. Through the force and ubiquity of his imagery, Adams made Yosem-

ite more famous than even he could have possibly imagined. The park was Adams's home, his palette, his love, and he crafted a very particular vision of Yosemite's spaces. "It is not important to portray people or their works in landscape," he once wrote. "Man, in the contemplation of nature, need not contemplate his external self."[42] Ironically, Adams's uninhabited vision drew ever more people eager to see this wonderland, which owed more to a landscape of the mind than to external realities. Like Roger Minick's rapt tourist perhaps, many were drawn by Adams's vision, and many, if not most, made a keepsake snapshot for their troubles. While some artists have challenged Adams's narrative, others hope to follow in his footsteps. Perhaps the lesson is this: Yosemite is not—and never has been—just *one* thing through the camera lens. Its legacy and enduring meaning are every bit as complex as the countless people drawn to depict it in images both prosaic and profound.

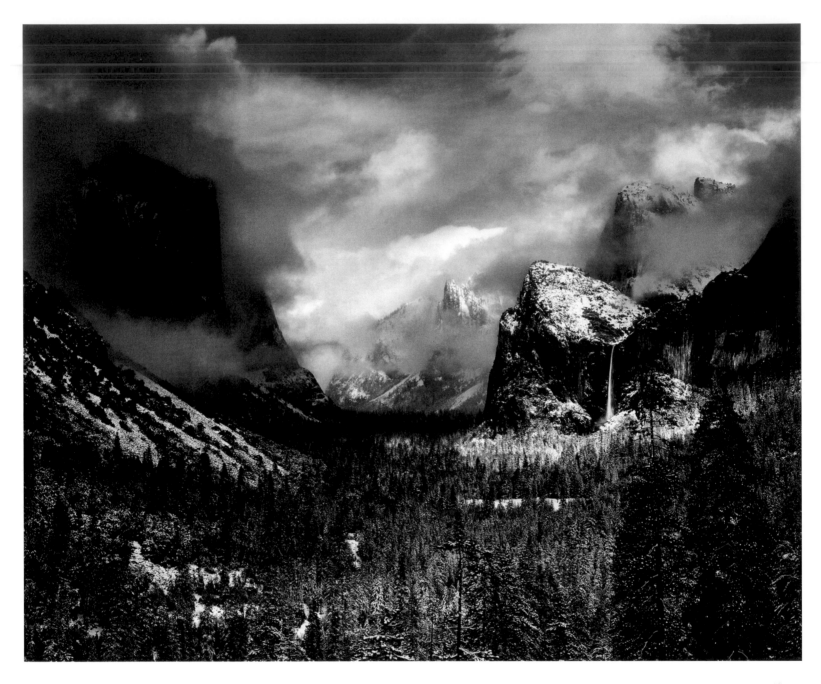

ANSEL ADAMS

Clearing Winter Storm, Yosemite National Park,
ca. 1935, printed 1980, gelatin silver print

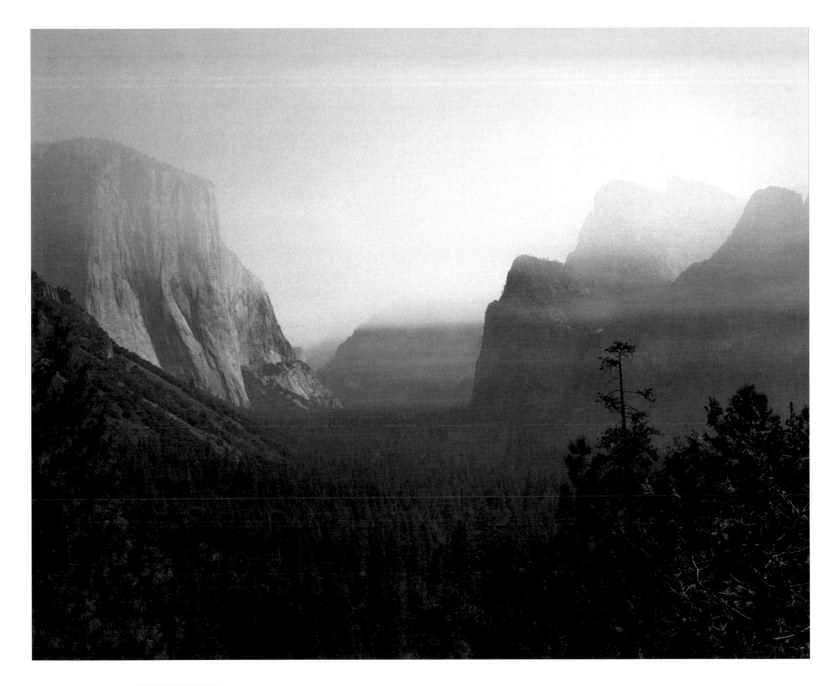

MARK KLETT AND BYRON WOLFE
Clearing Autumn Smoke, Controlled Burn,
2002, digital print

© 2002 Mark Klett and Byron Wolfe

NOTES

1. For Adams's account of making *Clearing Winter Storm, Yosemite National Park*, see Ansel Adams, with Mary Street Alinder, *Ansel Adams: An Autobiography* (Boston: Little, Brown, 1985), 241–42. Though *Clearing Winter Storm* has been variously dated because of Adams's own confusion about when he made the negative, Mary Alinder, Adams's assistant and biographer, claims the negative was slightly damaged in the photographer's 1937 darkroom fire and dates it to January 1935. See Mary Street Alinder, *Ansel Adams: A Biography* (New York: Henry Holt, 1996), 144.

2. Rebecca Solnit, *Savage Dreams: A Journey into the Landscape Wars of the American West* (Berkeley: University of California Press, 1994), 222.

3. "The California Camera Club's Trip to the Yosemite," *Camera Craft* 2, no. 2 (June 1901).

4. Adams, *Autobiography*, 69.

5. See Edward Prescott, "A Photographer Goes A-Botanizing to Yosemite," *Camera Craft* 8, no. 3 (February 1904), 110–16; and Julius Padilla, "Waterfalls of the Yosemite," *Camera Craft* 2, no. 4 (February 1901), 302–5.

6. F. J. Taylor, *The Yosemite Trip Book* (San Francisco: H. S. Crocker, 1926), 49.

7. David Robertson, *West of Eden: A History of the Art and Literature of Yosemite* (Yosemite National Park, Calif.: Yosemite Natural History Association and Wilderness Press, 1984), 112.

8. Arthur Clarence Pillsbury, "Autobiographical Sketch," http://www.acpillsburyfoundation.com/Autobiography.html.

9. Adams, *Autobiography*, 53.

10. For an excellent history of the pictorialist movement in California, see Michael Wilson and Dennis Reed, *Pictorialism in California: Photographs 1900–1940* (Malibu, Calif.: J. Paul Getty Museum; San Marino, Calif.: Henry E. Huntington Library and Art Gallery, 1994).

11. *Alvin Langdon Coburn, Photographer: An Autobiography*, ed. Helmut and Alison Gernsheim (New York: Frederick A. Praeger, 1966), 80.

12. For more on the artist and her work, see Susan Ehrens, *A Poetic Vision: The Photographs of Anne Brigman* (Santa Barbara, Calif.: Santa Barbara Museum of Art, 1995). Susan Ehrens kindly helped identify Yosemite as the location for certain of Brigman's photographs.

13. Quoted in Therese Thau Heyman, *Anne Brigman: Pictorial Photographer, Pagan, Member of the Photo-Secession* (Oakland: Oakland Museum of California, 1974), 3.

14. Anne Brigman, quoted in Frances K. Pohl, *Framing America: A Social History of American Art* (London: Thames and Hudson, 2002), 336.

15. Anne Brigman, "Just a Word," *Camera Craft* 15, no. 3 (March 1908), 87.

16. Quoted in Ehrens, *Poetic Vision*, 27. The premier arbiter of fine art photography in the United States at that time, Stieglitz bestowed the ultimate honor on Brigman in 1906 by naming her a fellow of the Photo-Secession group, the only artist west of the Mississippi to be so anointed.

17. Adams described the impact of his first trip to Yosemite at the age of fourteen as follows: "The first impression of the valley . . . was a culmination of an experience so intense as to be almost painful. From that day in 1916 my life has been colored and modulated by the great earth-gesture of the Sierra" (Ansel Adams, *Yosemite and the Sierra Nevada* [Boston: Houghton Mifflin, 1948], xiv).

18. Books and articles on Adams's life and work are legion. Aside from his autobiography, which proved critical to the writing of this essay, and Mary Street Alinder's biography (for both, see n. 1), some other sources consulted include Mary Street Alinder and Andrea Gray Stillman, eds., *Ansel Adams: Letters, 1916–1984* (Boston: Little, Brown, 1988); Anne Hammond, *Ansel Adams: Divine Performance* (New Haven, Conn.: Yale University Press, 2002); Jonathan Spaulding, *Ansel Adams and the American Landscape: A Biography* (Berkeley: University of California Press, 1995); and John Szarkowski, *Ansel Adams at 100* (New York: Abbeville Press, 2000).

19. For an excellent analysis of the environmental aspects of Adams's career, see Spaulding, *Adams and the American Landscape*.

20. Adams, *Autobiography*, 71.

21. John Szarkowski does a superlative job of summarizing the maturation of Adams's artistic vision. See Szarkowski, *Adams at 100*, 15–23.

22. Quoted in ibid., 76.

23. Adams's approach was equally defined by the Zone System, a method he pioneered, which precisely calculated the tonal range from black to white.

24. Adams, *Autobiography*, 109.

25. Ansel Adams to Edward Weston, November 29, 1934, Center for Creative Photography, Tucson, Arizona, AG38: Edward Weston 1/1 Adams.

26. Quoted in Judy Dater, *Imogen Cunningham: A Portrait* (Boston: New York Graphic Society, 1979), 47.

27. The Friends of Photography, an organization founded by Adams and others in 1967, ran the Yosemite workshops from 1981 until 2001, when the organization folded. Workshops are still held in Yosemite, under the auspices of the Ansel Adams Gallery and the Yosemite Association.

28. Nancy Newhall to David Brower, n.d., Beaumont and Nancy Newhall Collection, Center for Creative Photography, Tucson, Arizona, AG48: Correspondence, General 1960–1962.

29. "Lecture: Metropolitan Museum of Art, 1975," Center for Creative Photography, Tucson, Arizona, AG1:2:14:1.

30. Robertson, *West of Eden*, 144.

31. Ansel Adams to Alvin Langdon Coburn, May 18, 1964, Center for Creative Photography, Tucson, Arizona AG31:1:1:9.

32. Robertson, *West of Eden*, 145.

33. The school derives its name from a 1975 exhibition at the George Eastman House in Rochester, New York. Curated by William Jenkins, *New Topographics: Photographs of a Man-Altered Landscape* featured work by Robert Adams, Joe Deal, Stephen Shore, and Henry Wessel Jr., among others.

34. "Galen Rowell's Artist's Statement," http://mountainlight.com/rowell/gr_artistmaincnt.shtml.

35. Ibid.

36. Rowell, who received the Ansel Adams Award for his contributions to wilderness photography in 1984, was tragically killed in a plane crash in 2002.

37. Former artists-in-residence include John Divola, Richard Misrach, David Mussina, Ted Orland, and Michael A. Smith. See Dave Forgang, Foreword, in *Uelsmann/Yosemite: Photographs by Jerry N. Uelsmann* (Gainesville: University Press of Florida, 1996), unpaginated.

38. Quoted in Gretchen Garner, *Disappearing Witness: Change in Twentieth-Century American Photography* (Baltimore: Johns Hopkins University Press, 2003), 114.

39. Wanda Hammerbeck, conversation with the author, November 2003.

40. Mark Klett et al., *Yosemite in Time: Ice Ages, Tree Clocks, Ghost Rivers* (San Antonio, Tex.: Trinity University Press, 2005).

41. Quoted in Robert Gorman, "Yosemite and the Invention of Wilderness," *New York Times*, September 2, 2003.

42. Adams, *Yosemite and the Sierra Nevada*, xvi.

AMY SCOTT

REVISITING YOSEMITE

BY THE EARLY DECADES OF THE TWENTIETH CENTURY, Yosemite was no longer the wild and remote place that romantic-era painters had portrayed. While much of the park's allure was still based on its reputation as an ideal of wilderness and a geological marvel, it was also an accessible and bustling vacation spot. The Yosemite Valley Railroad, completed in 1907, shuttled visitors directly into the valley from Merced, but it was quickly replaced in the 1920s by long lines of cars as auto tourism gripped the park with unprecedented fervor. Soon, hotels, lodges, parking lots, and a range of facilities filled Yosemite from the valley to Glacier Point, ensuring a multifaceted vacation experience that included diversions such as golf and skiing in the 1930s and auto races by 1940. As the park's role in the public mind shifted from a cathedral of nature to a "playground for the people," Yosemite presented artists with greater physical and conceptual diversity and with a different set of aesthetic issues. For painters, the question of how to address Yosemite's relevance without relying on romantic clichés must have been especially vexing in the first decades of the twentieth century—Yosemite had been overwhelmingly popular with landscape painters of the Victorian era, to the extent that many considered it "overdone" as early as the 1870s. As the Yosemite experience increasingly combined elements of the emotional with the everyday, the question of how to represent a familiar landscape in a fresh light—how to depict a tourist destination in an artistically important and aesthetically interesting way—became one of the foremost challenges facing painters in Yosemite after 1890.

Though few studies have examined the topic beyond the heyday of Albert Bierstadt and Thomas Hill, painting did not end in Yosemite with the nineteenth century. More than a

WAYNE THIEBAUD
Yosemite Rock Ridge (detail; see p. 175)
© Wayne Thiebaud/Licensed by VAGA, New York

151

century after Bierstadt made Yosemite a national landscape and artistic icon, Wayne Thiebaud created *Yosemite Valley Ridge* for the nation's centennial. An enormous, flat image composed of hard edges and bright colors, Thiebaud's canvas depicts not a specific monument, but the soaring verticality that is the scenic gist of Yosemite, where El Capitan, Cathedral Rocks, and Half Dome loom large. Like the landscape it represents, *Yosemite Valley Ridge* can be interpreted in various ways. To some, the commercially inspired colors and clean shapes suggest a landscape on the edge, a comment on the overcrowding and development that characterize the valley floor. To others, the work is a satire, an ironic account of Yosemite, the experience of which is reduced here to a single, featureless monolith. According to Thiebaud, who found Yosemite "displacing" and "surreal," the painting is intended to communicate the psychological edginess he felt upon entering the valley, the sense of disorder that comes from being suddenly confronted with nature on such a scale.

Whereas romantic painting generally reflected a national agenda of westward expansion as well as emerging concerns with scenic preservation, Yosemite's more recent art history is less straightforward. As outside demands on Yosemite—from tourists, developers, promoters, and even the National Park Service—have multiplied exponentially over the past century, artists have had to become increasingly selective in what they choose to paint. As with most national parks, in Yosemite there exists a dichotomy between notions of sublime wilderness and the reality of mounting pressures from a growing contingent of visitors and administrators. This ever-present and widening fissure between expectations of a breathtaking visual experience and the more mundane aspects of a visit is amplified in the valley, Yosemite's long-standing artistic centerpiece and visitor

WAYNE THIEBAUD
Yosemite Valley Ridge, 1975, oil on canvas
© Wayne Thiebaud/Licensed by VAGA, New York, NY

hub, where both scenery and crowds are at their most intense. Here, on any given day, thousands of people can be found circling the roads in their cars, hiking the trails, lounging in the hotels, eating in the restaurants, shopping in the stores, swimming in the Merced, cooking at the campsites, and waiting for the shuttle buses. It is difficult to pretend that Yosemite is exotic while purchasing key chains in the gift shop; it is hard to imagine it as remote while sitting in traffic on the valley floor.

Alongside the widening gap between Yosemite as the ideal of the sublime and the modern reality of increasing visitation, other external changes have shaped Yosemite painting since the days of Bierstadt. The advent of portable cameras has meant that many (if not most) visitors have taken the production of Yosemite imagery into their own hands, virtually eliminating the need for the art-as-souvenir that sustained many nineteenth-century landscape artists. The rise of abstraction in the early twentieth century created a critical atmosphere that was increasingly hostile toward realism; by the 1930s, subjects that smacked of nostalgia or overt sentimentality were seen as particularly passé. Meanwhile, more modern themes—from beach culture to the social conditions of Depression-era California—emerged to capture the attention of those painters still interested in the representational. Yosemite painters of the twentieth century have also had to respond to a broadening range of expectations and tastes for wilderness imagery among art critics, park visitors, and the public generally. Some see Yosemite as a resort, a pleasure ground where amenities do not detract from, but rather add to, the scene. Others see an environment that has been despoiled, a place choked with crowds where any chance of a sublime experience is disrupted by the roar of tour buses. Weaned on decades of gorgeous photographs by Ansel Adams, many others still expect from Yosemite a visually inspiring, emotionally uplifting experience.

Despite—and sometimes because of—the glaring dichotomies between nature and culture, image and reality, Yosemite remained an artistically alluring spot for painters throughout the twentieth century. Whereas most romantic-era painters went to the valley with the relatively singular purpose of adding the park's highly recognizable scenery to their oeuvre, those who followed in their footsteps often, but not always, pursued a more varied agenda representative of their diverse audience and patrons. Some, like the watercolorist Gunnar Widforss, were employed by Yosemite's concessionaires; others, including the San Francisco painter Maynard Dixon and the Los Angeles artist Phil Paradise, were working for California boosters. Charles Sheeler and Georgia O'Keeffe were introduced to Yosemite by their mutual friend Ansel Adams. Since the 1980s, an even more diverse contingent of contemporary painters has been brought into the park through the Yosemite Museum's artist-in-residence program, many of whom have returned to Yosemite multiple times, and on their own terms.

Although Yosemite began its transition from remote locale to mass destination long before national park status was bestowed in 1890, its redefinition in visual terms was slower in coming. The most recognizable Yosemite artists of the first decades of the twentieth century actually belonged to the nineteenth: Thomas Hill retained a studio outside the Wawona Hotel until illness overtook him in 1905, Christian Jörgensen was a presence in the valley until 1917, and Charles Dorman Robinson was an active member of Yosemite's creative community well into the 1920s. The most visible of the lingering romantics to paint Yosemite, however, was probably Thomas Moran. He visited Yosemite for the first time in 1872 and produced mainly watercolors during that trip. His first major oil paintings of Yosemite were the result of a return visit, more than three decades later, in 1904. Part of a larger Western tour designed to secure his legacy as the foremost painter of the American West, Moran's trip yielded major canvases of Yellowstone and Arizona's Grand Canyon and Petrified Forest. That Moran included Yosemite on what was otherwise a return to the sites for which he had become known suggests the degree to which it had suffused America's romantic vision of nature and the West. Exhibited alongside its Yellowstone and

Arizona counterparts at the Century Club in New York that December, Moran's *Domes of the Yosemite* (p. 155) rounded out the artist's last comprehensive statement on the vast Western scenery on which his long career had been based. And while Moran's long-standing relationship with the Western landscape began in Yellowstone, it would end in California. Moran spent the winter of 1912 painting in Monterey, which provided a vantage point for a number of late Yosemite works. Always an avid traveler, Moran shuttled between California, New York, and the Grand Canyon with his daughter Ruth during his final years, with Santa Barbara serving as his main residence after 1918.

By the turn of the century, the political and religious agendas of Western expansion—themes inherent in Moran's earlier work—were no longer relevant, and images of Western wilderness had gained new meaning. Though the late work of painters such as Hill, Jörgensen, and Moran was increasingly out of touch with artistic developments from New York to San Francisco, it was nonetheless sustained by an audience reluctant to let go of Yosemite as a sublime, romantic experience. Increased awareness of diminishing natural resources had actually intensified the public's desire to experience lingering patches of "authentic" Western lands. The census of 1890 had called attention to the nation's dwindling timber supply and resulted in the Forest Reserve Act of 1891; concern for the mountains of Northern California in particular prompted the formation of the Sierra Club in 1892.[1] Painted at a time when visitors were still ferried to the Wawona Hotel by stagecoach, Moran's later Yosemite oils thus convey the lingering ruggedness of a turn-of-the-century visit, and echo the public's nostalgia for places that exemplified the wilderness ideal.

Amid growing concern over the vulnerability of wilderness was another event that helped set the stage for a shift in California's artistic scene: in 1906, a devastating earthquake shook San Francisco, shattering not only the lives of its citizens, but also romantic notions of nature as a grand, benign force. As San Francisco's art community struggled in the wake of

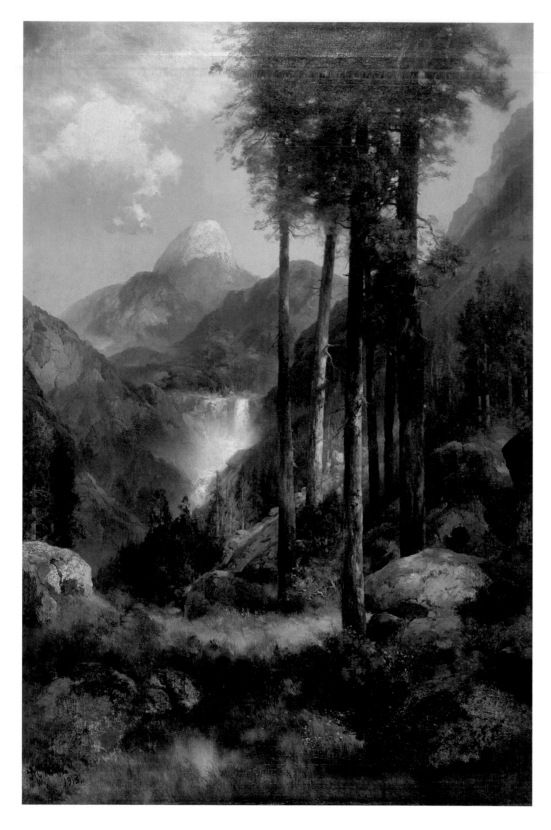

THOMAS MORAN
Vernal and Nevada Falls, Yosemite Valley, 1913, oil on canvas
Private collection; courtesy Montgomery Gallery, San Francisco

the catastrophe, many painters still interested in a gorgeous, beneficent view of nature shifted their attention to the south, where they joined forces with real-estate boosters and commercial developers to make Southern California some of the most-hyped real estate in the country.[2] Images of an unpopulated coastline, colorful gardens, and a romantic, Spanish fantasy past helped give rise to Southern California's less threatening version of nature. In terms of public taste when it came to landscape, the cultivated and the new replaced the wild and the ancient.

Although visitation to Yosemite continued to grow alongside an emphasis on healthful outdoor recreation in California, official readiness to sacrifice wilderness to the needs of urban development would come to be symbolized by a more notorious event. In 1903, San Francisco's mayor, James Phelan, applied to the Department of the Interior for water rights to the Tuolumne River in Yosemite's Hetch Hetchy Valley. Phelan was turned down at least twice, but when the city's water supply proved insufficient to douse the ravaging fires that followed the 1906 earthquake, the proposal gained momentum, and in 1908 the permit was approved. Suspended by the Taft administration the following year, Phelan's petition lingered until President Woodrow Wilson took office and passed the Raker Act of 1913, which granted permission to flood Hetch Hetchy and paved the way for the O'Shaughnessy Dam, completed in 1923.

The debate over Hetch Hetchy was prolonged and, at times, intense. For more than seven years, Yosemite's leading aesthetic proponents were pitted against a newer group of "utilitarian" conservationists, led by Gifford Pinchot, whose goal was to "put [land] to that use in which it will best serve the most people" and who felt that the construction of a dam would enormously increase use of the park by the general public.[3] The plan's most vociferous opponent was John Muir, who enlisted the help of two longtime friends, the painter William Keith and *Century Magazine* editor Robert Underwood Johnson. Keith created approximately forty oil sketches to illustrate an article by Muir, published by Johnson in 1908, in which the naturalist famously argued that damming Hetch Hetchy amounted to the destruction

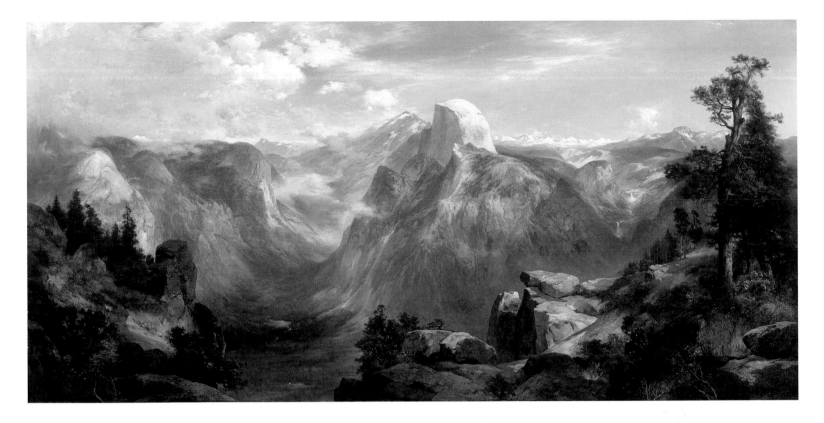

of civilization's most hallowed spaces. Muir's viewpoint was backed by the Sierra Club, which argued that the elevation of Yosemite's commercial use over its scenic value signaled a troublesome national deficit: "If this country were in danger of habitually ignoring utilitarian practice for the sake of running after sentimental dreams and aesthetic visions, we should advise it to cut down the California big trees to shelter its citizens. . . . But the danger is all the other way. The National habit is to waste the beauty of nature and save the dollars of business."[4]

Keith's Hetch Hetchy sketches have a poetic, intimate quality that reflects Muir's advocacy of a close, personal relationship between the individual visitor and Yosemite. Soft and sober, they represent a departure from Keith's grander style of the late 1870s as well as the darker version of tonalism that he practiced at the turn of the century. With their lighter colors and loose brushwork, Keith's paintings, together with Muir's words, portrayed Hetch Hetchy as a private, firsthand experience, an aesthetic counterpoint to its more grandiose neighbor, and an important component of Yosemite. The loss of Hetch Hetchy to the needs of a growing

THOMAS MORAN
Domes of the Yosemite, 1904, oil on canvas
Location unknown; photograph courtesy
J. N. Bartfield Galleries, New York

WILLIAM KEITH
Hetch Hetchy Valley, 1907–10, oil on canvas
Collection of Hearst Art Gallery,
Saint Mary's College of California, Moraga

metropolis signaled for many the decreasing relevance of scenic preservation on its own terms and was made all the more poignant by Muir's death in 1914. In the decades following the Hetch Hetchy "steal," as it came to be called, artists aided in creating a new, more popular image for Yosemite as patronage shifted from privileged Victorian-era collectors to an ever-increasing swath of the public.

At the same time that Hetch Hetchy's fate as a reservoir was sealed, automobiles reappeared in Yosemite for the first time in six years. By 1916, the newly formed National Park Service was working with Yosemite boosters such as David Curry (cofounder of the popular Camp Curry) and the Auto Club to entice motorists to the park with improved roads, reduced restrictions, and even private garages at some camps.[5] To accommodate the growing waves of motor enthusiasts, new accommodations—including the Tuolumne Meadows Lodge and the Glacier Point Hotel—were opened, and a variety of year-round entertainments were made available, including skiing and a winter carnival that featured a full-size ice rink. Peak-season visitors could enjoy Camp Curry's "firefall"—a bonfire pushed off Glacier Point that lured huge crowds and aggravated the competition. A golf course, nightly bear feedings, and an annual competition known as

MAURICE BRAUN
Yosemite Evening from Glacier Point,
1918, oil on canvas
Courtesy of The Irvine Museum, Irvine, California

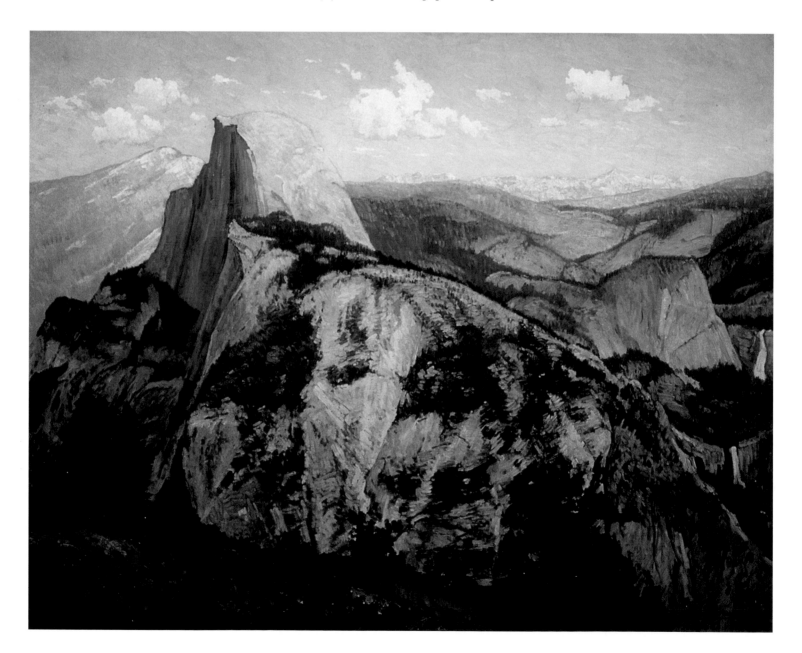

Indian Field Days were among the amusements in full swing by 1920. Boosters were quick to capitalize on the new blend of technology, nature, and commercial allure in a wave of Yosemite-themed images on a range of products, from railroad posters to fruit-crate labels. However, the generation of artists who followed Moran into the park were more concerned with Yosemite as an expression of mainstream California artistic style. Yosemite's painters since the Hetch Hetchy controversy, though less unified in style and purpose, have shared a willingness to leave behind the visual clichés of romanticism in articulating the park's changing image. Often tackling specifically modern issues head-on, from accessibility and relevance to urban-style problems, painters ever since have been working to define, and redefine, Yosemite as a landscape of ongoing cultural value and aesthetic worth.

Keith and Muir's campaign to protect Hetch Hetchy may have failed in part because, by 1913, Californians were simply less interested in unspoiled nature as a transcendent spectacle to behold. Instead of seeking the sublime, landscape painters were exploring more accessible and colorful scenes, such as those found in Monterey, Pasadena, Laguna, and San Diego—natural settings both more stylish and more civilized than Yosemite—as they celebrated the Golden State as a quasi-mythic arcadia of natural abundance in an ideal climate. The 1915 Panama-Pacific International Exposition in San Francisco bolstered popular ideas about California's natural and economic fertility with exhibitions of everything from agriculture and technology to California painting. While top honors in the latter went to the more stylistically advanced East Coast artists such as Theodore Robinson and John Henry Twachtman, the San Diego painter Maurice Braun was among the California painters to attract critical notice. Braun was at the height of his career, having cofounded the San Diego Art Guild that year and the San Diego Academy of Art just three years previously. In 1918, he made his first and only trip to Yosemite.[6]

According to the Auto Club's magazine, *Touring Topics,* which used one of Braun's Yosem-

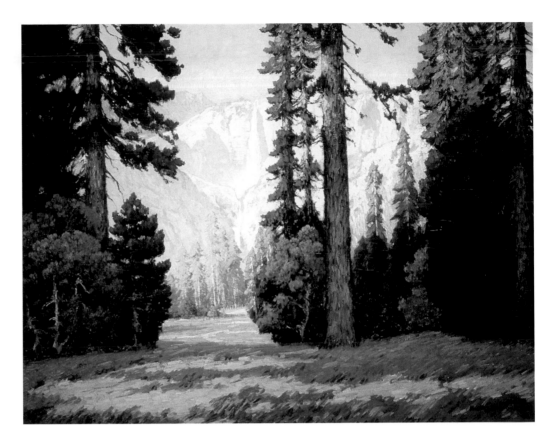

MAURICE BRAUN
Yosemite Falls from the Valley, 1918, oil on canvas
Courtesy of The Irvine Museum, Irvine, California

ite paintings on a 1928 cover, the artist had strayed into Yosemite in order to "conquer with paint and canvas the majesty of that chief jewel in the California scenic crown."[7] An apparent lack of horsemanship ("suffice it to record that the subsequent studies of Half Dome . . . were painted standing up"[8]) did not deter Braun from creating at least two significant works that convey the depth and range of Yosemite's aesthetic appeal as a destination equal in style to any coastal resort. In *Yosemite Evening from Glacier Point,* Braun selected a classic vista, then coated the picture in the purple tones of an evening glow, reflecting a specifically impressionist concern with changing light and time of day. Braun's *Yosemite Falls from the Valley* is a more modern painting, which conveys the park's reputation for impressive vistas alongside more intimate scenery by playing on the patterns of light and shadow. And in a place where the view is so often dominated by gray granite walls, Braun's paintings were among the first to explore the potential of rich color in Yosemite, from the grassy valley floor to Half Dome bathed in the light of a setting sun.

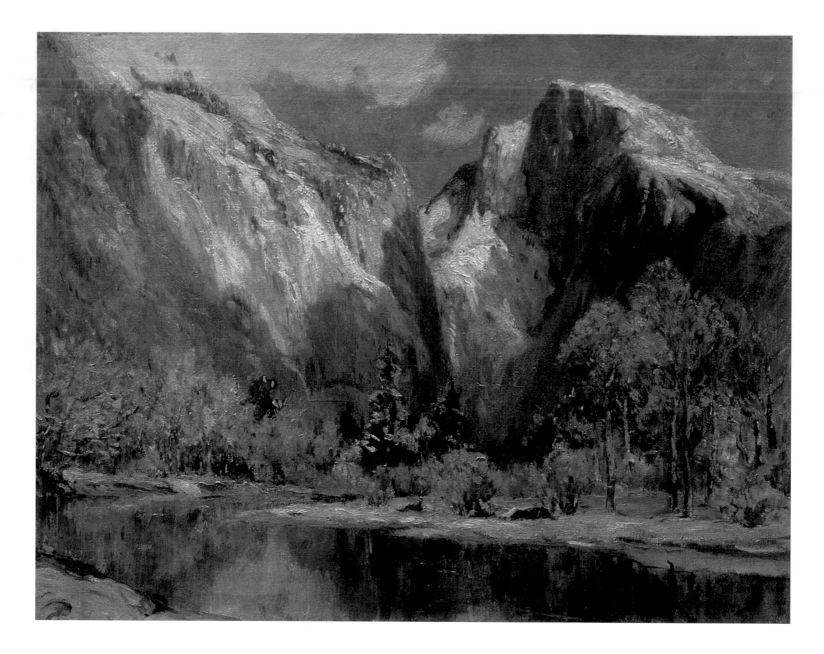

COLIN CAMPBELL COOPER
Yosemite in Winter, 1916, oil on canvas
Collection of Paul and Kathleen Bagley

Yosemite's ever-changing light effects also drew the attention of Colin Campbell Cooper, a Philadelphia-born artist and National Academician who settled in Santa Barbara, making one excursion to Yosemite in 1916. For Cooper, Yosemite was well suited to his interests in both architectural structure and garden subjects, providing a template for dualistic experiments in light and shadow, rigid construction, and loose brushwork, as in his one known work of the park, *Yosemite in Winter*. The San Francisco painter Theodore Wores was likewise intrigued by Yosemite's tendency to change with the time of day. He created a series of mostly 16-by-20-inch paintings during his visit to the park in the 1930s.

Works such as those by Braun, Cooper, and Wores, which were in step with California's current stylistic vogue, would have allowed viewers to take pride in their own good taste while rendering the park primarily as an object of uplifting aesthetic study. Created as Yosemite completed its transition from a remote scenic preserve to a comfortable tourist destination, their paintings represent an updated version of the romantic sublime, a vision that was still gorgeous but also more consistent with contemporary expectations of nature in California. Although impressionist paintings were often void of direct references to modernity, Braun's paintings in particular helped market the park as a cultivated, accessible

destination. To an audience now accustomed to seeing Yosemite more often in advertisements and posters than in art, the more assiduously groomed version of the park that Braun presented enhanced its destination appeal to an ever-widening audience of motorists who were "only beginning to appreciate [the] scenic wonders of Yosemite."[9]

In 1916, the year of Cooper's visit, the National Park Service was formed and the shift in Yosemite's purpose became official. Horace McFarland, once Muir's ally in the struggle over Hetch Hetchy and now a park system advocate, argued that Yosemite existed for "service and efficiency, and not an idea of pleasure

and ornamentation."[10] National parks were no longer isolated spots of inspiring scenery; at least in theory, they were now also healthful places of recreational value. The enthusiasm for Yosemite in particular soon created new problems, however. *Overland Monthly* noted in 1920:

It has only been during the past five years that the automobile has invaded the Yosemite, but not until the season of 1917 did people begin to have any idea of the ease with which a week-end trip could be made into the famous playground. Since then, the number of visitors has increased steadily, until now the housing of the vast number of enthusiasts has become a great problem.[11]

THEODORE WORES

Yosemite Valley and the Merced River, California, ca. 1930s, oil on board

Private collection; photograph courtesy Spanierman Gallery, LLC, New York

Although four hotels were in operation between the valley floor and Glacier Point by 1925, none were terribly well suited to winter stays. National Park Service director Stephen Mather was also in need of a place to lodge VIPs without embarrassment.[12] (Lady Astor had reportedly disdained the Sentinel Hotel as "primitive."[13]) The increasingly complex relationship between artificial and natural splendor in Yosemite culminated in the Ahwahnee Hotel, which opened its massive doors to a luxury-seeking audience in 1927. A masterwork of "parkitecture"—architecture that is rustic in feel and corresponds to its grand natural surroundings—the Ahwahnee was built by Yosemite's main concessionaire, Yosemite Park and Curry Company, and designed by the Los Angeles architect Gilbert Stanley Underwood. Underwood's original plans for a mas-

sive six-story structure had been scaled back to a more modest ninety-nine guest rooms and accompanying facilities. Featuring exposed granite, waxed pine, and polished cement floors, the establishment was described in a promotional brochure as a "resort hotel . . . distinctive in its treatment, delightful in atmosphere and thoroughly modern."[14]

The hotel's interior design had been settled on while construction was still under way. In October 1926, the husband-and-wife team of Phyllis Ackerman and Arthur Pope, both art historians, was commissioned to create an interior design, replacing an earlier scheme by the Los Angeles designer Henry Lovins that drew heavily on the Hispano-Moresque and Mayan revival styles then popular in Southern California. While Lovins's emphasis on an allover, stylized pattern adapted from indi-

HENRY LOVINS
Interior design for the Ahwahnee Hotel,
ca. 1925, watercolor on paper
Courtesy of the Hollywood Art Center Archive, Los Angeles

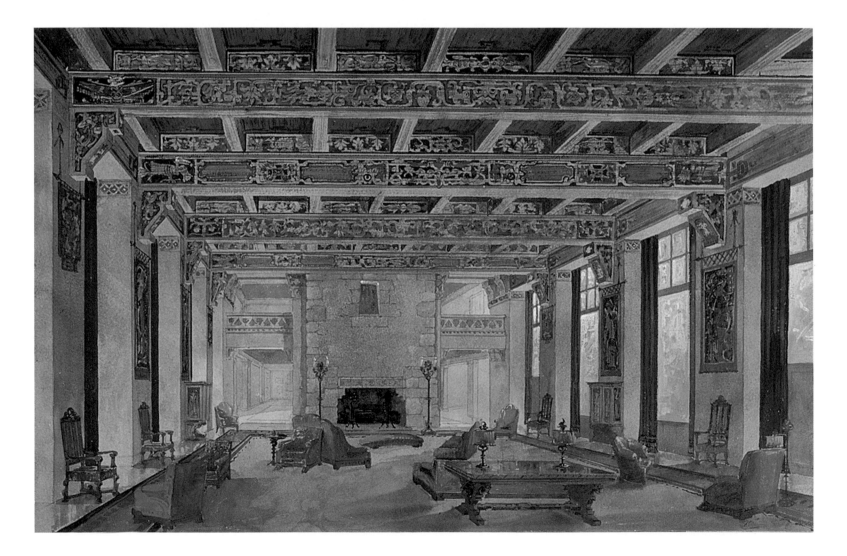

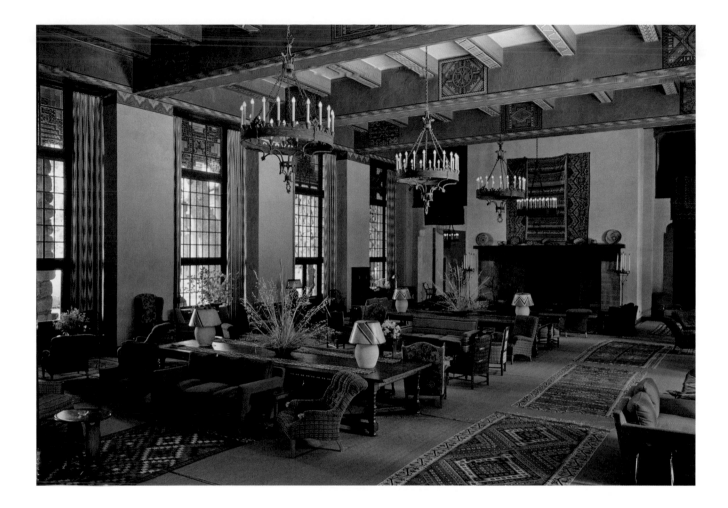

genous motifs remained the cornerstone of the final plan, his Mayan theme was set aside in favor of Ackerman and Pope's localized plan derived mainly from Hupa, Yuruk, and Pomo baskets. Stylized geometric floor mosaics in the lobby, a basket mural above the main fireplace, and ten stained-glass windows designed by Jeannette Dyer Spencer in the main room feature patterns that are "purely Indian," though developed with "modernistic freedom."[15] Interwoven with these Native elements were English textiles and furniture, Persian wall hangings, Navajo blankets, handwoven bedspreads from Kentucky,[16] and decorative elements ranging from Mexican terra-cotta table lamps to French gothic candlesticks. Adjacent to the main room, a huge dining hall with a thirty-four-foot ceiling, sugar-pine trestles, and rough stone columns culminates in a stained-glass window. Two common rooms, one designed in a fourteenth-century European hunting (or wildlife) theme and the other after the California Gold Rush

era, deviated from the Native motif, though they were certainly no less exotic. Intended to emphasize the Native presence in Yosemite as an exceptional part of the experience, the hotel's design was undoubtedly influenced by Yosemite Park and Curry Company president Donald Tressider, who changed the name from Yosemite All-Year-Round Hotel to Ahwahnee—after the valley's original residents, the Ahwahneechee—just prior to its opening.

This emphasis on a Native presence as part of the visual experience of Yosemite was supported by the annual event known as Indian Field Days, in which Tressider played an organizing role. With the establishment of the National Park Service in 1916, Indian Field Days was created to draw visitors to Yosemite through the late summer, when the waterfalls were diminished or altogether dry. Although promoters claimed that Indian Field Days was designed to "revive and maintain interest of

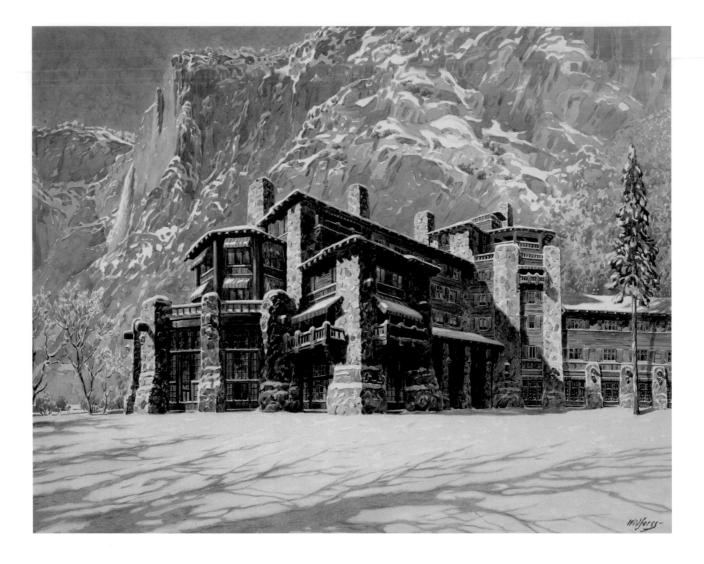

GUNNAR WIDFORSS

Ahwahnee Winter, n.d., watercolor

From The Ahwahnee Hotel Collection, courtesy of the Delaware North Companies, DNC P&R at Yosemite, Inc. Photography by Robert Woolard

Indians in their own games and industries, particularly basket and beadwork,"[17] it actually had little to do with traditional Native culture.[18] Local Miwok and Paiute people dressed in buckskin, fringe, feathers, and beadwork participated in parades, demonstrations, and contests. Some of these costumes were imported from Plains reservations, but much was created in the park, featuring hybrid designs based in large part on Native perceptions of tourists' expectations. Encouraged by cash awards, Native people thus modified their appearance to reflect white stereotypes of how Indians looked and behaved, furthering Yosemite's transformation into a place that had become part natural setting and part resort.[19]

Though altered to reflect prominent stereotypes, Native aesthetics and activities were an important part of the Yosemite experience

throughout the late 1920s, the heyday of Indian Field Days and the building of the Ahwahnee. Native people themselves were of less interest to white artists than they had been in the romantic era, however. Prior to 1890, painters and photographers had frequently depicted Indians within the landscape; Bierstadt, Hill, Keith, Constance Gordon-Cumming, Herman Herzog, and many others had explored Yosemite's Native population primarily in decorative terms, painting encampment scenes or small groups on horseback mostly as a way of adding scale and exotic flair to their romantic vistas. Toward the turn of the century, Jörgensen and Robinson had also depicted traditional aspects of Native life, including acorn granaries and thatched homes. With the advent of Indian Field Days, the relationship between Indians and visitors shifted: Native people were seen less in decorative terms and more as entertainers and artists. In be-

tween the rodeos, parades, and war dances, weavers such as Lucy Telles and Carrie Bethel were encouraged by collectors and cash prizes to create increasingly large baskets with elaborate and often individualized designs. Telles, Bethel, and others—such as Chris Brown, who performed dances of his own invention, wearing elaborate beadwork and featherwork of his own design—were celebrated for their creations, which became sought-after collectors' items. As patronage rose, major collections of significant works were amassed, which further encouraged visitors to view Native peoples relative to their participation in Yosemite-specific artistic activities that capitalized on their creative talents. Staying at the Ahwahnee, purchasing a basket, watching a rodeo, visiting with Telles: these all contributed to the notion of Yosemite as an authentically "Western" environment. This, in turn, helped ensure that the Yosemite experience remained an exceptional one within the burgeoning national park system.

The visual experience that Tressider and the National Park Service promoted jointly throughout the 1920s emphasized Yosemite as an occupied place with a human history. This combination of amazing scenery and human presence would be of increasing interest to many painters as the century progressed and scenic enjoyment became more of a group activity. Among the first artists to take an interest in Yosemite's natural splendor as well as the development within its midst was the Swedish-born watercolorist Gunnar Widforss, hired in 1927 by Tressider to create a series of views of the new Ahwahnee. Widforss was already an established painter of national parks by the time he arrived in Yosemite, having been encouraged early in his career by Stephen Mather; according to William Henry Holmes, he was "possibly the greatest watercolorist in America" at the time.[20] With a precise and exacting technique that blended the monumental character of his subjects with an intimate feel for detail, Widforss was a natural fit with Yosemite. His views of the Ahwahnee, covered in snow and set against Yosemite Falls, suggest the seamless blend of gorgeous nature and material luxury that Tressider hoped his prized hotel would exude.

With interest in both Yosemite's natural features and the facilities within their midst, Widforss's work depicts an ideal environment in which development and nature not only co-existed, but actually complemented each other. However, this sanitized image of the park belied a growing pressure on Yosemite's environment from outside forces and events. Within a little more than a year after Yosemite was made accessible to cars, visitation to the park doubled, prompting the Auto Club to support construction of the year-round Yosemite-Merced highway. In 1920, when construction began, seventy percent of Yosemite's 58,000 annual visitors came in private cars. The development of Yosemite as a destination for motorists was enthusiastically supported by travel magazines such as *Overland Monthly*, which cheerfully extolled the "plain evidence that man . . . has made a permanent invasion of this paradise of America." *Sunset Magazine* praised the views along the road to Glacier Point. In 1932, the *Standard Oil Bulletin* featured a view by Maynard Dixon, in which Half Dome is seen through a giant hole blasted in the mountainside.[21] Gazing at the

GUNNAR WIDFORSS
Yosemite Lodge Pool, 1922, watercolor
Private collection; photo courtesy William A. Karges Fine Art, Los Angeles and Carmel, California

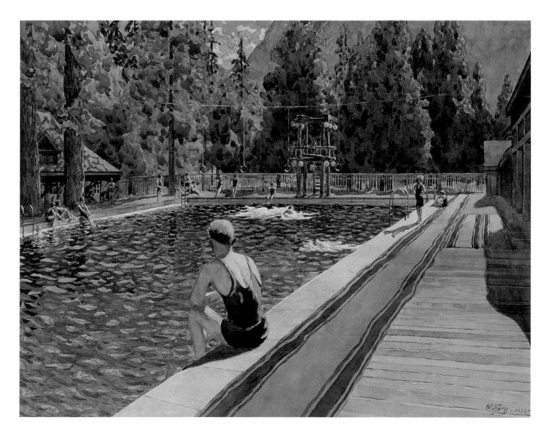

scenery through the oculus-like opening he has created, Dixon's worker embodies the irony inherent in the National Park Service's mission to "promote and preserve": one mountainside has been demolished to provide access to another.

The arrival of auto tourism quickly fostered a new form of nature appreciation, in which visitors enjoyed wilderness at higher speeds. As cars became part of the scenic landscape in Yosemite and other national parks, *Touring Topics* promoted this fusion by commissioning artists to create stylish cover images that reflected a seamless and untroubled blend of technology and tourism.[22] As early as 1915, the magazine happily proclaimed that "the road to Yosemite is already dotted with the cars of Southern California tourists and during the succeeding summer months a veritable procession of motorists will cover the route."[23] Combining images by well-known artists with a cool, clean aesthetic intended to reflect the reader's good taste, the Auto Club's magazine was a significant force in shaping a carefree—and, by the 1930s, a more distinctly urban—identity for Yosemite. With the onset of the Great Depression, *Touring Topics* changed its name to *Westways* and began commissioning scene painters such as Phil Paradise to create images for its covers. Paradise's 1946 cover image, *Riding among Redwoods* (p. 166), shows tourists zipping about the big trees in a manner that indicates more interest in their entertainment value than their scenic beauty. Infusing Yosemite's scenery with a sense of dynamism, novelty, and urbanity, *Riding among Redwoods* evokes the upscale experience that *Westways* marketed to its motoring audience, in which a psychological distance is maintained between landscape and visitor.[24] Juxtaposing a car full of tourists with a second group on horseback, the painting further suggests Yosemite's blend of urban comforts and rustic appeal, while emphasizing the inherent superiority of a sleek, fast ride.

Just as most calls for reduced development in Yosemite would come from outside the park service bureaucracy, it would take artists lured to the park by means other than the Auto Club to change Yosemite painting through

mid-century. The first of these was perhaps William Zorach, who spent five months painting and camping in Yosemite in 1920, joined by his wife, Marguerite, for part of the time. The Zorachs, both devoted modernists, were possibly the first artists to link Yosemite's awe-inspiring scenery with the intense inner passion from which abstraction was born. William would recall: "The

MAYNARD DIXON
Cover for *Standard Oil Bulletin* (August 1932)
Reproduced with permission of Chevron Corporation

STANDARD OIL
BULLETIN

PUBLISHED BY THE STANDARD OIL COMPANY OF CALIFORNIA
AUGUST 1932

PHIL PARADISE
Riding among Redwoods, 1946, gouache on board
Automobile Club of Southern California Archives

loneliness and vastness were overpowering. This was the Garden of Eden, God's paradise. I sketched and painted in ecstasy."[25] As is suggested in *Fantasy of a Night in Yosemite with All the Wild Creatures Keeping Me Awake,* a sketch of Marguerite reclining in a sleeping bag, William's view of Yosemite as Eden was a fanciful one that played on the mysterious side of nature. His attraction to Yosemite's effervescent waterfalls in particular is evidenced by a seven-foot-high oil, *Yosemite Falls* (p. 108).

Though Zorach saw Yosemite as Eden, it is hard to believe that he worked in relative solitude there; most contemporary accounts suggest that the park was hardly a lonesome place. As Chiura Obata observed, "Yosemite Valley is crowded with automobiles and the road is shiny with oil. . . . It has the appearance of camping in a tent as someone advertised, but compared to camping in the mountains it looks like living in a can."[26] At the time of Obata's first visit, in 1927, the Yosemite Park and Curry Company was busy lobbying the park service to build more parking lots. The argument against this was led by Frederick Law Olmsted, Jr., on the basis of the valley's more subtle attractions: the verdant meadows and trees that framed the spectacular views. Like Olmsted, Obata realized the value of Yosemite's more intimate spaces, and like the Zorachs, he understood that the park's spiritual side was not incompatible with modern painting. By seeking out less conventional views and simplifying the park's features in the manner of the Japanese Esorogato tradition in which he was trained, Obata was the first painter to create a truly unique and distinctive body of Yosemite work since perhaps William Keith. Watercolors such as *New Moon, Eagle Peak* (1927, p. 168), painted on silk, depart from the sleek commercial aesthetic of the Auto Club and the drama of romanticism. Obata's Yosemite work, which bears the imprint of his Japanese training, is often readily identifiable by simplified forms and the use of heavy, calligraphic line.[27]

TOP: **MARGUERITE THOMPSON ZORACH**
Stream in the Mountain, n.d., ink wash
Fresno Art Museum Collection, Fresno, California, Gift of Memorial Fund, 70.63. © Zorach Collection LLC

BOTTOM: **WILLIAM ZORACH**
Fantasy of a Night in Yosemite with All the Wild Creatures Keeping Me Awake, 1920, graphite on paper
Fresno Art Museum Collection, Fresno, California, Gift from the Collection of the Zorach Children, 85.15.15. © Zorach Collection LLC

LEFT: **WILLIAM ZORACH**
Yosemite Falls, 1920, oil on canvas
Courtesy C. K. Williams II. © Zorach Collection LLC

ABOVE: **CHIURA OBATA**
New Moon, Eagle Peak,
1927, watercolor and sumi ink on silk
Private collection. © Obata Family

CHIURA OBATA
Snow, Merced River, ca. 1950,
watercolor on silk

Private collection. © Obata Family.
Photograph by Sibila Savage

Following a solo exhibition of his Yosemite work in San Francisco in the spring of 1928, Obata returned to Japan, where his experience in the park became the basis for his *World Landscape Series*. Of the thirty-five woodblock prints that comprise the portfolio, twenty-seven are Sierra and Yosemite views, suggesting the considerable role the park played in defining Obata as a printmaker.[28] Obata's Yosemite work also coincided with a growing demand for Asian art in California, which was fueled by economic interests in Pacific Rim countries as well as diverse influences ranging from Hollywood productions to the work of the Los Angeles modernist Stanton Macdonald-Wright. The taste for Asian aesthetics was at its height in the 1920s and 1930s, before wartime racism stifled the careers of many.

Whereas Obata evoked a distinctly Japanese sense of style, with his delicate washes and elegant lines, Henry Sugimoto looked instead to Western and modern influences in creating his Yosemite works. Born in Japan and educated in San Francisco, Sugimoto studied the work of Paul Cézanne and Vincent van Gogh in Paris in the late 1920s before returning to California, where he immersed himself in landscape painting, including scenes of Yosemite and Carmel. Sugimoto's work of the 1930s was widely exhibited, suggesting that, despite the political rhetoric emphasizing the outsider status of many immigrants prior to World War II, it was possible for a Japanese American artist to work outside conventional expectations regarding ethnicity and styles. In *Mirror Lake* (1930, p. 170), Sugimoto used post-impressionist brushwork to capture Yo-

semite's volume and monumentality, although he struggled with the limitations of the painting surface: "It is very difficult to paint the cliffs and mountains on a small canvas. . . . If one is to try to capture this scenery, even a [46-by-31-inch] canvas seems too small."[29]

The substantive involvement of Japanese painters and printmakers in Yosemite—including the printmaker Hiroshi Yoshida, who created a number of works in 1925—came to an abrupt end in 1942, when President Franklin Roosevelt signed an order declaring Japanese Americans enemy aliens and ordering them into relocation camps. Obata would spend more than a year imprisoned in camps near San Francisco and in central Utah; Sugimoto was interned in Arkansas until 1945. In addition to being

deprived of some of its most inventive artists, Yosemite suffered also from reduced visitation and wartime neglect, until the end of gasoline rationing brought Americans back to national parks in record numbers in the 1950s. The abandonment of the Yosemite Valley Railroad, along with a nationwide surge in leisure time, assured the Auto Club a leading role in promoting Yosemite as a destination for year-round entertainment. The Camp Curry winter carnival, the Ahwahnee's Christmastime Bracebridge pageant (based on an English squire's dinner), the Yosemite Lodge firedive (in which a diver, wearing a flaming suit of cotton-covered coveralls, did a swan dive into the lodge pool[30]), auto races, and other amusements intensified the disconnect between visitors and scenery. As the valley increasingly resembled a theme park, newer topics of artistic interest, such as beach culture, Hollywood glamour, and urban sprawl emerged to compete for the attention of those California artists

still interested in representational painting. The seemingly contrived, "vaudeville type"[31] entertainments that proliferated in the valley may have been part of the reason that Bay Area artists, many of whom were immersed in abstract expressionism, steered clear of Yosemite throughout the 1930s and 1940s. Although Ansel Adams had taught at the California School of Fine Arts in San Francisco, his presence in the valley failed to ignite a more widespread interest in Yosemite among California painters, abstract or otherwise. He did, however, exert an enormous influence on a new generation of nature photographers, who came to the park in large numbers. This abundance of amateur and semiprofessional photographers coincided with the rise of the snapshot, as more and more visitors took the creation of Yosemite imagery into their own hands.

Though few Bay Area painters were drawn to Yosemite on account of Adams, the photographer's relationships with Alfred Stieglitz,

HENRY SUGIMOTO
Mirror Lake, Yosemite, 1930, oil on canvas

Museum of the American West Collection, Autry National Center, Los Angeles; purchase made possible by the Gold Acquisitions Committee, 2002. © Henry Y. Sugimoto Charitable Foundation

Georgia O'Keeffe, and others would have an impact on painting in the park through mid-century. In the summer of 1937, Adams spent several weeks with O'Keeffe at Ghost Ranch, her New Mexico retreat. From Ghost Ranch, they drove to Canyon de Chelly, where, surrounded by the sandstone mesas, Adams proselytized about Yosemite, finally convincing O'Keeffe to make a visit the following year. Thrilled at the prospect of what O'Keeffe might do with Yosemite, he urged her to bring her paints. He wrote to David McAlpin, an amateur photographer who was to be O'Keeffe's traveling companion:

I will do everything I can to assure safe and convenient transport of her sketching and painting materials. I plan to keep you all several days in camp in various places, and she will have a multitude of subjects that will excite her. During those stay-overs, the photographers go berserk why not O'Keeffe? . . . she will see things she has never seen before, and in conditions that are rare. . . . There is an extraordinary sculptural natural beauty that is unexcelled anywhere in the world.[32]

O'Keeffe rarely took her paints on extended, distant trips, however, and though she arrived in Yosemite without them, her ability to see its landscape afresh affected Adams profoundly: "To see O'Keeffe in Yosemite is a revelation; for awhile I was in a daze. Her mood and the mood of the place not a conflict but a strange new mixture for me. She actually stirred me up to photograph Yosemite all over again—to cut all the advertising rot and see things for myself once more."[33] Adams produced two albums based on this trip, *Sierra Nevada: The John Muir Trail* and *Yosemite 1938*, both of which he sent to O'Keeffe and Stieglitz before the end of the year. The striking work that fills these books—some of his best production—suggests the extent to which O'Keeffe inspired the photographer. Apparently, the experience moved her as well; twenty years later, in 1958, O'Keeffe wrote to Adams that "I often think of that Yosemite trip as one of the best things that I have done."[34]

Due, most likely, to the striking work by Adams that captured her presence in Yosemite in 1938, this trip has been far more celebrated than O'Keeffe's return visit in 1952, undertaken as part of a visit to Adams in his

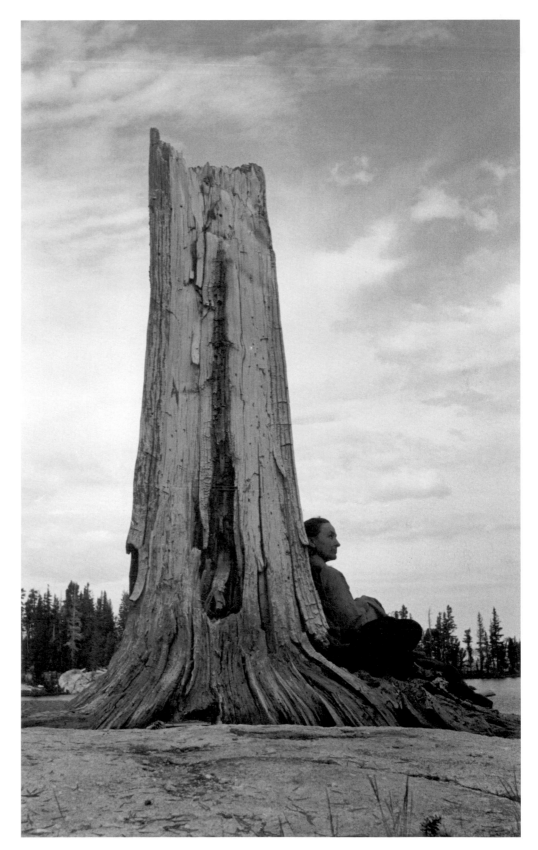

ANSEL ADAMS
Georgia O'Keeffe and Tree, ca. 1938, gelatin silver print

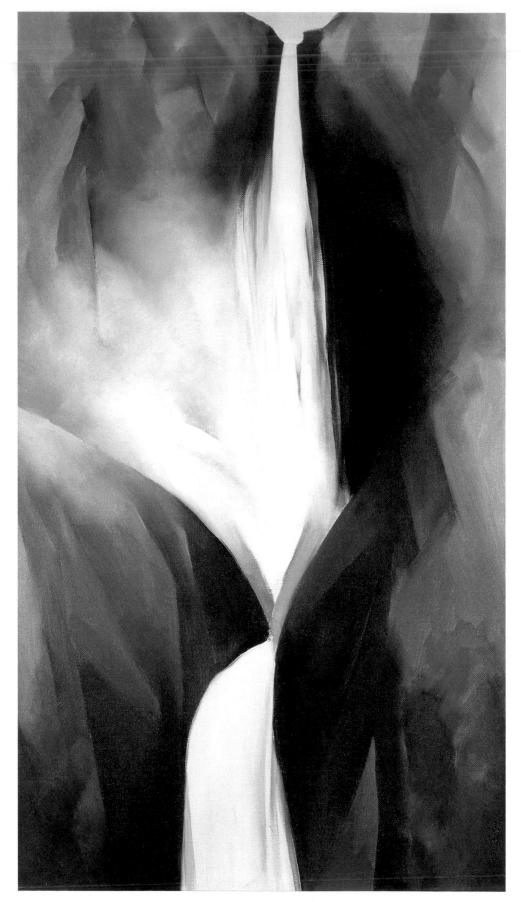

San Francisco home. One of the two paintings that resulted, *Waterfall I* is an instinctive reaction to the latent energy of Yosemite Falls. A simplified abstraction of the falls' tiered form, O'Keeffe's painting was, along with those by Zorach and Obata, among the first to focus on Yosemite's abstract potential, leaving behind both the sentimentality of romantic realism and the commercial appeal of images produced for its many boosters.

Waterfalls had interested O'Keeffe since a 1939 visit to Hawaii; she would paint them again in 1957 after a trip to Peru. Though clearly Yosemite Falls, *Waterfall I* is a straightforward, iconic image that emphasizes a clear, simple form. In Yosemite Falls, North America's highest waterfall and Yosemite's premier attraction, O'Keeffe found a natural altar, a powerful, gushing counterpoint to the crosses of the New Mexican desert or the skyscrapers and smokestacks that filled the works of her Eastern colleagues.

Waterfall I is also indicative of O'Keeffe's ability to edit out the peripheral elements of a scene. Her 1952 experience undoubtedly included more crowds and congestion than her earlier visit, when most of her seventeen days in Yosemite was spent in the backcountry with Adams. As air and water contaminants approached those found in Los Angeles that summer, O'Keeffe would have encountered in the valley what was in many ways an urban environment. Her ability to see past the smog, entertainments, sagging infrastructure, and campsites resembling "rural slums" was shared by her colleague Charles Sheeler. Like O'Keeffe, Sheeler was lured to Yosemite by Adams, whom he visited in 1956. Although he was best known for his interest in architectural and industrial subjects, Sheeler often cited the underlying systems of nature as a chief source of inspiration.[35] Not having immersed himself in pure landscape since a 1937 visit to the Blue Ridge Mountains, Sheeler was no doubt anxious to try his hand at Yosemite. It seems likely that he went with the intention of making photographs, though few of distinction survive. He would, however, revisit Yosemite in three paintings created between 1957 and

1959: two works titled *Yosemite* and a companion image *Sun, Rocks and Trees* (p. 174). All three depict the smooth, low boulders that dot many of the park's glacial slopes. Like his industrial works, Sheeler's Yosemite paintings are hard-edged, cubist-inspired abstractions that treat their subject in structural terms, suggesting a systematic approach to nature study and comment on its selective design. Although photographers such as Adams, Alma Lavenson, and Edward Weston had been exploring the park's more intimate side through close-ups of rocks, grasses, lichens, and other natural patterns since the 1930s, Sheeler was perhaps the first major painter to seriously do so—indicative, perhaps, of his move from "disinterest . . . to total rapture" while in Yosemite with Adams, the park's most ardent enthusiast.[36]

While O'Keeffe and Sheeler selected inherently different aspects of Yosemite's landscape as their subject matter, both demonstrated their innate talent for extracting the extraordinary from the everyday—just as Yosemite's visitation topped one million for the first time, in 1954. The National Park Service responded with "Mission 66," a long-range assessment of conditions and problems in the park system, accompanied by a ten-year developmental program. Mission 66 failed to anticipate the exponentially increasing number of tourists in Yosemite, however, which had doubled again by 1967. The brewing crisis of crowd control would link Yosemite to some of the social upheaval of the times. When 20 million people converged in Washington, D.C., for the first Earth Day in the spring of 1970, more than a few were likely toting a copy of Jack Kerouac's *Dharma Bums,* which was inspired by a 1955 trip the author took to Yosemite with the poet Gary Snyder. Kerouac's protagonist, a rugged version of his typical urban hepcat, urges his companions to reclaim their own America through a "great rucksack revolution [with] thousands or even millions of young Americans wandering around with rucksacks, going up to the mountains."[37] When Kerouac's scenario was realized fifteen years later in the same place it was first envisioned, however, the result was a disaster. Within months of the

first Earth Day, a large crowd of hippies gathered over the July Fourth weekend in Stoneman Meadow. Acting on complaints of noise and drug use, rangers attempted to remove them but were pelted with rocks and driven away. Unequipped to handle the escalating tension, park officials lost patience and called in armed reinforcements from California's Central Valley. Scuffles between campers and officials, riots, and even beatings took place throughout the night. The next morning, visitors were evicted for the first time in park history.

The discrepancy between the urban problems facing the overcrowded, highly developed valley and Adams's work depicting the park as a wilderness destination free from human intervention was now considerable. Even so, Adams's work reached new levels of popularity in the 1970s as he enlarged and reprinted some of his most famous negatives, a market that thrived on Americans' persistent talent for seeing national parks as unaltered wilderness. From the imposition of these expectations onto a changed landscape, satire, irony, and dislocation emerged as a counterpoint to Adams's vision, as photographers such as Ted Orland, Bruce Davidson, Roger Minick, and others aimed their lenses at trash cans, tourists, and souvenirs. Drawn in part by these new interpretive and artistic possibilities, painters also began returning to the park in greater numbers, forming a visible component of Yosemite's creative community for the first time in decades. Among the first and most prominent was Wayne Thiebaud, who in 1975 received a commission from the Department of the Interior for the upcoming bicentennial that resulted in *Yosemite Valley Ridge* (p. 152). Known for his landscapes using highly simplified forms and exaggerated perspectives, Thiebaud refined the experience of Yosemite to isolated shapes: *Yosemite Rock Ridge* (1976–82, p. 175) and *Horsetail Falls* (1969, p. 176) emphasize the smooth edges and vertical slopes that exist in abundance in Yosemite, a reductive approach that has much in common with that of his modernist predecessors O'Keeffe and Sheeler.

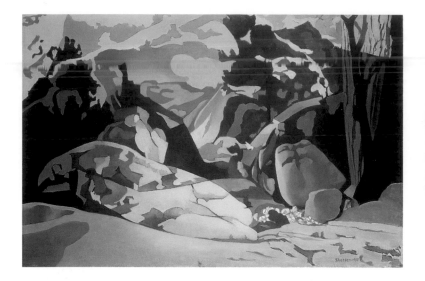

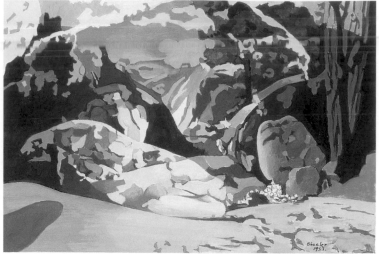

The arrival of Thiebaud in Yosemite coincided with a surge of expansion and change within the national park system and the valley itself. Beginning with the Wilderness Act of 1964, the National Park Service had, for the first time since its inception, begun to rethink its guiding attitude that the parks were playgrounds for the people, recognizing instead the intrinsic and cultural value of wilderness with a new slogan, "Vignettes of Pristine America." As part of this shift, the park service put an end to Camp Curry's beloved, yet traffic-jamming and noise-polluting firefall in 1969 and instituted shuttle buses on the valley floor in 1970. The sympathetic relationship between art and conservation was officially recognized with the reopening of the Yosemite Museum in 1970, as well as in the 1972 Smithsonian exhibition *National Parks and the American Landscape,* organized in celebration of Yellowstone's centennial.

This emphasis on the shared concerns of artists and park officials in shaping appreciation for Yosemite also became the impetus for the Yosemite Museum's establishment of the Yosemite Renaissance in 1982. Since then, the program has attracted artists with established relationships to Yosemite as well as those who are new to the park, with the goal of encouraging a continuum with the past while rethinking the way Yosemite has been represented. The program culminates in an annual exhibition and encourages both representational and nonrepresentational submissions, emphasizing only that the work need relate to the landscape,

ALL (CLOCKWISE FROM TOP LEFT):

CHARLES SHEELER
Yosemite, 1957, oil on canvas

Hirshhorn Museum and Sculpture Garden, Smithsonian Institution, Washington, D.C., Gift of Joseph H. Hirshhorn, 1966. Photograph by Lee Stalsworth

Yosemite, 1957, tempera on paper

© The Lane Collection. Courtesy, Museum of Fine Arts, Boston. Photograph © 2006 Museum of Fine Arts, Boston

Sun, Rocks and Trees, 1959, graphite and tempera on paper and Plexiglas

Addison Gallery of American Art, Phillips Academy, Andover, Massachusetts, Museum purchase. All Rights Reserved.

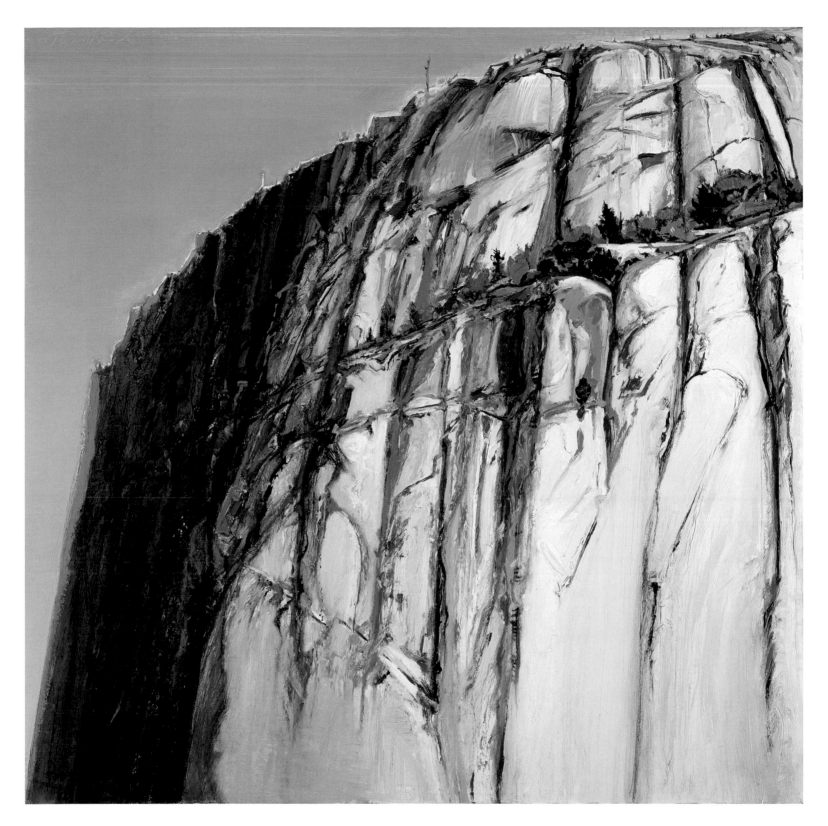

WAYNE THIEBAUD
Yosemite Rock Ridge, 1976–82, oil on canvas
© Wayne Thiebaud/Licensed by VAGA, New York, NY

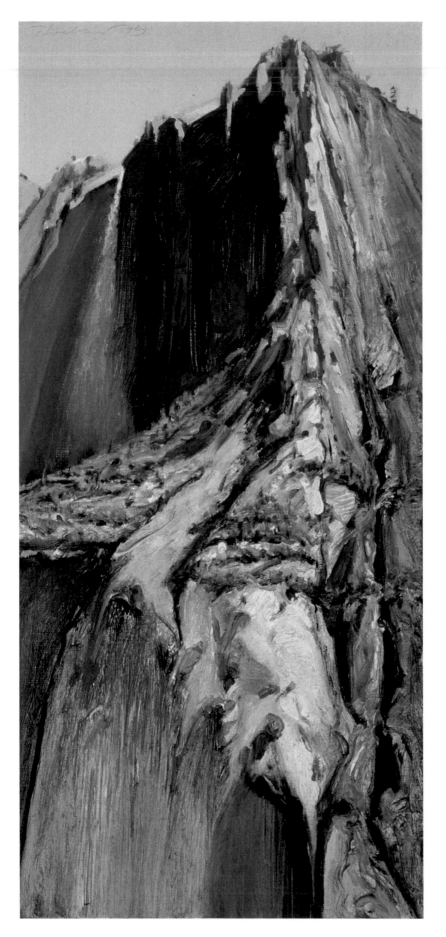

environment, wildlife, or people of Yosemite or the Sierra at large. Established artists also compete for selective residencies, in which lodging in the park is provided for up to one month.

Greg Kondos's first residency was in 1989; he completed another two the following year, when he painted *El Capitan, Yosemite*. Like Thiebaud, whom he met while a student at California State University, Sacramento, in the 1940s, Kondos uses spare, economic compositions with an emphasis on surface design and texture, resulting in a clean, fixed image whose static monumentality recalls the nineteenth-century classicism of Carleton E. Watkins. This relationship between iconic vistas and the modern experience of the park has been addressed by other artists-in-residence as well. Among them is Alyce Frank, who sees subtle gradations of tone in the granite walls that she amplifies in her paintings. In her *The Upper Falls at Yosemite* (ca. 1996, p. 178), for example, a classic composition has been updated by the placement of two red trees on the foremost picture plane.

The elemental, effervescent character of Yosemite's falls and pools, where water crashes on rocks and sprays visitors with mist, is the subject of *Rush Creek* (p. 179) by Glenn Carter, an artist-in-residence in 1997. Carter's image emphasizes the visceral aspect of the Yosemite experience, which is still one full of emotional impact. The relationship between what the Yosemite experience used to be, how visitors perceive the landscape today, and what has changed over time is implicit in the work of other contemporary artists interested in wilderness and its relevance to an increasingly urban world. Hiking deep into his sites, the British artist Tony Foster uses exacting detail to recall the exploratory and topographical methods of Yosemite's earliest European artists. His experience is documented in the finished works through notes and "souvenirs" (often pieces

WAYNE THIEBAUD
Horsetail Falls, 1969, oil on canvas

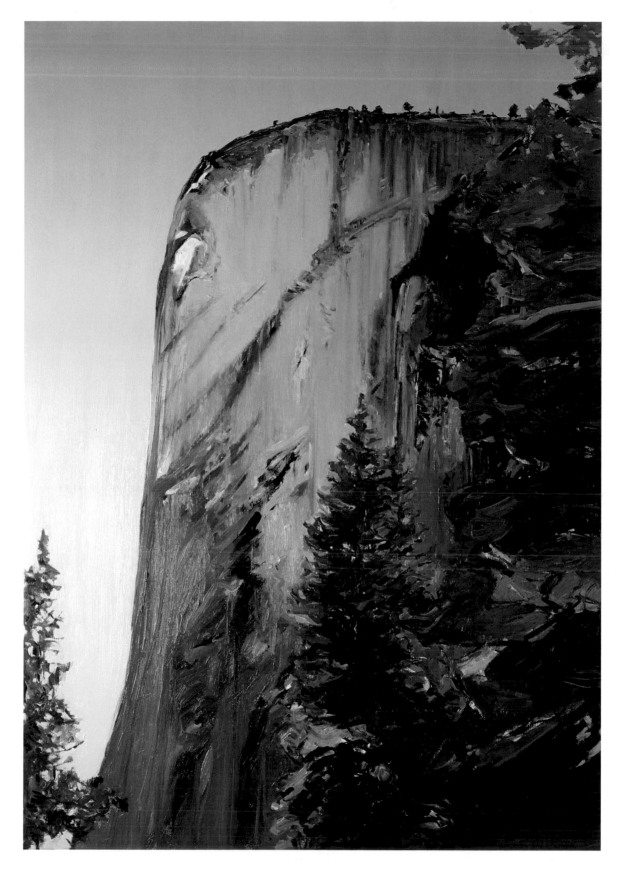

GREGORY KONDOS
El Capitan, Yosemite, 1990, oil on canvas

Collection of Kenneth B. Noack, Jr. © Gregory Kondos

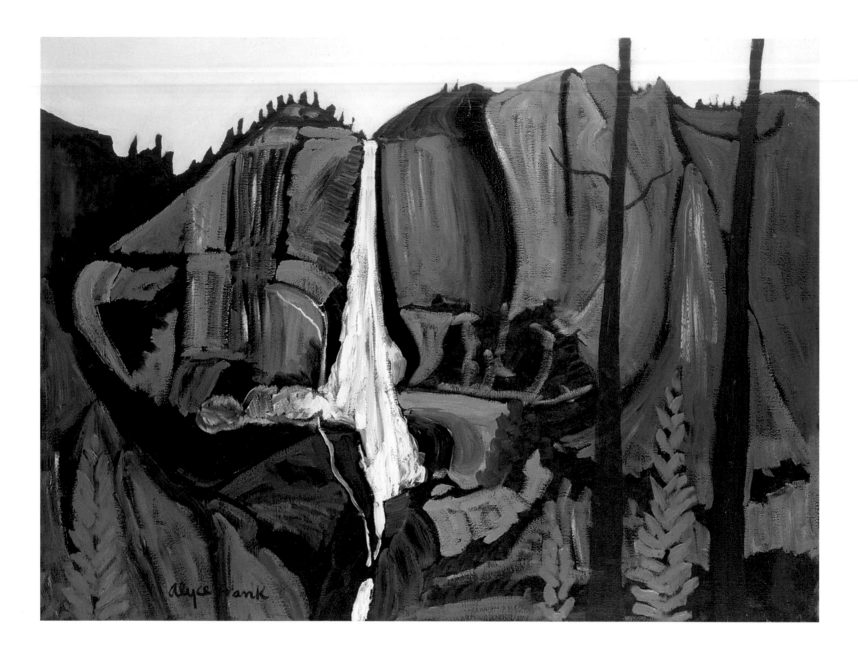

ALYCE FRANK
The Upper Falls at Yosemite, ca. 1996, oil on canvas
Courtesy Alyce Frank

of the physical landscape), which he attaches to the surface of his works, beneath the image, as in *Eight Days on Eagle Peak—Looking East* (2005, p. 180). Foster's use of a panoramic format, his reference to the time span involved in the work's creation, and his inclusion of actual elements of Yosemite's geology link natural and art history in a sort of conceptual key or map. His "souvenirs" also refer to the tourist's habit of taking home mementos, tying the modern experience in a direct and physical way to Yosemite's ancient, enduring character.

What is next for Yosemite's artists? A place where novelty and tradition often exist side by side, Yosemite remains an exceptional but increasingly delicate environment with a huge

and diverse audience, a complex management system and infrastructure, and an uncertain future. Most artists now bring an awareness of these demands—and the contradictions they impose on the landscape—with them into the park. Take two paintings completed in 2005: Phyllis Shafer's *Autumn in Yosemite Valley* (p. 181) and Marina Moevs's *River* (p. 182). Like many paintings based on seemingly distant places, both were begun in the park and finished in the studio; both share basic tenets of realism and an interest in the emotional or psychological aspect of the experience. But that is where the similarity ends. Shafer's swirling lines and fanciful clouds echo with sheer enthusiasm for an instantly recognizable vista—one that was made iconic by artists almost 150

GLENN R. CARTER
Rush Creek, 1997, mixed media on panel

Courtesy Glenn R. Carter

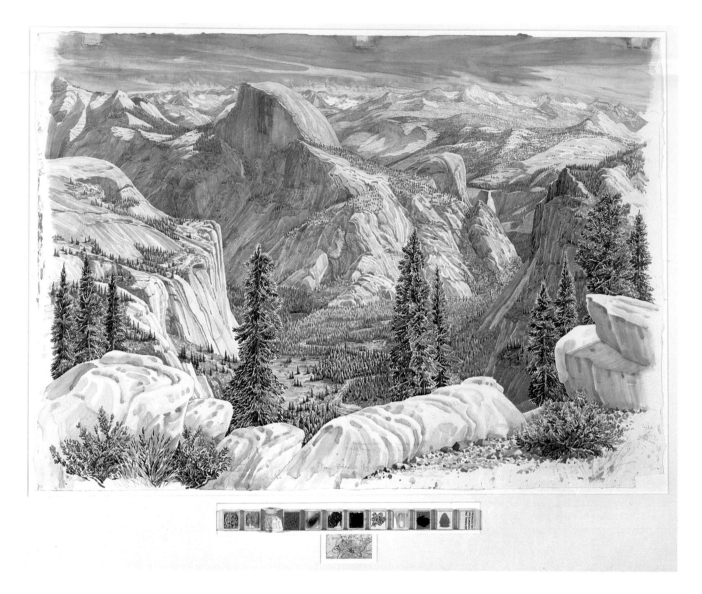

TONY FOSTER

Eight Days on Eagle Peak—Looking East,
2005, watercolor

Collection of the artist; courtesy
Montgomery Gallery, San Francisco

With BB. KP. MP. KO. July 11, 2005 on a hot, cloudless morning we set off from Tioga Road carrying painting and camping gear for 10 days. after 7 miles we camp near Yosemite Creek. July 10. 8:00 a.m. arrive at Eagle Peak. 7750'-relieved to find the vista as inspiring as my memory from 2004. find a splendid campsite on a ridge 300' below. set up drawing board on Eagle Peak, tying it to rocks and trees. start drawing. Half Dome is a very subtle shape. I frequently readjust my drawing. July 13. on site by 7:00. draw all morning, paint all afternoon. July 14. each day at 9:00 a 7" brown lizard scuttles over to inspect my painting. it stares critically—first with one eye then the other. it then executes a series of pushups on its front legs as if making obeisance, before rushing up the nearby Red Pine to snap up insects. July 15. where I sit to work in the sun my thermometer registers 118° at midday. July 16. adjusting my schedule to the oppressive heat. I work 7:00–1:30/ 4:00–8:00. July 17. wildlife: chipmunk, flicker, frog, gopher, snake, grey squirrel, ground squirrel, junco, lizard, mosquitos, mule deer, raven, stellars jay, swallowtail butterfly, tarantula, wasp, turkey vulture, western gold finch, woodpecker, yellow jacket. July 18. KO is menaced by a bear. it stands 6' high and walks towards him before, at the last minute, veering off into the bushes. July 19. last day on site. a conversation: "did you draw and paint all that freehand?" "er—yes" "wow—it's nearly as good as a photograph!" at 4:00 pack, hike down to camp at Yosemite Creek. 20 July hike out to the trail head arriving at midday. leave.

years ago. Moevs, however, has turned a corner from the same scene to find a quiet stream into which she's inserted a cabin. Though removed from its original context, the cabin is an image from the 1997 flood, when the Merced River overflowed and destroyed nearly half of the campsites in the valley.

Ruined by the storm, Moevs's cabin warns of nature's destructive potential and the comparatively ephemeral presence of Yosemite's built environment. Her real topic then, is not presence but absence, emphasized in the abandoned cabin and absolute calm that is the reflection of trees in the river. Kristina Faragher also works with issues of presence and abandon in *Gaping Mouth* (p. 183), a video installation completed in 2006 that takes as its subject the O'Shaughnessy Dam in Hetch Hetchy and the deserted Meyer's Ranch, among other topics. Faragher too uses reflections to juxtapose per-

manence and transience in a shot of El Capitan reflected in water: as the water moves, the rock ripples, turning ancient granite into something soft and ephemeral.

Faragher's work proves that Yosemite has long ceased to be one idea or even one park: it is part of the contemporary West, where tradition and invention often exist side by side. This intersection—between the material world and a more abstract, spiritual place—is perhaps the strongest current flowing through art being made in and about Yosemite today. Though Faragher uses the most contemporary of mediums, her piece actually takes its name from Yosemite's original residents, who termed the valley "place like a gaping mouth" and had a rich and complex series of legends that explained its history and how its monuments came into being. Long before painters or photographers set foot in the valley, Yosemite's

PHYLLIS SHAFER
Autumn in Yosemite Valley, 2005, oil on canvas
Private collection; courtesy Stremmel Gallery, Reno, Nevada

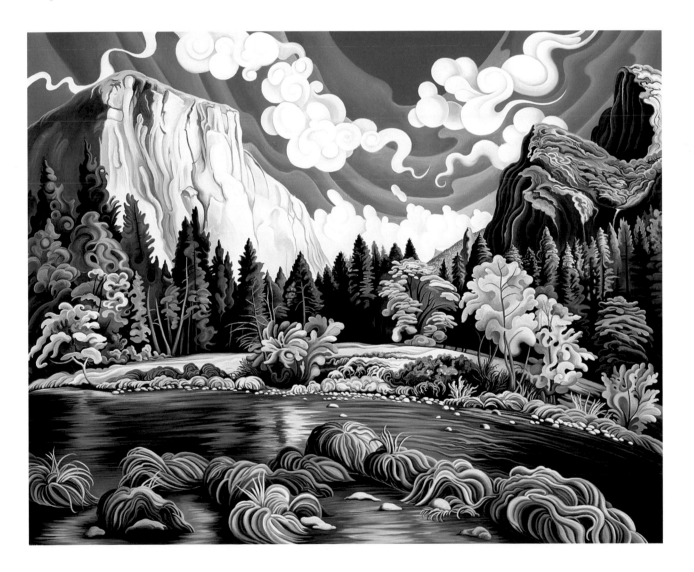

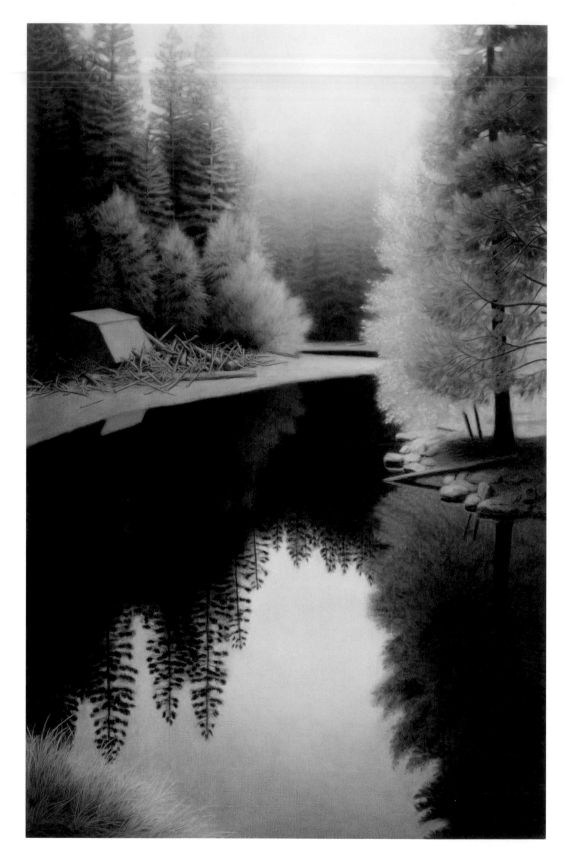

Native residents believed it was populated by bird and animal people, whose struggles formed its rocks and waterfalls. In Harry Fonseca's series on these legends (p. 184) contemporary stylistic language is used to depict these figures. Fonseca's work thus underscores what much of this chapter, and this book, is about: that Yosemite is an inherently animated place—its monuments are not static geologic specimens but filled with spirits. Like us, Yosemite is alive.

And this is what distinguishes the contemporary art of Yosemite from its nineteenth-century precedent: recognition of an animated, constantly changing landscape—natural and man-made—as well as our own power to affect that change. Where nineteenth-century artists saw a place of grand, static geology, contempo-

rary artists see flux, both good and bad, with our own presence often as the driving force. In contemporary art we do not see Yosemite from afar but are brought into direct contact with the place and asked to face our role within it.

Though protected in official terms, Yosemite of the twenty-first century is a place where the threat of disaster—natural and man-made—is ever-present. And Yosemite is, after all, a place with a proven history of artists adapting to environmental and economic change. It also assures an ever more interesting landscape of social and environmental consequence into the future.

KRISTINA FARAGHER
Gaping Mouth, 2006, still from video installation
Courtesy of Kristina Faragher; original score by Mark Kozelek and special thanks to Curt Lemieux

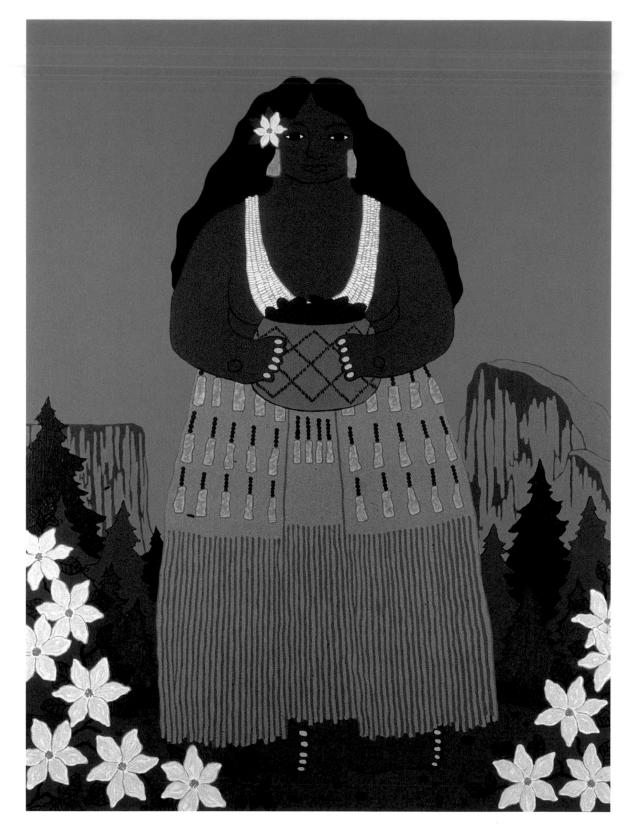

NOTES

1. Alfred Runte, *National Parks: The American Experience* (Lincoln: University of Nebraska Press, 1979), 71.

2. Stephanie Barron, Sheri Bernstein, and Ilene Susan Fort, *Made in California: Art, Image and Identity* (Los Angeles: Los Angeles County Museum of Art; Berkeley: University of California Press, 2000), 66–70.

3. From Pinchot's testimony before the House Committee on Public Lands, 1913; Barron, Bernstein, and Fort, *Made in California*, 66–70. The first chief forester of the United States and the most noted conservationist of his generation, Pinchot teamed with Phelan in presenting the committee with the case for creating a reservoir in the Hetch Hetchy Valley.

4. "Saving the Yosemite Park," *Outlook* 91 (January 1909), 236.

5. David A. Curry, "5,000 Yosemite Visitors Predicted for This Season," *Touring Topics* 8, no. 3 (April 1916), 21–22. Curry notes that the garages at Camp Curry would be free.

6. There is a slight discrepancy in the dating of Braun's *Yosemite Evening from Glacier Point* and *Yosemite Falls from the Valley*. Although the date of his visit was reported by *Touring Topics* in May of 1928 as having taken place in 1915, records in the Irvine Museum date both paintings to 1918.

7. "The Editor's Own Page," *Touring Topics* 20, no. 5 (May 1928), 9.

8. Ibid.

9. "National Parks of California Form State Assct," *Touring Topics*, June 1916, 9.

10. Quoted in Runte, *National Parks*, 100–101.

11. Edwin Gilbert Funston, "Each Moment a Delight," *Overland Monthly* 75 (June 1920), 484–86.

12. In her foreword to Dorothy Ellis's *Ahwahnee*, Jeannette Dyer Spencer states that Mather had "long dreamed of a resort hotel of the distinctive quality of the Ahwahnee" in Yosemite and that "this booklet is offered as a response to the many questions which have been asked concerning the hotel, its furnishings, and history" (in Ellis, *Ahwahnee, Yosemite National Park, California* [Yosemite, Calif.: Yosemite Park and Curry Company, 1935], 3). Spencer and her husband Ted, an architect, were the chief designers behind the postwar rehabilitation of the Ahwahnee.

13. Shirley Sargent, *The Ahwahnee: Yosemite's Classic Hotel* (Yosemite, Calif.: Yosemite Park and Curry Company, 1977; 4th rev. ed., Yosemite, Calif.: Flying Spur Press, 1984), 8.

14. *The Ahwahnee*, promotional brochure published by the Yosemite Park and Curry Company in 1929, Institute for the Study of the American West, Autry National Center, Los Angeles.

15. Spencer, in Ellis, *Ahwahnee*, 9.

16. Promotional brochure *The Ahwahnee*, 1929.

17. Tom Lewis (1923), quoted in Craig D. Bates and Martha Lee, *Tradition and Innovation: A Basket History of the Indians of the Yosemite–Mono Lake Area* (Yosemite National Park, Calif.: Yosemite Association, 1990), 91.

18. Ibid., 92.

19. Ibid.

20. Quoted in Bill and Frances Spencer Belknap, *Gunnar Widforss: Painter of the Grand Canyon* (Flagstaff: Northland Press for the Museum of Northern Arizona, 1969), 25.

21. "Californization," *Overland Monthly* 83 (July 1925), 268; Stella Benson, "Upstarts," *Sunset* 45 (December 1920), 105–6; *Standard Oil Bulletin*, August 1932.

22. David Louter, "Glaciers and Gasoline: The Making of a Windshield Wilderness, 1900–1915," in David M. Wrobel and Patrick T. Long, eds., *Seeing and Being Seen: Tourism in the American West* (Lawrence: University Press of Kansas, 2001), 250.

23. "Motor Invasion of Yosemite and Tahoe Begins," *Touring Topics*, June 1915, 16.

24. John Ott, "Landscape of Consumption," in Stephanie Barron, Sheri Bernstein, and Ilene Susan Fort, eds., *Reading California: Art, Image, Identity* (Los Angeles: Los Angeles County Museum of Art, 2000), 65.

25. Quoted in David Robertson, *West of Eden: A History of the Art and Literature of Yosemite* (Yosemite National Park, Calif.: Yosemite Natural History Association and Wilderness Press, 1984), 140.

26. Quoted in Janice T. Driesbach and Susan Landauer, *Obata's Yosemite: The Art and Letters of Chiura Obata from His Trip to the High Sierra in 1927* (Yosemite National Park, Calif.: Yosemite Association, 1993), 128.

27. These observations are derived from Janice Driesbach in ibid., 27–30.

28. Ibid., 14.

29. Quoted in Kristine Kim, *Henry Sugimoto: Painting and American Experience* (Los Angeles: Japanese American National Museum, 2000), 37.

30. Instituted by Donald Tresidder, the firedive was a dramatic stunt, but the diver, a champion swimmer, reportedly suffered several burns on more than one occasion. See Stanford E. Demars, *The Tourist in Yosemite, 1855–1985* (Salt Lake City: University of Utah Press, 1991), 111–12.

31. Shirley Sargent, *Yosemite's Inkeepers* (Yosemite National Park, Calif.: Ponderosa Press, 2000), 76.

32. Ansel Adams to David McAlpin, July 11, 1938, Center for Creative Photography, University of Arizona, Tucson.

33. Ansel Adams to Alfred Stieglitz, September 10, 1938, Beinecke Library, Yale University, New Haven.

34. Georgia O'Keeffe to Ansel Adams, July 8, 1958, Center for Creative Photography, University of Arizona, Tucson.

35. In June 1952, Sheeler wrote: "Nature, with its profound order, is an inexhaustible source of supply. Its many facets lend themselves freely to all who would help themselves for their particular need." Quoted in Martin Friedman, Bartlett Hayes, and Charles Millard, *Charles Sheeler* (Washington, D.C.: Smithsonian Institution Press, 1968), 30.

36. Donald Miller, "Picture Perfect: A Collection of Polaroids from Photographic Genius Ansel Adams Is on Display at the Naples Museum of Art," *Naples Daily News Neopolitan*, June 3, 2004.

37. Jack Kerouac, *The Dharma Bums* (1958; New York: Penguin Books, 1976), 97.

YOSEMITE FALLS AGAIN

LIKE ALL OF CALIFORNIA, Yosemite is a place of constant discovery and constant loss. In the spring of 1851, the valley's discovery by the Mariposa Battalion marked its loss by Chief Tenaya and the Ahwahneechees. In the summer of 2005, my kids shouted with joy as they discovered a new granite pool up the narrow Tenaya fork, named for the long-dead chief. They didn't mind the ten other people clambering around the rocks and diving into the cold, deep water. I shook my head: "Never used to be anybody up here." Generations have lamented Yosemite's fall from Eden. While the faithful grumble and say the place is going to hell, Half Dome and El Capitan look down in the serenity of their ancient pace.

On a hot July weekend, the parking lots and trams are as overflowing as the falls. Yosemite remains a sacred space, despite it all. Amid the mundane bustle of the valley floor, it calls out over the tourist din. As I stood in line at the Curry Village taco stand, waiting to order, the falls boomed in the distance—a chorus of ageless chants at full volume from the wettest year in a century. I ordered a bean and cheese burrito and watched Yosemite Creek leap over the edge—ecstatically.

For Native people of California, as Brian Bibby notes, "many places were viewed as living entities . . . with which people engaged in an ongoing conversation. Contact with such landmarks brought the individual into the realm of eternity."[1] This has certainly been the case for Yosemite, not only for Native people but for all people who seek to become native to this place. For Ansel Adams, as for many who love the park,

CHIURA OBATA
Evening Glow of Yosemite Waterfall,
Yosemite National Park, California (detail, see p. 188)
Fine Arts Museums of San Francisco, Achenbach Foundation for Graphic Arts, 1963.30.3126.23. © Obata Family

CHIURA OBATA
Evening Glow of Yosemite Waterfall,
Yosemite National Park, California, no. 23 of the
World Landscape Series, 1930, color woodcut

Fine Arts Museums of San Francisco, Achenbach Foundation for
Graphic Arts, 1963.30.3126.23. © Obata Family

Yosemite was a "great earth-gesture."[2] His art expressed a personal voyage into the realm of eternity through a life spent in conversation with its seasons and moods, its grand and intimate spaces.

The sacred and the profane meet in Yosemite every day. That contrast is the source of many of its conflicts and much of its magic. As we have seen in the preceding essays, artists have found many ways to approach the interrelations of art, nature, and commerce in Yosemite. While some avoid the crowd to focus on the eternal and the evanescent, others call our attention to Yosemite's fall and the paving of its paradise, implicitly challenging us to do better. Natural processes and biotic communities remain surprisingly vital in the wider park, despite the summer's human tide flooding in and out of the valley floor. The National Park Service manages to balance Yosemite's competing visions to a remarkable degree. It is an open question whether Yosemite's artists can do as well.

Perhaps the greatest challenge facing contemporary Yosemite artists is how to recognize and express the ongoing significance of the place. Since the first images made their way into the press, Yosemite has been a powerful symbol for the West and the nation. A place so identified with the romantic landscape may seem irrelevant to our hard-edged modern world. The sublime and the pastoral, key elements of the landscape tradition, are brought uniquely together in Yosemite. Such things may not seem central to contemporary art— but that does not mean they are no longer relevant.

The sublime, like angry gods of old, reminds us to be humble as it reveals a greater power to which we might attune our lives. The Miwok shared this sense of Yosemite. Their stories of powerful spirits within the rocks and falls resonate today because they fit the place, even now. In a world where the hubris and futility of our quest to dominate nature grow ever clearer, to experience the sublime is to recognize that the laws of nature do not bend to our will.

The pastoral, on the other hand, is a vision of calm and comfort, of balance and harmony between humanity and nature. As the sublime evokes a humble awe, the pastoral nurtures poise. It is the mode of classical arcadia, of paradise and the garden. To the Miwok and the Paiute, Yosemite was a garden—not a mythic, but a practical one—of foods and fibers carefully maintained and gratefully nurtured. It was their garden that Frederick Law Olmsted found so parklike when he encountered it in the 1860s. It is a model of management to which the National Park Service is slowly returning.

In evoking through its art both the sublime and the pastoral, Yosemite speaks to an ongoing ambivalence in our relationship with the wider natural world. Do we seek wilderness or do we seek the garden, and which is the more sustainable? Judging by some aspects of the park's history, perhaps we seek only to maximize our own pleasures and profits.

The coexistence of crass commerce and profound transcendence is one of Yosemite's quintessentially Californian qualities. For generations, Yosemite has stood as a challenge and a goad, calling us to be more than mere gold diggers, to dedicate ourselves to something more than getting and spending. Could we match our mountains? As Unitarian minister Thomas Starr King chided in the 1860s:

So many of us there are who have no majestic landscapes for the heart—no grandeurs in the inner life. We live on the flats. . . . We look up to no heights whence shadow falls and streams flow singing. . . . We have no sacred and cleansing fears. We have no consciousness of Divine, All-enfolding Love. We may make an outward visit to the Sierras, but there are no Yosemites in the soul.[3]

King was perhaps too hard on us. The philosopher George Santayana, writing in 1911, believed that Yosemite and the Western landscape were indeed shaping a new culture in California and the West. The great defining range of the Sierra Nevada "allows you, in one happy moment, at once to play and to worship, to take yourselves simply, humbly, for what you are, and to salute the wild, indifferent, non-censorious infinity of nature."[4]

As the park grew, that wild infinity grew harder to find. It remains, however, for those who know where to look. Yosemite's climbers stride around the valley with a muscular ease Walt Whitman would have loved. Like John Muir, they have found Yosemite's pumping heart on its vertical edge, balanced between

J. MICHAEL WALKER
The Removal of the Miwok from Yosemite, 2005, digital print
© J. Michael Walker

1851. The Removal of the Miwok from Yosemite.

RICHARD MISRACH
Burnt Forest and Half Dome, Yosemite, 1988,
chromogenic print

Museum of the American West Collection, Autry National
Center, Los Angeles; purchase made possible in part by
Marilyn and Calvin B. Gross, Bob and Lorna Sandroni, and
W. Brinson Weeks. © Richard Misrach, courtesy Fraenkel
Gallery, San Francisco, and Pace/MacGill Gallery, New York

terror and transcendence. Muir's death-defying exploits—like inching out on a narrow ledge under the lip of Yosemite Falls to gaze at the moonlight through its waters—are the stuff of legend passed around the fire at Camp Four. The climber and photographer Galen Rowell was part of a new generation who found that wildness lives on in Yosemite's vertical world— far above the crowds.

It's been some time since most Americans could claim the right to "sacred and cleansing fears." We inhabit a culture of comfort and irony, but negation can carry art and life only so far before the ancient search for beauty and meaning reasserts itself. Can Yosemite speak

to today's world? Just ask a climber clinging by fingertips over the thoughtless void.

In 1970, not long before he died of cancer, Shunryu Suzuki, First Master of Zen Center, San Francisco and Carmel Valley, traveled to Yosemite. Looking up at Yosemite Falls, he watched the water coming down "like a curtain thrown from the top of the mountain":

The water does not come down as one stream, but it is separated into many tiny streams. . . . I thought it must be a very difficult experience for each drop of water to come down from the top of such a high mountain. . . . It seems to me our human life may be like this. . . . When you do not realize that you are one with the river, or one with the universe, you have fear. Whether it is separated into drops or not, water is water. Our life and death are the same thing.[5]

ANSEL ADAMS

Tenaya Creek, Dogwood, Rain, Yosemite National Park, California, ca. 1948, gelatin silver print

Yosemite can reconnect us to life in ways both joyous and terrifying. As a symbol and as a real place, it joins opposites and transcends their limitations. For all its terrible grandeur, Yosemite can be as comfortably mundane as buying a six-pack at the village store or filling up the inner tube for a midsummer float on the Merced—the River of Mercy. Its greatest artists, its truest lovers, have felt at home there. When contemporary artist Tony Foster explores the intimate scale of Yosemite's annual flowering within the grand scale of geological time, he connects to a vision at the core of Yosemite art—on a trail back from Adams to Muir to the Ahwahneechee. The vision is of a garden observed and tended at close range, set within the great motions of time—a garden within a temple, the tender within the terrible, the pastoral within the sublime. As Yosemite holds these contrasts, it remains a symbol of empire, a natural cathedral, a tourist resort, and a well-loved home. As empire inevitably falls, Yosemite may become simply a home, or perhaps even a working garden again.

Long after humans have fallen away, winter storms will roll through the valley's ancient granite walls. Will other eyes look up and note their power? Dogwood will grow by the river. Will other hands tend their branches, make baskets of their life?

NOTES

1. Brian Bibby, *Deeper Than Gold: A Guide to Indian Life in the Sierra Foothills,* with photographs by Dugan Aguilar (Berkeley: Heyday Books, 2005), xviii.

2. Ansel Adams, *Yosemite and the Sierra Nevada* (Boston: Houghton Mifflin, 1948), xiv.

3. Thomas Starr King, "Selections from a Lecture-Sermon after Visiting Yosemite Valley," in Oscar J. Shuck, comp., *The California Scrapbook* (San Francisco: H. H. Bancroft, 1869), 457.

4. George Santayana, *The Genteel Tradition in American Philosophy* (1911; Cambridge, Mass.: Harvard University Press, 1967), 64.

5. Shunryu Suzuki, "Nirvana, the Waterfall," in *Zen Mind, Beginner's Mind* (New York: Weatherhill, 1973), 93.

SELECTED ARTIST BIOGRAPHIES

LAUREEN TRAINER

ANSEL ADAMS

BORN 1902, SAN FRANCISCO, CALIFORNIA
DIED 1984, CARMEL, CALIFORNIA

Tutored privately at home as a young boy, Ansel Adams studied piano in San Francisco from 1914 to 1927 and performed as a concert pianist until 1930. Having also studied with photofinisher Frank Dittman since 1916, Adams chose to become a photographer. He worked as a commercial photographer and in 1930 served as a columnist for the literary review *Fortnightly* in San Francisco. In 1932, he was a founding member of Group f/64, along with photographers Imogen Cunningham and Edward Weston, among others. Adams went on to create the photography department at the Museum of Modern Art in New York City with Beaumont Newhall in 1940, and the photography department at the San Francisco Art Association's California School of Fine Arts in 1946. Adams favored the stunning landscapes of the Sierra Nevada and Yosemite, where he lived and worked from 1937 to 1962. Adams taught his first photography workshop in Yosemite Valley in 1940. After World War II, he continued teaching workshops there annually until 1981. During his time in Yosemite, Adams produced photographs of the park's spectacular vistas and famous landmarks as well as of nature's details, recording the idyllic nature of Yosemite Park. Praised for his technical precision, he captured a broad range of light and dark tones in his black-and-white photographs. Adams received Guggenheim Fellowships in 1946, 1948, and 1958. Several universities, including the University of California at Berkeley, Yale University, and the University of Arizona, awarded Adams honorary degrees.

DUGAN AGUILAR

BORN 1947, SUSANVILLE, CALIFORNIA

A Maidu, Pit River, and Paiute Indian, Dugan Aguilar grew up in Susanville, California. After graduating in 1973 from California State University–Fresno, he took graduate classes in photography at the University of Nevada in Reno and the University of California at Davis and Santa Cruz. In 1978, inspired by an Ansel Adams workshop in Yosemite Valley, Aguilar decided to perfect his own photography, which is devoted to the Native peoples of California and Nevada. Aguilar, who currently resides in Sacramento and works as a graphic artist at the *Sacramento Bee,* has participated in such major exhibitions as *Memory and Imagination* in 1997 at the Oakland Museum of California, *Northern California Indians* in 1998 at the British Museum in London, and *Reflection of a People: Keeper of the Flame* in 2001 at the Crocker Art Museum in Sacramento.

JAMES MADISON ALDEN

BORN 1834, BOXSBOROUGH, MASSACHUSETTS
DIED 1922, FLORIDA

The descendant of a Mayflower immigrant, James Madison Alden spent his childhood in Boston. At age nineteen, he enlisted in the navy and was assigned to the West Coast as a surveyor. Serving on the steamer *Active* under the command of his uncle, Alden was charged with sketching scenes of interest during their tour of San Francisco Bay and the waters off Washington Territory. In January 1858 Alden became the official artist of the Northwest Boundary Survey, tasked with gathering information to help set the border between the northwestern United States and British America. The following year, an inland junket brought him to the Yosemite area, where he

created watercolors of the valley's falls and river. Alden then rejoined the *Active,* traveling inland to the Continental Divide and the base of the Rocky Mountains. He reenlisted in the navy in 1863, serving with Admiral David Porter until 1891. His last years were spent in Florida.

RAYMOND ANDREWS
BORN 1949, SCHURZ, NEVADA

The youngest of five children, Raymond Andrews is a Mono Lake Paiute Indian. He grew up in Lee Vining, where he worked first in area restaurants and later for the Community Health Representative Toiyabe, an organization serving Indian groups in Mono and Inyo counties. Andrews began weaving around 1963, learning first from his grandmother Minnie Mike and later his great-aunt Carrie Bethel. He began first with beadwork—mainly loomed pieces such as necklaces and belts—and later moved to baskets. Around twenty years ago, he created his first cradleboard for a nephew. Although his work utilizes established methods and materials, Andrews is participating in an art form historically practiced by women; his decision to continue weaving therefore represents a break with tradition. He was included in the 2005 exhibition *Precious Cargo: California Indian Baskets and Childbirth Traditions,* organized by the California Exhibition Resource Alliance. Andrews, who currently lives in Bishop, California, makes most of his works for family and friends.

THOMAS AYRES
BORN 1816, WOODBRIDGE, NEW JERSEY
DIED 1858, AT SEA NEAR SAN FRANCISCO

Thomas Ayres began his career as a draftsman in St. Paul, Minnesota. Lured by the promise of gold, he traveled to California in 1849. His pursuit of the precious metal proving unsuccessful, in 1855 he accepted an invitation from San Francisco writer and publisher James Mason Hutchings to join an expedition to Yosemite as an artist. Several of Ayres's sketches from this trip, reproduced in *Hutchings' California Magazine,* were the first published images of Yosemite Valley. Ayres subsequently worked with painter Thomas A. Smith in Sacramento

to complete a moving panorama of Yosemite Valley and its waterfalls. Before returning to the East Coast in 1857, Ayres created a second group of drawings of Yosemite. These images, exhibited at the American Art Union in New York City, led to a commission from *Harper's* magazine to illustrate a series of articles on California. In 1858, while on a sketching trip to Southern California for *Harper's,* Ayres died when his ship sank in a storm off San Francisco.

CARRIE BETHEL
BORN 1898, LEE VINING, CALIFORNIA
DIED 1974, LEE VINING, CALIFORNIA

Of Mono Lake Paiute descent, Carrie Bethel learned how to weave at a young age. Her first basket, completed in 1910 when she was twelve years old, was made of redbud and bracken fern with a split willow base and had an unusual design of ducks and flowers that Bethel had seen in a crochet book. Bethel later participated in the highly competitive basket-making contests at Yosemite Indian Field Days in 1926 and 1929, and gave weaving demonstrations at the Indian Exhibition of the 1939 Golden Gate International Exposition. She sold her baskets at a trading post near San Francisco, and many of her large works were purchased by the basket collector James Schwabacher. She supplemented her income from these sales by working as a cook for road crews and in domestic positions throughout her life. Bethel produced large, three-rod, red-and-black baskets from around the early 1920s until the 1960s. Beginning in the 1930s, she also crafted smaller, less expensive baskets in response to market demands. These smaller baskets, about 2 inches in diameter, 3/4 inch high, and decorated with glass beads, added a unique style to the Yosemite–Mono Lake tradition.

ALBERT BIERSTADT
BORN 1830, SOLINGEN, GERMANY
DIED 1902, NEW YORK CITY, NEW YORK

Brought to the United States from Germany at the age of two, Albert Bierstadt returned to his homeland in 1854 to study landscape painting. Three years later, he settled in New Bedford, Massachusetts, where he began painting views of the White Mountains. In 1859, Bierstadt

joined General Lander's expedition to the Pacific coast, spending the summer sketching the Great Plains and the Rocky Mountains before separating from the party to travel to Fort Laramie. When he returned to the East Coast, he settled in New York City. Bierstadt subsequently visited the West on several occasions, including an 1863 trip to Yosemite with artists Virgil Williams and Enoch Wood Perry. At his studio on Tenth Street in Manhattan, he turned his field sketches from these travels into full-scale, grand landscapes. His romantic paintings of the West as an edenic landscape made him one of America's most popular landscape artists. He was elected a member of the National Academy of Design in 1860. Bierstadt's popularity declined in the 1870s, however, as changing artistic tastes rendered his overtly dramatic canvases unfashionable.

WILLIAM BRADFORD
BORN 1823, FAIRHAVEN, MASSACHUSETTS
DIED 1892, NEW YORK CITY, NEW YORK

Born into a Quaker family, William Bradford was raised in Fairhaven, across the harbor from the bustling whaling community of New Bedford. As a youth, Bradford worked in his father's mercantile business and painted in his spare time, becoming known for his careful depictions of specific ships. By 1861 he had moved to the Tenth Street Studio Building in New York City, where he met the famed landscape painters Frederic Edwin Church and Albert Bierstadt. Inspired by their portrayals of such exotic locales as the Andes and the Rocky Mountains, Bradford began traveling north along the East Coast, reaching Labrador and eventually the Arctic in 1866. His paintings of frozen Arctic scenery and dramatic icebergs attracted international attention, including that of Queen Victoria, who bought his painting *Steamer Panther among Icebergs and Field-Ice in Melville Bay, under the Light of the Midnight Sun* in 1875. After returning from London in 1874, Bradford established a seasonal studio in San Francisco and added the Yosemite Valley to his oeuvre. He may have worked there with Eadweard Muybridge in 1878, when they both were listed as guests at the Leidig Hotel. He participated in the San Francisco Art Associa-

tion, along with Muybridge and the painters Virgil Williams and Enoch Wood Perry. By 1881, however, Bradford had returned to New York. His reputation, like that of Albert Bierstadt, declined in the 1880s, as official taste shifted from grand, romantic landscapes toward more naturalistic depictions of the everyday world.

MAURICE BRAUN
BORN 1877, NAGY BITTSE, HUNGARY
DIED 1941, POINT LOMA, CALIFORNIA

Maurice Braun's family moved from Hungary to New York City in 1881. Apprenticed for a short time to a jeweler at the age of fourteen, Braun later attended the National Academy of Design for five years. During this time, Braun joined the Salmagundi Club and became well known as a portrait painter. In 1902, he traveled to Europe for one year, where he studied under William Merritt Chase. Braun eventually settled in San Diego and turned to landscape painting, perhaps influenced by Chase and the French impressionists. His landscapes often capture the mood rather than the details of a scene. Braun founded the San Diego Academy of Art in 1912, cofounded the San Diego Art Guild in 1915 and the artists' association Contemporary Artists in 1929, and was actively involved in the San Diego Theosophical Society. Braun later divided his time between San Diego and Connecticut, where he lived in the artists' colonies of Silvermine and Old Lyme.

ANNE BRIGMAN
BORN 1869, HONOLULU, HAWAII
DIED 1950, EAGLE ROCK, CALIFORNIA

Anne Brigman moved from her birthplace of Hawaii to Oakland, California, in 1894. Trained as a painter, she turned to photography around 1902. Soon after moving to California, she began to photograph the California landscape, including Yosemite and the Sierra Nevada, often working with a nude model (usually her sister). In some images, the figure is placed to fit within a pattern of the landscape; in others, she is depicted as a metaphorical muse. Brigman often captured with a soft focus the more intimate side of the monumental landscapes she photographed. She also manipulated her

negatives—using pencils and paints, even etching them—and superimposed negatives in an enlarger to create new images. Brigman was the only woman Alfred Stieglitz admitted into the avant-garde Photo-Secession group, and the only West Coast photographer made a group fellow. The British Link Ring Society elected her a member, and three issues of *Camera Work* (a quarterly journal edited by Stieglitz) featured her photographs. In 1929, Brigman moved to Long Beach, California; twenty-one years later, she moved to nearby Eagle Rock, where she published *Songs of a Pagan*, a book of her poems and photographs. She worked as a freelance photographer until 1930, when diminishing eyesight forced her to abandon the practice.

CHRIS BROWN
BORN 1896 YOSEMITE VALLEY
DIED 1956

Chris Brown, the son of Lena Brown, a Southern Miwok who married John Brown in 1900, was named after one of the valley's resident artists, Christian Jörgensen. Brown may have been the great-grandson of Callipene, who was known as a healer and was, according to some, heir to Chief Tenaya, the original leader of the Ahwahneechees (inhabitants of the valley prior to white settlement). A prominent resident of the valley during the 1920s, Brown was known for the elaborate costumes and dances he designed for Indian Field Days. His costumes combined aspects of historic Plains clothing (consistent with tourist expectations) with Southern Miwok elements, although some believe that Brown himself was of Paiute heritage. Among his more distinctive creations were flicker-quill temakkela (of Miwok origin) and a unique dance style, which together made him one of the most photographed participants of Indian Field Days. In the 1930s, he built a sweathouse—a traditional structure heated by a wood fire and used for curative purposes prior to hunting—as part of the re-created Indian Village. Known as Chief Lemee (although he was not an actual chief), Brown worked as a cultural demonstrator at the Yosemite Museum for more than twenty years and was among the last native residents of Yosemite to speak "chief's talk," a language used only at ceremonial events.

GRAFTON TYLER BROWN
BORN 1841, HARRISBURG, PENNSYLVANIA
DIED 1918, ST. PETER, MINNESOTA

Born in Pennsylvania, Grafton Tyler Brown moved to San Francisco in 1855. He worked as a lithographic artist at C. C. Kuchel in San Francisco, becoming California's first black artist to establish himself professionally. For about a decade he created views of Virginia City, Santa Rosa, Fort Churchill, and other Western towns for the *Illustrated History of San Mateo County*. He remained active in the San Francisco area, establishing his own business, G. T. Brown and Co., in 1867. He sold the business in 1879 and a few years later moved to Victoria, British Columbia, where he participated in several geological surveys and painted landscapes of the Cascade Mountains. During the following years, Brown exhibited paintings and sketches of Portland, Tacoma, the Grand Canyon, and the Lower Falls of Yellowstone. By 1892, he had settled in St. Paul, Minnesota, where he worked as a draftsman and civil engineer during the last part of his life. No paintings have been found from these later years.

GEORGE HENRY BURGESS
BORN 1831, LONDON, ENGLAND
DIED 1905, BERKELEY, CALIFORNIA

George Henry Burgess studied at the Somerset House School of Design in London before immigrating to San Francisco to join the California Gold Rush. Although he would later travel to the 1858 gold rush in British Columbia, Burgess mined in California for only a short while. Returning to his artistic roots, he produced paintings and lithographs of California landscapes and San Francisco scenes. His depictions of Yosemite are often highly composed, with dark trees in the foreground framing a well-lit waterfall or similarly spectacular sight, and figures frequently providing a sense of scale. Burgess's city views document the furiously growing and ever changing city during the height of the Gold Rush.

FREDERICK BUTMAN
BORN 1820, GARDINER, MAINE
DIED 1871, GARDINER, MAINE

Frederick Butman moved from his home-town of Gardiner, Maine, to San Francisco in 1857. He was listed in the San Francisco city directory from 1859 to 1871. From 1860 to 1865 he explored a thousand miles up the Columbia River. Along with Antoine Claveau, Butman is considered one of the first painters of Yosemite. He was also well known in his day, reportedly having sold his landscapes in California for as much as $8,000.

GLENN CARTER
BORN 1951, SAN FRANCISCO, CALIFORNIA

Self-taught painter Glenn Carter moved to Santa Cruz from San Francisco in 1975, where he pursued his interest in abstract and mixed-media art, exhibiting his work in group and solo exhibitions in the Bay Area. In 1991, he began participating in the annual Yosemite Renaissance exhibitions. Carter was an artist-in-residence at Yosemite in 1996.

NELLIE CHARLIE
BORN 1867, LEE VINING, CALIFORNIA
DIED 1965, BISHOP, CALIFORNIA

Nellie Charlie's father, Pete Jim, was a head-man of the Mono Lake Paiute, and her mother, Patsy, was a basketmaker who probably taught her daughters the art. As a teenager, Nellie was married to Young Charlie, a Miwok man from Yosemite who was also married to her sister. They had six children together, including Daisy Mallory, who would also become a prominent weaver in Yosemite. Known for her skill and versatility, Nellie Charlie produced traditional baskets for use alongside new-style creations. A regular participant in the Indian Field Days competitions, by the 1920s she had developed several unique and recognizable designs, including patriotic symbols such as an eagle and a Union shield. In addition to her creations for sale, she put her inventive designs to functional use, producing knitting baskets, bassinets, laundry baskets, coasters, and fruit bowls for her children and grandchildren.

ANTOINE CLAVEAU
BORN 1815, FRANCE
DATE AND PLACE OF DEATH UNKNOWN

Antoine Claveau was active from 1838 to 1849 in Chile, where he participated in constructing the Teatro Dramático de Santiago. After moving to San Francisco in 1854, he painted portraits and landscapes until 1872. In 1857 Claveau began a 900-foot panorama of Yosemite Valley that he exhibited in Stockton that year and in San Francisco in 1858. Though Claveau's panorama is unlocated today, this is the first record of a painting of Yosemite on exhibition. Also resulting from his early visit is his 1858 painting *Yosemite Falls,* which is the first known representation of tourists in the valley. Claveau exhibited two paintings of Yosemite at the 1858 Mechanics' Industrial Exhibition in San Francisco. Although focused on industry, the Mechanics' Exhibition was nonetheless an important public venue for early California artists at that time, as the San Francisco Art Association would not be founded for another twelve years.

ALVIN LANGDON COBURN
BORN 1882, BOSTON, MASSACHUSETTS
DIED 1966, DENBIGHSHIRE, WALES

Alvin Langdon Coburn began taking photographs at the age of eight, and in 1902 opened his own studio in New York City. That same year, he cofounded the avant-garde Photo-Secession group with Alfred Stieglitz, Gertrude Käsebier, Edward Steichen, and Clarence H. White. Coburn's work was published in several issues of *Camera Work,* a quarterly journal published by Stieglitz. In 1903, he attended Arthur Wesley Dow's Summer School of Art in Ipswich, Massachusetts. The following year Coburn immigrated to London, returning to the United States from 1910 to 1913 to travel to the Grand Canyon and California. Coburn's early work comprised portraits of famous people such as Auguste Rodin and George Bernard Shaw; he later turned to hazy, grainy, gray-toned landscapes that suggest the influence of Edward Steichen and impressionism. Coburn was elected an Honorary Fellow of

the Royal Photographic Society in 1931. In subsequent years, he began to experiment with what he called *vortographs,* in which he photographed forms such as crystals and wood viewed through a microscope. These largely abstract and purely aesthetic photographs have the effect of looking at a kaleidoscope.

COLIN CAMPBELL COOPER
BORN 1856, PHILADELPHIA, PENNSYLVANIA
DIED 1937, SANTA BARBARA, CALIFORNIA

Encouraged to study art from a young age by his father, Colin Campbell Cooper was educated at the Pennsylvania Academy of Fine Arts, inspired by the 1876 Centennial Exposition in Philadelphia, and undertook further study in Europe, at the Académie Julian in Paris. From 1895 to 1898 he was an instructor of watercolor at the Drexel Institute in Philadelphia. Known for paintings of street scenes and skyscrapers in Philadelphia and New York, Cooper in the 1890s adopted the bright palette and vivid brushwork associated with impressionism. He also continued his travels—to the Far East and India—where his interest in architectural subjects led him to paint mosques and palaces. Elected to the National Academy of Design in 1908, Cooper made his first trip to California in 1915, when he exhibited in the Panama Pacific Exposition in San Francisco. He returned the next year, when he made his one recorded visit to Yosemite. Cooper eventually settled in Santa Barbara in 1921, where he served as a member of the California Art Club and the Santa Barbara Art Guild. He continued his role as a dean of the local art community until his death in 1937.

JANE CULP
BORN 1941, SPRINGFIELD, ILLINOIS

Jane Culp received a Bachelor of Fine Arts degree from Washington University and a Master of Fine Arts degree from the Yale University School of Art. Drawn to landscapes, Culp enjoys the physical experience and uniqueness of natural forms in the western United States. She often spends hours, or even days, looking for potential painting sites, making notes

about the light and time of day as she drives. Once she selects a site and hikes to her chosen vantage point, she often paints the same scene in different media, including watercolor, charcoal, ink, and acrylic, looking for the right combination of light and color to create atmosphere and texture. Her abstracted views evoke the drama and beauty of the site. Culp was an artist-in-residence at Yosemite in 1988.

IMOGEN CUNNINGHAM
BORN 1883, PORTLAND, OREGON
DIED 1976, SAN FRANCISCO, CALIFORNIA

Imogen Cunningham began taking photographs in 1901 and studied photographic chemistry at the University of Washington, graduating in 1907. From 1907 to 1909, she worked in photographer Edward Curtis's studio in Seattle, Washington, where she learned the platinum process. During the following two years, she continued her study of photography and its chemistry at the Technische Hochschule in Dresden, Germany. After returning to Seattle, she opened her own studio, which she ran for six years. In 1923, Cunningham relocated to San Francisco and again opened her own studio. That same year, she met Edward Weston and her style of photography changed: whereas her early photographs, often taken in misty woods with nudes posed in tableaux, had a romantic, soft quality, she now adopted the "straight photography" advocated by Weston, Ansel Adams, and other members of Group f/64 (which Cunningham cofounded in 1932). Her detailed images of plants and flowers, many of them photographed in her backyard, brought her critical acclaim. Cunningham was a visiting instructor at Ansel Adams's annual photography workshops in Yosemite. She was named a Fellow of the American Academy of Arts and Sciences in 1967; received a Guggenheim Fellowship and had her first book, *Imogen Cunningham: Photographs,* published by the University of Washington Press in 1970; and was proclaimed Artist of the Year by the San Francisco Art Commission in 1973.

WILLIAM E. DASSONVILLE
BORN 1879, SACRAMENTO, CALIFORNIA
DIED 1957, SAN FRANCISCO, CALIFORNIA

William E. Dassonville began his career as a portraitist, photographing some of the leading figures of the day, including naturalist John Muir and artists William Keith and Maynard Dixon, but he later turned to photographing California landscapes and San Francisco scenes. In the early 1900s, he produced several photographs of Yosemite, including scenes of the valley and Yosemite Falls, often using a raised vantage point that gives the sense that the viewer is floating above the foreground. Stylistically, Dassonville was a pictorialist, producing soft-focus, muted images. Interested in the chemical processes of photography, he created his own paper, called Charcoal Black, which produced photographs with a velvety surface. Several other photographers used Dassonville's paper in their work, including Ansel Adams, whose 1930 book *Taos Pueblo* (with text by Mary Austin) is printed on Charcoal Black. Dassonville was a member of the California Camera Club and published several articles in the organization's magazine, *Camera Craft*. Finding it difficult to support himself through his landscape work, Dassonville concluded his career as a medical photographer at Stanford University.

JUDY DATER
BORN 1941, HOLLYWOOD, CALIFORNIA

Judy Dater studied photography from 1959 to 1962 at the University of California, Los Angeles, before receiving Bachelor of Arts and Master of Arts degrees from San Francisco State University in 1963 and 1966, respectively. In 1964, Dater met photographer Imogen Cunningham, who became her mentor and inspiration. Following Cunningham's death, Dater organized an exhibition of the older artist's work and published *Imogen Cunningham: A Portrait 1979*. Dater worked exclusively in black-and-white until 1979, when she began experimenting with color. She works primarily on portraits, mostly of women, using available light. Although Dater has experimented with superimposed images, the majority of her work focuses on classical portraiture. Dater's photographs of women are featured in the book *Women and Other Visions* (1975), a collaboration between Dater and photographer Jack Welpott. Dater received National Endowment for the Arts grants in 1976 and 1988, and a Guggenheim Fellowship in 1978.

BRUCE DAVIDSON
BORN 1933, OAK PARK, ILLINOIS

Developing an interest in photography from an early age, Bruce Davidson worked as an apprentice to photographer Al Cox in 1947 and won his first award for photography at the age of sixteen. From 1951 to 1954, he studied photography at the Rochester Institute of Technology. After working as a darkroom technician at Eastman Kodak, he continued his studies at Yale University, working with Josef Albers, Herbert Matter, and Alexey Brodovitch. In 1958, he joined the photographers' cooperative Magnum. Davidson received a Guggenheim Fellowship in 1962, which he used to document the civil rights movement, from cross burnings in the South to a Malcolm X rally in Harlem. From 1966 to 1968, he photographed Harlem in order to capture the humanity of its denizens. During the same time, in 1966, Davidson created *Trip West,* a portfolio documenting his cross-country journey, which took him to Yosemite, among other places. Davidson's Yosemite work shows, not the grandeur of the valley or the park's spectacular waterfalls and rock formations, but a campground filled with RVs, cars, lawn furniture, cardboard boxes, and stationary tourists. Also in 1966 Davidson received the first grant in photography given by the National Endowment for the Arts, which led to the publication of his book *East 100th Street* by Harvard University Press in 1970.

JOHN DIVOLA
BORN 1949, SANTA MONICA, CALIFORNIA

John Divola received a Master of Fine Arts degree from the University of California, Los Angeles, in 1974. In the 1990s, he began working on a series titled *Four Landscapes*. The resulting portfolio contains twenty images,

each measuring 19 by 19 inches, and is divided into four sections, including one on Yosemite. Viewed as a whole, the *Four Landscapes* series explores the many components of California's landscape, from the sublime to the urban: *Isolated Houses* has five scenes from the high desert; *Stray Dogs* focuses on dogs in alleys; and *Boat at Sea* features a small dinghy floating near the horizon. Interested in documenting the encroachment of human culture on California's natural environment, Divola captures in his photographs the urge to leave culture and return to nature. Divola received fellowships from the National Endowment for the Arts in 1973, 1976, 1979, and 1990, the John Simon Guggenheim Memorial Foundation in 1986, and the Flintridge Foundation in 1997.

MAYNARD DIXON
BORN 1875, FRESNO, CALIFORNIA
DIED 1946, TUCSON, ARIZONA

As a teenager, Maynard Dixon began drawing the landscape surrounding Fresno, particularly the flats of the San Joaquin Valley near his family's ranch. After his family moved to Coronado in 1891, Dixon sent a letter to the famed Western illustrator Frederic Remington and received an encouraging response. Dixon's formal art training began in 1893, when he enrolled in the California School of Design in San Francisco (later renamed the Mark Hopkins Institute). He made his first trip to Yosemite the following year. In 1895 Dixon met Charles Lummis and started working as an illustrator for various newspapers and magazines, including the *San Francisco Morning Call* in 1895 and the *Overland Monthly* in 1896. Dixon began traveling the West in 1900, taking a lengthy horseback trip through Nevada, northeastern California, and eastern Oregon in 1901 with Edward Borein. After his studio was destroyed in the 1906 San Francisco earthquake, Dixon increased his illustration work for the growing field of Western literature. In 1907 he traveled to New York, where he met Charles Russell in 1908 and befriended Ernest Blumenschein and Robert Henri. He had several studios in the East between 1907 and 1912 and exhibited often in eastern venues, including the National Academy of Design. In 1912 Dixon opened a studio on Montgomery Street in San Francisco. He divorced his first wife in 1917 and married photographer Dorothea Lange in 1920; the two traveled frequently throughout the Southwest, visiting Rancho de Taos, New Mexico, for six months in 1931. Dixon was awarded a major retrospective in 1945 at the Los Angeles County Museum of Art and completed his last mural commission, for the Santa Fe Railroad, in 1946.

GUSTAVUS FAGERSTEEN
BORN 1828, PRUSSIA
DIED 1889

Prussian-born Gustavus Fagersteen settled in San Antonio, Texas, by 1858 and partnered with the photography firm Vivier & Fagersteen. He moved briefly to New Orleans in the 1860s and on to San Francisco at the end of the Civil War, where he joined with Benjamin Howland in the Art and Photography Gallery. By the summer of 1874, Fagersteen had relocated to Merced, and from there he began his fifteen-year association with Yosemite Valley. Together with S. C. Walker, Fagersteen succeeded James J. Reilly and Martin Mason Hazeltine as the proprietor of the valley's local photography concession, creating stereoviews of Yosemite's wonders and the tourist groups that came to view them.

KRISTINA FARAGHER
BORN 1961, LOS ANGELES, CALIFORNIA

Los Angeles artist Kristina Faragher explores recognizable imagery combined with distorted sound, abstract passages, and slowed movement in short video meditations on the relationship between human presence and urban or industrial environments. Much of her work is collaborative and interdisciplinary, and she often finds inspiration in historic events and places, which she maps through sound and projection. Faragher camps often in Yosemite and Sequoia National Parks; her video on Yosemite, *Gaping Mouth,* was shot in April 2006 using a DVX 100 Panasonic Talk camera. Faragher studied painting and drawing with figurative artist and animator Sam Clayberger.

From 1986 to 1994 she studied video and installation with Martin Kersels, Anne Bray, and Michael Brewster at Claremont Graduate University. Faragher exhibited a collaborative work with Charles Long titled *River Made* at SITE Santa Fe in 2006; in an exhibition titled *Artists in Motion* at the Museum of Contemporary Art, Los Angeles, in 2002; and in *Fictitious Citizens* at the Sweeney Art Gallery at the University of California, Riverside, also in 2002.

GEORGE FISKE
BORN 1835, AMHERST, NEW HAMPSHIRE
DIED 1918, YOSEMITE, CALIFORNIA

After moving to Sacramento in 1858, George Fiske worked in several different fields before becoming an assistant photographer. First apprenticing with Charles Weed, he then worked for Carleton E. Watkins at his Yo-Semite Gallery and later with photographer Thomas Houseworth. In 1874, he returned to Watkins's gallery, which had been renamed Yosemite Art Gallery, and the following year accompanied Watkins to the park. Interested in the beauty and grandeur of nature, he photographed the spectacular scenery of Yosemite. After Watkins lost his gallery due to bankruptcy, Fiske ran a boardinghouse with a business partner, but his interest in photography did not wane: he continued to create images of Yosemite and of Marin and Santa Clara counties. In 1879, he became the first photographer to live in Yosemite Valley year-round, residing in the park for forty years. Fiske spent much of his time photographing the park and its visitors, from tourists frolicking at Glacier Point to waterfalls and snow scenes. After his death, the Yosemite Park Company acquired a majority of Fiske's negatives, though many were later lost in a 1943 fire.

HARRY FONSECA
BORN 1946, SACRAMENTO, CALIFORNIA

Harry Fonseca attended Sacramento City College and California State University at Sacramento, studying with artist Frank LaPena for a short period at the latter; he soon left school, feeling stifled by academic formulas. Many of Fonseca's early works reference the basketry designs and dance regalia of the art-

ist's Maidu heritage. In 1979, he began work on a series featuring Coyote, a trickster character from Native American myth. Using a strong design element, he depicted Coyote in various guises—as a mod, dressed in Converse sneakers and a motorcycle jacket and riding on a skateboard, or as Uncle Sam. Fonseca would return to the series several times in subsequent years. He has also worked with the creation stories of the Maidu, many of which were recounted to him by his uncle. Creating images that feature traditional Maidu people and emphasize design elements over realism, he illustrated *Legends of the Yosemite Miwok* (1981), compiled and written by LaPena. Fonseca has received awards for his work from the Wheelwright Museum of the American Indian, Indian Art Now, and Indian Market, all in Santa Fe, New Mexico.

GUS FOSTER
BORN 1940, WAUSAU, WISCONSIN

After graduating from Yale University in 1963 with a degree in art history, Gus Foster worked for ten years as the curator of prints and drawings at the Minneapolis Institute of Arts. In 1972, he moved to Los Angeles and set up a photography studio there. Four years later, he moved to Taos, New Mexico. Working with a panoramic camera weighing close to seventy pounds, Foster climbs to mountaintops—including Sentinel Dome in Yosemite and summits along the Continental Divide—to capture 360-degree views of the surrounding landscape. Interested in capturing places still untouched by human development, Foster looks for views that reveal the eternal forces of nature.

TONY FOSTER
BORN 1946, LINCOLNSHIRE, ENGLAND

Since 1982, wilderness painter Tony Foster has been traveling the globe, looking for places unmarked by humans. Hiking, rafting, or canoeing to his chosen location, he may stay in one spot for a week to complete his paintings, creating large-scale watercolors up to six feet in size. These "watercolor diaries" of his trips include images of volcanoes, deserts, rainforests, glaciers, canyons, and mountains. Seven of these diaries have been turned into exhibition catalogues. In 1998, Foster won the Yosemite Renaissance Prize. He was elected a Fellow of the Royal Geographical Society in 1994, and in 2002 the Society awarded him the Cherry Kearton Medal and Award for artistic portrayal of wilderness areas.

ALYCE FRANK
BORN 1932, NEW IBERIA, LOUISIANA

After finishing college early, at the age of eighteen, Alyce Frank moved to Los Angeles, where she attended graduate school at the University of California, Los Angeles, and the University of Southern California. At the age of forty-three, having moved to a small town outside Taos, New Mexico, Frank began to paint. Inspired by German expressionism and fauvism, she creates boldly colored paintings based on landscape views, preferring her own forms and colors to literal transcriptions of nature. She prepares all of her canvases with a red ground and then adds layers of brilliant color, flattening space to create a resolutely two-dimensional surface. Frank focuses primarily on landscapes of the Southwest, particularly views around her home, but she has also created paintings of Yosemite, including *The Upper Falls of Yosemite* (ca. 1996).

CONSTANCE GORDON-CUMMING
BORN 1837, ALTYRE, SCOTLAND
DIED 1924, SCOTLAND

An intrepid traveler and world adventurer, Constance Gordon-Cumming produced more than a thousand paintings and authored seven books in her lifetime. In April 1878, she sailed from Tahiti to San Francisco. Remaining in California for five months, she visited Yosemite, the redwood forests, San Rafael, the San Joaquin and Sacramento valleys, Oakland, and Tulare Lake. Originally intending to visit Yosemite for only a weekend, Gordon-Cumming fell in love with the scenery and stayed for three months. She traveled throughout the park in a stagecoach and on horseback, viewing the valley, the high country, and Hetch Hetchy—even meeting a young John Muir. During this time she completed close to fifty drawings and watercolors, many of them 30 by 24 inches in size so as to show the grandeur and immensity of Yosemite's features. In them, she portrayed an edenic landscape using traditional compositional techniques: trees on either side of the image often guide the eye back to the center of the composition. Before leaving Yosemite, Gordon-Cumming hosted an impromptu exhibition, using small nails to hang her drawings and watercolors on the porch of her lodging. In 1884, she published *Granite Crags*, a volume of travel letters detailing her experiences in Yosemite.

WILLIAM HAHN
BORN 1829, EBERSBACH, GERMANY
DIED 1887, DRESDEN, GERMANY

As a young man, William Hahn studied at the art academies in Dresden and Düsseldorf, Germany, where he trained under artist Emanuel Leutze. He continued his training in Paris and Naples and ultimately immigrated to the United States, living for a short while in New York City. He then moved to Boston, where he shared a studio with William Keith. In 1872, Hahn and Keith both moved to San Francisco, sharing another studio space in the Mercantile Library Building with artists Thomas Hill and Virgil Williams. A genre and landscape painter, Hahn traveled in search of subjects throughout California, including Yosemite, Placerville, the Russian River, and the Sierra Nevada. His Yosemite canvases feature tourists as the main subject, with the scenery serving as a backdrop. Known for his genre scenes of developing California towns, Hahn's work was included in the *Life in America* exhibition at the Metropolitan Museum of Art in New York in 1939.

WANDA HAMMERBECK
BORN 1945, LINCOLN, NEBRASKA

Wanda Hammerbeck began her studies at the University of North Carolina, Chapel Hill, receiving Bachelor of Arts and Master of Arts degrees in 1967 and 1971, respectively. She earned a Master of Fine Arts degree from the

San Francisco Art Institute in 1977 and completed further postgraduate work at Yale University. Throughout her career, she has focused on the disjunction between individuals' urban and environmental realities and the effect of people on the landscape. She is a member of the Waters of the West project, which seeks to document the sources of water tapped to supply California and other Western states and the alteration of the land to satisfy the region's growing cities. Her work often asks the viewer to consider the political, economic, and environmental ramifications of the presence or absence of water. Hammerbeck received National Endowment for the Arts Fellowships in 1977, 1979, and 1980 and participated as a guest artist at Yosemite's annual photography workshop in 1986.

MARTIN MASON HAZELTINE
BORN 1827, VERMONT
DIED 1903, BAKER CITY, OREGON

Martin Mason Hazeltine began practicing photography as a young man in Vermont and trained in New York with his brother, George Irving Hazeltine, before moving to San Francisco in 1853, where he worked as a daguerreotypist. By 1857 he had established a partnership there with his brother, but by 1863 had moved to Mormon Island, then to Sacramento the following year, and after 1865 to the Mendocino coast of Northern California. By 1868 Hazeltine had relocated again, this time to Stockton, where he opened another studio and began creating stereoviews of some of his best-known photographs. Around 1868 he made the first of many trips to Yosemite, and in 1876 he joined forces with fellow photographer James J. Reilly to create a series of Yosemite Valley and Calaveras Big Trees stereoviews. Over the years, Hazeltine would produce thousands of Yosemite negatives, which were published under his own imprint as well as that of competing photographers, including Reilly, John P. Soule, C. L. Pond, Kilburn Bros., Thomas Houseworth and Co., and others. Hazeltine moved to Baker City, Oregon, during the late 1880s, where he created a series on Oregon, Washington, and Idaho, as well as Yellowstone National Park.

HERMAN HERZOG
BORN 1832, BREMEN, GERMANY
DIED 1932, PHILADELPHIA, PENNSYLVANIA

In 1849, at the age of seventeen, Herman Herzog entered the Kunstakademie Düsseldorf, where he studied with Johann Wilhelm Schirmer, Andreas Achenbach, and Hans Fredrik Gude. He found early success, selling enough paintings to be able to travel in Europe and continue studying. Herzog favored the mountainous regions of Norway, Switzerland, and Italy. His patrons included Queen Victoria and Grand Duke Alexander of Russia. In 1869, he immigrated to Philadelphia, where he spent time painting along the Hudson River Valley. On his first trip west, in 1873, he sketched Yosemite Valley and the Sierra Nevada. His many paintings of Yosemite Valley reveal both his penchant for mountain landscapes and the influence of the Hudson River School. Herzog favored dramatic and powerful views of nature that emphasize the comparatively diminutive stature of humans. A prolific artist, Herzog had more than a thousand works in his estate at the time of his death.

THOMAS HILL
BORN 1829, BIRMINGHAM, ENGLAND
DIED 1908, RAYMOND, CALIFORNIA

Thomas Hill began his career as an apprentice to a coach painter in Massachusetts and turned to portraiture and flower painting after moving to Philadelphia in 1853. He studied at the Pennsylvania Academy of Fine Arts, where he met with some success, winning a Baltimore prize for an allegorical painting. In 1861, Hill moved to San Francisco for health reasons and began painting his well-known landscapes. He left California to study in Paris for a short time before returning to Boston, where he worked from 1867 to 1871. During this time, he produced a large-scale painting of Yosemite Valley that was reproduced as a chromolithograph by Louis Prang and Co. and engraved as a book frontispiece in 1870. Hill returned to San Francisco in 1872 and two years later founded, along with artist Virgil Williams, the California School of Design. In the early 1880s, he established a studio in Yosemite, where he eventually produced more than five thousand canvases, primarily for the many tourists who came through the park.

DAVID HOCKNEY
BORN 1937, BRADFORD, ENGLAND

David Hockney studied at the Bradford School of Art from 1953 to 1957 and at the Royal College of Art in London from 1959 to 1962. Known for his paintings, drawings, photographs, prints, and opera set designs, he often uses people as his subject matter, even if they are not ostensibly the focus of the work. Hockney was labeled a Pop artist early in his career, but his style took a turn in the late 1960s when he visited Los Angeles, moving away from the poster-style imagery of his earlier work to a more naturalistic approach. Drawn to the city's laid-back lifestyle, Hockney began painting backyard scenes of people standing near the abstracted water of a pool. For these Southern California landscapes, he used a vibrant palette and worked in acrylics rather than oils, giving the work a smooth, flat surface. Turning to photo-collage in the 1980s, Hockney created images he called *joiners*: square photographs collaged together in a cubist-like manner. Hockney received a Companion of Honor Award for excellence in art from the British government in 1997 and the Lorenzo de Medici Lifetime Career Award in 2003. He has held several teaching posts and is the subject of Jack Hazan's 1974 film *A Bigger Splash*.

PHILIP HYDE
BORN 1921, SAN FRANCISCO, CALIFORNIA

After a trip to Yosemite with friends in 1938, Philip Hyde realized that the photographs he had taken were not of his buddies but rather of the landscape that overwhelmed and inspired him. While attending the California School of Fine Arts in San Francisco from 1947 to 1950, Hyde counted Ansel Adams and Minor White among his teachers and mentors. He later moved to the northern Sierra Nevada, where he began what would become his life's work: using photography to help protect and preserve the Western landscape. In 1955, he produced a series of photographs of Hetch Hetchy Valley, showing the decidedly unspectacular landscape created by the O'Shaughnessy Dam. He also documented the Glen Canyon region of the Colorado River (ca. 1963) before it was flooded by damming and sandstone ero

sion near Canyon de Chelly, Arizona (1964). Hyde later began documenting the changes to and destruction of desert environments, at which time he switched to color photography to capture the desert colors.

WILLIAM HENRY JACKSON
BORN 1843, KEESEVILLE, NEW YORK
DIED 1942, NEW YORK CITY, NEW YORK

Born in upstate New York, William Henry Jackson moved throughout the East with his family as a young boy. At age ten he moved to his uncle's home in Troy, New York, to begin school, and at age fifteen he took a job in a photographer's studio there. Following a stint in the Union Army and a failed romance, Jackson left for New York in 1866 and eventually made his way to St. Joseph, Missouri. There he took a job with a wagon train headed west to mining camps on the Oregon Trail, going all the way to Los Angeles. Jackson drove horses back to Omaha, where he established a photographic shop and married. By 1869 he had secured a commission from the Union Pacific to photograph its newly completed transcontinental line and the following year joined the U.S. Geological Survey led by Ferdinand Vandeveer Hayden. For the next eight summers Jackson worked with the survey, traveling to exotic western locales, including the Yellowstone region in 1871 (with the painter Thomas Moran), Colorado's Mountain of the Holy Cross in 1873, and the Indian pueblos of the Southwest in 1875. Jackson organized an exhibit on the survey, including many of his photographs, for the 1876 Centennial Exposition in Philadelphia. On his final survey with Hayden, in the summer of 1878, Jackson visited the Wind River Mountains and Yellowstone. In 1881 he began working with the Denver and Rio Grande Railroad, which took him to Yosemite. In 1897 he moved to Detroit and helped run the Detroit Photographic Company until 1924, when it filed for bankruptcy. Jackson returned east that same year, to Washington, D.C., where he painted historic Western scenes, including a series commemorating the Hayden survey. Jackson lived to the age of ninety-nine.

WILLIAM S. JEWETT
BORN 1812, SOUTH DOVER, NEW YORK
DIED 1873, SPRINGFIELD, MASSACHUSETTS

By 1833 William S. Jewett was painting portraits in his hometown in upstate New York. He studied at the National Academy of Design and specialized in portraits and occasional landscapes. In 1849 he followed the gold miners to California to paint their portraits, as well as those of other prominent Californians. He was the first professionally trained painter to live and work in San Francisco. After his real estate investments made him a wealthy man, he returned to New York in 1869 and married. He returned from a European honeymoon in failing health and died in 1873.

CHRISTIAN JÖRGENSEN
BORN 1860, OSLO, NORWAY
DIED 1935, PIEDMONT, CALIFORNIA

In 1899, Christian Jörgensen visited Yosemite for the first time, pitching a tent for several months before deciding to make the valley his home. He spent the summer months of the next nineteen years there. (The house he built was converted to a National Park Service museum for a time in 1922.) Interested in art from a young age, Jörgensen had studied at the San Francisco Art Association's California School of Design with Virgil Williams, who became a mentor to the young artist. From 1881 to 1883, Jörgensen served as an instructor at the school. Before settling in Yosemite, Jörgensen traveled throughout California, painting all twenty-one missions in the state. His images of these California landmarks were widely admired for their detailed topography. Jörgensen was one of the few artists to produce grand views of Western landscapes in watercolor, rather than oils, often working with muted colors in his depictions of such sights as the waterfalls of Yosemite and El Capitan. In 1905, Jörgensen built a home in Carmel, where he produced images of the California coastline and founded the Carmel artists' colony with George Sterling. In accordance with his wife's will, 250 of his paintings—many of them scenes of Yosemite—were donated to the Yosemite Museum.

WILLIAM KEITH
BORN 1838 OR 1839, OLD MELDRUN, SCOTLAND
DIED 1911, BERKELEY, CALIFORNIA

Scottish-born William Keith arrived in New York City in 1850 and was apprenticed to a wood engraver by 1856. He first traveled west in 1858, on assignment from *Harper's* magazine to produce illustrations of Western scenes. Keith then moved to England for a short time, where he worked for the *London Daily News*. On his return to the United States, he opened his own engraving firm in San Francisco and began painting, with his wife, Elizabeth Emerson, as his teacher. In 1868, Keith was commissioned by Northern Pacific Railroad to produce paintings of scenes along its route. He continued his studies in Düsseldorf from 1869 to 1870 and shared a studio with artist William Hahn in Boston from 1871 to 1872, before returning to California. Keith worked in Yosemite during this time, producing detailed and realistic scenes in a style that rested heavily on the use of browns, greens, and yellows applied with a thick brushstroke. While in Yosemite, Keith befriended John Muir, a fellow Scotsman. After travels in Munich and the American South, Keith returned to California once again. In 1890, he hosted the tonalist painter George Inness in his studio, and his style changed as a result: his later works were more intimate, moody, and transparent.

MARK KLETT
BORN 1952, ALBANY, NEW YORK

Originally trained as a geologist at St. Lawrence University in Canton, New York, Mark Klett obtained a master's degree in photography from the State University of New York. He soon took a job as a photographer with the U.S. Geological Survey, and his early work was recognized in 1979 with an Emerging Artist Fellowship from the National Endowment for the Arts. From 1977 to 1984 he served as the chief photographer and project director for the Rephotographic Survey Project, retracing the steps of the first Western survey teams more than a hundred years earlier. He joined the University of Arizona in 1982 as a fine arts

specialist and was named Regents' Professor of Art in 2001. In 2005 Klett was given a major retrospective at the Patricia and Phillip Frost Art Museum at Florida International University in Miami. Titled *Mark Klett: Ideas about Time,* the exhibition explored the central notion of mapping changes in the landscape, with an emphasis on the effects of both geology and human development. Also in 2005, Klett's rephotographing of images of Yosemite resulted in the publication of *Yosemite in Time: Ice Ages, Tree Clocks, Ghost Rivers,* with Byron Wolfe and Rebecca Solnit.

GREGORY KONDOS
BORN 1923, LYNN, MASSACHUSETTS

Encouraged by his parents to pursue his love of drawing, Gregory Kondos enrolled at Sacramento Junior College (now City College) in 1941 to study art. Three years of military service in the Pacific in the 1940s interrupted his studies, but after his discharge he returned to school, completing his degree in 1946. He spent a year at the Art Center College of Design, Pasadena, and then switched to California State University, Sacramento, intent on becoming a college professor. He accepted a position in the art department at Sacramento Junior College, his alma mater, and taught there for twenty-four years. On his retirement, the campus art gallery, which he founded, was named in his honor. Kondos focuses on the California landscape in his paintings, which were at first influenced by artist Willem de Kooning and abstract expressionism but later tended more toward the painterly realism of artist Wayne Thiebaud. Many of Kondos's landscape paintings focus on Yosemite. Kondos was selected as an artist-in-residence at Yosemite in 1990 and a member of the National Academy of Design in 1995.

ALMA LAVENSON
BORN 1897, SAN FRANCISCO, CALIFORNIA
DIED 1989, PIEDMONT, CALIFORNIA

A self-taught photographer, Alma Lavenson was influenced by Edward Weston, Ansel Adams, and Imogen Cunningham and, like these fellow members of Group f/64, advocated for "straight" photography. From 1930 to 1968, Lavenson photographed mining towns in California around the Mother Lode country. Her photographs from this series often concentrate on the towns' architecture, such as Main Street hotels, or on cemeteries; few include people, giving the towns a ghostly, quiet feel. In 1979, Lavenson received a National Endowment for the Arts grant for a retrospective exhibition and the Dorothea Lange Award for outstanding women photographers.

ROGER MINICK
BORN 1944, RAMONA, OKLAHOMA

In 1964, while attending the University of California, Berkeley, Roger Minick began his career as an apprentice photographer at the studio of the Associated Students of the University of California. His first large project, begun in 1966, involved photographing Sacramento and the San Joaquin River delta; the project would be published as a book, *Delta West: The Land and People of the Sacramento–San Joaquin Delta* (1969). In 1972, Minick received a Guggenheim Fellowship to photograph the Ozarks in Arkansas. He turned his eye back to California in 1979, photographing the freeways and architecture of Southern California. He also documented Mexican American residents of East Los Angeles and undocumented workers near San Diego. In 1980, he completed the *Sightseer Series,* based on several different national parks. The series comments on tourists and their interaction with nature.

RICHARD MISRACH
BORN 1949, LOS ANGELES, CALIFORNIA

In the 1960s, Richard Misrach commenced work on a documentary-style survey of street people in Berkeley, California. In 1979, he began the *Desert Cantos,* a project that would occupy him for two decades. The work's title suggests its connection to poetry, and to Dante in particular. Like Dante's *Divine Comedy, Desert Cantos* is an epic work. A narrative structure groups the photographs, which chronicle the American desert, capturing both the beauty and the horror of the land. Clouds, mountains, and endless horizons intermix with nuclear test sites, bomb craters, and the ravages of fires set by humans. In many cases, two seemingly incongruous elements are joined, as when a beautiful sunset falls over a test site. Other series by Misrach include *Golden Gate* (1999–2001), images of the famed bridge at different times of day and at different times during the year; *Cancer Alley* (2000), which chronicles an industrial area along the Mississippi River; and *On the Beach* (2003), an aerial perspective of human activity on the beach. Misrach received National Endowment for the Arts Fellowships in 1973, 1977, 1984, and 1992; a Ferguson Grant from the Friends of Photography in 1976; a Guggenheim Fellowship in 1978; and the 2002 Kulturpreis for lifetime achievement in photography from the Deutsche Gesellschaft für Photographie.

MARINA MOEVS
BORN 1955, BOSTON, MASSACHUSETTS

Los Angeles–based artist Marina Moevs has long been interested in landscape as a suggestive narrative—one that begins with the threat of natural disaster and ends with the new state or condition that emerges from it. Born and educated on the East Coast, in 1989 Moevs moved to Southern California. There, the blurred lines between nature and urban sprawl in the Los Angeles area became a major focus of her work. Moevs first visited Yosemite in October 2004 and was among the first painters to comment on the precarious tension between natural forces and development within the park.

THOMAS MORAN
BORN 1837, BOLTON, ENGLAND
DIED 1926, SANTA BARBARA, CALIFORNIA

Born into a family of artists, Thomas Moran started out as a wood engraver but later turned to oils and watercolors, his preferred media for the rest of his career. With his brother Edward, one of his first teachers, Moran traveled around England from 1861 to 1862, studying the atmospheric effects that J.M.W. Turner captured in his work. In 1866 or 1867, Moran met Jean-Baptiste-Camille Corot, who would influence his approach to landscape. While traveling in Europe in 1871, Moran joined F. V. Hayden's surveying expedition to Yellowstone, and it was there that he discovered the

subject material that would bring him international acclaim. Remaining in the United States, Moran visited the Grand Canyon in 1873 and the Mountain of the Holy Cross in Colorado in 1874, producing large-scale canvases of these famous sites. Moran first visited Yosemite in 1872. He returned in 1904 and produced a series of paintings of the park. Moran was a member of the National Academy of Design, the Pennsylvania Academy of Fine Arts, and the Salmagundi Club, among other professional organizations. Mount Moran in the Teton Mountains and Moran Point in Yosemite are named after him.

GILBERT MUNGER

BORN 1837, MADISON, CONNECTICUT
DIED 1903, WASHINGTON, D.C.

Apprenticed at age thirteen as an engraver at the Smithsonian Institution, Gilbert Munger studied such landscape painters associated with the Hudson River School as John Ross Key and Frederic Edwin Church. Following a stint in the Union Army, Munger moved to New York, where he shared a studio with Frederick Butman. In 1866 his work was selected for the National Academy of Design's annual exhibition. Aware of Albert Bierstadt's success with Western landscapes, including Yosemite, Munger boarded one of the first trains for San Francisco once the transcontinental railroad was completed in 1869. That year his connections in Washington helped him obtain a position on Clarence King's fortieth-parallel survey team in the Rocky Mountains. He accompanied King again in 1870, going to Mount Shasta with the photographer Carleton Watkins; work by both of them was published in King's *Mountaineering in the Sierra Nevadas*. One of California's best-known landscape painters of the 1870s, Munger exhibited at the San Francisco gallery Snow and Roos alongside Albert Bierstadt, Thomas Hill, and John Ross Key. During this time he made his first visit to Yosemite, which became a popular subject for him. In 1877 Munger moved his studio to London, where he gained some success among Europe's cosmopolitan elite. He moved again in 1886 to Paris, where his style changed to reflect the French taste for poetic scenes influenced by

the Barbizon artists. He returned to New York in 1893 and continued to paint until his death a decade later.

DAVID MUSSINA

BORN 1947, ERIE, PENNSYLVANIA

David Mussina received a Master of Arts degree in sociology from Boston College and is currently a faculty member in the photography department at the School of the Museum of Fine Arts, Boston. A landscape photographer, he has traveled to several national parks, including Yosemite, the Grand Canyon, Yellowstone, and Glacier. Using black-and-white film, Mussina documents the interactions of tourists with nature, pointing out the disjunction between the man-made spaces created by the boardwalks and railings that confine the movement of visitors and the wide-open spaces promoted by the national park system. Famous landmarks appear in some images, but they are not the subject of the photograph: typically, they are placed in the background while the people who come to view the scenery occupy the foreground. Mussina received an artist's fellowship from the Massachusetts Council on the Arts and Humanities in 1987 and a Medford Cultural Council grant in 1998. He was an artist-in-residence at Yosemite in 1990.

EADWEARD J. MUYBRIDGE

BORN 1830, KINGSTON-UPON-THAMES, ENGLAND
DIED 1904, KINGSTON-UPON-THAMES, ENGLAND

Born Edward Muggeridge, Eadweard J. Muybridge adopted the Saxon spelling of his name early on. After immigrating to the United States in 1852, he worked as a publisher and book dealer in San Francisco; it was not until 1860, when he returned to England for a number of years, that he took up photography. In 1867, he settled again in California, where he began making and selling landscape photographs, often using the pseudonym Helios. He made the arduous trip to Yosemite for the first time that year, carrying his equipment and darkroom with him, like all photographers of the time. Using a small view camera, he produced twenty photographs of the park for *Yosemite: Its Wonders and Its Beauties*, an 1868 guidebook by John S. Hittell. Muybridge also

worked with a larger-format camera and a stereoscopic camera to create his images, which not only capitalized on the spectacular scenery but also played with light, mist, and shadows. Between 1867 and 1873, Muybridge created over two thousand photographs of the West, which included some of the earliest shots of Yosemite's Native residents. However, he is best remembered for his photographic studies of Occident, Leland Stanford's favorite racehorse, in motion, which were published in *Scientific American* in 1878.

CHIURA OBATA

BORN 1885, SENDAI, JAPAN
DIED 1975, BERKELEY, CALIFORNIA

Chiura Obata immigrated to the United States in 1903 and settled in California, where he worked as an illustrator and commercial designer. Obata founded the East West Art Society in 1921 to create an artistic dialogue, both to promote cross-cultural understanding through art and as a means of maintaining a connection to his homeland. In 1927, he visited Yosemite and the Sierra Nevada for the first time, creating more than one hundred watercolors and sketches during his visit. He included many of these images as prints in his *World Landscape Series–America*, a project he supervised while on a visit to Japan in 1928. One of the images, *Lake Basin in the High Sierra*, won first place at the Eighty-seventh Annual Exhibition at Ueno Park, Tokyo. Mostly woodblocks, the prints feature luminous color, dramatic skies, and strong graphic elements, including the use of black outlining; many are very intricate, requiring up to 160 separate impressions. After Obata's return to California, he worked on California landscapes in a style that fused Japanese *sumi-e* painting with the Western conventions of naturalism. In 1942, during World War II, Obata was sent to a Japanese American relocation camp. He continued to work during his internment until his release in 1945, creating more than one hundred sketches and paintings, and even forming an art school that served more than six hundred students. The book *Topaz Moon*, edited by Obata's granddaughter, Kimi Kodani Hill, and featuring the art made during his internment, was published in 2000.

GEORGIA O'KEEFFE
BORN 1887, SUN PRAIRIE, WISCONSIN
DIED 1986, SANTA FE, NEW MEXICO

Georgia O'Keeffe grew up on a small farm in Wisconsin. Her art studies began in 1904–5 with John H. Vanderpoel at the Art Institute of Chicago and continued with William Merritt Chase at the Art Students League in New York City in 1907 and with Arthur Wesley Dow at Columbia University in 1914–15. In May 1916, photographer and dealer Alfred Stieglitz gave O'Keeffe her first exhibition at his New York City gallery, 291. Later that year, she was appointed head of the art department at West Texas State Normal College in Amarillo. In 1917, O'Keeffe visited New Mexico for the first time. Drawn to the architecture, the light, and the sparse desert landscape of the Southwest, she would return often in subsequent years; in 1945, she bought a house in Abiquiu. In 1938, O'Keeffe made her first trip to Yosemite, accompanied by Ansel Adams, David McAlpin, and Godfrey and Helen Rockefeller. Drawing inspiration from O'Keeffe's presence, Adams produced several fine photographs during the trip, but O'Keeffe herself did not create any paintings. However, a subsequent visit in 1952 to Yosemite did result in two canvases. In 1971, O'Keeffe suffered a partial loss of sight. She continued working in pencil and watercolor until 1982 and also sculpted in clay until her health failed in 1984. She died two years later, at the age of ninety-eight.

TED ORLAND
BORN 1941, SAN FRANCISCO, CALIFORNIA

Photographer Ted Orland believes that if you lead an interesting life, you'll make interesting art, and he carries his camera everywhere he goes. In 1966, he visited Yosemite as a student at Ansel Adams's annual photography workshop. This experience marked the beginning of a close connection to the park. For the next fifteen summers, he returned to Yosemite as an instructor at the workshops. As an assistant to Adams, Orland worked from 1972 to 1975 on the printing of Adams's special-edition Yosemite prints. From 1984 to 1986, he was the director of the photography workshops (run by the Ansel Adams Gallery). In 1987,

Orland became the first photographer to be accepted into the National Park Service's artist-in-residency program at Yosemite. Recognized in 1988 with a certificate of special recognition from the United States Congress for his work to help conserve Mono Lake, Orland continues to be active in photographing the Yosemite region. His book *Man and Yosemite: A Photographer's View of the Early Years* (1980) presents a photographic interpretation of Yosemite's early history. He generally works in black-and-white, preferring to use natural light and often hand-tinting his images. Orland's photographs of Yosemite often assume an ironic viewpoint, focusing on the tourist experience.

PHIL PARADISE
BORN 1905, ONTARIO, OREGON
DIED 1997

Born in Oregon, Phil Paradise grew up in Bakersfield, California. He moved to Los Angeles in the 1920s, where he enrolled in the Chouinard Art Institute. He also worked at Paramount Studios and would later teach at both Chouinard and Scripps College. By 1930 Paradise was known for his watercolor scenes that celebrate the burgeoning urban society and beach culture of Southern California. He became president of the California Watercolor Society in 1939 and set up a print shop in Cambria in 1940. From there he continued to create some of his most memorable images, including his 1946 cover of *Westways,* the magazine for the Auto Club of Southern California.

JULIA PARKER
BORN 1929, GRATON, CALIFORNIA

Julia Parker, of Kashia Pomo and Coast Miwok descent, met her husband, Ralph Parker, at Stewart Indian School in Nevada. The couple settled in his family's home in Yosemite, and Julia began to learn traditional weaving methods from Ralph's mother, Lucy Telles. Julia Parker weaves coiled and twined baskets, as well as baskets in the Pomo style; she also creates miniature baskets, incorporating traditional materials and designs along with her own innovations. In 1960, Parker helped the National Park Service revive demonstrations

of basket weaving at the Yosemite Museum, a role once held by Telles. Throughout the 1970s, Parker taught classes to other Native women in Yosemite and at local museums. In the 1980s, she became a full-time National Park Service employee in the Indian Cultural Program; in this role, she has spent the past two-and-a-half decades teaching throughout California. As an elder and cultural demonstrator, Parker is a key figure in preserving traditional weaving techniques, along with the plants used in basketry and their habitats.

RONDAL PARTRIDGE
BORN 1917, SAN FRANCISCO, CALIFORNIA

The son of photographer Imogen Cunningham and artist Roi Partridge, Rondal Partridge has been surrounded by artists throughout his life. At the age of five, he began helping his mother in the darkroom. By age sixteen, he was apprenticed to photographer Dorothea Lange, driving her throughout California as she documented migrant workers' lives. From 1937 to 1938, Partridge worked with Ansel Adams in Yosemite. Partridge's own work in Yosemite concentrates on the park's infrastructure, the congestion of its parking lots, and its crowded campsites, rather than the natural beauty celebrated by Adams. Partridge has also documented the changing landscape of the San Francisco Bay Area. In addition to his urban scenes and architectural views, he has photographed still lifes and portraits of figures from the prominent to the obscure.

ENOCH WOOD PERRY
BORN 1831, BOSTON, MASSACHUSETTS
DIED 1915, NEW YORK CITY, NEW YORK

In 1848, at the age of seventeen, Enoch Wood Perry had saved enough money from his job in a New Orleans grocery store to travel to Europe. He remained on the continent until 1860, studying with Emanuel Leutze in Düsseldorf, Germany, and Thomas Couture in Paris. He also served as a U.S. consul in Venice, Italy, before returning to the United States. There, he established a successful studio in New Orleans, painting portraits of notable figures. In 1862, like many painters of

the time, Perry decided to travel west to capture the majestic landscapes of the Rockies and California. In 1863, he met Albert Bierstadt in San Francisco and traveled with the well-known painter and Virgil Williams to Yosemite. Perry continued to produce portraits, painting the king of Hawaii in 1863 and Mormon leader Brigham Young in Utah in 1864. He often exhibited his genre scenes, for which he gained popularity, at the National Academy of Design, where he was elected a member in 1869.

ARTHUR C. PILLSBURY
BORN 1870, MEDFORD, MASSACHUSETTS
DIED 1946, NEAR BERKELEY, CALIFORNIA

Arthur C. Pillsbury settled in Auburn, California, in 1883 with his parents, who were both doctors. In 1895, while a student at the newly opened Stanford University, he made his first visit to Yosemite by bicycle. He arranged to buy a photography studio there in 1897 with Julius Boysen. Between 1900 and 1903 Pillsbury ran his Oakland business, Pillsbury's Pictures, in the winter and spent summers in Yosemite, where he photographed many of the park's more prominent visitors, including Theodore Roosevelt. Increasingly he experimented with artistic effects and began producing and selling orotones, photographs backed in gold that gave off a holographic sheen. Following the 1906 San Francisco earthquake, Pillsbury photographed the devastation, including the Palace Hotel. The same year in Yosemite Valley he opened his Studio of the Three Arrows, which included a nature center and a theater in which he showed films about the natural world. By 1911 Pillsbury had adopted the orphaned children of his oldest brother, who was killed in an auto accident. He and his family spent six months of the year in Yosemite, returning each summer to open the photography studio. Throughout the 1920s, Pillsbury continued to work on his inventions, including a panoramic camera and a film advancer for a motion picture camera. He lectured on nature throughout the 1930s and died in the Berkeley area in 1946.

JAMES J. REILLY
BORN 1838, SCOTLAND
DIED 1894, SAN FRANCISCO, CALIFORNIA

Scottish-born James J. Reilly arrived in California in 1856. He became a citizen in 1866, after serving in the Union Army during the Civil War. In 1870 Reilly traveled from Niagara Falls in upstate New York to California with Charles Bierstadt, the brother of the famed landscape painter. Later that year, Reilly opened a studio in Yosemite, eventually joining forces with rival photographer Martin Mason Hazeltine in 1876. He spent the next several summers in Yosemite Valley, where he sold scenic views and portraits to tourists. He also befriended John Muir. Reilly moved from Stockton to San Francisco in 1873, but he continued to operate his Yosemite concession during the summers until 1877, when he moved to Marysville. There he opened a gallery and operated as a landscape and portrait photographer for the next seven years, returning to San Francisco in 1885. Diminished work prospects and squandered earnings left him despondent by 1894, when he died from carbon monoxide poisoning following a suicide attempt.

CHARLES DORMAN ROBINSON
BORN 1847, EAST MONMOUTH, MAINE
DIED 1933, SAN RAFAEL, CALIFORNIA

Charles Dorman Robinson's father moved his family from the East Coast to California in 1848. Intrigued by ships in San Francisco's harbor, Robinson began sketching at an early age. He began his formal training in Charles Christian Nahl's studio at the age of seven, and at thirteen earned an award for best marine drawing in the juvenile department at the Mechanic's Institute. He returned to the East Coast for a short time in 1861, studying with George Inness and William Bradford. After moving back to San Francisco, he wrote and illustrated for *Century Magazine* and *Overland Monthly*. He turned to painting full-time in 1875. Robinson visited Yosemite for the first time in 1880, and returned to the valley each summer for the next twenty-four years. His large-scale canvases of Yosemite emphasize light and atmosphere, and suggest the influence of Inness. After the 1906 San Francisco

earthquake and fire destroyed many of Robinson's early works, he created new paintings of Yosemite, many of which were also lost in another fire in 1921.

GALEN ROWELL
BORN 1940, OAKLAND, CALIFORNIA
DIED 2002, BISHOP, CALIFORNIA

Introduced to the wilderness before he could walk, Galen Rowell began climbing mountains at the age of ten and made his first roped climbs in Yosemite by the age of sixteen. Over the next fifteen years, he would make more than one hundred first ascents in Yosemite and the Sierra Nevada. At first, Rowell took photographs as a way of sharing his adventures and the scenery he witnessed with his friends, but in 1972 he took up photography as a career. The following year, he received a cover story assignment from *National Geographic* magazine to document the first clean ascent of the northwest face of Half Dome in Yosemite. Rowell continued to receive magazine assignments throughout his career, while also pursuing his own fine art landscape photography. Traveling around the world, he photographed sites in Yosemite, coastal California, and other parts of the American West, as well as in Antarctica, Tibet, Nepal, and Latin America. In documenting the beauty of a location, whether a single tree or a larger-than-life waterfall, he looked for both the big and the small in the landscape. His color photographs are saturated with vibrant, bold colors. In 1984, Rowell received the Ansel Adams Award for Conservation Photography from the Sierra Club for his contributions to the art of wilderness photography. He is remembered today as one of Yosemite's most ardent enthusiasts and adventuresome photographers.

ADOLPH SCHWARTZ
BORN 1829, KARLSRUHE, GERMANY
DIED 1872, NEW YORK CITY, NEW YORK

A lieutenant in the German Army by the age of twenty, Adolph Schwartz joined the liberal revolution sweeping through Europe and found himself in jail for conspiring with the republican movement. In 1850, he escaped

from prison and made his way to New York City. Seven years later, he moved to California, where he made friends with Johann Augustus Sutter, James W. Marshall, and John Charles Frémont. He fought with Generals Grant and McClellan in the Civil War before retiring from the military in 1864. Subsequently, he worked as an architect, first in Illinois and then in New York. Throughout his life and travels, Schwartz documented his surroundings with pen-and-ink drawings and watercolors, executing detailed renderings of places he had seen. In 1859, he published an article in *Hutchings' California Magazine,* titled "Pen and Pencil Sketches of Bear Valley: Its Surrounding Scenery, and Mineral Resources." It is possible that he traveled with the photographer Charles Weed to Yosemite in 1859.

PHYLLIS SHAFER
BORN 1958, BUFFALO, NEW YORK

After receiving a Master of Fine Arts degree from the University of California, Berkeley, in 1988, Phyllis Shafer continued to exhibit her work and teach part-time in the San Francisco Bay Area. In 1994, she moved to Lake Tahoe, a place that deepened her interest in the natural world and its relationship to psychological states of being. For the past twelve years, she has been a full-time instructor at Lake Tahoe Community College. Long associated with the Lake Tahoe region, Shafer made her first extensive painting trip to Yosemite in 2004. During this and successive trips, she has created a body of work related to Yosemite and the High Sierra.

CHARLES SHEELER
BORN 1883, PHILADELPHIA, PENNSYLVANIA
DIED 1965, DOBBS FERRY, NEW YORK

Best known as a precisionist painter and photographer, Charles Sheeler began his studies under William Merritt Chase at the Pennsylvania Academy of Fine Arts from 1903 to 1906. He first became interested in modern art during a trip to Europe with Morton Livingston Schamberg, an abstract painter. By 1912, Sheeler was supporting himself as a commercial photographer, while also producing a

series of sharply focused images of rural farmhouses and barns that reflect an affinity for geometric shapes. Over time, Sheeler's paintings and photographs grew more similar, both tending to pare down a subject to the most essential elements of line and shape. Sheeler became interested in industrial subjects in the 1920s, when he was hired by the Ford Motor Company to photograph the River Rouge plant near Detroit. A number of precisionist photographs resulted from this assignment and inspired several paintings of the same subject. In 1956, Sheeler visited with Ansel Adams in California. At Adams's urging, he traveled to Yosemite, creating a small series of paintings that focus on pure landscape, works that explore close-up views of nature and its patterns.

STEPHEN SHORE
BORN 1947, NEW YORK CITY, NEW YORK

A self-taught artist, Stephen Shore received a photographic darkroom kit at the age of six; was influenced by Walker Evans's book *American Photographs* at the age of ten; and at fourteen presented his photographs to Edward Steichen, then a curator at the Museum of Modern Art in New York City, who bought three works. At seventeen, Shore met artist Andy Warhol and began to visit his studio, The Factory, photographing Warhol and his creative process. Seven years later, Shore became the first living photographer to have a solo exhibition at the Metropolitan Museum of Art in New York. In 1972, he embarked on a cross-country trip that would last for several years. Along the way, he captured the American landscape, from street corners, gas stations, diners, and motels, to more traditional landscapes like national parks. Visiting Yosemite in 1979, Shore focused his camera not on the park's falls or El Capitan, but instead on the relationship between tourists and the scenery.

THOMAS STRUTH
BORN 1954, GELDERN, GERMANY

Thomas Struth studied painting with Gerhard Richter and photography with Bernd and Hilla Becher at the Kunstakademie Düsseldorf from 1973 to 1980. While still a student, he began

taking black-and-white photographs of city scenes, often devoid of people. The series *The Architecture of Streets* and *The Panorama of the City,* both begun in 1976, document the urban planning patterns of large metropolises such as Düsseldorf, Berlin, Paris, and New York City. The *Tower Hamlets* series (1977) depicts the working districts of London, and *Rhine Port, Düsseldorf* (1979–82) features scenes of the industrial area of Düsseldorf. In his later work, Struth started using color film and increased the scale of his prints. *Museum Photographs,* begun in 1989, explores the relationships between the viewer and artworks on display. The *New Pictures from Paradise* series, commenced in 1998, took Struth across the world, from Australia to China to Japan to Brazil, in search of woods and rainforests to photograph. In 1999, Struth traveled to Yosemite. Although Yosemite's famous landmarks are visible in his work, as Struth's subjects, his real focus seems to be on the park's roads and the tourists pulling off to the side to photograph natural monuments, much as the artist himself was doing.

DON SUGGS
BORN 1945, FORT WORTH, TEXAS

Don Suggs received his Bachelor of Arts, Master of Arts, and Master of Fine Arts degrees from the University of California, Los Angeles. In 1983, the school hired Suggs as an instructor of painting and drawing. He also has taught at Florida State University, Tallahassee; Franconia College, New Hampshire; University of Southern California, Los Angeles; and the Otis Art Institute, Los Angeles. A painter and photographer, Suggs received a 1991 National Endowment for the Arts Fellowship for his painting. In 1996–97, he was an artist-in-residence at Yosemite, where he spent a lot of time studying the habits of tourists. In his composite photographs of Yosemite, he and you, the viewer, are voyeurs witnessing scenes played out day after day in national parks across the country.

HENRY SUGIMOTO
BORN 1900, WAKAYAMA, JAPAN
DIED 1990, NEW YORK CITY, NEW YORK

At the age of nineteen, Henry Sugimoto traveled from Japan to join his parents, who had immigrated to Hanford, California. Determined to become an artist, Sugimoto moved to San Francisco to attend the California College of Arts and Crafts and the California School of Fine Arts. Like many artists of the time, he completed his training by traveling to Europe, spending two years in France. He then returned to San Francisco, and his career flourished throughout the 1930s; he had his first solo exhibition at the California Palace of the Legion of Honor in 1933. Drawing on the colors and techniques of the French impressionist paintings he had seen in France, Sugimoto often chose iconic California sites, such as Yosemite, for his idyllic landscapes. During World War II, he was forced into a Japanese American relocation camp in Fresno and then into the Jerome and Rohwer camps in Arkansas. After his release, Sugimoto abandoned beautiful landscapes and focused instead on narrative and figurative works, many of which tackled complex stories concerning civil rights. His palette also changed, as he drew on the bold and vibrant colors of Mexican muralists like Diego Rivera and José Clemente Orozco.

ISAIAH TABER
BORN 1830, NEW BEDFORD, MASSACHUSETTS
DIED 1912, SAN FRANCISCO, CALIFORNIA

Before turning to photography in the 1860s, Isaiah Taber joined the California Gold Rush, maintained a ranch, and worked as a dentist in San Francisco. After working for the photography firm of Bradley and Rulofson for seven years and later for G. D. Morse, he opened his own studio in San Francisco in the mid-1870s, becoming a prominent portrait and landscape photographer. When photographer Carleton E. Watkins went bankrupt in 1875–76, Taber acquired a large number of Watkins's negatives, many of Yosemite Valley, which he reprinted under his own name and used to make illustrations for *Century Magazine*. By the 1890s,

Taber had studios in England and Europe, and he won the photographic concession of the 1893–94 Midwinter Fair in San Francisco. Taber produced more than thirty thousand images of California and the West and 100,000 portraits throughout his career. Tragically, all of his glass-plate negatives—most of his life's work—were lost in the 1906 San Francisco earthquake and ensuing fires.

JULES TAVERNIER
BORN 1844, PARIS, FRANCE
DIED 1899, HONOLULU, HAWAII

Jules Tavernier began his studies at the École des Beaux-Arts in Paris. He exhibited at the Paris Salon from 1865 to 1870, fought in the Franco-Prussian War, and in 1871 immigrated to London. The following year, he moved to New York City and quickly found work as an illustrator for *New York Graphic, Leslie's Illustrated Newspaper, Scribner's,* and *Harper's Weekly*. Commissioned by *Harper's* to undertake an overland sketching tour of the West, Tavernier and artist Paul Frénzeny traveled together from New York to San Francisco, Tavernier creating compositions and Frénzeny adding details and copying their images onto engraving blocks. After arriving in California in 1874, Tavernier settled in San Francisco and became an active member of the art community there. He traveled to Yosemite in 1881 with two other painters. While there, he created several studies of the valley, which he turned into grand landscape paintings after his return. Tavernier's scenes of Yosemite and other landscapes appealed to some of California's richest men, including Leland Stanford, who would become his client. Tavernier was a founder of the Bohemian Club, a cofounder of the Palette Club, and vice president of the San Francisco Art Association.

LUCY TELLES
BORN 1885, MONO LAKE, CALIFORNIA
DIED 1955, YOSEMITE, CALIFORNIA

Lucy Telles, of Yosemite Miwok and Mono Lake Paiute descent, grew up in Yosemite Valley and Mono Lake. She learned to weave from her mother and by the 1920s was one of the best weavers in the Yosemite Valley. Telles

used traditional materials such as bracken fern and redbud, but she often included new and innovative designs as well, which were popular with tourists. She modified traditional Miwok shapes and began to use two colors, red and black, in each basket, where before only one color had been used. She also experimented with new motifs, such as butterflies and flowers, as well as adding beadwork. These innovations had a profound effect on younger weavers, and her work helped to shape Yosemite basketry. Telles demonstrated weaving methods to visitors in the Indian Village at the Yosemite Museum, and in the 1930s she began to make sizable baskets, including one that took four years to complete. When finished, in 1933, it was recognized as the largest basket ever woven in the Yosemite region and was exhibited at the 1939 Golden Gate International Exposition in San Francisco. In 1950, Telles started but was unable to finish a basket that would have been larger than her 1933 creation, with a base measuring 18 inches in diameter.

WAYNE THIEBAUD
BORN 1920, MESA, ARIZONA

Wayne Thiebaud began his career in the animation department of Walt Disney Studios in 1936. He then studied commercial art at Frank Wiggins Trade School, attended Long Beach Junior College, served in the air force, and later returned to commercial art as a layout designer and cartoonist for Rexall Drug Company. He earned a Master of Arts degree from California State College, Sacramento, in 1953. At this time, Thiebaud was working in an expressionist style, applying gestural brushwork to the depiction of everyday objects. By the late 1950s, he was still concentrating on familiar objects, such as pies and cakes, but his style had changed: perhaps returning to his commercial roots, he began smoothing the texture of his brushstroke, simplified his subjects to the basic elements of form, and created ordered canvases with bright, posterlike colors. Thiebaud introduced the human figure into his paintings in the 1960s and focused on the hills and landscapes of San Francisco in the

1970s. In 1995, he illustrated a limited-edition reprint of Frederick Law Olmsted's management plan for Yosemite, titled *Yosemite and the Mariposa Grove: A Preliminary Report, 1865,* for which he won an Award of Excellence from the National Park Service. Thiebaud has held a number of teaching positions, won numerous awards, and is a member of the American Academy and Institute of Arts and Letters and the National Academy of Design.

LEANNA TOM
BORN CA. 1850, YOSEMITE VALLEY, CALIFORNIA
DIED 1965, COLEVILLE, CALIFORNIA

The daughter of Captain and Suzie Sam, both of Paiute heritage, Leanna Tom mastered the art of weaving Pauite twined utilitarian baskets as a young girl and began weaving fancier baskets for sale after observing the success of her niece, Lucy Telles. In 1916 she entered a new-style basket in the nearby Bishop Harvest Days Festival and soon became known for her blending of traditional patterns with those inspired by beadwork. Throughout the 1920s her finely woven baskets won many prizes in the Indian Field Days competitions. After her first husband died, she married a Paiute man, Mack "Bridgeport" Tom (who was also married to her sister, Louisa Tom), with whom she had four children. The family lived in Yosemite Valley during the summers, where Tom worked in the kitchen at the Sentinel Hotel as well as on her basketry. Winters were spent at her husband's ranch in Mono Basin. She moved to Coleville following his death in 1937.

JERRY UELSMANN
BORN 1934, DETROIT, MICHIGAN

Jerry Uelsmann developed an interest in photography during high school and went on to study with Minor White and Ralph Hattersley at the Rochester Institute of Technology. He published his first image in *Photography Annual* in 1957, the year he graduated, and later studied audiovisual communication, art history, and design at Indiana University, receiving Master of Fine Arts and Master of Science degrees in 1960. Among his professors at Indi-

ana University was Henry Holmes Smith, whom Uelsmann credits with changing his approach to photography. From 1960 to 1974, Uelsmann taught at the University of Florida in Gainesville. Known for his surrealistic images, Uelsmann subverts the idea that photography documents the "real" or the "facts of a scene." He combines and manipulates his negatives to produce otherworldly effects, working with between three and eight enlargers in the darkroom and never using digital techniques. Uelsmann received a Guggenheim Fellowship in 1967 and a National Endowment for the Arts Fellowship in 1972. He taught with Ansel Adams in Yosemite in the early 1970s; *Uelsmann/Yosemite,* featuring photographs he made of Yosemite between 1973 and 1995, was published in 1996.

J. MICHAEL WALKER
BORN 1952, LITTLE ROCK, ARKANSAS

Los Angeles–based artist J. Michael Walker has explored the city's Hispanic roots. He immersed himself in Mexican culture when he moved to Chihuahua, Mexico, in 1974. In 1995, Walker began a series that imagined the Virgin of Guadalupe, Mexico's patron saint, as a real woman. Another series, *All the Saints of the City of Angels,* an ongoing, multiyear project that has so far resulted in sixty paintings, two books, and several exhibitions, explores the connections among the Hispanic cultures of Los Angeles, the city's street names, and Catholic saints. The large-scale, mixed-media paintings detail the convergence of stories surrounding these saints and streets. In *The Removal of the Miwok from Yosemite* (2005), Walker presents the park experience in an unconventional light: memorialized by several generations of artists for its beauty, Glacier Point appears in Walker's landscape as a place of conflict between Native people and Europeans. Walker has received nine grants from the Cultural Affairs Department of the City of Los Angeles since 1989, and one from the California Council of the Humanities in 2000. He was a California Arts Council artist-in-residence from 1989 to 1992.

CARLETON E. WATKINS
BORN 1829, ONEONTA, NEW YORK
DIED 1916, IMOLA, CALIFORNIA

Lured to the West by the California Gold Rush, Carleton E. Watkins found work in a San Francisco photography studio in 1853. Three years later, he had his own studio and was hired to take photographs that were used to settle land disputes and mining interests. Watkins embarked on his first photographic expedition to Yosemite in 1861, and the valley would subsequently become a major focus of his life's work. Unable to capture the vastness of Yosemite with a traditional camera, Watkins had a carpenter create a mammoth-plate camera capable of producing 18-by-22-inch negatives. In 1863, he published *Yo-Semite Valley: Photographic Views of the Falls and Valley,* and in 1864 his Yosemite photographs played an influential role in persuading the United States Congress to pass legislation to preserve Yosemite Valley. Watkins opened his Yosemite Art Gallery in San Francisco in 1871; however, the Panic of 1873 ultimately caused Watkins to close his studio in 1875, and many of his negatives went to his creditors. Watkins re-created much of his Yosemite work, though the 1906 San Francisco earthquake and resulting fires destroyed most of his glass-plate negatives.

CHARLES WEED
BORN 1824, NEW YORK CITY, NEW YORK
DIED 1903, OAKLAND, CALIFORNIA

Charles Weed became the manager of R. H. Vance's Sacramento photography studio in 1858, before moving to San Francisco to run Vance and Weed, a satellite of the Sacramento studio. He visited Yosemite for the first time in 1859, when he accompanied a tourist party led by the writer and publisher James Mason Hutchings. In 1859, Weed took a photograph of Yosemite Falls, believed to be the first photograph ever taken of Yosemite. Before he left the valley, Weed took at least twenty 11-by-14-inch views and forty stereoviews. Displayed at Vance and Weed and published as an engraving in *Hutchings' California Magazine,* Weed's photographs introduced many to Yosemite. Following photographer Carleton E. Watkins's lead, on his next trip to Yosemite, in 1864,

Weed used a mammoth-plate camera capable of producing 17-by-22-inch prints. Twenty-six of Weed's photographs, including several of his mammoth-plate views of Yosemite, were exhibited at the Exposition Universelle in Paris in 1867, where they won an award for landscape photography. In 1865, Weed traveled to Hawaii, photographing the island's famed volcanoes before continuing on to Hong Kong. The later part of his career was spent as a photoengraver.

EDWARD WESTON
BORN 1885, HIGHLAND PARK, ILLINOIS
DIED 1958, CARMEL, CALIFORNIA

Edward Weston's career began at the age of sixteen, when his father gave him a camera. After moving to California from Illinois in 1906, the largely self-taught Weston made a living taking portraits and documenting weddings and funerals. Recognizing the need for further training, he briefly attended the Illinois College of Photography and then returned to California. In 1911, Weston opened his own studio in Tropico (now Glendale, in greater Los Angeles). Successful as a pictorialist, Weston won several awards, and his soft-focus images were published in numerous magazines, including *American Photography*. Weston's style changed in 1922; he rejected pictorialism, preferring to capture the straight, hard-edge, almost abstract lines of his subjects. That same year, he traveled to New York City, where he met Alfred Stieglitz, Paul Strand, Charles Sheeler, and Georgia O'Keeffe. Weston moved to Mexico City in 1923 and opened a studio with photographer Tina Modotti. He returned to California three years later and began a series that drew the viewer's attention to the texture and sculptural quality of everyday objects, such as vegetables, using close-ups and dramatic contrasts. In 1929, Weston moved to Carmel, and in 1932 he cofounded Group f/64. In 1937, he became the first photographer to receive a Guggenheim Fellowship, which he used to spend two years traveling and photographing the West, including a visit to Yosemite in 1938. In 1940, Weston participated at the U.S. Camera Yosemite Photographic Forum with Ansel Adams and

Dorothea Lange. Suffering from Parkinson's disease, Weston took his last photograph in 1948 but continued to supervise the printing of his negatives.

GUNNAR WIDFORSS
BORN 1879, STOCKHOLM, SWEDEN
DIED 1934, GRAND CANYON, ARIZONA

Gunnar Widforss studied mural painting at the Institute of Technology in Stockholm from 1896 to 1900 and was already an accomplished artist when he came to the United States from Sweden in 1921. At the encouragement of Stephen Mather, the first director of the National Park Service, Widforss visited several of the most prominent national parks, including Yosemite, Yellowstone, and the Grand Canyon. After settling in California, Widforss continued to paint these grand landscapes and expanded his oeuvre to include Bryce Canyon and Zion in Utah. Widforss was commissioned in 1927 to create a series of images of Yosemite's new Ahwahnee Hotel, but he remains best known for his work at the Grand Canyon, where he maintained a studio on the canyon's rim. After suffering a fatal heart attack at the age of fifty-four, Widforss was buried in the Grand Canyon Cemetery. In 1969, the Yosemite Museum held the first major retrospective of his work.

VIRGIL WILLIAMS
BORN 1830, DIXIFIELD, MAINE
DIED 1886, ST. HELENA, CALIFORNIA

Raised in Massachusetts, Virgil Williams studied at Brown University before moving to New York City, where he began his art training with Daniel Huntington. He went on to study with William Page in Rome from 1853 to 1860, eventually marrying Page's daughter, Mary. Upon returning to the United States, Williams operated his own studio in Boston for two years. In 1862, R. B. Woodward commissioned Williams to design and install an art gallery in San Francisco. Woodward's Art Gallery opened in 1865 with an exhibition of sixty-six paintings by Williams, Charles Christian Nahl, and Thomas Hill. Soon after the opening, Williams returned to Boston and taught drawing at Harvard University and the Boston School of Technology. He moved to San Francisco in

1871, becoming the first director of the newly formed California School of Design three years later. He held that position for twelve years and counted Hill and Christian Jörgensen as his pupils. Although Williams continued to create scenes of Italy inspired by his early student days in Rome, he also produced landscapes of the wine country and other California views.

ALICE JAMES WILSON
BORN 1899, MONO LAKE, CALIFORNIA
DIED 1959, NEAR MARIPOSA, CALIFORNIA

The daughter of Bridgeport Tom and Louisa Sam Tom, both of Paiute heritage, Alice married a Chukchansi Yokuts man named Fremont James before she turned seventeen, and they had four children. After they separated in the 1920s, she married Westley Wilson, from a prominent Miwok family. The Wilsons lived in the Indian Village in Yosemite Valley, where Alice worked as a maid in the Sentinel Hotel and demonstrated basketry first at the Ahwahnee Hotel and later behind the Yosemite Museum. An accomplished weaver by age sixteen, Wilson created both utilitarian and new-style, or fancy, baskets for the Indian Field Days competitions. Recognized for her naturalistic patterns that incorporated animal and human motifs, Wilson made her largest basket in the early 1930s, around the time that Lucy Telles and Carrie Bethel were garnering recognition for their sizable creations. Wilson also became known for her beadwork and created a number of beaded pieces, including sashes, an elaborate cradleboard, and several fine baskets. She did not weave regularly after the 1940s but continued to produce smaller beaded works, such as gloves and pins, which were popular with visitors.

THEODORE WORES
BORN 1859, SAN FRANCISCO, CALIFORNIA
DIED 1939, SAN FRANCISCO, CALIFORNIA

At the age of twelve, Theodore Wores studied with artist Joseph Harrington, who taught him composition and perspective. One of the first students to enroll at the newly opened California School of Design, Wores studied under

Virgil Williams for a year in 1874 before moving to Munich to study at the Akademie der Bildenden Künste München. In Munich he met William Merritt Chase and Frank Duveneck, and he spent several years traveling with the "Duveneck Boys," a group of art students known for both their devotion to realism in painting and their carousing. In 1879 the group went to Italy, where Wores met James McNeill Whistler. After Wores returned to San Francisco in 1881, he became known for his paintings of Chinatown, which were praised for their artistic and documentary qualities. He embarked on a trip to Japan in the mid-1880s and continued his travels in London, New York City, and Boston. After returning to the United States in 1898, he painted California landscapes, including Yosemite, and did portraiture for the first time. His house and studio burned in the fire following the San Francisco earthquake of 1906. Wores was appointed dean of the San Francisco Art Institute from 1907 to 1913. After his tenure, he traveled extensively once again, returning in 1926 to build a new studio in an old church in Saratoga, California. Throughout his career, Wores's artistic palette moved from the browns of the Munich School to the pastels of the impressionists. In his later years, he concentrated on painting the orchards and flowering gardens around his studio.

MARGUERITE THOMPSON ZORACH
BORN 1887, FRESNO, CALIFORNIA
DIED 1968, BROOKLYN, NEW YORK

Marguerite Thompson Zorach grew up in Fresno, where her parents created a home environment that valued art and music. She studied piano, French, and German in high school before enrolling in Stanford University in 1908. Soon thereafter, she joined her aunt in Paris, where she saw works by Henri Matisse and the fauves at the annual Salon d'Automne. Drawn to the progressive in art, she began studying at John Duncan Fergusson's Académie de la Palette, where she met fellow student William Zorach in 1911. Together, they devised an ideological approach to art and life that emphasized individuality and freedom of expression over traditional social constraints or mores, principles that guided them for the next fifty years. Marguerite married William in 1912 in New York, where the two artists often mounted exhibitions in their home. Although she lived most of her life in New York, Marguerite was interested in landscape and often spent part of each year in a rural setting, such as Maine, New Hampshire, or, in 1920, Yosemite. Inspired by the Armory Show of 1913, she was strongly influenced by cubism and admired African, Japanese, and Native American art. She exhibited with Edith Halpert in New York and had a joint exhibition with her husband at the California Palace of the Legion of Honor in San Francisco in 1945–46.

WILLIAM ZORACH
BORN 1887, EURBURG, LITHUANIA
DIED 1966, BATH, MAINE

William Zorach immigrated to the United States with his family at the age of four. He left school after eighth grade and obtained an apprenticeship at the W. J. Morgan Lithograph Company in Cleveland, which allowed him to explore his artistic talents and help support his family. While still apprenticing, he attended night school at the Cleveland School of Art from 1902 to 1905. Zorach moved to New York City in 1908 and enrolled at the National Academy of Design, where he studied for two years before traveling to Paris. Disenchanted with that city's traditional academies and the Salon-style painting they encouraged, Zorach ended up studying at the Académie de la Palette, where, in 1911, he met his creative companion and future wife, Marguerite Thompson. The couple returned to New York to live, drawn by the rumblings about modern art taking off in the city. There, they joined a community of artists that included Marsden Hartley, John Marin, and Arthur Dove. Influenced by post-impressionism, Zorach broke free from the constraints of his apprenticeship and academic thought, using flat areas of color, heavy outlines, and the bold colors employed by Henri Matisse. Zorach spent most of the year painting views of New York, but traveled to the countryside every summer. In 1920, he and his wife spent the summer camping in Yosemite, where he created perhaps the first truly abstract painting of Yosemite Falls. Zorach continued to experiment with mediums and styles, working in watercolor, printmaking, and sculpture and embracing the new aesthetic ideas of cubism.

ADDITIONAL READING

Browne, Turner, and Elaine Partnow, eds. *Encyclopedia of Photographic Artists and Innovators.* New York: Macmillan, 1983.

Cummings, Paul. *Dictionary of Contemporary Artists.* 6th ed. New York: St. Martin's Press, 1994.

Dawdy, Doris Ostrander. *Artists of the American West: A Biographical Dictionary.* Chicago: Sage Books, 1974.

Eldredge, Charles C., Julie Schimmel, and William H. Truettner. *Art in New Mexico, 1900–1945: Paths to Taos and Santa Fe.* New York: Abbeville Press, 1986.

Falk, Peter Hastings, ed. *Who Was Who in American Art, 1564–1975: 400 Years of Artists in America.* 3 vols. Madison, Conn.: Sound View Press, 1999.

The Getty (The J. Paul Getty Trust). "Union List of Artist Names Online." http://www.getty.edu/research/conducting_research/vocabularies/ulan/

Hillstrom, Laurie Collier, and Kevin Hillstrom, eds. *Contemporary Women Artists.* Detroit: St. James Press, 1999.

Hughes, Edan Milton. *Artists in California, 1786 1940.* 2nd ed. San Francisco: Hughes Publishing, 1989.

———. *Artists in California: 1786–1940.* 3rd ed. Sacramento: Crocker Art Museum, 2002.

Johnstone, Mark. *Contemporary Art in Southern California.* Sydney, Australia: Craftsman House, 1999.

Kovinick, Phil, and Marian Yoshiki-Kovinick. *Women Artists of the American West.* Austin: University of Texas Press, 1998.

Landauer, Susan, William H. Gerdts, and Patricia Trenton. *The Not-So-Still Life: A Century of California Painting and Sculpture.* Berkeley and San Jose: University of California Press and San Jose Museum of Art, 2003.

Lester, Patrick D. *The Biographical Directory of Native American Painters.* Tulsa: SIR Publications, 1995.

Matuz, Roger, ed. *St. James Guide to Native North American Artists.* Detroit: St. James Press, 1998.

Mautz, Carl. *Biographies of Western Photographers: A Reference Guide to Photographers Working in the Nineteenth Century American West.* Nevada City, Calif.: Carl Mautz, 1997.

McGlaufill, Alice Coe, ed. *Dictionary of American Artists: Nineteenth and Twentieth Century.* Poughkeepsie, N.Y.: Glen Opitz/Apollo Book, 1982.

McGowan, Alison C., ed. *Who's Who in American Art, 2003–2004.* New Providence, N.J.: Marquis, 2003.

Moss, E. Lynne. "Rendering the Forces of Nature." *American Artist,* January 1998, 32–36.

Moure, Nancy Dustin Wall. *California Art: 450 Years of Painting and Other Media.* Los Angeles: Dustin Publications, 1998.

Naylor, Colin, ed. *Contemporary Photographers.* 2nd ed. Chicago: St. James Press, 1988.

Robertson, David. *West of Eden: A History of the Art and Literature of Yosemite.* Yosemite, Calif.: Yosemite Natural History Association and Wilderness Press, 1984.

Samuels, Peggy, and Harold Samuels. *The Illustrated Biographical Encyclopedia of Artists of the American West.* Garden City, New York: Doubleday, 1976.

Struth, Thomas. *New Pictures from Paradise.* Munich: Schirmer/Mosel Production, 2002.

Truettner, William H., ed. *The West as America: Reinterpreting Images of the Frontier, 1820–1920.* Washington, D.C.: Smithsonian Institution, 1991.

University of California, Los Angeles. *Teaching Artists: The UCLA Faculty of Art and Design, October 7–November 9, 1986.* Los Angeles: Wight Art Gallery, UCLA, 1986.

ACKNOWLEDGMENTS

The idea that myth and history are powerful, interwoven forces in the creation of the American West was at the heart of Gene Autry's vision in 1988 when he established the institution now known as the Autry National Center. It is notable that Autry's museum went beyond his own cinematic legacy to reveal a much more profound understanding of the West as a place both real and invented, a place of historic consequence and contemporary distinction, a place full of diversity and situated within a unique environment. His acquisition in 1991 of Thomas Moran's third major Western painting, *Mountain of the Holy Cross* (1875), cemented the relevance of the Western landscape art to the broader mission of this new institution. In many ways, this publication and the exhibition it was designed to accompany are the product of Autry's original vision, for no landscape is more central to our obsession in the West with mythic places and historic destinations than Yosemite National Park.

What began as a relatively straightforward concept—to assemble a major exhibition on this landscape of artistic and historic consequence—soon evolved into a far-reaching effort to reveal the ways that artists have shaped Yosemite's cultural image and attendant value. It has been an ambitious undertaking, one realized only through the contributions of many individuals and institutions. The blend of iconic images with artworks rarely seen, of established scholarship and new research, was shaped substantially by an advisory panel that met annually at the museum for three successive years. Though panel members came from many institutions and fields, all were Yosemite devotees who gave generously of their time and insights. Foremost among them are the authors of this book: independent scholar Brian Bibby; William Dev-

erell of the Huntington-USC Institute on California and the West; Gary F. Kurutz of the California State Library; Kate Nearpass Ogden of the Richard Stockton College of New Jersey; and Jennifer A. Watts of the Huntington Library, Art Collections, and Botanical Gardens. The advisory panel was further served by the participation of Harvey Jones and Drew Heath Johnson of the Oakland Museum of California; Craig Bates, Barbara Beroza, and David Forgang of the Yosemite Museum; Bob Hansen of the Yosemite Fund; and independent scholar Patricia Trenton. Present at our first two meetings also was the distinguished California photo historian and collector Peter Palmquist. Peter's sheer enthusiasm for Yosemite—its aesthetic significance and impact on nineteenth-century photographers—was unrivaled and infectious, and both the exhibition and this publication were substantially improved by his involvement prior to his death in November 2003.

Assembling an exhibition about a place with such a profound visual history as Yosemite's requires that many lenders part with significant and/or large groups of works for some time. My thanks go to both the individuals and the institutions who lent graciously and generously: Brian Allen, Addison Gallery of American Art; Brad Anderholm, DNC Parks and Resorts at Yosemite, Inc.; Julie Armistead, Hearst Art Gallery; Scott Atkinson, Crocker Art Museum; Stephen Becker, Maren Jones, and David Crosson, California Historical Society; Timothy Burgard, Fine Arts Museums of San Francisco; John Cahoon, Seaver Center for Western History Research; Kevin Conche, University of California, Berkeley Art Museum; Sean Corcoran, George Eastman House; Alma Lavenson Associates; Weston Naef, J. Paul Getty Museum; Ana and Deryck O'Brien, Bruce Robertson, and Robert Sobieszek, Los

Angeles County Museum of Art; John Petersen and Hal Fischer, Timken Museum of Art; Matt Roth and Morgan Yates, Auto Club of Southern California; Tod Ruhstaller, Haggin Museum; Britt Salveson and Marsha Tiede, Center for Creative Photography; Karen Sinsheimer, Santa Barbara Museum of Art; Jessica Smith and Jennifer A. Watts, Huntington Library, Art Collections, and Botanical Gardens; Jean Stern and James Swindon, Irvine Museum; Rick Stewart, Amon Carter Museum; and, of course, Mark Medeiros, Drew Heath Johnson, and Harvey Jones of the Oakland Museum of California.

This exhibition and publication were also heavily dependent on the generosity of private collectors, whose commitment equaled that of their institutional counterparts. Collectively, they made a substantive contribution to the unique group of works and media seen here; many of these artworks were brought together for the first time due to their generosity. I am grateful to Jan Adams, Nick and Mary Alexander, Ann and Robert Arns, Paul and Kathleen Bagley, Robert and Margaret Bayuk, Patty Burnett and Robert Burdick, Diane B. Lloyd Butler, Roger and Kathy Carter, Susan Ehrens and Leland Rice, Jim Farber, Marilyn and Calvin Gross, Eldon Grupp, Stuart Handler, Kimi Kodani Hill, Moni Kondos, Jeanie Lawrence, Trudy and Oscar Lemer, Elizabeth Lovins, Nancy and Lester McKeever, Kenneth B. Noack, Jr., Brian F. O'Neill and Robert English, Meg and Elizabeth Partridge, Mr. and Mrs. Gene Quintana, and Ranson and Norma Webster for the consideration they showed.

Dealers were also a source of invaluable information, and this project is indebted to those who answered numerous queries, helped locate specific works, and aided in our conversations with collectors and artists. They include Elizabeth Beaman and Alexis Thoman, Sotheby's New York; Gretchen and John Berggruen, John Berggruen Gallery; Justin Black, Mountain Light Gallery; Len Braarud, Braarud Fine Art; Frish Brandt and Dawn Troy, Fraenkel Gallery; Kimberly Davis, LA Louver; Thomas DeDoncker, Thomas DeDoncker Fine Art; Eleana Del Rio, Koplin

Del Rio Gallery; Michael Frost, J. N. Bartfield Galleries; Whitney Ganz, Karges Fine Art; Joel Garzoli, Garzoli Gallery; Lilly and Lyle Gray, Babcock Galleries; Alfred Harrison, North Point Gallery; Phyllis Hattis, Phyllis Hattis Fine Arts; Susan Herzig and Paul M. Hertzmann; Stephen Johnson; Meredith Nix and Gayle Maxon-Edgerton, Gerald Peters Gallery; Lisa Peters and Peter Fairbanks, Montgomery Gallery; Ralph Sessions, Spanierman Gallery; Gretchen and Barry Singer, Barry Singer Gallery; George Stern, George Stern Fine Art; Turkey Stremmel, Stremmel Gallery; Meredith Ward, Meredith Ward Fine Art; and Mark Zaplin and Richard Lampert, Zaplin Lampert Gallery.

Of course, this project would not have been complete without the interest and involvement of many of Yosemite's best contemporary artists, several of whom created new work, seen here for the first time. To all of the artists whose work has made Yosemite come alive as a vital and relevant contemporary landscape, I extend my thanks and gratitude. The works of Dugan Aguilar, Raymond Andrews, Matt Bult, Glenn Carter, Jane Culp, Judy Dater, Bruce Davidson, John Divola, Kristina Faragher, Harry Fonseca, Gus Foster, Tony Foster, Alyce Frank, Brian Grogan, Wanda Hammerbeck, David Hockney, Wolf Kahn, Bruce Klein, Mark Klett and Byron Wolfe, Greg Kondos, Susan LeVan, Roger Minick, Richard Misrach, Marina Moevs, David Mussina, Don Nice, Ted Orland, Julia Parker, Rondal Partridge, Richard and Tina Savini, Phyllis Shafer, Stephen Shore, Thomas Struth, Don Suggs, Wayne Thiebaud, Jerry Uelsmann, Theodore Waddell, J. Michael Walker, and Barbara Zaring are shown here alongside those of their predecessors, from Albert Bierstadt and Ansel Adams to Carrie Bethel, demonstrating that Yosemite's grip on the contemporary imagination remains firm.

I am privileged to work on a daily basis with a crew of gifted professionals at the Autry National Center, and this exhibition and publication also reflect their considerable talents and devotion. The very concept for the exhibition began with senior curator Michael Duchemin, whose 1998 exhibition *Western Wonderlands: Touring America's National Parks* set a prece-

dent and provided a model. The present project received a major boost at the outset from the substantial body of research that historian Louise Pubols conducted prior to 2000. Additional support and encouragement came from John Gray, president and CEO; Stephen Aron, executive director of the Institute for the Study of the American West; and Jonathan Spaulding, executive director of the Museum of the American West. The management of the exhibition and the publication was handled at the museum with finesse by Laleña Lewark and Marlene Head, respectively, while the elegant and outstanding presentation of the same was made possible by Andi Alameda, Dawn Benander, Kate Bergeron, David Burton, Evelyn Davis, George Davis, Eric Gaard, Tessa Gonzalez, Kimberly Hernandez, Sandy Lee, Mark Lewis, Cheryl Miller, Anna Norville, Sandra Odor, Joanna Pollock, Linda Strauss, Laureen Trainer, Marilyn Van Winkle-Kim, Maria Ventura, and Elsie Walton. Welcome guidance and support also came from Eric Engles, as well as UC Press editors Deborah Kirshman, Sigi Nacson, and Sue Heinemann. Deborah, Sigi, and Sue helped guide us through every step of production and are ultimately responsible for this handsome volume.

A final round of thanks and special tribute go to Mrs. Gene Autry, the Autry National Center Board of Trustees, the Yosemite Fund, and the Auto Club of Southern California for their support of *Yosemite: Art of an American Icon*. This exhibition and publication are ultimately the product of their stewardship and understanding of the power of art to shape the West, its landscape, and its peoples in meaningful and long-lasting ways.

INDEX

Page numbers in italics refer to illustrations.

CONTRIBUTORS

BRIAN BIBBY is an independent scholar who organized the exhibitions *The Fine Art of California Indian Basketry* (Crocker Art Museum, Sacramento) and *Precious Cargo: California Indian Baby Baskets and Childbirth Traditions* (Marin Museum of the American Indian). His work with Yosemite National Park includes reports on the "Native American Cultural Landscape" (1994), "Native American Oral History Project" (1995–97), and "The Ethnogeography of Yosemite National Park" (2002).

WILLIAM DEVERELL is professor of history at the University of Southern California and director of the Huntington-USC Institute on California and the West. He is the author of *Railroad Crossing: Californians and the Railroad, 1850–1910* (1994) and *Whitewashed Adobe: The Rise of Los Angeles and the Remaking of the Mexican Past* (2004), and he edited *The Blackwell Companion to the American West* (2004).

GARY F. KURUTZ is director of special collections at the California State Library in Sacramento. He has written extensively on Western pioneer photography, rare Californiana, and California Gold Rush literature. He has created several exhibitions devoted to early photography and has published multiple works on California photography and booster history.

KATE NEARPASS OGDEN is associate professor of art history at the Richard Stockton College of New Jersey. Her areas of concentration are American art, nineteenth- and twentieth-century European art, and the history of photography. She wrote her dissertation on nineteenth-century painting and photography in Yosemite.

AMY SCOTT is curator of visual arts at the Museum of the American West at the Autry National Center. Previously, she was a curator at the Gerald Peters Gallery in Santa Fe, where she produced exhibitions and publications on Western American and European art. Scott received her M.A. in art history from the University of Missouri in Kansas City, where she also worked as a curatorial associate at the Nelson-Atkins Museum of Art and an art history instructor at Park College. She is enrolled in the Ph.D. program in visual studies at the University of California, Irvine.

JONATHAN SPAULDING is executive director and chief curator at the Museum of the American West at the Autry National Center. His publications include *Ansel Adams and the American West: A Biography* (1995).

LAUREEN TRAINER is associate director of education at the Autry National Center's Museum of the American West. She received her M.A. in art history from the University of Arizona and has worked at the Philadelphia Museum of Art, the Art Institute of Chicago, and the Zimmerli Art Museum at Rutgers University.

JENNIFER A. WATTS is curator of photographs at the Huntington Library, Art Collections, and Botanical Gardens in San Marino, California. She has organized exhibitions on panoramic photography of the American West and water in Los Angeles, as well as ones showcasing the work of Mark Klett, Robert Shlaer, and Edward Weston. With Claudia Bohn-Spector, she coauthored *The Great Wide Open: Panoramic Photography of the American West* (2001), named the top catalogue by the American Library Association in 2002. She also edited *Edward Weston: A Legacy* (2003).

THIS BOOK IS PUBLISHED IN CONJUNCTION WITH THE EXHIBITION
YOSEMITE: ART OF AN AMERICAN ICON, ORGANIZED BY THE AUTRY NATIONAL CENTER:

AUTRY NATIONAL CENTER, LOS ANGELES
PART I: SEPTEMBER 22, 2006–JANUARY 21, 2007; PART II: NOVEMBER 10, 2006–APRIL 22, 2007

OAKLAND MUSEUM OF CALIFORNIA
MAY 19–SEPTEMBER 2, 2007

NEVADA MUSEUM OF ART, RENO
OCTOBER 13, 2007–JANUARY 13, 2008

EITELJORG MUSEUM OF AMERICAN INDIANS AND WESTERN ART, INDIANAPOLIS
MARCH 22–AUGUST 9, 2008

University of California Press, one of the most distinguished university presses in the United States, enriches lives around the world by advancing scholarship in the humanities, social sciences, and natural sciences. Its activities are supported by the UC Press Foundation and by philanthropic contributions from individuals and institutions. For more information, visit www.ucpress.edu.

University of California Press
Berkeley and Los Angeles, California

University of California Press, Ltd.
London, England

Autry National Center
Los Angeles, California

Front illustrations, opposite title: detail from Mark Klett and Byron Wolfe, *Clearing Autumn Smoke, Controlled Burn* (p. 147), © Mark Klett and Byron Wolfe; opposite contents: detail from Gregory Kondos, *El Capitan, Yosemite* (p. 177), © Gregory Kondos.

Text: 9.25/13 Scala
Display: DIN, Scala

Sponsoring editor: Deborah Kirshman
Assistant editor: Sigi Nacson
Project editor: Sue Heinemann
Editorial assistants: Lynn Meinhardt, Anne Smith
Copyeditor: Jennifer Knox White
Indexer: Ruth Elwell
Designer: Nola Burger
Production coordinator: John Cronin
Compositor: Integrated Composition Systems
Printer and binder: Friesens

Library of Congress Cataloging-in-Publication Data

Yosemite : art of an American icon / edited by Amy Scott.
 p. cm.
 Catalog of an exhibition at the Museum of the American West, Autry National Center, Los Angeles, Sept. 22, 2006–Apr. 22, 2007; Oakland Museum of California, May 19–Sept. 2, 2007; Nevada Museum of Art, Oct. 13, 2007–Jan. 13, 2008; Eiteljorg Museum of American Indians and Western Art, Mar. 22–Aug. 9, 2008.
 Includes bibliographical references and index.
 ISBN-13: 978-0-520-24921-9 (cloth : alk. paper)
 ISBN-10: 0-520-24921-6 (cloth : alk. paper)
 ISBN-13: 978-0-520-24922-6 (pbk. : alk. paper)
 ISBN-10: 0-520-24922-4 (pbk. : alk. paper)
 1. Yosemite National Park (Calif.)—In art—Exhibitions. 2. Landscape painting, American—California—Yosemite National Park—Exhibitions. 3. Landscape photography—California—Yosemite National Park—Exhibitions. 4. Indian art—California—Yosemite National Park Region—Exhibitions. I. Scott, Amy, 1971– . II. Autry National Center. III. Oakland Museum of California.
 N8214.5.U6Y56 2006
 759.194'47—dc22 2006012105

Manufactured in Canada

15 14 13 12 11 10 09 08 07 06
10 9 8 7 6 5 4 3 2 1

The paper used in this publication meets the minimum requirements of ANSI/NISO Z39.48–1992 (R 1997) (*Permanence of Paper*).